First published Halloween 2001 by
Strega
an imprint of FAB Press
PO Box 178, Guildford, Surrey, GU3 2YU, England, UK

www.fabpress.com/strega/

A CIP catalogue record for this book is available from the
British Library

ISBN 1-903254-12-4

Further information about Halloween can be found at the author's website:
www.thehalloweenbook.com

Halloween

PAGAN FESTIVAL TO TRICK OR TREAT

MARK OXBROW

STREGA

Acknowledgements

With thanks to all my family and friends - especially Craig for his invaluable typing, the Beltane and Samhuinn crews, Caitlin and Angus for putting up with me, Harvey and Debs for believing in me, Alison at the Royal Museum, David at the City Arts Centre, Susan at Groam House Museum, Manfred Jahreiß for the front cover picture, Tig for the Calanais photos, Anna, Julie and Jake the raven, the guardian of the Witches' Well, Claudine and Herve, Rochelle at the Global Halloween Alliance, Christopher for his Celtic Studies, Jon of 'American Nightmare', the 'prank queen' of the NYC Halloween Parade, Brandi at Voodoo Authentica, Timandra, Richard for Haiti weirdness, Alison at Polygon, the National Library of Scotland, the Museum of Scotland, the wonderful Sauniere Society folks and anyone else I've just forgotten...

Contents

This book is dedicated to The Cailleach Bheur and the Powerpuff Girls.
(Don't ask...)

Invitation

I once met a storyteller.

He had just told a wild tale of faeries and goblins to a pack of wide-eyed children. As they dispersed I wandered over and thanked him, then asked him a little question: "What sort of story do people like best?"

He smiled and told me how he knew all sorts of short stories and tall tales, adventures and ripping yarns, comedies, tragedies, love stories, epics and tiny twee faery stories. He had been all over the world and told his tales to everyone from young children to village elders and whenever he asked what kind of story they would like to hear the answer was always the same:

"Tell me a scary story."

So, would you like to hear a scary story?

Within these pages is the fantastical secret history and evolution of Halloween.

Witches, ghosts, skeletons and things that go bump in the night hold a strange fascination the world over and one night above all has become synonymous with the whole pandemonium: Halloween – October 31st – is an annual spookfest that has grown into a multimillion-dollar industry. Money wise it is now the largest 'secular' festival in the world and is second only to Christmas in dollars spent. But truly Halloween is not a celebration which demands plastic monster masks and gallons of fake blood – all you really need is a few candles, a sheet with a couple of eyeholes, a cunningly carved lantern and, most importantly, lots of friends to share the scary stories.

This book has at its heart a journey - a quest. The journey began thousands of years ago with the earliest myths from around the world as our ancestors watched the stars in the night sky and plotted their motions, created their calendars, worked rituals and magic. On our quest we will meet with ancient Goddesses – the queens of winter – and watch as they are slowly transformed from deity to hag, fallen from grace to fairytale witches. From the lands of 'the Celts' with their feast of Samain we will cross the threshold into the lands of Faerie. This is a journey deep into the shadows of history and our path leads us to the darkest of times as thousands of men, women and children were tortured, hanged and burned – accused of witchcraft and devil worship.

Samain was the ancient threshold between summer and winter. We will cross over into the dark half of the year and venture into the inky blackness of subterranean caves to meet the dead of winter.

Halloween has been condemned and attacked by rightwing religious fundamentalists who have sought to have the festival banned from schools and have mounted a concerted campaign of hatred and misinformation against its celebration. But what are the facts behind their allegations and what is the truth of Christianity's lasting influence on All Hallows' Eve? In the pages of this book I will attempt to illuminate the hidden secrets of Halloween and, as with any half-decent quest, we will emerge from the dark into the real world a little wiser and wee bit more enlightened.

For me this book is the end of a rather personal journey that has seen my life disintegrate and be gradually reconstructed. Rest assured that this is the only bit of this book where you'll find me poring over my own weird tale – you can happily ignore this and turn to the first chapter! But some of you might like to know who I am, and how I came to be writing this book.

For over a decade I have been learning, researching and investigating folktales, witch and faery lore, the dark goddess - 'the Cailleach Bheur' - and the history and customs of Samain and Halloween. I sought to find the real roots of the festival I knew and loved. It seems the things I found equally found me and as I learned about the Cailleach she noticed my attention. I never knew why I felt the winter months so keenly and had a primal need to mark its onset and its end. For years I have been involved in the Beltane Fire Festival in Edinburgh and helped in a little way to keep the fires burning on May eve. In time I had the opportunity to bring together the diverse talents of hundreds of Beltane folk to create the Samhuinn Festival in the very heart of the City's Old Town.

The Halloween festi grew and flourished but my life became somehow bound to winter's dawn and the influence of its dark goddess. Three years ago on the eve of Halloween night I directed a rehearsal for the Samhuinn Festival. It was a dire, cold night and we trudged down from the Castle to the shadow of St Giles and ran through the next evening's performance. As we finished my brother unexpectedly showed up. He looked worried and told me that our father hadn't been in touch for a day or two and wasn't answering his phone. For a couple of months my father had been pretty down and the combination of prescribed drugs he had to take for epilepsy, insomnia and anxiety weren't helping. My girlfriend drove us to his house and we found all the lights off and his car sat in the driveway. When we got no response from inside we called the police. They broke the front door in and found my father lying in bed. He had attempted to take his life. Empty pill bottles lay strewn in the kitchen and family photos lay by his side. Nothing seemed very real. He was still breathing and his heart was slowly beating as the ambulance came and took us to intensive care. As they hooked him up to machines to keep him alive and made a list of the drugs he had taken I started to make the phone calls to everyone.

Halloween was very real. I woke wondering if I had dreamed it all, then it flooded back in a disjointed blur. I went to the hospital and was told how close my father had come to dying. Tubes with air and fluids and blood stuck out of him. The doctor couldn't be sure about his chances of survival – if he made it through that night he might be strong enough to live. That night – Halloween night. My girlfriend was the only one who knew as the Samhuinn Festival noisily processed down the Royal Mile. Painted dancers wheeled and leapt, drummers pounded out driving rhythms, the night was lit up with cascading fireworks and burning torches. We screamed and frolicked and turned the real world upside down. We were lords and ladies of misrule, reigned over by the Queen of Winter... the Cailleach Bheur.

We have only ever had one lady who plays the Cailleach. I knew she was the one when we first met and she takes on the role as though she was born to it. We affectionately know her as 'Girl Tom'. That night she crept, in total silence, down the cobbled street, in the midst of the chaos, enshrouded in her black velvet cloak. She stood and watched the bedlam of the summer and winter courts, the duel of the winter and summer kings and then finally she was revealed. Her skin was a deep rich blue, her waist-length hair whipped about her, the intricate copper bodice that clung to her shone in the firelight as she seethed, grasped at the sky, twisting and writhing with life.

The next morning was cold and clear. Winter was here and I scrubbed smeared bodypaint from my skin then made my way to the hospital. My father was still unconscious but at least he was still alive. The nurses said reassuring things and painfully slowly he recovered. As the weeks and months went by he grew coherent and gradually regained the use of the half of his body where the blood had pooled. He could walk and talk and smile and there, walking the black and white tiled corridors of the Hospital, was 'Girl Tom' as her real self – out of costume and character – with her hair neatly tied up and in the white uniform of her day job.

That winter was dark and unforgiving. It ate away at me and the following winter I fell into my own fight against depression and learned that the winter dragon that I was battling was a merry little inherited illness. I lost my girlfriend and my home to it. It tore me to pieces and took my life apart around me.

For the last year or so I've been on the mend and I'm well enough to know that the quest has been the making of me. I met my darkest fears and survived them. The Festival of Halloween has taken on a deeper significance for me – it is the one night where in some way we all face up to death and defeat it with every dance and scream and smile. It's as though we fall into the grave then climb back out and remember how good it is to be alive.

This book is my attempt to put all the feelings and magic of the night into words, to dissect our fascination with fear and fright, to illuminate the dark Queen of Winter and to chronicle the curious, phantasmagorical history of Halloween.

above:
Vintage Halloween
card.

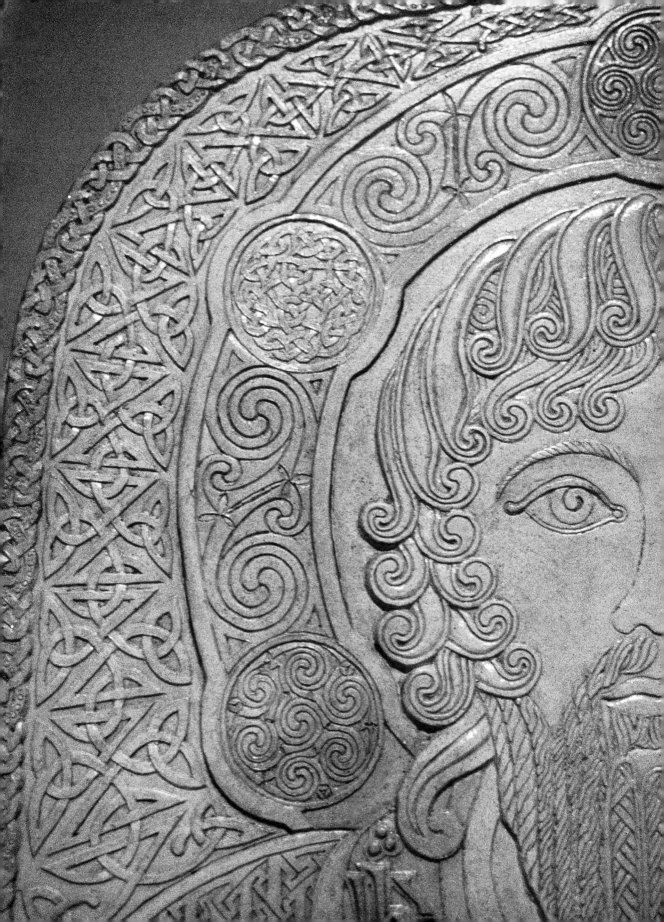

Summers End

The Coming of Winter

I have news for you; the stag bells, winter snows, summer has gone.
Wind high and cold, the sun low, short its course, the sea running high.
Deep red and bracken, its shape is lost; the wild goose has raised its
accustomed cry.
Cold has seized the birds' wings; season of ice, this is my news.
[1]

Most texts that document the history of Halloween begin with 'the Celtic Festival of Samhain' and relate that this was the 'Celtic Festival of the Dead.' Is there truly any evidence that this was a religious festival - were there Druid priests practising ritual human sacrifice - was there ever a 'Celtic Festival of the dead'?

'The Celts' have been portrayed as bloodthirsty barbarians, romantic and mystical warriors and pagan nature worshippers. But just who in reality were 'the Celts' and how did they really celebrate Samhain?

Halloween falls at the end of October - at the turning of the year when summer ends and winter begins. In Celtic times this time was known as the feis of Samain. There are a multitude of spellings depending on the manuscript consulted or the nationality of the Gaelic rendering. In the modern Gaelic languages the festival is called Samhain (Irish), Samhuinn (Scots Gaelic), and Sauin (Manx).

In the 'Q' Celtic or Goidelic languages of Scots and Irish Gaelic Samhuinn literally means 'summer's end' - the 'end' or 'concealment' of the summer half of the year. In Scotland and Ireland, Halloween is the night on which it begins - Oíche Shamhna in Irish, Oidhche Shamhna in Scots Gaelic, Oie Houney in Manx.

In the 'P' Celtic or Brythonic languages Nos Calan Gaeaf is the 'eve of the winter's calend' or the first of the winter half of the year. They borrow the Latin term 'calenda' to form Calan Gaeaf in Welsh, Kala-Goañv in Breton and Kalann Gwav in Cornish.

Any exploration of what Samhuinn was and what it may have meant to the Celts must first tackle the thorny issue of who 'the Celts' were in the first place. Ideas about 'the

opposite:
Celtic Design
by George Bain.

(Courtesy of Groam House Museum, Rosemarkie, Scotland. http://www.cali.co.uk/HIGHEX P/Fortrose/Groam.htm)

Celts' have undergone a huge revision in the last few years and the vast majority of books on the subject are now outdated - their basic foundations have been undermined.

There were no such people as 'the Celts'. Those folk who are commonly referred to as 'the Celts' were actually the members of numerous independent tribes. They were not a single united group like our modern countries and kingdoms. These were separate warring tribes - each with their own individual identity.

What made these tribes 'Celtic' was not their race or location but their shared culture; they spoke a similar set of languages, were highly skilled in working iron and precious metals, held like beliefs, and their common culture expressed itself through their visual art, epic tales, poetry and songs.

It is this 'Celtic culture' that binds the disparate Iron-Age tribes of Europe together. 'Celtic culture' is said to begin with the Hallstadt culture and flower with the La Tene culture. It was until recently thought that 'the Celts' were a race that had invaded the British Isles and become dominant because of their superior iron weapons. But now the accepted wisdom is that the British 'Celts' were in fact the same native tribes who had inhabited the isles during the Bronze Age and who then went on to adopt the new 'Celtic culture' at some time between 900 and 600 BC.

Archaeology can tell us a lot about the Celtic tribes. Through the study of artefacts and the excavation of their sacred enclosures; votive pits and shafts and from the finds of votive offerings discovered in bogs, lakes and lochs we can build a picture of some of their religious practices. Examination of their homes and everyday objects tells us how they lived and forensic examination of skeletal remains tells us how they died. But looking for written sources to accompany these material artefacts is frustrating.

We have to turn to the writings of the Greek and Roman chroniclers to find contemporary descriptions of 'the Celts' and these are generally propaganda materials depicting the Celtic peoples as bloodthirsty unhygienic barbarians.

Native literature, such as the Irish texts, was not written down until early mediaeval times and was the work of Christian monks in the Tenth Century. By then the British Isles had been Christian for centuries and even when the ancient Celtic tales and verse were faithfully transcribed their meanings were long forgotten, their symbols indecipherable. But despite the fact that references to Samhuinn are fragmentary we can piece together an impression of what the festival was and how it fitted into the Celtic culture.

There are numerous books on the Druids. They range from the scholarly academic tomes to the mystical New Age books on practical Druidry for beginners. What is quite staggering is in fact the almost total lack of source material that we have for their existence. From the same few scraps of evidence it has been argued that the

Druids were primitive shamanic wild-men dressed in animal skins and that they were highly sophisticated Pythagorean philosopher-magi in elegant white robes. Whoever the Druids were and whatever their rites and practices were, we have a contemporary description of their destruction that gives us some hint of their power. In 61 AD on the island of Mona, now known as Anglesey, the sacred Druid sanctuary had become a centre for resistance against the might of the Roman invasion. In the sacred lake, Llyn Cerrig Bach in Anglesey, over a hundred and fifty votive offerings were found - weapons and Celtic aristocratic ornaments - gifts for the gods.

...Britain was in the hands of Suetonius Paulinus, who in military knowledge and in popular favour, which allows no one to be without a rival, vied with Corbulo, and aspired to equal the glory of the recovery of Armenia by the subjugation of Rome's enemies. He therefore prepared to attack the island of Mona, which had a powerful population and was a refuge for fugitives. He built flat-bottomed vessels to cope with the shallows, and uncertain depths of the sea. Thus the infantry crossed, while the cavalry followed by fording, or, where the water was deep, swam by the side of their horses.

On the shore stood the opposing army with its dense array of armed warriors, while between the ranks dashed women, in black attire like the Furies, with hair dishevelled, waving brands. All around, the Druids, lifting up their hands to heaven, and pouring forth dreadful imprecations, scared our soldiers by the unfamiliar sight, so that, as if their limbs were paralysed, they stood motionless, and exposed to wounds. Then urged by their general's appeals and mutual encouragements not to quail before a troop of frenzied women, they bore the standards onwards, smote down all resistance, and wrapped the foe in the flames of his own brands. A force was next set over the conquered, and their groves, devoted to inhuman superstitions, were destroyed. They deemed it indeed a duty to cover their altars with the blood of captives and to consult their deities through human entrails.
[2]

What drives an army to utterly annihilate an island full of men and women - old and young alike? It is hardly an act of bravery to butcher unarmed women and burn their bodies. The Roman soldiers were not driven to the massacre by anger or by duty but by fear. What they saw on the sacred isle of Mona terrified them so much that they destroyed it utterly.

...women, in black attire like the Furies... the Druids, ...pouring forth dreadful imprecations, scared our soldiers ... so that, as if their limbs were paralysed, they stood motionless...

The Annals of Tacitus admit that the Roman soldiers – seasoned veterans – were paralysed with fear when they heard the Druid incantations and when they saw the women priestesses among the warriors. These women were dressed in flowing black robes and ran with their hair wild and with fiery torches in their fists – appeared to the Romans 'like the Furies' and here we find the source of their fear.

above:
Vintage Halloween
card.

We may find some insight into the thoughts and fears in the soldiers' minds by looking at extant Roman writings. In Livy's 'History of Rome' ca 10 AD we find a description of the 'Bacchantes' – a foreign religious cult that grew rapidly into the very heart of Rome.

...the women, in the habit of Bacchantes, with their hair dishevelled, and carrying blazing torches, ran down to the Tiber; where, dipping their torches in the water, they drew them up again with the flame...

Compare this with the description of the Druidesses on Mona.

...while between the ranks dashed women, in black attire like the Furies, with hair dishevelled, waving brands...

Tacitus was writing his Annals from Rome over forty years after the destruction of Mona – this was no eyewitness report. Was he influenced by Livy and the similarities he perceived between the Bacchantes and the Druidesses with their wild and exotic foreign rites?

The Romans had good reason to fear the Celts. In 386 BCE 'the Celts' had invaded Italy and sacked Rome – burning it to the ground and occupying the remains for seven months. Writings about the Celtic peoples must have only added to their reputation for brutality. The Druids in particular were thought to be drenched in the blood of human sacrifices – the colossus described below is the infamous 'wickerman'.

In Gaul, the heads of enemies of high repute they used to embalm in cedar oil and exhibit to strangers, and they would not deign to give them back even for a ransom of an equal weight of gold. But the Romans put a stop to these customs, as well as to all those connected with the sacrifices and divinations that are opposed to our usages. They used to strike a human being, whom they had devoted to death, in the back with a sword, and then divine from his death-struggle. But they would not sacrifice without the Druids. We are told of still other kinds of human sacrifices; for example, they would shoot victims to death with arrows, or impale them in the temples, or having devised a colossus of straw and wood, throw into the colossus cattle and wild animals of all sorts and human beings, and make a burnt offering of the whole thing.
[3]

But were the Roman soldiers standing in the cold waters facing the shrieking hordes on Anglesey scared by the stories they had heard or simply by the physical reality of the forces opposing them? They had faced formidable armies before and fought to the death. There was little reason that a raggle-taggle group of warriors, a few wizened Druids and some wild women could really pose much of a threat to the might of Rome.

Was there some deeper fear that drove them - a fear that the black-clad women who

ran wildly and screamed and streaked fire through the night air were not real women at all - these were some horrific supernatural beings?

The Furies were the fearsome avenging spirits of retributive justice - they punished crimes outwith the reach of human justice. But was it the Furies that the Roman soldiers thought stood opposing them or something far worse?

The Roman soldier in particular lived in fear of attack by 'the strigae.' These were witches who had the power to shapeshift and would suck the very life essence out of men - weakening them till they eventually died. The 'strix' was a witch who would remove her clothes and rub oil on her naked body - this rite allowed her to take the form of the screech owl and to fly by night to seek human prey.

In the 'Metamorphoses', Pamphile is seen stripping naked and speaking charms while rubbing her body with unguent until, '...*she shook all parts of her body, and as they gently moved, behold, I perceived a plume of feathers did burgeon out upon them, strong wings did grow, her nose became more crooked and hard, her nails turned into claws, and so Pamphile became an owl.*'

The strigae were thought to murder babies by stealing them from their cradles then suckling the infants to their poison breasts. Hekate was also known as Trioditis - Trivia in Latin - because she was the guardian of the three-fold Gate of the Underworld. She ruled over malevolent witchcraft, divination, dreams and visions and presided over birth and death. Serpents and owls were sacred to her and three strigae attended her.

> *Hekate of the Path, I invoke thee...*
> *dancing with dead souls the Bacchic rite...*
> *lover of the desolation of solitude...*
> *Ungirded, possessed of form unapproachable...*
> *Keeper of the Keys of all the Universe...*
> *I entreat, O Maiden,*
> *your presence at these sacred rites...*
> [Excerpts From An Orphic Hymn]

When the Romans stood, paralysed with fear as the black clad priestesses ran screaming back and forth on the far shore, did they see mere women or did they see the strigae screeching and tearing off their clothes? Did they slaughter the Celts and burn their groves as a simple strategic move or did they do it out of fear that these creatures would seek revenge and suck the very life from their bodies?

Still reeking with the scent of the burnt groves and smouldering bodies Suetonius and his men found that while they were decimating the isle of Mona there was a revolt on mainland Britain. The Romans had wronged Boudicca of the Iceni tribe. She had been whipped and her daughters raped and she raised an army from the tribes of the Celts and struck back.

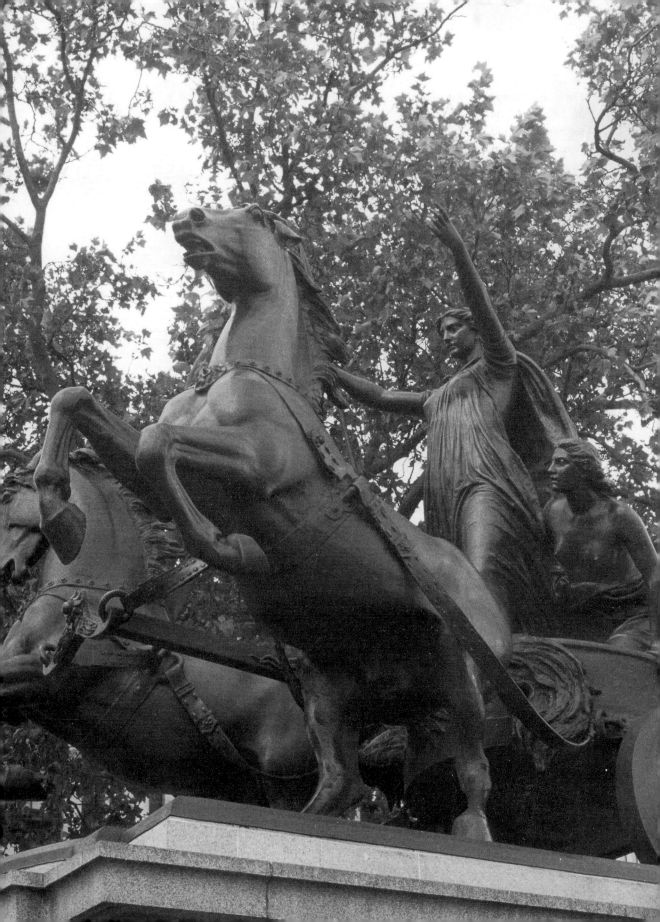

Suetonius while thus occupied received tidings of the sudden revolt of the province. Prasutagus, king of the Iceni, famed for his long prosperity, had made the emperor his heir along with his two daughters, under the impression that this token of submission would put his kingdom and his house out of the reach of wrong. But the reverse was the result, so much so that his kingdom was plundered by centurions, his house by slaves, as if they were the spoils of war. First, his wife Boudicea was scourged, and his daughters outraged. All the chief men of the Iceni, as if Rome had received the whole country as a gift, were stript of their ancestral possessions, and the king's relatives were made slaves. Roused by these insults and the dread of worse, reduced as they now were into the condition of a province, they flew to arms and stirred to revolt the Trinobantes and others who, not yet cowed by slavery, had agreed in secret conspiracy to reclaim their freedom. It was against the veterans that their hatred was most intense. For these new settlers in the colony of Camulodunum drove people out of their houses, ejected them from their farms, called them captives and slaves, and the lawlessness of the veterans was encouraged by the soldiers, who lived a similar life and hoped for similar licence....
[2]

Boudicca (long known as Boadicea) was queen of the Iceni tribe who were centred in modern-day Norfolk. Seeking retribution, she led her army to destroy the towns of Camulodunum (Colchester) and Londinium (London) massacring the Roman garrisons.

Suetonius, ... with wonderful resolution, marched amidst a hostile population to Londinium, which, though undistinguished by the name of a colony, was much frequented by a number of merchants and trading vessels. Uncertain whether he should choose it as a seat of war, as he looked round on his scanty force of soldiers, ...he resolved to save the province at the cost of a single town. Nor did the tears and weeping of the people, as they implored his aid, deter him from giving the signal of departure and receiving into his army all who would go with him. Those who were chained to the spot by the weakness of their sex, or the infirmity of age, or the attractions of the place, were cut off by the enemy...
[2]

Finally Boudicca's forces met with the legionnaires in a last decisive battle.

At first, the legion kept its position, clinging to the narrow defile as a defence; when they had exhausted their missiles, which they discharged with unerring aim on the closely approaching foe, they rushed out in a wedge-like column. Similar was the onset of the auxiliaries, while the cavalry with extended lances broke through all who offered a strong resistance. The rest turned their back in flight, and flight proved difficult, because the surrounding wagons had blocked retreat. Our soldiers spared not to slay even the women, while the very beasts of burden, transfixed by the missiles, swelled the piles of bodies. Great glory, equal to that of our old victories, was won on that day. Some indeed say that there fell little less than eighty thousand of the Britons, with a loss to our soldiers of about four hundred, and only

opposite:
Boadicea
Bronze statue of Boudicca and her daughters on their war chariot. This monument stands at one end of Westminster Bridge, near the Houses of Parliament in London.

(image © Mark Oxbrow)

as many wounded. Boudicea put an end to her life by poison.
[2]

Boudicca took her own life in defeat and local legend tells that she was buried on the site of that last fateful battle – beneath platform 10 of today's King's Cross Station. [http://www.findagrave.com/pictures/6497.html]

Though the Celtic peoples of much of mainland Britain were Romanised, the Celtic tribes of Caledonia (the Roman name for Scotland) beyond the Antonine wall and the whole of Ireland were never conquered or assimilated. There the Celtic culture survived and many of its myths and legends were transcribed in later Christian monasteries.

In a tale known as 'The Wasting Sickness of Cú Chulaind and the Only Jealousy of Emer' the annual assembly at Mag Muirthemni was held over Samuin.

Each year the Ulaid held an assembly: the three days before Samuin and the three days after Samuin and Samuin itself. They would gather at Mag Muirthemni, and during these seven days there would be nothing but meetings and games and amusements and entertainments and eating and feasting. That is why the thirds of Samuin are as they are today.
[4]

...As well as meetings, games, entertainments and copious amounts of drinking and feasting Samuin was marked by attacks by strange supernatural women...

Cú Chulaind walked on until he sat down with his back against a stone; he was angry but sleep overcame him. While sleeping he saw two women approach: one wore a green cloak and the other a crimson cloak folded five times, and the one in green smiled at him and began to beat him with a horse whip. The other woman then came and smiled also and struck him in the same fashion, and they beat him for such a long time that there was scarcely any life left in him. Then they left.
[4]

It is interesting to see that sitting against a standing stone led to dreams of otherworld women.

We also find that Samuin features in 'The Wooing of Etain' and 'The Dreams of Oengus'. In 'The Intoxication of the Ulaid' we are given another description of the feis of Samuin and its accompanying drink.

The province was thus divided into thirds for a year, or until Conchubur held the feis of Samuin at Emuin Machae. One hundred vats of every kind of drink were provided, and Conchubur's officers said that the excellence of the feast was such that all the chieftains of Ulaid would not be too many to attend.
[4]

We have no grim descriptions of a 'Celtic festival of the Dead'. These are not solemn rites or mournful gatherings; they are the liveliest social events of the season.

In the 'Dictionary of Celtic Mythology' we find the following description.

Samain (old Ir.) Samhain (mod Ir.) Samhuinn (sc. G.) Sawin (Manx)
> *'By abundant testimony, Samain was the principal calendar festival of early Ireland. Each of the five provinces sent assemblies to Tara for a feis held every third year.'*
> *'In part Samain ceremonies commemorated the Dagda's ritual intercourse with three divinities, the Morrigan, Boand, and Indech's unnamed daughter... in Irish and Scottish Gaelic oral tradition, Samain time is thought the most favourable for a woman to become pregnant.'*
[5]

Hardly suitable activities for a 'festival of the dead' but we do find this was a time of supernatural attacks as with this tale of the destruction of Tara.

Aillén mac Midgna - the 'burner' who brought destruction upon Tara
Aillén was a fairy musician of the Tuatha Dé Danann who resided at the sídh Finnachaid... Every Samain (Hallowe'en), Aillén would come to Tara playing his timpán. After the men of Tara were lulled to sleep by his music, Aillén would spew forth flames from his mouth and burn the dwelling to the ground. Each year Tara would be rebuilt, and for each of twenty-three years Aillén returned, until Fionn mac Cumhaill arrived on the scene. The hero first made himself immune to Aillén's musical charms by inhaling the poison of his own spear, whose point was so venomous as to forbid sleep. After this Fionn skewered Aillén with his poisoned point.
[5]

One of the best things about going back to the original sources and translations is that you find out what other writers and academics have chosen to omit. In Ronald Hutton's 'The Stations of the Sun' he joins virtually every book on 'the Celts' that quotes the 'Tochmarc Emire' on Samhain by simply stating.

'Samhain, when the summer goes to its rest.'
Tochmarc Emire in The Tain, trans. Thomas Kinsella, 1970

That's it. No context - no explanation of why it is there or what purpose it serves. Then I sat down and read the whole translation of the Tochmarc Emire. There I was, sitting in the silent, austere confines of the National Library of Scotland, quietly reading when I suddenly found myself trying to stifle my laughter and hide under the table as the other folk stared over at me.

Cúchulainn's courtship of Emer
Cúchulainn himself went to a place called the Gardens of Lug - Luglochta Logo - to

woo a girl he knew there. Her name was Emer... She was out on the green with her foster-sisters...
[6]

So far, so sensible. Cúchulainn is riding high in his chariot and spies the fair Emer amid a group of girls. He circles her, comes to a halt then engages in some Celtic hero style flirting...

Cúchulainn greeted the troop of girls and Emer lifted up her lovely face. She recognised Cúchulainn, and said:

"May your road be blessed!"
"May the apple of your eye see only good," he said.

They spoke together in riddles.
Cúchulainn caught sight of the girl's breasts over the top of her dress.
"I see a sweet country," he said. "I could rest my weapon there."

..."No man will travel this country," she said, "who hasn't gone sleepless from Samain, when the summer goes to its rest, until Imbolc, when the ewes are milked at spring's beginning; from Imbolc to Beltine at the summer's beginning and from Beltane to Brón Trogain, earth's sorrowing autumn."
[6]

You don't have to be a master of cunning sexual innuendo to figure out what Cúchulainn meant as he gazed on Emer's breasts and said, "I could rest my weapon there." You'll be glad to know that, like all good stories, this one has a happy ending with Cúchulainn, after many trials, finally winning Emer as his bride.

...and he slept ever after with his wife. They never parted again until they died.
[6]

'Cúchulainn's courtship of Emer' is filled with magical verse poetry...

> *At the doorway to the west,*
> *where the sun sets,*
> *a herd of grey horses, bright their manes,*
> *and a herd of chestnut horses.*
>
> *At the doorway to the east,*
> *three types of brilliant crystal,*
> *whence a gentle flock of birds calls*
> *to the children of the royal fort.*
>
> *A tree at the doorway to the court,*
> *fair its harmony;*

above:
Vintage Halloween
card.

a tree of silver before the setting sun,
its brightness like that of gold.

Three score trees there
whose crowns are meetings that do not meet.
Each tree bears ripe fruit.
For three hundred men.

There is in the síd a well
with three fifties of brightly coloured mantles,
a pin of radiant gold
in the corner of each mantle.

A vat of intoxicating mead
was being distributed to the household.
It is there yet, its state unchanging -
it is always full.
[6]

Here we find a wondrous place with richly laden fruit trees, a faerie mound with a well and an endless vat of mead. From these roots grew a thousand tales of faerie folks and enchanted otherworlds.

It is hardly surprising that with the harshness of winter almost upon them the Celtic peoples chose not to dwell on the coming storm but to indulge in one last glorious festival before the snow and ice.

Winter Cold
Cold, cold, chill tonight is wide Moylburg; the snow is higher than a mountain, the deer cannot get at its food.

Eternal cold! The storm has spread on every side; each sloping furrow is a river and every ford is a full mere.

Each full lake is a great sea and each mere is a full lake; horses cannot get across the ford of Ross, no more can two feet get there.

The fishes of Ireland are roving, there is not a strand where the wave does not dash, there is not a town left in the land, not a bell is heard, no crane calls.

The wolves of Cuan Wood do not get repose or sleep in the lair of wolves; the little wren does not find shelter for her nest on the slope of Lon.

Woe to the company of little birds for the keen wind and the cold ice! The blackbird with its dusky back does not find a bank it would like, shelter for its side in the Woods of Cuan.

Snug is our cauldron on its hook, restless the blackbird on Leitir Cró; snow has crushed the wood here, it is difficult to climb up Benn Bó.

The eagle of brown Glen Rye gets affliction from its bitter wind; great is its misery and its suffering, the ice will get into its beak.

It is foolish for you - take heed of it - to rise from quilt and feather bed; there is much ice on every ford; that is why I say 'Cold!'
[7]

But there were more than wolves and eagles and the incoming cold to fear at the end of summer. There was the fearsome 'yr Hwrch Ddu Gwta', the tail-less Black Sow, a malevolent spirit recounted in this old Anglesey rhyme.

A Tail-less Black Sow
And a White Lady
Without a head
May the Tail-less Black Sow
Snatch the hindmost.
A Tail-less Black Sow
On Winter's Eve,
Thieves coming along
Knitting stockings.

In the 'Lebor Gabala Erren' - the Book of Invasions of Ireland - we find that two thirds of the harvest and the children were handed over to the supernatural Fomorians.

Two-thirds of their shapely children, it was not generous against military weakness - a lasting tax through ages of the world - two-thirds of corn and of milk. To hard Mag Cetna of weapons, Over Eas Ruaid of wonderful salmon, it was prepared against help, against feasting for them, every Samain eve.

There is a famous Irish tale 'The Adventures of Nera' which was apparently also known in ancient times as the 'Cattle Raid of Aingen'. It is truly one of the wildest tales in early Irish literature - in it the dead talk, though they cannot walk, and a man named Nera braves the many terrors of Samhain eve.

On the eve of Samhain, the King and Queen of Connacht, Ailill and Medb, were in their royal fort at Ráth Cruchan. It was a dark and frightful night full of superstition and dread. King Ailill wagered a reward to anyone who was brave enough to put a 'withe' - a willow reed - round the foot of either of two men who had been hanged the day before.

Every man who tried returned half scared to death and still clutching the withe. Finally Nera trudged off to the gallows. Every time he tried to bind the withe round the foot of a corpse it sprang off again. Then the dead man hanging from the gallows

gazed down at Nera and spoke. He told him that he needed to put an extra spike on the wood to keep it closed. Then Nera put an extra spike on it and the withe stayed put around the dead man's foot.

The hanged man then asked Nera for a favour in return. He wanted to be carried to the nearest house so he could get a drink, as he was thirsty when he was hanged. Nera cut the corpse down from the gallows and carried him on his back to the nearest house. Unfortunately there was a lake of fire around it. 'There will be no drink in that house,' said the dead man, 'the fire is always raked there'.

Nera then walked on, carrying the corpse on his back, till they came upon a second house. There they could not enter as a lake of water surrounded the house. 'There is never a washing nor a bathing tub nor a slop pail in it at night after sleeping.'

Finally Nera took the dead man to a third house and there they entered. There was water to drink and there were tubs for washing and bathing in. There was even a slop pail on the floor. The hanged man took a drink from each in turn and spat the last sip from the slop pail onto the faces of the folk asleep in the house, so that they died.

Nera was by now quite frightened and ran away from the house where they say that the dead man remains to this day. When Nera returned to the royal fort of Ráth Cruachan to claim his reward he saw a terrible sight. The royal fort was in flames and the King and his men had all been beheaded. Nera descended into the underworld through the cave of Cruachan to regain the severed heads. There he lived with a bean-sidhe who told him that the devastation of the royal fort had only been a vision and to avoid it happening he had to destroy the faerie mound in which he was. Nera managed to escape the underworld with his faery wife and child and Fergus mac Roigh destroyed the mound and plundered its treasures.

The cave of Cruachan exists to this day and is still avoided at Halloween. In Christian tradition the cave of Cruachan is known as 'Ireland's gate to Hell.' We find that Christianity later associated countless pagan sacred sites with the devil and that the old gods and faery folks are recast as demons or fallen angels in thrall to Hell.

...Gwynn, known always as Gwynn ap Nudd, is the Welsh King of the Fairies in the widest sense of the word. It would appear that Gwynn is no less a person than the god of the next world for human beings...

Christian bias, however, gave Gwynn a more sinister position. We are told that God placed him over a brood of Devils in Annwn, lest they should destroy the present race. A saint of the name of Collen one day heard two men conversing about Gwynn ap Nudd, and saying that he was the King of Annwn and the fairies.

"Hold your tongues quickly," says Collen, "these are but devils."

"Hold thou thy tongue," said they, "thou shalt receive a reproof from him."

And sure enough the saint was summoned to the palace of Gwynn on a neighbouring hilltop, where he was kindly received, and bid sit down to a sumptuous repast.

"I will not eat the leaves of the trees," said Collen; for he saw through the enchantments of Gwynn, and, by the use of some holy water, caused Gwynn and his castle to disappear in the twinkling of an eye.

The story is interesting, as showing how the early missionaries dealt with the nature gods. Gwynn, according to Collen, is merely a demon.
[8]

In 'Odes to the Months' the famous bard Aneurin gives a vivid description of each month in the calendar. Aneurin was born circa 500 AD; a 'P' Celtic - Welsh speaking - Briton from what is now Southern Scotland. As the bard of Manau Gododin, now Mid-Lothian, he tells of the tribe's preparations at their stronghold (on the site of today's Edinburgh Castle) for a mighty battle. In his epic poem 'The Gododdin' he recounts of story of their feasting and valour, their defeat and slaughter. The Christian influence in 'Odes to the Months' is clear from the final few lines.

Whilst the twelve months proceed so sprightly,
Round the youthful mind, is the spoiler Satan;
Justly spoke Yscolan,
"God is better than an evil prophecy."
[9]

But the following extracts give us a flavour of the feelings that the months of the end of summer evoked in the 'Celtic tribes'.

Month of October - penetrable is the shelter;
Yellow the tops of the birch, solitary the summer dwelling;
Full of fat the birds and the fish;
Less and less the milk of the cow and the goat;
Alas! to him who merits disgrace by sin!
Death is better than frequent extravagance;
Three things follow every crime,
Fasting, prayer, and charity.

Month of November - very fat are the swine;
Let the shepherd go; let the minstrel come;
Bloody the blade, full the barn;
Pleased the sea, tasteless the caldron;
Long the night, active the prisoner;
Respected is every one who possesses property;
For three things men are not often concerned,
Sorrow, angry look, and an illiberal miser.
[9]

The cattle herding year was divided into two equal halves. At Beltane, May eve, the cattle were taken out of their winter shelters and driven between two sacred fires to protect them on the long perilous journey from the low valleys to the high mountain

pastures. Six months were spent in 'the summer sheilings' before the cattle were driven back down at Samhuinn. This was the time when the cattle were butchered for winter larders or kept warm and fed in stalls till the next spring. In Anuerin's poem we find a single line speaking of the slaughter or sheltering of livestock:

Bloody the blade, full the barn;

The droving of the cattle each Beltane and Samhuinn was mimicked by the flitting of the Seelie and Unseelie faerie courts. The Beltane fires and crosses of rowan twigs and red thread tied to the cattle's tails were thought to prevent mischievous or malevolent attacks by the faery folk. All the harvests were to be gathered in by Samhuinn - oats, barley, wheat, turnips, nuts, berries and apples. After summer's end the faeries would blight the berries still on the hedgerows and the last unlucky sheaf to be cut would be named 'the Cailleach' and dressed as an old woman - it was a great dishonour to be last to finish the harvest and to cut the last sheaf.

The Gaelic year was later divided into four quarters. A 'ràidh,' a season or quarter of the year, a space of three months gives the root of the names of the seasons. They are known as 'earrach' - spring, 'samhradh' - summer, 'fogharadh' - harvest, and 'geamhradh' - winter. There is an ancient riddle that describes the nature and character of the four seasons.

> *Thàinig ceathrar a nall,*
> *Gun bhàta, gun long,*
> *Fear buidhe, fionn,*
> *Fear slatagach, donn,*
> *Fear a bhualadh na sùisde,*
> *'S fear a rùsgadh nan crann.*
> *Toimhseagan.*
>
> *Four came over,*
> *Without boat or ship,*
> *One yellow and white,*
> *One brown, abounding in twigs,*
> *One to handle the flail*
> *And one to strip the trees.*

I once had a fine conversation with the head of the School of Celtic Studies at Edinburgh University. We discussed the notion that the seasons can be defined as a day is defined and linked to the four cardinal directions...

At the dawn if you stand and watch the sunrise in the east you face the start of the day and - 'Earrach' - spring, is derived from 'ear', the head, the front, the east.

The right hand - 'deas' - is the name given to the south and to turn to the right is turn 'deosil' - clockwise or sunwise. 'Samhradh' - summer, is from 'samh' - the sun - and literally means the sun season or quarter.

above:
Vintage Halloween
card.

25

'Fogharadh' - autumn or harvest - is probably from 'fogh' - ease, hospitality and 'foghainn' - to suffice, abundance. These were the hazy days as the leaves turned all the oranges and reds of the sunset.

To turn left from the sunrise - to the north - was an unlucky turn 'widdershins' and 'tuaitheal', from 'tuath' - the north - means wrong, to the left, against the sun.

'Geamhradh - winter - appears to have the same root as words meaning to bind or to be stiff as winter is the frozen season bound by snow and ice. Its root is found in 'gèamhlag' - a crowbar, 'gèimheal' - a chain and 'geamhtach' - short, stiff, and thick.

It has been proposed, in 'Celtic New Age' books, that the Celts linked their notion of the year with their interpretation of a single day and equally with a whole lifetime. Life grows in the darkness of the womb and is born out into the world at dawn. We grow up through the morning to our prime of life as the sun reaches its zenith at noon and midsummer. With a fine bountiful harvest we celebrate the fruits of our labours with a family of our own then eventually we grow old. The light of the sun fades and the leaves turn to gold and red as we slip away till the day ends and we return to the darkness from which we came.

This is a poetic idea that the Celts may have shared - but we can never prove it. 'The Celts' have suffered hundreds of years of mystical idealisation with New Age words put in their mouths centuries after they fought and died. The 'Celtic Twilight' is an ethereal dreamworld based on a romantic longing for a lost paradise that never really existed. The true 'Celtic culture' was magnificent - battles were met with frenzy, feasting and drinking were legendary, visual art and craftsmanship was unsurpassed and the bards sung eulogies and told tales of love and strength and the world of magic. Equally their life was harsh and unforgiving. They kept slaves and ruthlessly slew their enemies, keeping their decapitated heads as trophies. They were quick to anger, quarrelsome and drank to excess. The Celtic tribes were indeed passionate about life and death but we trivialise their memory to turn them into a mere romantic ideal.

We do have some solid physical evidence for a calendar belonging to the Gauls - the 'Coligny calendar'. The town of Coligny lay in the former territory of the Gaulish Ambarri tribe and it must be stressed that this calendar cannot be taken to be universal among the Celtic tribes.

In November 1897 fragments of a bronze calendar were found near the town of Coligny in France... The bronze pieces were inscribed with Roman numerals and indeed the fragments were unearthed along with a classical-styled statue of a divine figure (now identified as Mars) in what were most likely the remains of a Gallo-Roman temple complex.

The broken pieces were once a single bronze tablet, which seems to have been intentionally broken. Each month was named with a heading followed by daily notations beneath it. The passage of the days could be tallied by the use of peg-holes

placed to the left of the numerals. The epigraphy of the calendar dates it physically to approximately 250 - 300 AD. However, the nature of the calendar, when compared to Classical references to Celtic calendar practices, proves that it is based on a much earlier system dating back to at least the last few centuries of Pre-Roman conquest Gaul, if not much earlier. Although the calendar was inscribed in the Gallo-Roman period, the very structure of the calendar itself shows little direct Roman influence aside from the lettering and numerals. There is a thorough examination of the Coligny calendar to be found thanks to the work of Christopher Gwinn.

The date of SAMON- xvii is identified as TRINVX SAMO SINDIV, which can be readily interpreted as an abbreviation of 'Trinouxtion Samonii sindiu' - 'The three-night-period of Samonios [is] today'. This is one of the very few dates in the calendar that is given a specific name, testifying to its importance as a festival.

Since Samoni- is obviously the origin of the modern name Samhain, it is reasonable to equate the 'Trinouxtion Samonii' with the feast that is still one of the most important dates in the Celtic ritual year....

The Calendar of Coligny is a luni-solar calendar; in other words, it attempts to bridge the divide that arises between the shorter lunar year and the solar year. The goal is to keep the months in line with the seasons. This is a complicated process, which few cultures have mastered - even our own calendar requires periodic tweaking to keep it in line with the seasons.

It seems evident, however, that the ancient Celts created in their calendar a system that rivalled, if not surpassed those of the classical world and, in some cases, developed a system that (had it survived), would have rivalled even those utilised during the scientific flowering of the Renaissance.
[10]

Over the decades there has been much debate as to whether or not Samain was the 'Celtic New Year'. It was certainly the end of summer and the first of winter but was it any more the 'new year' than Beltane - May eve - the dawn of summer?

Samain begins in darkness and ushers in the dark half of the year - the time of the 'little sun'. Classical sources such as Julius Caesar's 'De Bello Gallico' tell us that to the Celts night and darkness came before light.

...spatia omnis temporis non numero dierum, sed noctium finiunt; dies natales et mensum et annorum initia sic obseruant, ut noctem dies subsequatur...

...they define all amounts of time not by the number of days, but by the number of nights; they celebrate birthdays and the beginnings of months and years in such a way that the day is made to follow the night...

If a day began at sunset as our day begins at midnight would your year begin at Samain as all the activities of the old year - harvesting and cattle herding - came to their end?

above:
Vintage Halloween card.

The essence of 'Celtic' magical belief seems to me to be a desire for balance. The two equal halves of summer and winter, Beltane and Samain, light and dark, day and night, life and death, female and male. The gods and goddesses were not all powerful - tipping the scales. The deities brought order and balance to the chaos of nature. Offerings and sacrifices were made as a fair exchange for a good harvest or protection from disease.

Beltane was a time to protect your homes, livestock and family, a gathering to bring the community together after the long winter, to look forward and to start new relationships and new ventures.

Samain was a celebration of the time that had been; you feasted on the best of the harvest and the fresh meat before it was salted for winter. The feis of Samain was a festival that brought the folk together not to mourn but to party - to dance and drink and to tell tales and reminisce by a raging fire before the winter snow and ice.

right:
The Nobleman
Detail from Woodcut by Hans Holbein.

Notes

[1] Irish, author unknown, ninth century.
 Trans. Prof. Kenneth Hurlstone Jackson, A Celtic Miscellany, Penguin Classics, 1951

[2] Tacitus, The Annals of Tacitus, 109 CE
 Trans. A.J Church and W. J Brodribb, 1976

[3] Strabo, Geographia, c. 20 CE

[4] Early Irish Myths and Sagas
 Trans. Jeffrey Gantz. Penguin Classics, 1981

[5] Dictionary of Celtic Mythology
 J. MacKillop, Oxford University Press

[6] The Tain Arans
 Trans. Thomas Kinsella from the Irish epic Táin Bó Cuailnge, Oxford paperbacks, 1970.

[7] Irish; author unknown, eleventh century.
 Trans. Prof. Kenneth Jackson, A Celtic Miscellany, Penguin Classics

[8] Celtic Mythology and Religion
 Alexander MacBain. Eneas Mackay, 1917

[9] Anuerin, 'The Ode to the Months'
 Trans. William Probert, 1820

[10] Celtic studies by Christopher Gwinn, http://www.christophergwinn.com/celticstudies

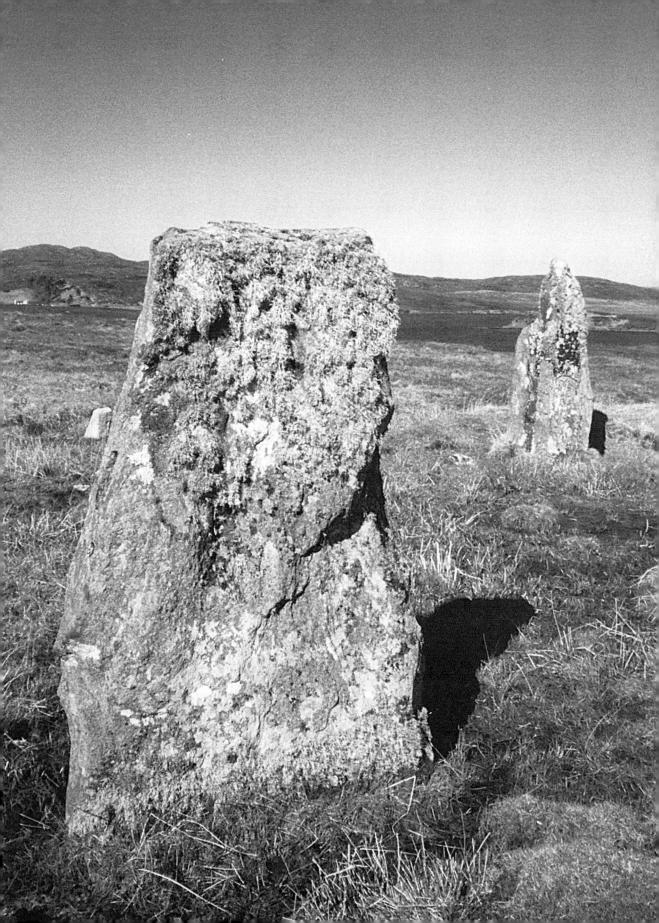

Starshine and Moonlight

It's time to use a little imagination. We are going to condense thousands of years of history into a few hours – pretend that centuries pass in a matter of minutes. This timescale will hopefully give you some idea of the scale of history. In this chapter we'll look back at these distant times and how our ancient ancestors were calculating and marking the same time of the year that we celebrate at Halloween.

Right now, at the beginning of the 21st century, it is a Wednesday evening - at just a little after 8pm. I want you to imagine that Christ was born at midday, so that everything after noon today is AD and everything before is BC.

At midmorning, between 10 and 11am today, the iron-age 'Celtic' tribes were flourishing in the British Isles. Over one and a half thousand years before this Stonehenge was being completed at just before 5am. It was started at around 2am – at the same time as the Great Pyramid was being built. There is much nonsense written about Stonehenge and the Druids. The simple fact is that Stonehenge was built well over a thousand years before the Druids and 'the Celts'.

Now when you are reading this chapter I'd like you to bear this in mind: if today is Wednesday at 8pm then Columbus landed in the Americas about two hours ago – the Caves at Lascaux were being painted 2 to 4 days ago.

I can remember being about four years old. It was the middle of the night and my father woke me and carried me downstairs and out into the back garden. I stood bewildered and still half asleep in my pyjamas as my parents pointed to a big fat hedgehog that was snuffling about in the flowerbeds. The dark was alive with wonders, owls swooped like ghosts and foxes screeched from the woods. I wavered a little and rubbed my eyes then stared up at the night sky.

The moon was made of bright quicksilver and a million stars shone in the inky blackness. Night-time was a forbidden, magical place between the everyday times of dusk and dawn. When the sun set all the rules could be broken, the ordinary world slept, snuggled beneath the covers and out crept the things of the night. Witches stood up on my roof by the chimney, cackling away to themselves, leaning on their willow brooms. Goblins burrowed down under the rhubarb and ate the strawberries.

opposite:
Calanais stones
Isle of Lewis, Scotland.

(image © Dogworrier.com)

Giants sat on the tops of hills, their immense feet soaking in the lochs down in the valleys below.

Curiosity led me on to learn the names of the stars, of their groups and constellations. But something is lost in the naming, the classification, numbering and filing. Star charts of the southern and northern hemisphere in summer and winter are a little like the toe tags on the bodies in a mortuary. Height: 5 foot 2 inches, hair: blond, eyes: blue. No amount of detailed description can truly capture the essence of a star.

Little children know this to be true. They gaze up at the Great Bear and the Little Bear, at Orion with his belt and at tiny Venus. In nurseries and kindergartens across the world they sing in countless languages, "Twinkle twinkle little star, how I wonder what you are…" They stare up into the night sky with wide eyes and open mouths.

Thousands of years ago our ancestors stared up at the same stars. They saw their patterns. Mapped the constellations and watched them rise and set with the seasons. As hunters and gatherers became farmers they needed to set times of year for sowing the seed and reaping the harvest. They watched the night skies and sought signs of rising and setting stars to guide their year.

Near Orion, in the constellation of Taurus, the bull, is a tiny, shining cluster of seven stars. They huddle together, inseparable, the seven sisters of legend: the Pleiades. This little group of stars have been studied and have served as our calendar around the whole world. Before we had writing, before we had art, we watched for the Pleiades.

When the Pleiades rise just before sunrise on the distant horizon then the light half of the year is at hand. This is the time we know as Beltane, May eve, the beginning of summer. Half a year later, as the days grow ever shorter and the strength of the sun fades, the Pleiades rise at sunset. Seven stars shine as the sun slips away to the west. Now is the dawning of the dark half of the year, the time when winter draws in. As the Pleiades rise at sunset it is Halloween time and thousands of years before knives cut pumpkins our ancestors gathered at this time to watch the stars and mark the change of the seasons.

As the winter gradually drew in these ancient peoples gathered beneath the canopy of the stars, they sat in rough circles about glowing bonfires to keep themselves safe and warm and some among them would tell tales. They would point up at the groups of stars and give them names. Constellations became the beasts that they hunted, the creatures they feared. The night sky became a vast illustration, a tapestry of magical characters whose stories came alive in the winter's tales. With their fingers they painted these pictures on the bare rock of cave walls.

Ice Age star map discovered
BBC News Online science editor Dr David Whitehouse
Wednesday, 9 August, 2000, 01:00 GMT 02:00 UK

A prehistoric map of the night sky has been discovered on the walls of the famous painted caves at Lascaux in central France. It is a map of the prehistoric cosmos which is thought to date back 16,500 years, shows three bright stars known today as the Summer Triangle. A map of the Pleiades star cluster has also been found among the Lascaux frescoes. And another pattern of stars, drawn 14,000 years ago, has been identified in a cave in Spain. According to German researcher Dr Michael Rappenglueck, of the University of Munich, the maps show that our ancestors were more sophisticated than many believe.

Scientific heritage

The Lascaux caves, with their spectacular drawings of bulls, horses and antelope, were painted 16,500 years ago. Discovered in 1940, the walls show the artistic talents of our distant ancestors. But the drawings may also demonstrate their scientific knowledge as well. The caves could be prehistoric planetariums in which humanity first charted the stars. The sky map has been found in a region of the Lascaux caves known as the Shaft of the Dead Man. Painted on to the wall of the shaft is a bull, a strange bird-man and a mysterious bird on a stick.

Summer triangle

According to Dr Rappenglueck, these outlines form a map of the sky with the eyes of the bull, birdman and bird representing the three prominent stars Vega, Deneb and Altair. The ancient star map shows a bull, birdman and a bird on a stick. Together, these stars are popularly known as the Summer Triangle and are among the brightest objects that can be picked out high overhead during the middle months of the northern summer.

Around 17,000 years ago, this region of sky would never have set below the horizon and would have been especially prominent at the start of spring. "It is a map of the prehistoric cosmos," Dr Rappenglueck told BBC News Online. "It was their sky, full of animals and spirit guides."

Seven sisters

But the sky map is not the only evidence that prehistoric man took a keen interest in the night sky. Nearer to the entrance of the Lascaux cave complex is a magnificent painting of a bull. Hanging over its shoulder is what appears to be a map of the Pleiades, the cluster of stars sometimes called the Seven Sisters. Inside the bull painting, there are also indications of spots that may be a representation of other stars found in that region of sky. Today, this region forms part of the constellation of Taurus the bull, showing that mankind's identification of this part of the sky stretches back thousands of years.

The archaeologists who have looked at Dr Rappengleuck's conclusions have so far agreed that they are reasonable and that he may have uncovered the earliest evidence of humanity's interest in the stars.

[1]

So, it begins with paint and stories and fingertips.

There is a rather huge and complicated book that looks at the ancient myths of the world, at the gods of antiquity and at the stars in the sky and seeks to show that they are one and the same.

'Hamlet's Mill' - Giorgio de Santillana and Hertha von Dechend
'An essay on myth and the frame of time'

...what emerges here lifts the veil of a fundamental archaic design. The real actors on the stage of the universe are very few, if their adventures many. The most "ancient treasure" - in Aristotle's words - that was left to us by our predecessors of the High and Far-Off Times was the idea that the gods were really stars, and that there are no others. The forces reside in the starry heavens, and all the stories, characters and adventures narrated by mythology concentrate on the active powers among the stars, who are the planets. What, abstractly, might be for modern men the various motions of those pointers over the dial became, in times without writing, where all was entrusted to images and memory, the Great Game played over the aeons, a neverending tale of positions and relations, starting from an assigned Time Zero, a complex web of encounters, drama, mating and conflict...
...the design, which turns out to be constant: the constellations were seen as the setting, or the dominating influences, or even only the garments at the appointed time by the Powers in various disguises on their way through their heavenly adventures.
[2]

All cultures throughout history have sought to name the stars and have told their own version of the tale of the Pleiades. For example, in the Kumulipo, a Polynesian cosmogonic myth from Hawaii...

> *At the time when the earth became hot,*
> *At the time when the heavens turned about,*
> *At the time when the earth was darkened,*
> *To cause the moon to shine,*
> *The time of the rise of the Pleiades.*
> [2]

Here is a translation from a ceremonial song of Pawnee, a tribe of American Plains Indians:

> *Look as they rise, up rise*
> *Over the line where sky meets the earth;*
> *Seven Stars!*
> *Lo! They are ascending, come to guide us,*
> *Leading us safely, keeping us one.*
> *Oh, Seven Stars,*
> *Teach us to be, like you, united.*

We have to look to the ancient Greeks for our naming and tales of the Pleiades. Our earliest sources for ancient Greek calendars are clay tablets of the 13th century BC, the writings of Homer and Hesiod. Hesiod notes the use of observations of constellations and star groups to reckon the time of year: the harvest coincides with the visible

above:
Vintage Halloween
card.

rising of the Pleiades before dawn.

Then the famous god of the two strong arms answered her: "Be of good cheer, neither let these things distress thy heart. Would that I might so surely avail to hide him afar from dolorous death, [465] when dread fate cometh upon him, as verily goodly armour shall be his, such that in aftertime many a one among the multitude of men shall marvel, whosoever shall behold it."

So saying he left her there and went unto his bellows, and he turned these toward the fire and bade them work. [470] And the bellows, twenty in all, blew upon the melting-vats, sending forth a ready blast of every force, now to further him as he laboured hard, and again in whatsoever way Hephaestus might wish and his work go on. And on the fire he put stubborn bronze and tin [475] and precious gold and silver; and thereafter he set on the anvil-block a great anvil, and took in one hand a massive hammer, and in the other took he the tongs.

First fashioned he a shield, great and sturdy, adorning it cunningly in every part, and round about it set a bright rim, [480] threefold and glittering, and therefrom made fast a silver baldric. Five were the layers of the shield itself; and on it he wrought many curious devices with cunning skill.

Therein he wrought the earth, therein the heavens therein the sea, and the unwearied sun, and the moon at the full, [485] and therein all the constellations wherewith heaven is crowned—the Pleiades, and the Hyades and the mighty Orion, and the Bear, that men call also the Wain, that circleth ever in her place, and watcheth Orion, and alone hath no part in the baths of Ocean.
[3]

Atlas and Pleione, daughter of Ocean, had seven daughters called the Pleiades, born to them at Cyllene in Arcadia, to wit: Alcyone, Merope, Celaeno, Electra, Sterope, Taygete, and Maia.
[4]

We have now the seven sisters but why are they named 'the Pleiades' and why does there seem to only be six stars in the cluster today? The origin of the name 'the Pleiades' remains open to debate. It may simply be from the name of their mother Pleione or it may actually come from 'plein': 'to sail'. In the Mediterranean the Pleiades would have been visible at night throughout the summer half of the year. From mid May till the beginning of November was the sailing season in antiquity.

There are only six stars easily visible to the naked eye but there were seven stars in the Pleiades. One was thought to have become virtually invisible, to have faded for one of two reasons: some said that one of the stars, Electra, who was the mother of Dardanus, fell grieving at the fall of the city of Troy and as she hid her face in her hands so she vanished from the night sky. Alternatively it is Merope who has faded from view. While her sisters were all married to gods, Merope alone married a mere mortal man and dared not show herself in their company. Today modern astronomers tell us that the 'invisible' Pleiad is Celaeno. If you are gifted with particularly good vision and a clear moonless night you might just make her out among her brighter sisters.

overleaf:
Calanais stones
Isle of Lewis, Scotland.

(image © Dogworrier.com)

35

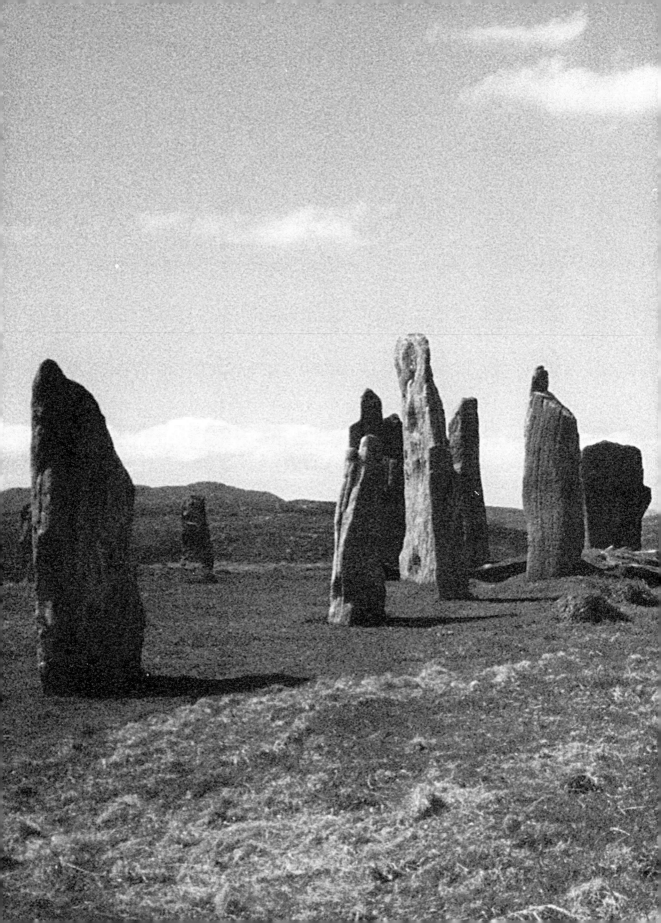

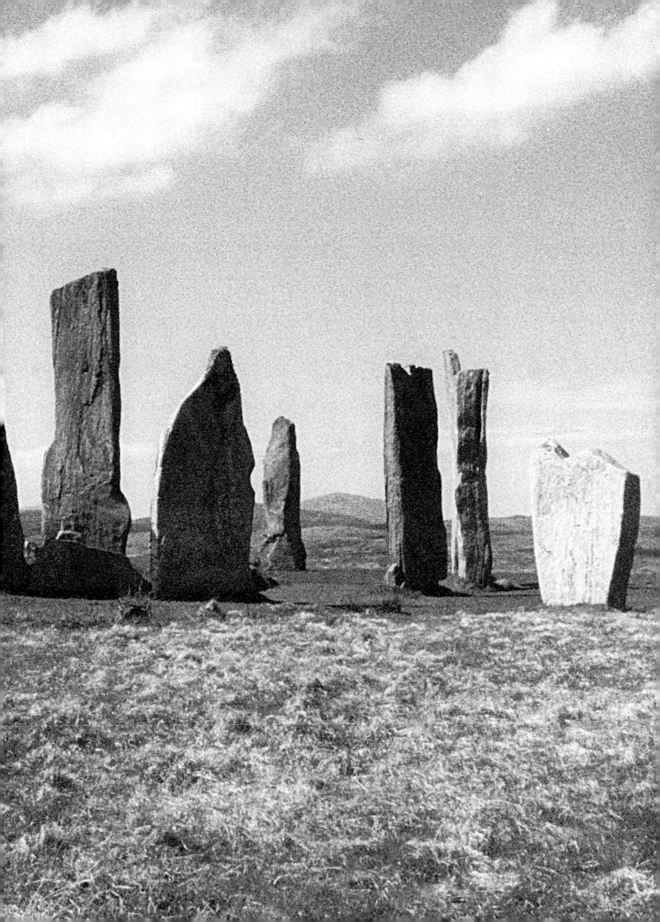

These seven sisters had begun their lives upon the earth. It was told that for seven or even twelve years the hunter, Orion, had pursued them. Orion was tireless in his pursuit and eventually Zeus took pity on the seven maidens and placed them in the sky as stars along with Orion. For all eternity he will follow them across the heavens yet never catch them. Another tale tells that the seven maidens killed themselves in grief over the death of their sisters, the Hyades, and were given a place in the heavens.

Australian Aborigines tell a startlingly similar tale of a hunter chasing the seven maidens as part of the legends of the Dreaming. The artists of Groote Eylandt, the largest island off the coast of North East Arnheim Land, paint the Pleiades and Orion on pieces of tree bark.

Across the world old Navajo rock art of northwest New Mexico depicts the Pleiades, a pattern of a few stars that represent all the myriad stars in the sky. They name the Pleiades 'Dilyehe' and their likeness appears on ceremonial gourd rattles and in traditional sand paintings. Most of the Navajo sacred ceremonies are not performed until Dilyehe is watching in the evening sky. These ceremonies cease as the Pleiades leave the evening sky the following spring.

The Pleiades were also featured in the sacred ceremonies of the Mesopotamian priests and shamans of India. 'The striking of the drum covered with a specific hide was meant as a contact with heaven at its most significant point.' They were creating a magical instrument that served as a way to connect the earth with the heavens, symbolised by the Pleiades.

...a close look at shamanic items always discloses very ancient patterns. For instance, the drum, the most powerful device of the shaman, representing the universe in a specific way, is the unmistakable grandchild of the bronze lilissu drum of the Mesopotamian Kalu-priest (responsible for music, and serving the god Enki / Ea). [Cuneiform texts survive that explicitly state that the hide is said to be Anu. Also "Sugugalu," the hide of the great bull, "an emblem of Anu." and further in Petronius, Trimalchio speaking of the month of May, states "Toteus coelus taurulus fiat" ("the whole heaven turns into a little bull")]

The cover of the lilissu drum must come from a black bull, "which represents Taurus in heaven,"... comparing the sacrifice of the Mesopotamian bull, the hide of which was used to cover the lilissu drum, with the Indian Ashmaveda, a huge horse sacrifice which only the most successful King could afford... the Indian horse must have the Krittika, the Pleiades, on his forehead, and this too... is what the Akkadian text prescribes concerning the bull...
[2]

The notion that the gods are the stars or that the gods placed the stars in the sky survives into the Old Testament of the Bible. In Amos (5:8): *"Seek him* [seek the Creator - not the creation] *that maketh the seven stars* [the Pleiades] *and Orion, and turneth the shadow of death* [setting] *into the morning* [rising], *and maketh the day dark with night...."*

The constellations of Ursa Major and the Pleiades have long been associated with catastrophes. In the writings of Homer Achilles marched on the city of Troy with the image of the Pleiades and Ursa Major on his shield. Did the destruction of Troy cause Electra to hide her face in grief and vanish from the sky? In later Jewish legends the Pleiades are associated with Noah's flood and the drowning of the whole world.

Now the deluge was caused by the male waters from the sky meeting the female waters which issued forth from the ground. The holes in the sky by which the upper waters escaped were made by God when he removed stars out of the constellation of the Pleiades; and in order to stop the torrent of rain, God had afterwards to bung up the two holes with a couple of stars borrowed from the constellation of the Bear. That is why the Bear runs after the Pleiades to this day; she wants her children back, but she will never get them till after the Last Day.
[5]

Hamlet's Mill notes that the Pleiades are associated with whirlpools and this strangely draws us back to Halloween.

There is a tradition from Borneo of a "whirlpool island" with a tree that allows a man to climb up into heaven and bring back useful seeds from the "land of the Pleiades"... The Polynesians have a whirlpool... which serves in most cases as entrance to the abode of the dead.

The engulfing whirlpool belongs to the stock-in-trade of ancient fable. It appears in the Odyssey... and again, in other cultures, in the Indian Ocean and in the Pacific... Such stories have belonged to the cosmographical literature since antiquity.

Medieval writers... located the 'gurges mirabilis', the wondrous eddy, somewhere off the coast of Norway, or of Great Britain. It was the Maelstrom, plus probably a memory of Pentland Firth.

("A great whirlpool there is between Ireland and Scotland on the North. It is the meeting of many seas [from NSEW] - it resembles an open caldron which casts the draught down (and) up, and its roaring is heard like far-off thunder"
W. Stokes, the prose tales of the Ronnes Dindsenchas 1895)'
[2]

The whirlpool in the Pentland Firth exists to this day, seething and boiling away. It is known as Corrywrecken and legend tells that the mighty giantess, the Cailleach, washes her plaid cloak white in its waters to draw in the winter season.
[See Chapter Three: 'The Queen of Winter']

To investigate the wild variety of names, tales and associations that the Pleiades have had may seem like a meandering aside from a journey to the heart of Halloween. The point is simple: throughout history and pre-history, everyone from desert tribes to the civilizations of antiquity have seen these seven stars rise in the evening as the seasons changed and summer turned to winter. This sign in the stars signposted a major transition on the earth and our ancestors marked this time of year and in time they celebrated it.

In ancient Egypt a festival was marked throughout the land and even the Great Pyramid seems strangely associated with Halloween. At this point I must introduce a highly entertaining and odd book that supplies some of the following information. Any work of non-fiction is only ever as good as its sources and when the sources are dubious, so is the new work. A year or two ago I was wandering around the packed shelves of an ex-library book sale. These are wonderful events... a rare opportunity to buy all sorts of interesting and out of print books that the public libraries no longer have the space or inclination to stock. There, among a dazzling array of bad novels and out of date travel guides, sat a hefty tome: two inches thick and built like two house bricks in a hardcover.

'The Great Pyramid - Its Divine Message - an original co-ordination of historical documents and archaeological evidences' by D. Davidson & H. Aldersmith. This is a glorious thing. It is stuffed full of diagrams and line illustrations, surveying plans and technical tables of facts and figures. Precessions of equinoxes and the motion of the Earth's orbit, maps, a thousand ancient quotes, figures, geometrical sums and formulae and there amid the bewildering confusion of Egyptian data are plans and schematics for Stonehenge.

Normally this would fill me with fear. Books with the Great Pyramid and Stonehenge have a bad habit of slipping in Atlantean ancient architects or Alien astronaut-astronomers by some sleight of hand. Nowadays they try to convince us that the Pyramids of Giza are aligned to mimic the stars of Orion's belt. They suggest that some miraculous lost knowledge lays waiting in a secret chamber within the Great Pyramid or buried deep in a hidden place between the front paws of the Sphinx.

Thankfully there were no little green men or lost civilisations lurking in the book. Instead there is a well-researched and thought provoking examination of the wonders that our ancient ancestors were capable of. There is something vaguely annoying about the idea that the human race was incapable of creating these marvels without the aid of mystical Atlanteans or helpful extraterrestrials. The ancient folk of the world were perfectly capable of constructing the pyramids, the standing stone circles and a host of other sculptural, architectural, geometric and creative wonders. We should not deny their abilities.

Anyway, amid the dizzying facts and figures are descriptions of Egyptian phenomena and festivals at the very time of year that today is All Hallows.

Travel to Egypt and stand at the north side of the Great Pyramid of Giza at noon on November 1st. Take a hat. Possibly take a parasol too. The sun's rays gleam off the east and west sides of the Pyramid and bright reflections illuminate the sands due north west and north east.

The Great Pyramid lies directly to the south of and at the centre of the Nile delta. The fertile lands of Egypt spread out like a fan between the Pyramid in the south and the Mediterranean Sea in the north. At noon on November 1st reflections from the Great

ISIDIS
Magnæ Deorum Matris
APVLEIANA DESCRIPTIO.

Nomina varia Ifidis.

Ifis
Minerua
Venus
Iuno
Proferpina
Ceres
Diana
Rhea feu
 Tellus
Peffinuncia
Rhramnufia
Bellona
Hecate
Luna
Polymor-
 phus dæ-
 mon.

Ἶσις παɴδεχὴς πο-
λύμορφ@ δαί-
μων.
Μυειόνυμ@ φύσις,
ὕλη.

*Expl cationes fym-
bolorum Ifidis.*

A Diuinitatem, mun-
 dum, orbes cœleftes
BB Iter Lunæ flexuo-
 fum, & vim fœcun-
 datiuam notat.
CC Tutulus, vim Lu-
 næ in herbas , &
 plantas.
D Cereris fymbolum,
 Ifis enim fpicas in-
 uenit.
E Byffina veftis mul-
 ticolor , multifor-
 mem Lunæ faciem .
F Inuentio frumenti.
G Dominium in om-
 nia vegetabilia.
H Radios lunares.
I Genius Nili malo-
 rum auerruncus.
K Incrementa & de-
 crementa Lunæ.
L Humectat. vis Lunę.
M Lunæ vis victrix, &
 vis diuinandi.
N Dominium in hu-
 mores & mare.
O Terræ fymbolũ, &
 Medicinæ inuentrix.
P Fœcunditas, quæ fe-
 quitur terram irri-
 gatam.
Q Aftrorum Domina.
R Omnium nutrix.
S } Terræ marifque
M } Domina.

Ἀϰεϼ Θεῶν Μήτηρ ταύτη πολιένμ@ ΙΣΙΣ.

left:
Isis
The sister-wife of Osiris. She was the principal goddess of ancient Egypt. Worshipped by Cleopatra in a private temple in Alexandria; the cult of Isis spread to Rome and Greece.

41

Pyramid give lines that point off to the north west and north east - these lines exactly define the Nile delta from Lake Mareotis in the north eest to Lake Menzaleh in the north east.

In short, the Great Pyramid was built here at this exact spot in such a way that on this one date, the date of the commencement of the season of sowing seeds, the noon sun sends reflections across the sands exactly signifying the limits of the fertile lands.

...the Pyramid was thus operating as a Sundial of the Seasons.
[6]

A noon shadow appears on the north face of the Great Pyramid on 14th-15th October this heralds the early sowing period in the delta and the beginning of the barley and flax harvests. Other effects accurately record the spring and autumn equinoxes and the summer and winter solstices. The Great Pyramid had been precisely positioned to mark out the days of an agricultural year but Egypt was also a land of magic and religion.

...the simplicity of the Great Pyramid, and of other works belonging to the same reign, the utter lack of internal or external ornament and inscription, removes the Pyramid entirely from the particular kind of religious atmosphere associated generally with every form of Egyptian architecture.
[6]

Ultimately religion finds its way into every part of Egyptian life.

The rites of Osiris in ancient Egypt were annually celebrated on the day of the Festival of the Dead, November 1st. Owing to the fact that the noon reflections of the Great Pyramid defined the day of the celebrations, Osiris, in later Egyptian times, was associated with the Pyramid. Hence the fact that Isis, the female counterpart of Osiris, was designated in later times, 'the Queen of the Pyramid,' and the 'Mistress of the commencement of the year.'
[6]

This 'annual Festival of the Dead' is really a concept too far. This was Sir James George Frazer's great theory: that November 1st was globally a celebration of the dead with ancestor worship, ghosts and dying and resurrecting vegetation gods popping their clogs left, right and centre. Frazer is one of those great old scholarly writers who never set foot outside their Universities yet were authorities on customs and practices from the four corners of the world. Mention Frazer to a modern academic and they tend to glance away uneasily and uncomfortably shuffle their feet. His methods have fallen so far out of fashion that they appear like a particularly fluorescent pair of Bermuda shorts at a glittering premiere full of Armani suits and Versace dresses.

In Ancient Egypt the god whose death and resurrection were annually celebrated

with alternate sorrow and joy was Osiris, the most popular of all Egyptian deities; and there are good grounds for classing him in one of his aspects with Adonis and Attis as a personification of the great yearly vicissitudes of nature, especially of the corn. ...
[7]

Osiris was the offspring of an intrigue between the earth-god Seb (Keb or Geb, as the name is sometimes transliterated) and the sky-goddess Nut. The Greeks identified his parents with their own deities Cronus and Rhea. When the sun god Ra perceived that his wife Nut had been unfaithful to him, he declared with a curse that she should be delivered of the child in no month and no year. But the goddess had another lover, the god Thoth or Hermes, as the Greeks called him, and he playing at draughts with the moon won from her a seventy-second part of every day, and having compounded five whole days out of these parts he added them to the Egyptian year of three hundred and sixty days. This was the mythical origin of the five supplementary days that the Egyptians annually inserted at the end of every year in order to establish a harmony between lunar and solar time. On these five days, regarded as outside the year of twelve months, the curse of the sun god did not rest, and accordingly Osiris was born on the first of them.

At his nativity a voice rang out proclaiming that the Lord of All had come into the world. But Osiris was not the only child of his mother. On the second of the supplementary days she gave birth to the elder Horus, on the third to the god Set, on the fourth to the goddess Isis, and on the fifth to the goddess Nephthys. Afterwards Set married his sister Nephthys, and Osiris married his sister Isis.

Reigning as a king on earth, Osiris reclaimed the Egyptians from savagery, gave them laws, and taught them to worship the gods. Before his time the Egyptians had been cannibals. But Isis, the sister and wife of Osiris, discovered wheat and barley growing wild, and Osiris introduced the cultivation of these grains amongst his people, who forthwith abandoned cannibalism and took kindly to a corn diet. Moreover, Osiris is said to have been the first to gather fruit from trees, to train the vine to poles, and to tread the grapes.

Eager to communicate these beneficent discoveries to all mankind, he committed the whole government of Egypt to his wife Isis, and travelled over the world, diffusing the blessings of civilisation and agriculture wherever he went. In countries where a harsh climate or niggardly soil forbade the cultivation of the vine, he taught the inhabitants to console themselves for the want of wine by brewing beer from barley. Loaded with the wealth that had been showered upon him by grateful nations, he returned to Egypt, and on account of the benefits he had conferred on mankind he was unanimously hailed and worshipped as a deity.

But his brother Set with seventy-two others plotted against him. Having taken the measure of his good brother's body by stealth, the bad brother fashioned and highly decorated a coffer of the same size, and once when they were all drinking and making

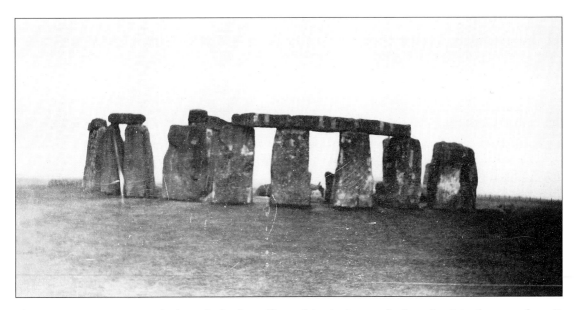

above:
Stonehenge
Vintage photograph,
circa 1929.

(image © Bacci collection)

merry he brought in the coffer and jestingly promised to give it to the one whom it should fit exactly. Well, they all tried one after the other, but it fitted none of them. Last of all Osiris stepped into it and lay down. On that the conspirators ran and slammed the lid down on him, nailed it fast, soldered it with molten lead, and flung the coffer into the Nile. This happened on the seventeenth day of the month Athyr, when the sun is in the sign of the Scorpion, and in the eight-and-twentieth year of the reign or the life of Osiris. When Isis heard of it she sheared off a lock of her hair, put on mourning attire, and wandered gloomily up and down, seeking the body.

...when Isis had found the corpse of her husband Osiris, she and her sister Nephthys sat down beside it and uttered a lament which in after ages became the type of all Egyptian lamentations for the dead. "Come to thy house," they wailed. "Come to thy house. O god. On! Come to thy house, thou who hast no foes. O fair youth, come to thy house, that thou mayest see me. I am thy sister, whom thou lovest; thou shalt not part from me. O fair boy, come to thy house... I see thee not, yet doth my heart yearn after thee and mine eyes desire thee. Come to her who loves thee, who loves thee, Unnefer, thou blessed one! Come to thy sister, come to thy wife, to thy wife, thou whose heart stands still. Come to thy housewife. I am thy sister by the same mother; thou shalt not be far from me. Gods and men have turned their faces towards thee and weep for thee together... I call after thee and weep, so that my cry is heard to heaven, but thou hearest not my voice; yet am I thy sister, whom thou didst love on earth; thou didst love none but me, my brother! my brother!"...

The lamentations of the two sad sisters were not in vain. In pity for her sorrow the sun-god Ra sent down from heaven the jackal-headed god Anubis, who, with the aid of Isis and Nephthys, of Thoth and Horus, pieced together the broken body of the murdered god, swathed it in linen bandages, and observed all the other rites which the Egyptians were wont to perform over the bodies of the departed. Then Isis fanned the cold clay with her wings: Osiris revived, and thenceforth reigned as king over the dead in the other world.

There he bore the titles of Lord of the Underworld, Lord of Eternity, Ruler of the Dead. There, too, in the great Hall of the Two Truths, assisted by forty-two assessors, one from each of the principal districts of Egypt, he presided as judge at the trial of the souls of the departed, who made their solemn confession before him, and, their heart having been weighed in the balance of justice, received the reward of virtue in a life eternal or the appropriate punishment of their sins.

In the resurrection of Osiris the Egyptians saw the pledge of a life everlasting for themselves beyond the grave. They believed that every man would live eternally in the other world if only his surviving friends did for his body what the gods had done for the body of Osiris. Hence the ceremonies observed by the Egyptians over the human dead were an exact copy of those which Anubis, Horus, and the rest had performed over the dead god...

[7]

The rites of Osiris in ancient Egypt were celebrated at the start of the sowing season, November 1st, as the grain was planted so was the body of Osiris buried, as the grain grew he was reborn. The History of Herodotus written in 440 BC gives a description of the festival.

The Egyptians were also the first to introduce solemn assemblies, processions, and litanies to the gods; of all which the Greeks were taught the use by them. It seems to me a sufficient proof of this that in Egypt these practices have been established from remote antiquity, while in Greece they are only recently known.

The Egyptians do not hold a single solemn assembly, but several in the course of the year...

At Sais, when the assembly takes place for the sacrifices, there is one night on which the inhabitants all burn a multitude of lights in the open air round their houses. They use lamps in the shape of flat saucers filled with a mixture of oil and salt, on the top of which the wick floats. These burn the whole night, and give to the festival the name of the Feast of Lamps. The Egyptians who are absent from the festival observe the night of the sacrifice, no less than the rest, by a general lighting of lamps; so that the illumination is not confined to the city of Sais, but extends over the whole of Egypt. And there is a religious reason assigned for the special honour paid to this night, as well as for the illumination which accompanies it.

[8]

Were these lamps lit for the dead as Frazer thought? If nothing else we can see that November 1st held an extremely important place in the calendar of ancient Egypt. Without the aid of mystical Atlanteans or lost civilizations we find links across the wide Atlantic Ocean. The peoples of South America built Pyramids too and they too were carefully aligned.

Any appreciation of ancient Meso-America's architectural splendour must begin with Teotihuacán, the City of the Gods. Its two gigantic pyramid temples, dating from about the time of Christ, are the largest and oldest in the Americas and were models for all the rest. There, too, stand the remains of the Pyramid of the powerful

god Quetzalcoatl, the Plumed Serpent. Teotihuacán was destroyed by fire in the 7th century, but the worship of Quetzalcoatl was subsequently adopted by the Toltecs, who settled in central Mexico in the 10th century and established their capital at Tula. Their Aztec conquerors were, in turn, heirs to the cult of the Plumed Serpent.
[9]

Teotihuacán is strange and spectacular. Its name is commonly translated from the Nahuatl as "City of the Gods". It has a central 'Avenue of the Dead', a 'Pyramid of the Sun', a 'Pyramid of the Moon' and a 'Pyramid of the Feathered Serpent'. I'm not certain who named these or when but they certainly had a flair for the dramatic.

Teotihuacan was laid out according to a set of alignments that tied it intimately to the movements of the stars and to the mountains on the horizon. The east-west axis led from a spot near the Pyramid of the Sun to a point of great significance on the western horizon. Astronomer-anthropologist Anthony Aveni of Colgate University explains that on the day that the sun passes directly overhead in spring, about May 18, the revered Pleiades star cluster makes its first annual predawn appearance. It was at this point on the western horizon that the Pleiades set.
[10]

The Maya have various interpretations of the Pleiades. They appear as the Four Hundred Boys, whose story is told in an episode of the Popol Vuh, the book of the dawn of life.

The Four Hundred boys were struggling with a log they intended to use as a lintel for their hut. The Monster Crocodile Zipacna moved the log into place for them; but the boys decided he was arrogant for doing this without help, and decided to kill Zipacna by crushing him in the bottom of a hole. Zipacna survived by trickery. Later, when the boys got drunk to celebrate the dedication of their hut, Zipacna pulled down their hut on top of them. All Four Hundred Boys perished, and rose to the sky as the Pleiades. Their deaths were later avenged when the Hero Twins killed Zipacna.
[11]

The ancient Maya used 17 different calendars calculated by their priests. To this day they calculate these calendars to set the times to sow and harvest crops and the times of celebrations and sacred ceremonies. The two most important calendars are the Haab and the Tzolk'in. The Haab is based on the rotation of the earth around the sun and lasts 365 days. Unlike our calendar it has 18 months with 20 days in each month and an extra 19th month lasting only 5 days. The Tzolk'in, the sacred calendar of the Maya, is based on the cycles of the Pleiades. It is still used for divination by the contemporary traditional Maya. The cycle of the Pleiades takes 26,000 years, which the Maya divided by 1,000 to make up years lasting 260 days.

These seven stars, seven tiny points of light, have been a celestial calendar. They have affected how life has been lived around the world for thousands of years. The

Pleiades, by the simple fact of their rising in the evening, have focused the attention of the whole world on that time of year and allowed our ancient ancestors to calculate the time that we today call Halloween.

> *The Titanian star inflames the ceiling of heaven*
> *and illuminates the sea with warm exhalations;*
> *it traverses the sky in fiery brilliance*
> *and ascends the vault of the lofty firmament.*
> *Phoebus' glow extinguishes the white moon,*
> *the fiery flashes of the pleiads do not dart forth,*
> *the sun's effect dispels the nocturnal clouds;*
> *the dewy moistures evaporate in the heat,*
> *nor does the dark stormcloud enshroud the leafy trees.*
> *The mist departs from the meadows,*
> *the scorching blaze parches the tiny ponds,*
> *and its radiance warms the circle of the world.*

The 'Hisperica Famina' is an obscure Latin text. It is thought to be the work of a Sixth Century Irish Monk. In these two translated verses we can see that the 'Pleiads' were thought important enough to be named separately from the other stars in the heavens and described as 'glittering' and 'fiery'. At the same time as the Irish Monks were transcribing the tales and verses of 'the Celts' they were noting the significance of the Pleiades.

> *The bounds of day are made to glow by one of the stars,*
> *the darkness of night is lit up by the other star.*
> *The glittering pleiads adorn the chiselled sky*
> *which hold the two triones with brilliant radiance...*
> *...The sky holds a vast array of constellations*
> *concerning which I do not wish to bore my audience.*

above:
Vintage Halloween
card.

Notes

[1] http://news.bbc.co.uk/hi/english/sci/tech/newsid_871000/871930.stm
 The official Cave of Lascaux website can be found at:
 http://www.culture.fr/culture/arcnat/lascaux/en/

[2] Hamlet's Mill - An essay on myth and the frame of time
 Giorgio de Santillana and Hertha von Dechend, London, Macmillan, 1970

[3] The Iliad
 Homer

[4] Apollodorus, Library and Epitome
 Trans. by Sir James George Frazer, London, 1921

[5] Folklore in the Old Testament: studies in comparative religion, legend and law
 Sir James Frazer, London, 1918

[6] The Great Pyramid - Its Divine Message
 D. Davidson & H. Aldersmith, Williams and Norgate ltd, London, 1941

[7] The Golden Bough
 Sir James Frazer, 1922

[8] History of Herodotus
 Trans. by George Rawlinson, London, 1875

[9] Great Architecture of the World
 John Julius Norwich (ed.), London, Mitchell Beazley, 1975

[10] National Geographic magazine
 George E. Stuart, Dec. 1995

[11] Popol Vuh
 D. Tedlock, 1996

opposite:
Standing Stone
One of three
remaining stones and
the Bronze Age mound
at Hully Hill, near
Edinburgh.

(image © Mark Oxbrow)

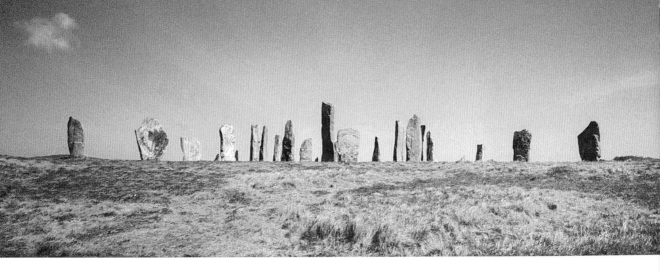

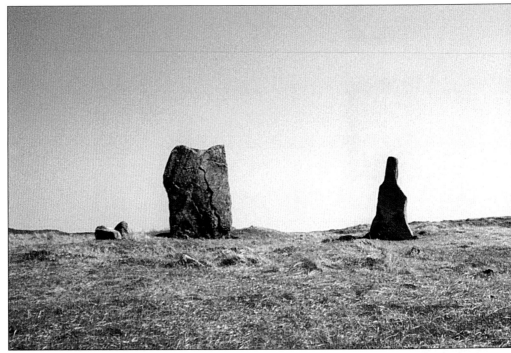

this page:
Calanais stones
Isle of Lewis, Scotland.

(image © Dogworrier.com)

opposite:
Aiofe
Stepmother of the
Children of Lir.
Painting by John
Duncan.

(Courtesy of City of Edinburgh
Museums and Art Galleries.
With thanks to David
Patterson.)

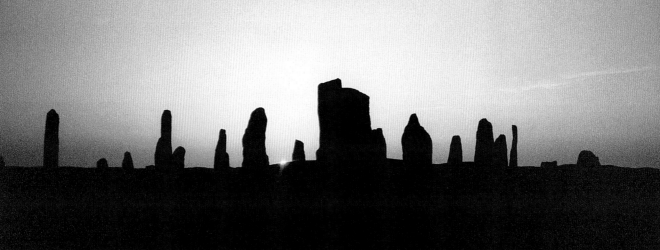

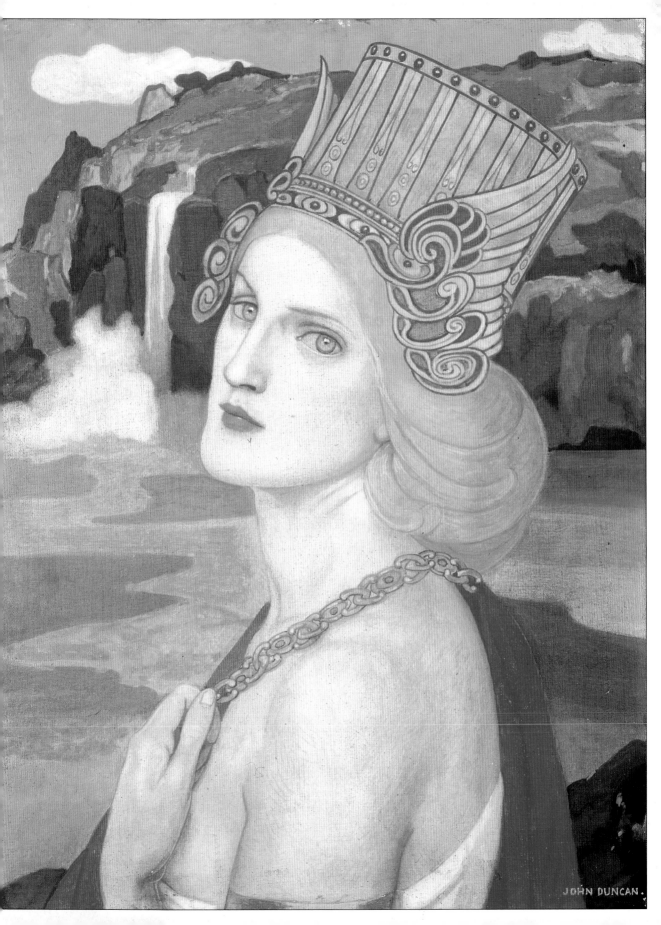

The Queen of Winter

She may pass on with unblench't majesty,
Be it not don in pride, or in presumption.
Som say no evil thing that walks by night
In fog, or fire, by lake, or moorish fen,
Blew meager Hag, or stubborn unlaid ghost,
That breaks his magick chains at curfeu time,
No goblin, or swart faery of the mine,
Hath hurtfull power o're true virginity.
[1]

The 'Blue meager hag' of Milton is but one of myriad guises that the blue skinned Queen of Winter and Halloween has worn since her birth in pre-history...

We have grown accustomed to the witch's sharp wizened features. Beneath her pointy black hat we find an equally pointy nose, a jutting chin, her wrinkled complexion and gnarled fingers. She rides her broomstick and grins at us with a mouthful of crooked teeth like mouldering tombstones. She peers over bubbling toxic cauldrons and cackles at her mischief making. We have grown up with this with the wicked witches of 'The Wizard of Oz' and the weird sisterhood of the Disney Villainesses - Maleficient of 'Sleeping Beauty', the Wicked Queen of 'Snow White', Cruella De Vil of '101 Dalmations', The Queen of Hearts in 'Alice in Wonderland' Ursula in 'The Little Mermaid' and Yzma in 'The Emperor's New Groove'. They may still be found lurking in the Villains Lair online, which can be found at this web address... http://disney.go.com/worldsofdisney/villains/index.html.

But where did this archetypal image of 'the witch' originate? Long before there was even a word for 'witch' there were dark hags stalking the length and breadth of the British Isles. Ulster in Ireland was home to 'Cally Berry' - a malignant, supernatural hag, on the Isle of Man was the 'Old Woman of Gloominess' - an unfortunate creature who once fell into a crevice when she was trying to step from the top of Barrule to the top of Cronk yn Irree Lhaa.

Caillagh ny Groamagh (Manx - Old Woman Of Gloominess, sullen witch)
A Manx weather spirit... If 1 February - feast of St Brigid, pre-Christian Imbolc - is

opposite:
Raven
From "the space where I am" - a performance sculpture installation created by artist Anna Perch-Nielsen.

(Image of 'Jake' the Raven with kind permission of the artist and of Jake's owner Julie Ross, Edinburgh Birds of Prey. 'Jake, our resident Raven is able to pick up the telephone when it rings, dance to his favourite song and is an expert thief from pockets.' http://www.birdsofprey.org.uk)

a fine day she comes out to warm herself, but if it is a wet day she stays inside... The tradition is clearly related to the American Groundhog Day, 2 February, centred in Pennsylvania.
[2]

Like the 'Cally Berry', the 'Black Annis' of England became a nursery bogeyman - a frightful apparition to scare small children into going to bed.

In Leicestershire she has been remembered as 'Black Annis', who is associated with the Easter 'hare hunt' and has a 'cat Anna' form. An eighteenth century title deed refers to land known as 'Black Anny's Bower Close'. Her cave was in the Dane Hills, but was filled in. According to a local poet:

> *'An oak, the pride of all the mossy dell,*
> *Spreads its broad arms above the stony cell;*
> *And many a bush, with hostile thorns arrayed,*
> *Forbids the secret cavern to invade.'*

She is credited in the local folklore with devouring lambs and young children... she has a blue face and only one eye. The poet continues:

> *' 'Tis said the soul of mortal man recoiled*
> *To view Black Annis' eye, so fierce and wild.*
> *Vast talons, foul with human flesh, there grew*
> *In place of hands, and features livid blue*
> *Glared in her visage; whilst the obscene waist*
> *Warm skins of human victims close embraced.'*
> [3]

In Scotland there are found the 'Carlins' - in particular the Lowland 'Gyre Carling'. Sir Walter Scott dubbed her the 'mother witch of the Scottish peasantry'. When King James the Fifth of Scotland was just a boy the poet Sir David Lindsay told him tales of heroes, giants and 'the Gyir Carlyng'. The poem (from the Bannatyne MS.) relating the story of the Gyre Carling is a mad affair - all the dogs in East Lothian pursue her to the summit of North Berwick Law. Here the King of Faerie attacks her with wee furry moles till eventually she escapes to the Mediterranean Sea and marries the Devil...

> *...Thair dwelt ane grit Gyre Carling in awld Betokis bour,*
> *That levit upoun menis flesche...*

The Gyre Carling is said to live upon men's flesh. Were these foul hags some folk memories of human sacrifices to dark ancient goddesses? A good tale needs many things - among them suspense, threat, conflict and a gruesome villain. We only have to look at our continuing fascination with Vampires to see that a creature that drinks blood and eats human flesh taps the vein of some deep primal fear. Behind the Vampire tales are legends of blood drinking supernatural hags and nightmare

creatures that drained the life from sleeping folk. But behind the weird hags of the British Isles lies a far older being - the Queen of Winter - the 'Cailleach Bheur'.

Deep in a pitch black cave sits an ancient hag. She pulls her tattered woollen plaid shawl about bony shoulders and brushes a strand of dark hair back from her face with a twisted hand. She peers out into the inky shadows with her one good eye - a single white eye against the blue-black skin of her wrinkled face, like a winter full moon in a midnight sky. She sits and waits for the sun to set, for the night of Halloween to come. There, in the quiet darkness, the Cailleach waits for her reign to begin.

Tonight we sit in our nice warm homes, cooking dinner in the oven, watching stories flickering across our television sets and sending emails round the globe. All these comforts are only a few generations old. We had a coal fire when I was a child. My mother remembers when the grainy black and white TV was the cutting edge of technology. My grandmother listened to the whizzes and crackles of a crystal set radio. All this in three generations.

Dates alone can't tell you how ancient a thing really is. Numbers don't add up to understanding. Can you truly imagine how long a thousand years is? Two thousand years? Some things are so old that they watch whole civilisations rise, fall and fade away. The Cailleach sits and waits for her time to come. She has been there for an eternity. Our ancestors named mountains after her. They worshipped her, told tales of her, feared her. Her earliest name is lost to us now. She is simply 'the Cailleach Bheur': the harsh old woman.

At the new National Museum of Scotland in Chambers Street, Edinburgh there is a wooden figure. It is tucked away in a round room with a collection of Pictish carved stones and an assortment of magical charm stones and votive offerings of animal skulls, bones, swords, wooden vessels and ornate bronze and iron cauldrons. She was hauled out of a bog at Ballachulish in the West Highlands.

Glimpses of the Sacred
Religious beliefs and rituals have always been ways of making sense of the world. They were fundamental to the lives of Scotland's early people. But early belief and rituals are difficult to understand today. There are no written records to provide insights. Even so, surviving material allows glimpses, however partial, of some aspects of these basic human attitudes and activities.

The Ballachulish figure is female and probably represents a goddess. But who she was, or what she represented, is unknown. The figure was found in a bog, covered by the remains of a wickerwork structure. The bog, overlooking the entrance to a sea loch, was probably a sacred place.
c. 720-510 BC.

That is all the NMS sign tells you. It is impossible to say for sure who this effigy is but when even the extremely careful National Museum chooses the word 'goddess' you are on reasonably safe ground. She is about five feet tall and black as pitch. Two tiny

white pebble eyes stare out at you as you go by. She was found in the back of the Bishop's garden in Ballachulish in 1883. At that time the local population refused to actually touch her and she was only transported to Edinburgh after she was first placed in a coffin making moving her more acceptable. Whoever she is: even two and a half thousand years after she was carved from living wood she still has power. The Cailleach Bheur is the ancient Queen of Winter. Possibly the oldest Goddess of the British Isles: worn down over the centuries from deity to giantess, from giantess to the archetypal witch. Her name now is Gaelic, from the 'Q' Celtic Goidelic culture that spread through the Highlands - but it seems she was there from ages before, waiting for them to come and call her crone.

Near Fortingall is Glen Lyon, home to a curious collection of pre-historic stones known as 'the Old Woman and her Family'.

But if the selected grazing ground was at the very head of the glen, then a very much more potent force had to be appeased - The Cailleach! No beast dared be moved until an advance party had gone up the glen, past Loch Lyon, and up Glen Cailleach to the lonely spot where the Old Woman has her house of Tigh nam Bodach. Fresh thatch was placed on the roof, the walls were repaired and then the stones known as the Old Woman and her Family were reverently brought outside to watch over the herds. Nothing but bad luck would come if she was displeased.

When the herds moved down in October, the family were carefully sealed up for the winter, and the house was made weathertight. This ritual was carried on for centuries until the pattern of farming changed, sheep replaced cattle, and the people of Glen Lyon were evicted or emigrated in their hundreds to the Lowlands and abroad. But the Cailleach is still there, as she has been since the mists of time. Her little house is now roofed with stones, and each successive generation of local shepherd or stalker looks after her and maintains the old tradition... When I visited her lonely dwelling she was securely fastened in for the winter, along with her family of five.

The Cailleach and her Children are very heavy water-worn stones shaped like dumb-bells. The Cailleach herself is some eighteen inches high while her baby is only three - though some people swear it is growing. Once every hundred years she bears another. This shrine is possibly connected with the pagan cult of the Mother Goddess, and may be the only surviving one in Britain. Strange and unpleasant things are supposed to happen if she is disturbed from her winter's sleep.
[4]

A quick look in a musty old Scots Gaelic-English dictionary in the National Library of Scotland puts her name in context in the language.

Caileag - a little girl *Cailin - a girl, maid, nymph*
Cailleach - an old woman *Cailleach-Dhubh - a nun*

The word 'Cailleach' comes from 'Caillech', which has its roots in 'Caille'- veil - a loan to Gaelic from the Latin 'Pallium' - as the Goidelic languages are without the letter 'P'.

The Cailleach was therefore the 'veiled' or 'hooded' old woman. This in turn led to Nuns being known as Cailleachs. But the name is also linked to owls - the most mysterious and 'wise' of the birds of prey - and to the tinder that was vital to kindling a fire.

Cailleach-oidhche - an owl, Common owl, tawny owl
Cailleach-oidhche-mohr - eagle owl
Cailleach Spuinge - touch-wood: lignum carosium, ignem facile concipiens, soft tinder
[5]

The supernatural Cailleach was distinguished from a nun by being referred to as Cailleach Bheur. J. Gregorson Campbell gives the qualifying adjective as beura or bheura, meaning 'shrill, sharp, cutting'.
[3]

The wizened old hag goddesses appear closely linked to particular locations throughout the British Isles. 'The Cailleach' is not a national deity of a whole country but is rather bound closely to the land - associated with particular mountains, rivers, lochs and other wild places. Her form - the powerful old giantess - may be almost identical wherever she appears but her name and her tales are localised. It has been argued that the Hag of Beare - Cailleach Bhéirre - is the eldest of the Cailleachs.

The Irish Triads say there are three great ages:
'The age of the yew tree, of the eagle and of the Hag of Beare.'

The Hag of Beare
It is of Corca Dubhne she was, and she had her youth seven times over, and every man that had lived with her died of old age, and her grandsons and great-grandsons were tribes and races. And through a hundred years she wore upon her head the veil Cuimire had blessed. Then age and weakness came upon her and it is what she said:

Ebb-tide to me as to the sea; old age brings me reproach; I used to wear a shift that was always new; to-day, I have not even a cast one.

It is riches you are loving, it is not men; it was men we loved in the time we were living.

There were dear men on whose plains we used to be driving; it is good the time we passed with them; it is little we were broken afterwards.

When my arms are seen it is long and thin they are; once they used to be fondling, they used to be around great kings.

The young girls give a welcome to Beltaine when it comes to them; sorrow is more fitting for me; an old pitiful hag.

above:
Vintage Halloween
card.

I have no pleasant talk; no sheep are killed for my wedding; it is little but my hair is grey; it is many colours I had over it when I used to be drinking good ale.

I have no envy against the old, but only against women; I myself am spent with old age, while women's heads are still yellow.

The stone of the kings on Feman; the chair of Ronan in Bregia; it is long since storms have wrecked them, they are old mouldering gravestones.

The wave of the great sea is speaking; the winter is striking us with it; I do not look to welcome to-day Fermuid son of Mugh.

I know what they are doing; they are rowing through the reeds of the ford of Alma; it is cold is the place where they sleep.

The summer of youth where we were has been spent along with its harvest; winter age that drowns everyone, its beginning has come upon me.

It is beautiful was my green cloak, my king liked to see it on me; it is noble was the man that stirred it, he put wool on it when it was bare.

Amen, great is the pity; every acorn has to drop. After feasting with shining candles, to be in the darkness of a prayer-house.

I was once living with kings, drinking mead and wine; to-day I am drinking whey-water among withered old women.

There are three floods that come up to the dun of Ard-Ruide: a flood of fighting-men, a flood of horses, a flood of the hounds of Lugaidh's son.

The flood-wave and the two swift ebb-tides; what the flood-wave brings you in, the ebb-wave sweeps out of your hand.

The flood-wave and the second ebb-tide; they have all come as far as me, the way that I know them well.

The flood-tide will not reach to the silence of my kitchen; though many are my company in the darkness, a hand has been laid upon them all.

My flood-tide! It is well I have kept my knowledge. It is Jesus Son of Mary keeps me happy at the ebb-tide.

It is far is the island of the great sea where the flood reaches after the ebb: I do not look for floods to reach to me after the ebb-tide.

There is hardly a little place I can know again when I see it; what used to be on the flood-tide is all on the ebb to-day!
[6]

The 'Hag of Beare' tells of the predominant Irish Cailleach but old Irish hags appear in many places and many guises.

In Ireland she has a 'wizard's wand' with which, when herding her cows, she strikes a bull, turning it into a stone, and she is connected with cairns and dolmens. There is a 'hag's chair' in County Meath. In Northern Ireland she formed a cairn on Carnbane by spilling stones from her apron, and she broke her neck when leaping from an eminence. 'She lives in a cave on the hills above Tiernach Bran.' Her black dog gives milk which imparts great strength to a man who drinks it. She is credited with some of the feats of 'Aine ae Cnuic' - Aine of the hill, Knockainy, 'the Queen of the Limerick fairies ', and she is the 'banshee' of some Leinster and Meath families, as Cleena, Grian of Cnoc Grèine, Aine, Una and Eevil are of other families, there having evidently been 'culture mixing' and the mixing of myths. Most of the Irish stories emphasize the Cailleach's great strength and longevity. She had seven periods of youth' and was a great lover:

> *It is riches*
> *Ye love, it is not men:*
> *In the time when we lived*
> *It was men we loved.*
> *My arms when they are seen*
> *Are bony and thin:*
> *Once they would fondle,*
> *They would be round glorious kings.*
> [3]

But did this dark goddess, who is found throughout the British Isles, truly grow from a single localised deity of the Beare peninsula? Opinion, as always, is divided but I would say that the Cailleach Bheur travelled west from the Highlands of Scotland to the Beare peninsula in Ireland rather than the other way about.

It may well be, judging from the late character of the Irish material, that the drift of lore regarding her was from Scotland to Ireland rather than from Ireland to Scotland. She plays no part in Danann myth and, as Miss Eleanor Hull, who has collected the Irish evidence, points out, 'she is not mentioned in Cormac's glossary or in Cóir Anmann, which contains the most ancient Irish existing traditions of the gods, nor yet in the Dindsenchus or Agallamh na Senorach.
[3]

To say she is 'big in Scotland' is a huge understatement - a Gaelic poem tells of a mountain loch in Mull, named' Crù-lochan' - 'horse-shoe lakelet', reputed to be 'the deepest loch in the world'. The Cailleach Bheur merely says:

> *The great sea reached my knee*
> *And the horse-shoe tarn reached my haunch.*

Her legends and her place names are rooted far more deeply and spread more widely in the Highlands of Scotland. In Ireland she is only one figure in a crowded room of assorted Gods and Goddesses, heroes and faery folk. She gets lost in the chaos. But in Scotland she is centre stage - the dark heart of the Caledonian winter.

Bha da shleagha chaola chatha
air an taobh eile dh'an chaillich
Bha 'h-aodann dubh-ghorm air dreach a 'ghuail
'S a deud cnabadach cnamh-ruadh.

Bha aon suil ghlumach 'na ceann
Bu luaithe na rionnag gheamhraidh;
Craobh mhineach chas air a ceann
Mar choill inich de 'n t-seana chrithinn.

There were two slender spears of battle
upon the other side of the carlin
her face was blue-black, of the lustre of coal,
And her bone tufted tooth was like rusted bone.

In her head was one deep pool-like eye
Swifter than a star in winter
Upon her head gnarled brushwood
like the clawed old wood of the aspen root
[7]

In Scotland the Cailleach Bheur is not simply recognised as a national goddess - her former status must be pieced together from hundreds of place names, stories and scraps of folklore. If you travel around Scotland you find her in countless wild places... 'Beinn na Caillich', 'Lochan na Cailliche', 'sgrìob na Caillich', 'Bàthaich na Caillich'... and fragments of ancient tales where she drops boulders from her plaid, lets a well flood or turns herself to stone. If you take all of these disparate rags and painstakingly sew them together then, stitch by stitch, you find a magical pattern forming and in time you hold an immense patchwork quilt.

The Cailleach Bheur is in the folk-stories associated with the coldest and stormiest period of the year. She is called 'the daughter of Grianan' or 'Grianaig' - that is, of the 'little sun'. In the old Celtic calendar the 'big sun' shines during the period from Beltane - 1st May - till Hallowe'en, and the 'little sun' is the sun of the winter period. 'Daughter of the little sun' does not mean, however, that the sun is either her father or mother, but simply that she was born during the cold season.
[3]

...a run of below-freezing temperatures across Scotland, which reached its lowest point overnight on Friday in the Sutherland village of Altnaharra. It experienced the coldest March night in the UK for 36 years, as the temperature dipped to -21ºC.
[8]

above:
Vintage Halloween
card.

Last night it fell to -21 degrees Centigrade in a wee village in the Highlands - that's about -6 degrees Fahrenheit. It is the beginning of March, a whole month after Imbolc when the thaw towards summer is meant to start. Adders slither from their winter holes and once upon a time charms and prayers were said to St. Bride and she was welcomed into folks' homes. But now we slip and slide about on sheet ice and trudge through thick snow while thousands of remote homes have lost their electricity and motorways, rail lines and airports have been closed across Scotland. Sometimes people ask me if these ancient goddesses might still be around and right now as I come to write about her I suspect that the Cailleach is sat atop a frozen mountain grinning to herself. Somehow it wouldn't be quite right to relax in the comforting warmth of a sunny day and write about the Queen of Winter and by the looks of the weather outside there is no chance of that. If I had a fire I'd throw another log on it.

Her teeth are red as rust and her hair matted, confused and long and 'white as an aspen covered with hoar frost'. She wears a kerchief or 'mutch'. All her clothing is grey and she is wrapped in a dun-coloured plaid drawn tightly about her shoulders. On her feet are buskins. She is of enormous stature and great strength, and capable of travelling very swiftly and of leaping from mountain to mountain and across arms of the sea. In her right hand she carries a magic 'slachdan', 'beetle', 'rod', which is also referred to as a 'farachan', 'hammer'. Dr. Macbain derives 'slachd' from an early Irish word signifying 'thrash', 'beat', 'strike' and connects it with English 'slay' and Latin 'lacerare', 'lacerate'. With her magic hammer or rod the Cailleach smites the earth, so that it may be hardened with frost and the grass prevented from growing. She is the enemy of growth.

The late Mrs. W. J. Watson (E.C. Carmichael) had heard in the Highlands and islands much about the Cailleach 'as a wild hag with a venomous temper, hurrying about with a magic wand in her withered hand, switching the grass and keeping down vegetation to the detriment of man and beast'.
[3]

There is a very old dance called 'Cailleach-an-dùdain' - 'Cailleach of the mill dust' - which some think to be a relic of an ancient religious rite. In it a man and a woman dance and a 'magic wand' is used to revive 'the dead'...

It is danced by a man and a woman. The man has a rod in his right hand, variously called slachdan - druidic wand - and slachdan geasachd - magic wand. The man and woman gesticulate and attitudinize before one another, dancing round and round, in and out, crossing and recrossing, changing and exchanging places.

> *The man flourishes the wand over his own head and over the head of the woman whom he touches with the wand, and who falls down, as if dead, at his feet.*

> *He bemoans his dead 'carlin', dancing and gesticulating round her body. He then lifts up her left hand, and looking into the palm, breathes upon it, and touches it with the wand. Immediately the limp hand becomes alive, and moves from side to side and up and down. He rejoices and dances round the figure on the*

floor. Having done the same to the right hand and to the left and right feet in succession, they also become alive and move. Though the limbs are living the body is still inert.

The man kneels over the woman and touches her heart with the wand. The woman comes to life, and springs up confronting the man. Then the two dance vigorously and joyously as in the first part. The tune varies with the varying phases of the dance. It is played by a piper or fiddler, or sung as a 'port-a-beul' - mouth-tune - by a looker-on or by the performers themselves. The air is quaint and irregular. The words, which are curious and archaic, commence as follows:

> *Cailleach an dùdain, dùdain, dùdain,*
> *Cailleach an dùdain, cum do dheireadh rium.*
> [9]

In the Pentland Firth to the West of Scotland lies the mighty whirlpool of Corrywrecken. These dark waters still seethe and it is here in this immense natural cauldron that the Cailleach Bheur ushers in the winter. At Samhuinn she descends on the whirlpool, removes her huge dun-coloured plaid and washes it in the heaving waters till it is white as frost and snow..

Mrs. K. W. Grant, a native of Easdale, Argyll, writes:
"Before the washing the roar of a coming tempest is heard by people on the coast for a distance of twenty miles, and for a period of three days before the cauldron boils. When the washing is over the plaid of old Scotland is virgin white."
The Cailleach, Mrs. Grant notes, is associated with "wintry tempests" and the "bitter, stinging winds of spring".
[3]

In the depths of winter while she reigns from her high mountains of Ben Nevis and Schiehallion. She is an awesome figure - revered and feared for her ferocious storms and dark moods, but she does not wholly control the weather or the seasons. As winter fades and the first warm days of spring melt the ice the Cailleach Bheur cannot turn back the coming summer. She is powerless to prevent the dawning of the 'big sun'.

There are two conflicting tales that tell us of the Cailleach Bheur and the coming of summer. One tells that she keeps a maiden captive at her mountain seat of Ben Nevis - 'venomous or stormy mountain' - throughout the dark half of the year but as the months go by her son falls in love with the fair girl. In time he releases her and they elope, chased across Scotland by his enraged mother...

...on Ben Hynish in Tiree there is a rocky chasm called Leum an eich, 'the horse's leap'. Over it Cailleach Bheur's son fled from her on horseback with his bride. The Cailleach pursued him; and, on leaping across, the forefeet of his steed, on alighting on the opposite brink of the fissure, struck a piece out of the rock; hence the name by which the gap is still known.
[3]

opposite:
Ben Breck
One of many Scottish mountains associated with the Cailleach.

(image © Mark Oxbrow)

The Cailleach Bheur was livid at this betrayal but, as the winter wanes, the hunted becomes the hunter and her son turns and chases his dark mother. Overwhelmed by the end of winter and with her son hot on her heels she bitterly throws her wand or hammer under a whin - gorse - bush or a holly tree - which is why no grass will grow beneath them.

> *Thilg i e fo'n chrasibh chruaidh chuilinn,*
> *Air nach do chinn gas feur no fionnadh riamh.*
>
> *She threw it beneath the hard holly tree,*
> *Where grass or hair has never grown.*
> [3]

Defeated, she now either disappears in 'a whirling cloud of angry passion' or turns herself to stone - hence 'the hag stones' - single standing stones that dot the landscape.

The alternate tale sees the Cailleach Bheur noticing the spring thaw and undertaking the perilous journey off to a blessed isle in the west. She uses the mountaintops and small islands as stepping-stones and in the dead of night she drinks from the Well of Youth - 'before bird tasted water or dog was heard to bark'. As she tastes the magical waters her gnarled old skin smoothes, her old bones straighten and she turns from aged crone to fair young girl - 'always at sixteen years of age'. Sacred wells are to be found throughout the British Isles and some are still visited on May morning by pilgrims seeking a cure or good health - they leave a rag or 'cloutie' on an over hanging briar and as it rots a way so their malady fades.

It has been said, particularly online, that the Cailleach becomes either Brigit or St. Bride as a result of her miraculous transformation. There is absolutely no evidence for this - it is a modern misinterpretation of the folktales. The Cailleach is renewing herself and she will rapidly age to the blue skinned hag by Samhuinn. This magical transformation of maiden to hag or hag to maiden appears in heroic tales and medieval literature. She seeks shelter, one dark night, with the Fians - 'a creature of uncouth appearance' in need of hospitality. Oisean and Fionn both turned her away when she sought to warm herself with them beneath their blankets but Diarmaid lets her by the fire. Then when the crone seeks to *be under the warmth of the blanket together with himself* he lets her beneath, merely turning a fold of the blanket between them; in a short while he is taken aback to find that the hag has transformed into 'the most beauteous woman that men ever saw'.

This tale is also told in the legend of Sir Gawain and the Loathly Lady. King Arthur is saved by an ugly misshapen woman and demands the hand of a fair knight in return. Sir Gawain says he will marry the loathsome lady and with due ceremony they are wed. As they prepare to go to bed on their wedding night Gawain finds his bride has changed into a beautiful maiden. She tells him she is under a spell that makes her spend half her time as maiden and half as hag but that Gawain may choose when the spell works. He may have her as a fair maiden in his bedchamber but crone in the

court by day or she may walk in the sunlight young and beautiful but spend the nights misshapen and ugly. Gawain in a moment says that he cannot choose, for the choice must be hers and with that the spell is broken forever. He gives her what a woman wants most - her own right to rule herself - and his bride is from then on the fairest lady in the land. Elements of this tale reappear in Chaucer's 'The Wife of Bath's Tale'...

The knight, under pain of death, has to discover what thing a woman most desires. He receives the answer from an ugly old hag on condition that he will marry her. It is that women desire to have sovereignty over husband and love and also mastery in married life. The knight marries the hag and, when he kisses her, she becomes as fair 'as any lady, empress or queen'.
[3]

In some places there are 'maidens' made out of a sheaf of corn - in others the sheaf was called 'the Cailleach' and it was dressed up and given to the last to finish their harvesting. The unlucky late crofter had to keep 'the Cailleach' through the winter - it was finally broken up and fed to the cattle the following spring.

The first done made a doll of some blades of corn, which was called the 'old wife,' and sent it to his nearest neighbour. He in turn, when ready, passed it to another still less expeditious, and the person it last remained with had the 'old woman' to keep for that year. ...

In harvest, there was a struggle to escape being the last done with the shearing and when tillage in common existed, instances were known of a ridge being left unshorn - no person would claim it - because of it being behind the rest. The fear entertained was that of having the 'famine of the farm' - 'gort a bhaile' - in the shape of an imaginary old woman, to feed till next harvest. Much emulation and amusement arose from the fear of this old woman...

The fear of the Cailleach in harvest made a man in Saor-bheinn, in the Ross of Mull, who farmed his land in common with another, rise and shear his corn by moonlight. In the morning he found it was his neighbour's corn he had cut.
[10]

These harvest customs are the exception - the Cailleach Bheur is otherwise not associated with domestic animals or cultivation. She is a goddess of the wilderness and, like the goddess Artemis, is the patroness or the wild beasts of forest and mountain. Her 'cattle' are the wild deer that she tends, protects and milks. J.G. McKay suggests that the Cailleach Bheur was in fact a 'Deer Goddess' of pre-history attended by the priestesses of a matriarchal 'Deer Cult'.

The 'Deer Goddess' is never spoken of as such. Each is described as a beàn-sidhe or supernatural or 'fairy' woman. One... is universally known... being called the Cailleach... of this or that ben, staith, river or district. All are gigantic: they are the most tremendous creatures of Gaelic myth. One was so tall that when wading across the Sound of Mull, 'the water reached only to her knee'.

The gigantic stature of these Old Women, their love for their deer, the fact that their dealings are almost exclusively with hunters, and the fact that each is referred to as a beàn-sidhe, or supernatural woman, seems sufficient for calling them Deer-Goddesses.

There are an immense number of tales, traditions, references, notices of customs, and various minor matters which show conclusively that there formerly existed in the Highlands of Scotland two cults, probably pre-Celtic, a deer-cult and a deer-goddess cult.
[11]

The red deer stag, of all the Highland beasts, seems bound to the turning seasons. They lose their magnificent antlers as the spring grows warmer and grow new antlers in their stead. At Beltane these are still 'in velvet'. As the year passes the deer graze and run wild, then as autumn turns to winter the stags fight - head to head. This is the rutting season - when the males compete for females -the stags clash in bloody battles, heaving against one another, cutting with their antlers and charging headlong into their rivals. At Samhuinn the stag seems at the height of its strength and virility - their roaring cries echoing through the glens. Unsurprisingly the deer were viewed as supernatural creatures, as fairy cattle or even as otherworld women transformed into shape of beast. The Cailleach Bheur is thought to drive her herd of deer to pasture in Glen Nevis or in the Ross of Mull, and then to wild beaches on winters nights where they feast on 'sea-tangle'.

The deer-cult and deer-goddess cult date from some remote time when woman was supreme. The nymphs of Artemis possibly correspond to the groups of priestesses... The Highland Glaistig was a woman of mortal race, to whom a 'fairy' nature had been given, a statement which may well be a folk-memory of ceremonies at the initiation of priestesses.
[11]

There still exists an ancient song known as 'the Croon of the Glaistig of Ben Breck' - please note that the translator has, for some reason, substituted 'Cailleach' with 'lady' in the English.

Cronan Glaistig Na Beinne Brice

Is e so an Cro\nan a bhiteadh Glaistig na Beinne Brice a' seinn d'a h-eildean am feadh a bhiodh i'gan iomain roimpe air an t-sliabh:

Cailleach Beinne Bric, horo/!
Bric horo/! Bric horo/!
Cailleach mhor an fhurain a\ird
Cha leiginn mo bhuidheann fhiadh
Bhuidheann fhiadh, bhuidheann fhiadh
Cha leiginn mo bhuidheann fhiadh
A dh'iarraidh shlige duibh' a 'n tra\igh.

above:
Vintage Halloween
card.

Gu'm b'annsa leo\ biolair fhuar,
Biolair fhuar, biolair fhuar,
Gu'm b'annsa leo\ biolair fhuar,
A bhiodh an cois an fhuarain a\ird.

The Croon of the Glaistig of Ben Breck

This is the croon which the Glaistig of Ben Breck used to sing to her hinds while she was driving them before her on the mountainside:

Lady of Ben Bric, horo!
Bric, horo! Bric, horo!
Lady of Ben Bric, horo!
Great Lady of the fountain high.
I ne'er would let my troop of deer,
Troop of deer, troop of deer,
I ne'er would let my troop of deer,
A-gathering shellfish to the tide.
Better liked they cooling cress,
Cooling cress, cooling cress,
Better liked they cooling cress
That grows beside the fountain high.

But she is far from simply a 'Deer Goddess'. She is closely associated with many different wild beasts and birds - there are even the three Hebridean Cailleachs of Raasay, Rona and Sligachan who are particularly fond of fish. The Cailleach Bheur is spoken of as the protectress of a herd of swine, as assuming the guise of a hare, a crow, a quail, a gull, a cormorant, an eagle or a heron. The Cailleach Bheur is also said to have assistants - giant storm-brewing hags that ride through thunderous skies on wolves and wild boar.

Though the Cailleach Bheur protects her herds from hunters admirably she is far less competent when it comes to her guardianship of wells. In an Argyllshire tale she is meant to cover the well on the summit of Ben Cruachan with a stone slab every evening and then remove the slab at sunrise.

But one evening, being aweary after driving her goats across Connel, she fell asleep by the side of the well. The fountain overflowed, its waters rushed down the mountain side, the roar of the flood as it broke open an outlet through the Pass of Brander awoke the Cailleach, but her efforts to stem the torrent were fruitless; it flowed into the plain, where man and beast were drowned in the flood. Thus was formed Loch Awe.... The Cailleach was filled with such horror over the result of her neglect of duty that she turned into stone. There she sits... among the rocky ruins at the pass overlooking the loch, as on the rocks at Cailleach Point in Mull she gazes seaward.

[3]

The Cailleach Bheur is just as accident-prone when she is carrying huge boulders about the countryside.

In numerous fragmentary folk-stories she is, along with her helpers, a shaper of Scotland. One given by Hugh Miller tells how she carried on her back a pannier filled with earth and stones and formed almost all the hills of Ross-shire... When standing on the site of the huge Ben Vaichaird, the bottom of the pannier is said to have given way, and the contents, falling through the opening, produced the hill, which owes its great height and vast extent of base to the accident... when the Cailleach was constructing a bridge across the Sound of Mull, commencing at the Morvern side, the strap of her creel, filled with stones, snapped suddenly and the contents of the creel formed the cairn called in Gaelic 'Carn na Caillich.'
[3]

This clumsy giantess, dropping boulders and snoozing on mountainsides, is far from the venomous bad-tempered hag that blasts the land with snow and ice and strips the leaves from the trees. As Christianity took hold the Cailleach was less a terrifying dark goddess and more a rather dotty old lady.

Folklorists have speculated on the origins of the Cailleach. She has been thought to be the 'Deer Goddess' of an ancient matriarchal 'Deer Cult', an import of the Irish Cailleach Bhéirre - the 'Hag of Beare', an imported Norwegian descendant of 'nature myths', an ancient personification of winter or the personification of 'the Eastern Sea'. To further muddy the water we find a strong argument for her descent from an ancient form of the Greek goddess Artemis and even striking similarities with the Hindu goddess Kali...

...collected from a 'Saxon-Hungarian woman', named Malvinia, a folk-tale of a very great witch, who was head over eight witches: She was harsh to her son's wife, to whom she set the task of washing a brown fleece white. The young woman washes it at a brook, but old Winter took pity on her and, taking the fleece from her, made it white. When she returned home with the fleece and some mountain flowers, the old witch was enraged and she and the other witches mounted goats and began a contest against all growth, like the Scottish Cailleach and her helpers.
'Snow and hail, wind and rain were summoned to do battle, but the warm sun shone out, the south wind breathed, and Spring triumphed. The nine witches were turned into stone, and 'there they sit', said Malvinia, 'on their goats, on the top of the mountain of Silash in Temesvar; and on the anniversary of their defeat the fountains in their heads overflow and their faces become blurred with weeping'...
...The earliest form of Artemis was 'connected with the waters and with wild vegetation and beasts'...in Arcadia, Laconia and Sicyon she was worshipped as 'the lady of the lake'... She was also 'the goddess of the marsh' in Arcadia and Messene. 'She was associated frequently with rivers as in Elis.' ... 'The goddess of still and running water is also naturally a goddess of trees and fish.'
...In some respects, as has been shown, the chief Cailleach resembles the primitive Artemis of Greece. The view that she was merely a 'deer goddess' ignores

her associations with swine, goats, sheep, wolves, birds and fish as well as deer, her connections with trees and plants, with mountain wells, rivers, lochs, marshes and the ocean, with tempests and thunder and with hills, rocks, cairns, boulders and standing stones.
[3]

Kali - the dark goddess of Hindu mythology - is also a blue skinned deity with a fearsome reputation. She drank the blood of demons and has a third eye on the flat of her forehead. Though their names do not have the same root - Kali is a feminine derivative of Kala 'a portion/a small part' - the two are distinctly similar.

The Druids of the ancient Celtic world have a startling kinship with the brahmins of the Hindu religion and were, indeed, a parallel development from their common Indo-European cultural root which began to branch out probably five thousand years ago. It has been only in recent decades that Celtic scholars have begun to reveal the full extent of the parallels and cognates between ancient Celtic society and Vedic culture...
[13]

I believe that we find in the tales of the Cailleach Bheur a melting pot of cultural traditions, forgotten religions and anthropomorphised seasons. (From time to time you need to use big words...) Storytellers have seldom been shy of taking a good tale and reworking it for their own local audience - so features of the landscape are given names and stories to suit their characteristics and curious tales from faraway lands are changed to fit existing native characters. There do seem to be half remembered glimpses of the rites of some ancient religion - with the dark goddess of former times worn down to giantess and hag but its nature was lost to us millennia ago. Many of the tales of the Cailleach Bheur cast her clearly as a personification of winter though she is as often at the mercy of the weather or on some quite unconnected task. None of the models entirely explains her as she appears in so many different guises and has a multiplicity of roles and associations. What is clear is that the origins of the Cailleach Bheur stretch so far back into pre-history that they may be lost to us forever. We can only guess at her antiquity and wonder at her continuing endurance.

But what of the charges of human sacrifice - of hags devouring flesh? Perhaps it is due to the way our distant ancestors might have interpreted archaeological sites from previous centuries and cultures. This is demonstrated in the casting of megalithic standing stones and later burial mounds as giant's circles, hag stones and faery mounds by subsequent generations. Man made sites become thought of as magical places where supernatural beings may still lurk. Among the exhibits in the Museum of Scotland is a collection of finds from a cave up at Covesea. This cave was once hung with decapitated heads and the floor was strewn with bones and precious jewellery.

At various times in the past, death was treated as crossing into another world - that of the ancestors and gods. Around 800 BC, and again during the 1st millennium AD, this secluded sea cave was treated as a natural threshold or borderline area between

this world and the otherworld. Many people were buried here and, around 800 BC, rituals in the cave included suspending the severed heads of children near the entrance. As the flesh rotted, the bones fell off and landed on the floor of the cave. The children may have been wearing gold-covered rings in their hair. Other precious objects were also found. Alongside this ritual activity connected with the dead, there were signs of ordinary, seasonal use of the cave as a fishing and gathering camp. [14]

This site had first been witness to arcane rites about 2,800 years ago. Then around a thousand years later it was used again. When the folk rediscovered the cave after a thousand years of absence they found the skulls of decapitated children and a midden of bones and beads. We look at the evidence in context with a wealth of archaeological knowledge and sophisticated dating techniques. They saw a cave full of bones and probably came to the logical conclusion that there was a filthy great big supernatural creature eating folk and dropping their gnawed bones in her cave. This may account for some of our tales of monstrous hags eating men's flesh but I suspect that it has more to do with the telling of a good scary story on a dark night...

A couple of years ago I ventured north to visit the Cailleach Bheur. My girlfriend of the time drove us up on a bright balmy day. The sun shone as the summer began to show its face, the trees were full of blossom and the spring flowers bloomed. We arrived late in the tiny village of Fortingall in Perthshire and lodged in a bed and breakfast for the night. Fortingall clung tenaciously to its Halloween traditions - a bonfire was kindled on the nearby 'Carn nam Marbh' - 'mound of the dead' - and the children leapt the flames. The village is home to the oldest living tree in Britain - the Fortingall Yew tree is over three thousand years old - and there are three stone circles in a nearby field. But the ultimate destination of our journey was Schiehallion - 'Sìdh Chailleane' - 'the faery hill of the Caledonians'.

This magical mountain lies at the centre of Scotland and is conical in shape - like a flattened witch's hat. Here the Cailleach Bheur is said to have unearthed huge masses of stones as she ploughed 'sgrìob na Caillich' - the 'Old Wife's Furrow'. After a good night's sleep we wandered down to breakfast to be met by the landlady apologising for the terrible change in the weather. Overnight the summer had disappeared and the countryside was cloaked in a thick layer of snow. The morning drive up the narrow road to Schiehallion was indescribably beautiful. The trees were white frosted with glistening icicles like crystals, the mountain shone as the sun illuminated the snow and the air itself seemed frozen. It was as though the Cailleach knew we were arriving - the 'queen of the little sun' could not have her guests come visit her at home in the warmth of a summer's day - it seemed she borrowed a day from the depths of winter just for us. Within a few hours we were down in the valley beyond, at Kinloch Rannoch, the sun was blazing in the blue sky and the unexpected snows were already melting. From then on the days were bright and clear without a hint of a snowflake or hailstone. The gods and goddess of antiquity fade from memory, their religions become mythologies and their temples fall to ruins but in the dark nights in the dead of winter the Cailleach Bheur still lives.

Notes

[1] Comus - A Mask presented at Ludlow Castle 1634
John Milton

[2] Dictionary of Celtic Mythology
J. MacKillop, Oxford University Press, 1998

[3] Scottish Folk-lore and Folklife: studies in race, culture and tradition
D. A. MacKenzie, London, 1935

[4] Perthshire in History and Legend
Archie McKerracher, Edinburgh John Donald c1988

[5] Dwelly's Illuminated Gaelic to English Dictionary.

[6] The Hag of Beare. Trans. Lady Augusta Persse Gregory (1852-1932)
The Kiltartan Poetry Book New York: G. Putnam's Sons, 1919. pp. 68-71.

[7] Pagan Celtic Britain
Anne Ross, Cardinal, 1974 trans. & quot. Campbell 1862.

[8] The Scotland on Sunday 4th March 2001

[9] Carmina Gadelica
Alexander Carmichael, 1928

[10] Superstitions of the Highlands and Islands of Scotland
John Gregorson Campbell, 1900

[11] The Deer-Cult and the Deer-Goddess Cult of the Ancient Caledonians
J. G. McKay, Folklore 1932

[12] Folktales of the West Highlands
Campbell of Islay, Volume II No. 46

[13] Our Druid Cousins
Peter Berresford Ellis, Hinduism Today magazine, Feb 2000
http://www.hinduism-today.com/2000/2/

[14] 'Crossing the threshold' display board
Museum of Scotland. Chambers Street, Edinburgh

above:
Vintage Halloween
card.

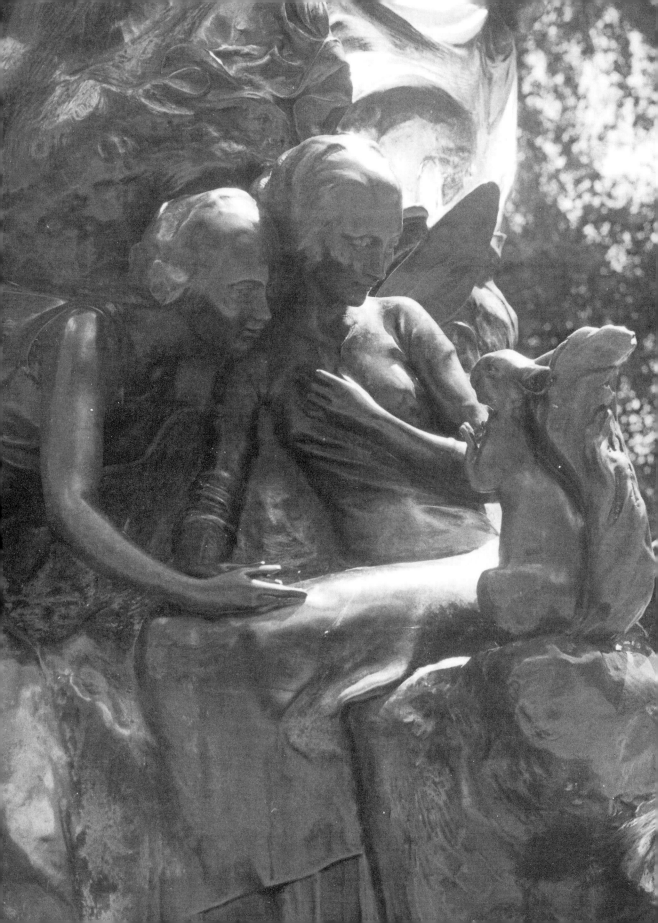

faery folks

Tis Hallowmasses' e'en,
And round the holy green,
The fairy elves are seen,
Tripping light.

In Scotland it is thought ill luck to call the faeries by name. They are called the 'good neighbours'. It is not a wise move to insult the faery folk or belittle then. But that is precisely what has happened to the faery race in the last hundred years or so. We have 'belittled' them - made them small and pretty with little glittery gossamer wings and cute pointy ears. Throughout this book you will notice that I use the word 'faery' instead of 'fairy'. Lets imagine that a 'fairy' is the delicate thing of nursery tales and picture books, that little girls with their parents' box camera took photographs of tiny flitting fairies that played in the river by the bottom of their garden.

Now imagine what a 'faery' is. A faery may be as tall as you or I, or taller. They appear radiant and glamorous or loathsome and terrifying. The faery folk are to be feared and respected, placated with offerings of milk and food, they are the noble borealis race who live in a mysterious otherworld that we can merely dream of. Faeries have the power to bless or curse, cure or kill. They do not suffer fools, at all. So, if you were so inclined, just how would you go about seeing a faery?

People who see sichts
It was believed that children born on All Saints Eve were in after life patronised by the Good Neighbours, and endowed with the peculiar faculty of 'seeing sichts'.
[1]

Fear not, if you were not born on Halloween you may still catch a glimpse into the land of Faery.

There seems to be no definite rule as to the circumstances under which the Fairies are to be seen. A person whose eye has been touched with Fairy water can see them whenever they are present; the seer, possessed of second sight, often saw them when others did not; and on nights on which the shï-en (faery hill) is open the chance passer-by sees them rejoicing in their under-ground dwellings. A favourite

opposite:
Fairies on the Peter Pan Bronze Sculpture
Kensington Gardens, London. The sculpture was placed on 1 May 1912 – Beltane morning – by Sir James Matthew Barrie, the author of the play 'Peter Pan' and the book 'Peter and Wendy'. He was born in Kirriemuir, Scotland and he clearly knew a lot about faeries.

(image © Mark Oxbrow)

73

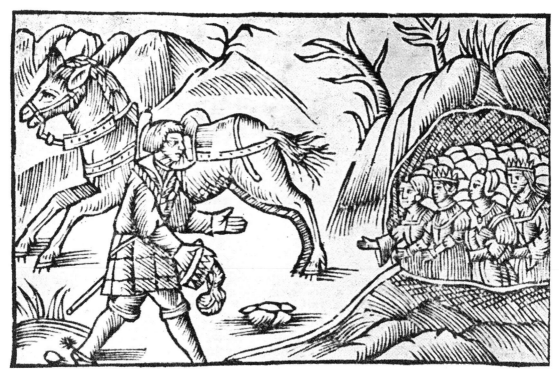

above:
Fairy hill
A kilted Knight is
greeted by the faeries
in their hollow hill.

(From Olaus Magnus, Historia
de Gentibus Septentrion-Alibus
(Antwerp 1558). Courtesy of the
Fortean Picture Library.)

time for their encounters with men seems to be the dusk and wild stormy nights of
mist and driving rain, when the streams are swollen and 'the roar of the torrent is
heard on the hill.'
[2]

There is an ancient saying that 'faery folk live in old oaks' but they are usually more
at home in a hollow hill. Throughout the British Isles there must be thousands of
these strange dwellings. Some are small mounds, often Neolithic burial sites, a
tumuli or an old hillock in the corner of a field where the farmer still refuses to
plough. These little faery homes might be large enough for an average elfin family but
a decent sized faery village needs a large wild hill, often an ancient hill fort, or
preferably an isolated mountain fit for a faery queen.

Of hills having the reputation of being tenanted by Fairies may be mentioned
Schiehallion (Sith-chail-lionn), in Perthshire, and Ben-y-ghloe (Beinn a Ghlotha);
and in Argyllshire, Sìthein na Rapaich, 'the Fairy dwelling of tempestuous weather,'
in Morven and Dunniquoich (Dùn Cuaich, the Bowl-shaped hill) Dùncleacainn and
Shien-sloy (sìthein sluaigh, the multitude's residence), near Inverary
[2]

Schiehallion has already been mentioned as one of the mountain homes of the
Cailleach. It is known in translation as the 'Faery hill of the Caledonians'.

At the head of Glen-Erochty (Gleann-Eireochd-aidh, the Shapely glen), in Athol, in

Perthshire, there is a mound known as Càrn na Sleabhmh, which at one time was of much repute as a Fairy haunt. Alasdair Challum, a poor harmless person, who went about the country making divinations for his entertainers by means of a small four-sided spinning top (dòduman), was asked by a widow where her late husband now was. Allistir spun round his teetotum and, examining it attentively, said, "He is a baggage horse to the Fairies in Slevach Cairn, with a twisted willow withe in his mouth."
[2]

Here we find that a poor unfortunate dead person has been pressganged into fetching and carrying for the faeries in their home. It was widely believed that the spirits of the dead would wait out the years until judgement day living with the faeries in their hollow hills. But it wasn't just the dead who might find themselves in Elfland; many a foolish mortal has stumbled across the threshold to the faery realm.

How mortals could enter a faery hill
It was believed that if, on Hallowe'en, any person should go round one of these (faery) hillocks nine times, contrary to the course of the sun, a door would open, by which he would be admitted into the realms of fairyland.
[3]

No one with an ounce of sense in his or her head would ever go widdershins around anything. Going counter-clockwise, 'contrary to the course of the sun' just invites bad luck. In the Highlands everything that could be was done sun-wise - deosil - clockwise; everything from passing food or drink clockwise around a table to walking sun-wise around fields and homes with a burning fire torch to protect them.

It appears by an ancient MS. and the tradition of a few old people in Perthshire, that the badge of the Hays was the mistletoe. There was formerly in the neighbourhood of Errol and not far from the Falcon stone, a vast oak of an unknown age, and upon which grew a profusion of the plant; many charms and legends were considered to be connected with the tree, and the duration of the family Hay was said to be united with its existence. It was believed that a sprig of mistletoe cut by a Hay on Allhallowmas Eve, with a new dirk, and after surrounding the tree three times sunwise and pronouncing a certain spell, was a sure charm against all glamour or witchery and an infallible guard in the day of battle. A spray gathered in the same manner was placed in the cradle of infants and thought to defend them from being changed for elf-bairns by the fairies.
[4]

To walk widdershins about a church or a faery hill is an extremely foolish thing to do, especially at Halloween.

About a mile beyond the source of the Forth, above Lochcon, there is a place called Coir-shi'an... which is still supposed to be a favourite place of their (the faeries') residence. In the neighbourhood are to be seen many round, conical eminences;

particularly one near the head of the lake, by the skirts of which many are still afraid to pass after sunset. It is believed, that if, on Hallow-eve, any person goes alone round one of these hills nine times, towards the left hand (sinistrorsum), a door shall open, by which he will be admitted into their subterranean abodes....
[5]

It's Halloween night and you are out and about for a moonlight stroll. You are just minding your own business and accidentally walk round a faery mound nine times widdershins. (Don't say I didn't warn you not to.) Suddenly a thin sliver of silver light radiates from he hillside. You wander over as a door opens where moments before there was only grass and heather. Weird and wonderful music drifts in the air and the sweet smell of honeyed wines and blackberry pies wafts by. Out in the night all is cold and dark and wet. You take a deep breath, and then step inside.

Faery festivities
There are stated seasons of festivity which are observed with much splendour in the larger dwellings. The brugh is illumined, the tables glitter with gold and silver vessels, and the door is thrown open to all comers. Any of the human race entering on these occasions are hospitably and heartily welcomed; food and drink are offered them, and their health is pledged. Everything in the dwelling seems magnificent beyond description, and mortals are so enraptured they forget everything but the enjoyment of the moment. Joining in the festivities, they lose all thought as to the passage of time. The food is the most sumptuous, the clothing the most gorgeous ever seen, the music the sweetest ever heard, the dance the sprightliest ever trod. The whole dwelling is lustrous with magic splendour.

All this magnificence, however, and enjoyment are nothing but semblance and illusion of the senses. Mankind, with all their cares, and toils, and sorrows, have an infinitely more desirable lot, and the man is greatly to be pitied whom the Elves get power over, so that he exchanges his human lot and labour for their society or pleasures. Wise people recommend that, in the circumstances, a man should not utter a word till he comes out again, nor, on any account, taste Fairy food or drink. If he abstains he is very likely before long dismissed, but if he indulges he straightway loses the will and the power ever to return to the society of men. He becomes insensible to the passage of time, and may stay, without knowing it, for years, and even ages, in the brugh. Many, who thus forgot themselves, are among the Fairies to this day. Should they ever again return to the open air, and their enchantment be broken, the Fairy grandeur and pleasure prove an empty show, worthless, and fraught with danger. The food becomes disgusting refuse, and the pleasures a shocking waste of time.

The Elves are great adepts in music and dancing, and a great part of their time seems to be spent in the practice of these accomplishments. Elfin music is more melodious than human skill and instruments can produce, and there are many songs and tunes which are said to have been originally learned from the Fairies. The only musical instrument of the Elves is the bagpipes, and some of the most celebrated pipers in Scotland are said to have learned their music from them.
[2]

There are countless tales and ballads concerning the journeys of mortals into the land of Faerie. They share some common traits: the crossing of a 'threshold' - usually a doorway, a cave entrance, breaking the surface of the water or crossing a bridge to an island. 'Time dilation' - after a time the mortal may return to our world to find either that they have been gone for years in the real world or just for a single night. I recently heard a lecture on 'Time Travel' at the Science Festival. It was particularly interesting to hear the theories on the use of 'wormholes' to travel through space and time. It seems that cutting edge scientific thinking is agreeing with folklore - to travel in time you have to enter a 'wormhole' a weird otherworldly threshold that is unlike anything in the known world. The folktales tell us more about journeys to and from Faeryland: just as we may visit their world - so the faeries can, on occasions, venture forth into ours. In the mortal world they dance and make mischief, steal unguarded babes and spoil the fruit on the branch.

They are said to come always from the west. They are admitted into houses, however well guarded otherwise, by the little hand-made cake, the last of the baking (bonnach beag boise), called the Fallaid bannock, unless there has been a hole put through it with the finger, or a piece is broken off it, or a live coal is put on the top of it; (Bonnach beag boise, gun bhloigh gun bhearn, Eirich's big sinne a stigh, i.e. Little cake, without gap or fissure, rise and let us in, is the Elfin call.) by the water in which men's feet have been washed; by the fire, unless it be properly 'raked' (smàladh), i.e. covered up to keep it alive for the night; or by the band of the spinning wheel, if left stretched on the wheel.

The reason assigned for taking water into the house at night was that the Fairies would suck the sleeper's blood if they found no water in to quench their thirst. The water in which feet were washed, unless thrown out, or a burning peat were put in it, let them in, and was used by them to plash about in (gan loireadh fhéin ann) all night. Unless the band was taken off the spinning wheel, particularly on the Saturday evenings, they came after the inmates of the house had retired to rest and used the wheel. Sounds of busy work were heard, but in the morning no work was found done, and possibly the wheel was disarranged.
[2]

On two nights, above all others, the Faery folk are to be found out in the mortal realm: at Beltane, the eve of the month of May, and a half a year later - at Halloween.

It is related that one Hallowe'en two farm-servants, while on their way to Todholes to see their sweethearts, heard sounds of most enchanting music issuing from Polveoch Burn. Turning aside to discover from whence it came, they were astonished to see in a green opening among the trees a company of fairies, male and female, dancing to a band of pipers. All were dressed in the most elegant style, and their delicate little bodies swirled round in a fashion that quite entranced the awestruck swains. One, however, thought the strange sight could bode no good, and he beat a hasty retreat, leaving his companion gazing admiringly on the dazzling show. Long he stood and feasted his eyes and ears on the exquisite scene and the delicious melody, when, his presence being discovered by one of the company, he was invited

to take part in the dance, and presented with fruit and wine. He daringly accepted; the refreshments seemed to put a new life into him, and he joined in the dance with the most lively spirit, acquitting himself so well that he was made quite a hero by the little ladies in green, who did all in their power to make him enjoy himself. To drink of the fairies' wine was to lose all calculation of time, and twelve months went round and found the young fellow still enjoying himself with the wee folks. On Hallowe'en following he was found at the same place by his companion, who, refusing a drink that was proffered him, gave offence to the fairies, and, dragging hold of his friend, pulled him away, and broke the spell that bound him. He could scarcely believe he had been twelve months with the fairies, and said the time only seemed like an hour or two. Ever afterwards he was endowed with second sight.
[6]

Faery Knots
The fairies danced round the Hallow-fires and, whilst they were doing so, they kept casting knots of blue ribbons with their left hands, and throwing them over their left shoulders. These knots could not be unloosed and were called 'fairy-knots'. Those who were fascinated by their beauty, and were foolish enough to lift them, came immediately under the power of the 'fair-folk' and were liable to be carried off by them at any moment.

The faeries' last dance
The fairies had their last dance on the 11th of November, when they retired to their dwellings. These dwellings were green knolls scattered all over the country. There was always a well near those green hillocks....
[7]

The Testimony of an Irish Priest
We now pass directly to West Ireland, in many ways our most important field, and where of all places in the Celtic world the Fairy-Faith is vigorously alive; and it seems very fitting to offer the first opportunity to testify in behalf of that district to a scholarly priest of the Roman Church, for what he tells us is almost wholly the result of his own memories and experiences as an Irish boy in Connemara, supplemented in a valuable way by his wider and more mature knowledge of the fairy-belief as he sees it now among his own parishioners.

"On November Eve it is not right to gather or eat blackberries or sloes, nor after that time as long as they last. On November Eve the fairies pass over all such things and make them unfit to eat. If one dares to eat them afterwards one will have serious illness. We firmly believed this as boys, and I laugh now when I think how we used to gorge ourselves with berries on the last day of October, and then for weeks after pass by bushes full of the most luscious fruit, and with mouths watering for it couldn't eat it."
[8]

Fairies were believed to defile blackberries at Michaelmas and Hallowe'en.
[7]

But there were far worse things than bad blackberries on Halloween night. In Scotland it is said that there are two opposing courts of faeries. It is thought that they are locked in an endless battle, like night and day, winter and summer. In the northern skies their terrible battles are seen in the rainbow colours of the aurora borealis, the northern lights. Faery blood falls and forms red lichens on rocks.

There is the Seelie Court. They are the canny faeries, generally benevolent towards mankind. They are the fair summer folk who would tidy a cottage or plait the hair of a sleeping milkmaid. Their elegant queen is clad in green and rides a milk white steed adorned with tiny silver bells.

Then there is the Unseelie Court: malevolent, foul, devious, wretched, terrifying things of your darkest dreams. They are 'the Sluagh' who tear through the night sky and drag off unwary travellers. With them are 'the host', spirits of the unforgiven and evil dead.

'It was these men of earth who slew and maimed at the bidding of their spirit-masters, who in return ill-treated them in a most pitiless manner. They would be rolling and dragging and trouncing them in mud and mire and pools.'
[9]

The Sluagh
In Gaelic a whirlwind is called 'Oiteag Sluagh.'

They fly about in great clouds up and down the face of the earth, like starlings and come back to the scenes of their earthly transgressions. No soul of them is without clouds of earth, dimming the brightness of the works of God, nor can any win Heaven until a satisfaction is made for their sins on earth.

On bad nights the sluagh are said to shelter themselves behind little docken stems and small ragwort stalks. They often fight battles in the air and can be seen and heard on clear frost nights advancing and retreating noisily one against the other. After the battles their crimson blood may be seen as stains on rocks and stones. Fuil nan Sluagh, the blood of the hosts, is the beautiful red 'Crotal', of the rocks melted by frosts...
[2]

The superstitious folk used simple verses like "Brave bonefire, burn a', Keep the fairies a' awa" as charms to protect themselves.

The wife of a farmer in Lothian had been carried off by the fairies, and, during the year of probation, repeatedly appeared on Sunday in the midst of her children, combing their hair. On one of these occasions she was accosted by her husband; when she related to him the unfortunate event which had separated them, instructed him by what means he might win her, and exhorted him to exert all his courage, since her temporal and eternal happiness depended on the success of his attempt. The farmer, who ardently loved his wife, set out on Hallowe'en, and, in the midst of a plot of furze, waited impatiently for the procession of the fairies. At the ringing of the fairy bridles, and the wild unearthly sound which accompanied the cavalcade, his heart failed him, and he suffered the ghostly train to pass by without interruption. When the last rode by, the whole troop vanished, with loud shouts of laughter, and exultation; among which he plainly discovered the voice of his wife, lamenting that he had lost her forever.
[10]

At Hallowe'en the kelpie and the water-bull lay in wait for the belated traveller at the ford.
[7]

It is well known that Highland Fairies, who speak English, are the most dangerous of any.
[2]

It has been said that the spirits of dead stay with the faeries. Countless churches have a 'sidhe' – a faerie mound – nearby and these are sometimes called 'the mound of the dead'. It was thought that the spirits of mortals were of tiny size and would live in the faerie mound until they are finally called for on Judgement Day. To plough up, destroy or desecrate a sidhe would not only to tempt the wrath of the faeries but was also an act of gross disrespect against the spirits of your ancestors.

About the middle of last century, a clergyman at Kirkmichael, Perthshire, whose faith was more regulated by the scepticism of philosophy, than the credulity of superstition, would not be prevailed upon to yield his assent to the opinion of the times. At length, however, he felt from experience that he doubted what he ought to have believed. One night, as he was returning home at a late hour, from a meeting of Presbytery, and the customary dinner which followed, he was seized by the fairies, and carried aloft into the air. Through fields of ether and fleecy cloud he journeyed many a mile, descrying the earth far distant below him, and no bigger than a nutshell. Being thus sufficiently convinced of the reality of their existence, they let him down at the door of his own house, where he afterwards often recited to the wondering circle, the marvellous tale of his adventure. Some people will believe that "spirits" of a different sort had a little to do with the worthy minister's conviction, and that his "ain gude grey mare " had more to do with bringing him to his own door than the fairies.

[Dr. Buchan, a gentleman rarely surpassed in his knowledge of Celtic Legendary Traditions and Folklore.]

Even the pet cat isn't safe.

On Halloweven the fairies rode on cats at the Holme Glen, Dalry. On that night considerate housekeepers shut up their cats, to prevent them from being laid hold of by the fairies.
[7]

There are thresholds between the seasons just as there are thresholds between the worlds. At Beltane and Halloween we cross from one half of the year to the next - winter to summer, summer to winter. It is at these times, when the veil is thin, that the faeries travel across the country to their next dwelling place. At Halloween the faeries flit from their summer homes to their winter lodgings. These journeys are known as faery rides or raids - it is on these travels that we may catch a glimpse of the 'good neighbours.'

> *...In the hinder end of harvest, on All-hallowe'en,*
> *When our good neighbours dois ride, if I read right,*
> *Some buckled on a bunewand, and some on a been,*
> *Ay trottand in troups from the twilight;*
> *Some said led by a she-ape, all grathed into green,*
> *Some hobland on a hemp-stalk; hovand to the hight;*
> *The King of Pharie and his court, with the Elf queen,*
> *With many elfish incubus was ridand that night.*
> *There an elf on an ape, an unsel begat,*
> *Into a pot of Pomathorne;*
> *That bratchart in a busse was born;*
> *They found a monster on the morn,*
> *War faced nor a cat.*
> [11]

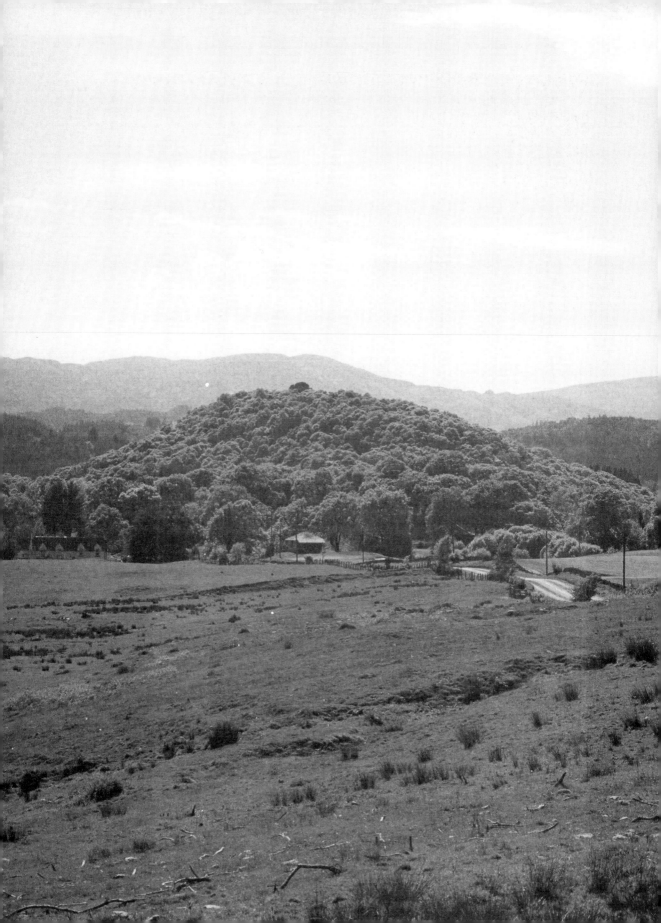

opposite:
Doon Hill
The Faery Hill at
Aberfoyle where the
Reverend Robert Kirk
met with the elvan
folk. He is said to live
there still, ministering
to the 'good
neighbours'.

left:
**Reverend Robert
Kirk's grave**
Aberfoyle kirkyard.

(images © Mark Oxbrow)

Most famous of the tales of faery rades is the ballad of Tam Lin. It tells the tale of a fair maid named Janet who walks in the woods, despite dire warnings, and meets Tam Lin. He is an enchanting man who has been stolen by the faeries. He 'entertains' her by his fountain and she returns home pregnant. When next she visits Tam she is told that there is only one chance for her to rescue her love. When the faeries ride out at Halloween she must seize him from his horse and hold him tight no matter what he is transformed into.

Tam Lin

1
O I forbid you, maidens a',
That wear gowd on your hair,
To come or gae by Carterbaugh,
For young Tam Lin is there.

2
There's nane that gaes by Carterhaugh
But they leave him a wad,
Either their rings,
or green mantles,
Or else their maidenhead.

3
Janet has kilted her green kirtle
A little aboon her knee,
And she has broded her yellow hair
A little aboon her bree,
And she's awa to Carterhaugh,
As fast as she can hie.

4
When she came to Carterhaugh
Tam Lin was at the well,
And there she fand his steed standing,
But away was himsel.

5
She had na pu'd a double rose,
A rose but only twa,
Till up then started young Tam Lin,
Says, Lady, thou's pa nae mae.

6
Why pu's thou the rose, Janet,
And why breaks thou the wand?
Or why comes thou to Carterhaugh
Withoutten my command?

7
'Carterhaugh, it is my ain,
My daddie gave it me;
I'll come and gang by Carterhaugh,
And ask nae leave at thee.'

8 *Janet has kilted her green kirtle*
 A little aboon her knee,
 And she has snooded her yellow hair
 A little aboon her bree,
 And she is to her father's ha,
 As fast as she can hie.

9 *Four and twenty ladies fair*
 Were playing at the ba,
 And out then cam the fair Janet,
 Ance the flower amang them a'.

10 *Four and twenty ladies fair*
 Were playing at the chess,
 And out then cain the fair Janet,
 As green as onie glass.

11 *Out then spak an auld grey knight,*
 Lay oer the castle wa,
 And says, Alas, fair Janet,
 for thee But we 'll be blamed a'.

12 *'Haud your tongue, ye auld fac'd knight,*
 Some ill death may ye die!
 Father my bairn on whom I will,
 I 'II father nane on thee.'

13 *Out then spak her father dear,*
 And he spak meek and mild;
 'And ever alas, sweet Janet,' he says,
 'I think thou gaes wi child.'

14 *'If that I gae wi child, father,*
 Mysel maun bear the blame;
 There's neer a laird about your ha
 Shall get the bairn's name.

15 *'If my love were an earthly knight.*
 As he's an elfin grey,
 I wad na gie my ain true-love
 For nae lord that ye hae.

16 *'The steed that my true-love rides on*
 Is lighter than the wind;
 Wi siller he is shod before,
 Wi burning gowd behind.'

above:
Vintage Halloween
card.

85

17 *Janet has kilted her green kirtle*
A little aboon her knee,
And she has snooded her yellow hair
A little aboon her bree,
And she's awa to Carterhaugh,
As fast as she can hie.

18 *When she cam to Carterhaugh,*
Tam Lin was at the well,
And there she fand his steed standing,
But away was himsel.

19 *She had na pu'd a double rose,*
A rose but only twa,
Till up then started young Tam Lin,
Says Lady, thou pu's nae mae.

20 *Why pu's thou the rose, Janet,*
Amang the groves sae green,
And a' to kill the bonie babe
That we gat us between?
As green as onie glass.

21 *'o tell me, tell me, Tam Lin,' she says,*
'For's sake that died on tree,
If eer ye was in holy chapel,
Or christendom did see?'

22 *'Roxbrugh he was my grandfather,*
Took me with him to bide,
And ance it fell upon a day
That wae did me betide.

23 *'And ance it fell upon a day,*
A cauld day and a snell,
When we were frae the hunting come,
That frae my horse I fell;
The Queen o Fairies she caught me,
In yon green hill to dwell.

24 *'And pleasant is the fairy land,*
But, an eerie tale to tell,
Ay at the end of seven years
We pay a tiend to hell;
I am sae fair and fu o flesh,
I 'm feard it be mysel.

25 'But the night is Halloween, lady,
 The morn is Hallowday;
 Then win me, win me, an ye will,
 For weel I wat ye may.

26 'Just at the mirk and midnight hour
 The fairy folk will ride,
 And they that wad their true-love win,
 At Miles Cross they maun bide.'

27 'But how shall I thee ken, Tam Lin,
 Or how my true-love know,
 Amang sac mony unco knights
 The llke I never saw?'

28 'o first let pass the black, lady,
 And syne let pass the brown,
 But quickly run to the milk-white steed,
 Pu ye his rider down.

29 'For I'll ride on the milk-white steed,
 And ay nearest the town;
 Because I was an earthly knight
 They gie me that renown.

30 'My right hand will be glovd, lady,
 My heft hand will be bare,
 Cockt up shall my bonnet be,
 And kaimd down shall my hair,
 And thae's the takens I gie thee,
 Nae doubt I will be there.

31 'They'll turn me in your arms, lady,
 Into an esk and adder;
 But hold me fast, and fear me not,
 I am your bairn's father.

32 'They'll turn me to a bear
 And then a lion bold;
 But hold me fast, and fear me not,
 As ye shall love your child.

33 'Again they 'll turn me in your arms
 To a red het gaud of aim;
 But hold me fast, and fear me not,
 I'll do to you nae harm.

above:
Vintage Halloween
card.

34 'And last they 'll turn me in your arms
Into the burning gleed;
Then throw me into well water,
O throw me in wi speed.

35 'And then I'll be your ain true-love,
I'll turn a naked knight;
Then cover me wi your green mantle,
And cover me out o sight.'

36 Gloomy, gloomy was the night,
And eerie was the way,
As fair Jenny in her green mantle
To Miles Cross she did gae.

37 About the middle o the night
She heard the bridles ring;
This lady was as glad at that
As any earthly thing.

38 First she let the black pass by,
And sync she let the brown;
But quickly she ran to the milk-white steed,
And pu'd the rider down.

39 Sae weel she minded whae he did say,
And young Tam Lin did win;
Syne coverd him wi her green mantle.
As blythe 's a bird in spring.

40 Out then spak the Queen o Fairies,
Out of a bush o broom:
'Them that has gotten young Tam Lin
Has gotten a stately groom.'

41 Out then spak the Queen o Fairies,
And an angry woman was she'
'Shame betide her ill-far'd face,
And an ill death may she die,
For she's taen awn the boniest knight
In a' my compnnie.

42 'But had I kend, Tam Lin,' she says,
'What now this night I see,
I wad hae taen out thy twa grey een,
And put in twa een o tree.'
[12]

above:
Vintage Halloween
card.

Notes

[1] Chambers Popular Rhymes, p. 265.

[2] Superstitions of the Highlands and Islands of Scotland
John Gregorson Campbell, 1900

[3] Thistledown (new edition)
R. Ford, 1922

[4] The Bridal of Caolchairn; and other poems
Allan, John Hay, calling himself John Sobieski Stolberg Stuart,
formerly John Carter Allen, London, 1822

[5] Sketches of Perthshire
P. Graham, 1812

[6] Folk Lore and Genealogies of Uppermost Nithsdale
William Wilson, 1904

[7] British Calendar Customs : Scotland
Mary Macleod Banks, London : W. Glaisher for the Folk-Lore Society, 1937-1941

[8] The Fairy Faith in Celtic Countries
Walter Yelling Evans-Weinz, London, 1911

[9] A dictionary of fairies hobgoblins, brownies,
bogies and other supernatural creatures.
Katherine Briggs. London Allen Lane 1976

[10] Minstrelsy of the Scottish Border, ed. T. F. Henderson
Sir Walter Scott, 1902

[11] Montgomery's Flyting Against Polwart
(The first known edition was that of 1621)
Watson's Collection of Scots Poems - 1709

[12] Johnson's Museum
Communicated by Robert Burns, 1792

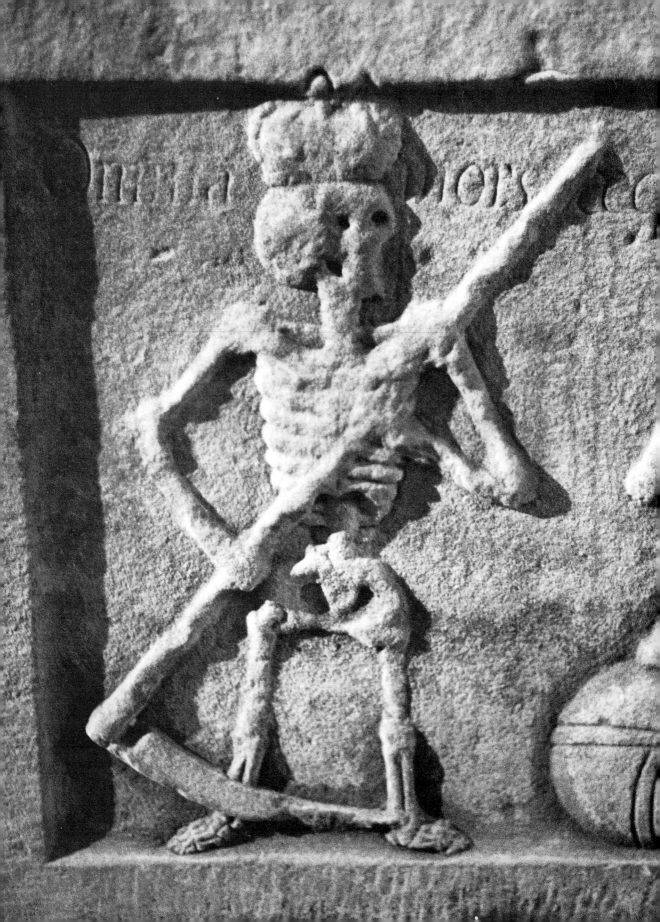

The Danse Macabre

You only have to venture into an old graveyard to see that Christianity has long held a fascination with death and the dead. Carved tombstones bear 'Memento Mori' – reminders of death – skulls, bones, skeletons. The 'dearly departed' and 'fondly remembered' are merely resting in their quiet graves patiently waiting for the trumpet call of Judgement Day when their bodies will rise from the dirt and the dead will walk the earth. A cornerstone of Christianity is the belief that Jesus Christ conquered death and returned from the dead – he was resurrected. Many earlier religions had believed in an idyllic afterlife – the fragrant Elysian Fields, the Blessed Isle of Avalon, Valhalla... or in reincarnation and the transmigration of the soul. Christianity taught that the spirits of your ancestors survived death and awaited you on the other side.

It has long been written that Halloween grew from the 'Celtic Festival of the Dead' but there is scant evidence for this idea. Halloween is in reality the result of a Christian Festival of the Dead. History has tended to give us two conflicting explanations of the origins of the Christian festival of All Hallow's Eve. Either the Catholic Church saw the pagan feis of Samain as a direct threat that had to be eradicated and decided to replace it with a Holy festival or alternatively the dedication of the festival of All the Saints on November 1st was purely coincidental. The truth may, in fact, be altogether more interesting and unexpected. The following is a good example of the commonly held wisdom as to the birth of the All Hallows festival.

November 1st. Eve and Day

Hallow Tide, the festival of All Saints or All Hallows, begins with its eve, Hallowe'en: it was appointed a festival in the seventh century, when the Pantheon in Rome was dedicated by the Church to the memory of the Virgin Mary and All Martyrs. The date at that time was May 1st, but in the year 837 November the 1st was chosen as a more suitable time for this observance. This date synchronised with Samhuinn, the great autumn festival of the Celts; 'all the gods of the world, from sunrise to sunset, were worshipped on that day.' [The Book of Lismore]

The commemoration is thus both Christian and pre-Christian and its observances bear testimony to both influences. Its rites were destined to ensure the consecration of gathered fruits and crops, the purification from evil influences by fire, and communion with and commemoration of the dead. The chief features in

opposite:
'The King of Terrors'
A finely carved gravestone, which is now housed in the crypt at Rosslyn Chapel, Midlothian.

(image © Mark Oxbrow)

Scotland were bonfires, divination, saining, and the ceremonial lighting of the neid fire. As spirits were believed to roam abroad on Hallowe'en they might then be questioned about future destiny, or compelled, under certain spells, to restore those who had fallen under their power. Fairies gave access to their abodes, and witches now held one of their three annual convocations.

At the beginning of a lunar month, the eve of Samhuinn was moonless and, in these northern regions, dark, as befitted the 'season of innumerable mystic rites'. [Car. Gad. II, p. 322.] The later New Year of Jan. 1st attracted some Hallowmas customs to itself, but many were practised at the earlier date in Scotland till comparatively recent times.
[1]

There is very little evidence that the pre-Christians considered Samain to be a festival of the dead. We have no records of them honouring the departed with rites or customs, no sacrifices or offerings are made at burial places. We have a few tales of the living dead walking at Samain and the spirits of the unforgiven dead flying with the sluagh in the winter skies but no hint that this was the 'Celtic festival of the dead.' Christianity came to Britain and Ireland long before the Celtic myths and legends were written down. When they were finally committed to parchment the scribes were Christian monks who were not recording the tales verbatim but putting their own spin on them. Samain was clearly a 'weird night' when supernatural forces were loosed into the world but was it ever truly a festival of the dead until Christianity brought the martyred Saints to the day?

All Saints' Day
Several anniversaries honouring the saints were celebrated in the early Church, notably 13th May and the 1st Sunday after Pentecost; it is not clear how 1 November became the feast of All Saints in the Western Church. According to John Hanning, this day was first chosen in Ireland. Another theory was that Pope Gregory III dedicated an oratory in St. Peter's basilica to all the apostles, martyrs and confessors on that day and that Egbert of York, who was particularly close to Gregory, accepted that day, whence it passed, into Bede's 'Martyrology'.

By the end of the 8th Century, 1 November seems to have been well established throughout Europe as the date commemorating all the saints. Alcuin of York, a liturgical expert in Charlemagne's service, commended Archbishop Arno of Salzburg for celebrating the feast on that day; and Pope Gregory asked Louis the Pious to extend the feast of 1 November throughout the empire. Finally in numerous books of the 9th Century 1 November is given as the 'natale omnium santorum'.
[2]

To the pre-Christian Celts the feis of Samain was a threshold between summer and winter. Such thresholds between two states of being were always important and often uncanny places where special protections and precautions were necessary. The sunrise and sunset were thresholds between day and night. The surface of a loch or lake was a threshold between the world above and the underwater otherworld below - a sidhe mound was a gateway between our world and the faerie otherworld. Even

the doorway to your own home was an important threshold between your haven and the outside - to be protected with rowan wood charms or May blossom branches. On such a night as Samain the dead may indeed walk but this was a festival for the living to be thankful of the harvests of fruits and nuts and to gather for a final feis before the winter set in. From that root Christianity came and grew a wholly new festival. Conventional accounts do not satisfactorily explain how and why the festival of All Saints appeared in place of Samain but then I found a rather obscure article in a 1948 edition of the Medieval Studies Journal.

...The classical accounts of Ado and Baronius on the origins of the feast of All the Saints scarcely explain when and why the commemoration of our Lady and all the martyrs on May 13th was extended to a commemoration of All the Saints, and when and why, besides this commemoration, that November 1st was instituted. It is clear that the extension of the commemoration to all the Saints, its transfer to November 1st and its spread to all parts of the Church are unrelated to each other...

...The first records of the observance of the feast of All the Saints on November 1st are found in parts of the world far away from Rome, and that precisely in those parts the date of November 1st had a very definite significance. [3]

Far from being a festival that originated in Rome then spread to the rest of Catholic Christian Europe the earliest records of a festival of All the Saints appear in Ireland and England. The 'Félire Oengusso' was a rhymed martyrology. An English translation of the last line of the quatrain for November 1st would read: 'The hosts of Hilarius, sure multitudinous, ennoble stormy Samain'; this shows that the Celtic seasonal feis was recognised by the Church in Ireland.

The Breviary originally had only two parts, summer and winter; similarly the Irish knew only two seasons, one ending on Hallow's Eve, the other on what on the Continent is known as Walpurgis Night. ...in the mid-eighth century York calendar we read:

Multiplici rutilet gemma seu in fronte November
Cunctorum fulget sanctorum lande decorus.

Comparing this entry with that for November 1st in the 'Félire Oengusso', the late eighth century Irish festology, and with the recommendations made by the Synod of Riesbach in Bavaria (AD 798) and by Alcuin (AD 800) of the observance of the festivita omnium sanctorum on the Kalends of November... suggested that the commemoration of All the Saints on November 1st was introduced from Ireland via Northumbria to the Continent. [3]

It should be reinforced that there is a significant difference between a festival of All the Saints and All the Martyrs. The vast majority of Saints in the Catholic Church had been martyred for their faith. They had been put to death and later canonised. But not all Saints were Martyrs. The conversion of Ireland and Scotland was remarkably

bloodless. We find that the 'Celtic' saints like St. Columba and St. Kentigern died in extreme old age after long and illustrious lives. Therefore any festival of All the Martyrs would fail to include virtually every Saint in Scotland and Ireland.

The Irish word for 'Saint' (noíb) did not denote in the first instance martyrs, but had the general meaning of 'holy person'. It may be noted that in the ancient Irish Church, due to the scarcity of relics and martyrs, the rule that an altar should enshrine the relic of a martyr could not be observed. It was a custom peculiar to Ireland to use instead relics of confessors other than bodily relics, e.g. St. Patrick's staff or bell and St. Brigid's mantle.
[3]

Conventionally Saints' days were set to commemorate the date of their martyrdom. Consequently Celtic Saints are often associated with older pre-Christian festivals as their new Saints' days supplanted existing pagan days.

...in the Irish calendar February 1st became the feast of the greatest native Saint, (Brigid) not for any historical reason, but because this feast took the place of the old seasonal feast of Inbolc.' (Imbolc)
[3]

Celtic Christianity was a vibrant thriving faith. For a long time it flourished in relative isolation and evolved quite separately to Roman Catholicism.

Ireland was the first country to develop a vernacular Christian literature outside the Graeco-Roman world. This is one of the chief reasons why so many of the elementary terms of Church life had in Ireland a connotation somewhat different from that in other parts of the world.
[3]

So we find that the pre-Christian feis of Samain was first recognised by the Irish Christian Church as a significant day. Then from here we find the concept of a festival of All the Saints - martyrs and non-martyrs - spreading out to England and finally to the continent. In time the festival of All Saints Day became universally accepted. Now that all the Canonised dead had a day of memorial attention moved to the other dead - the departed souls of the faithful - the ancestors, relatives and loved ones of the congregations.

All Souls' Day
Though The Church always encouraged prayers for the faithful departed it was slow to institute a specific day. In the Spain of Isidore of Seville, Pentecost Monday was set aside for commemorating the dead. Around 980 Widukind of Cowey mentions a tradition in Germany of prayer for the dead on 1 October. But not until the Clunic movement was in full bloom was 2 November singled out as a special day of remembrance. The choice is attributed to Odilio, abbot of Cluny, but his contemporary, Pope Sylvester II, approved of the day also and under Bishop Notgar the

opposite:
Gravestone
Carved with skull and crossbones. Dalmeny kirkyard, Lothian.

(image © Mark Oxbrow)

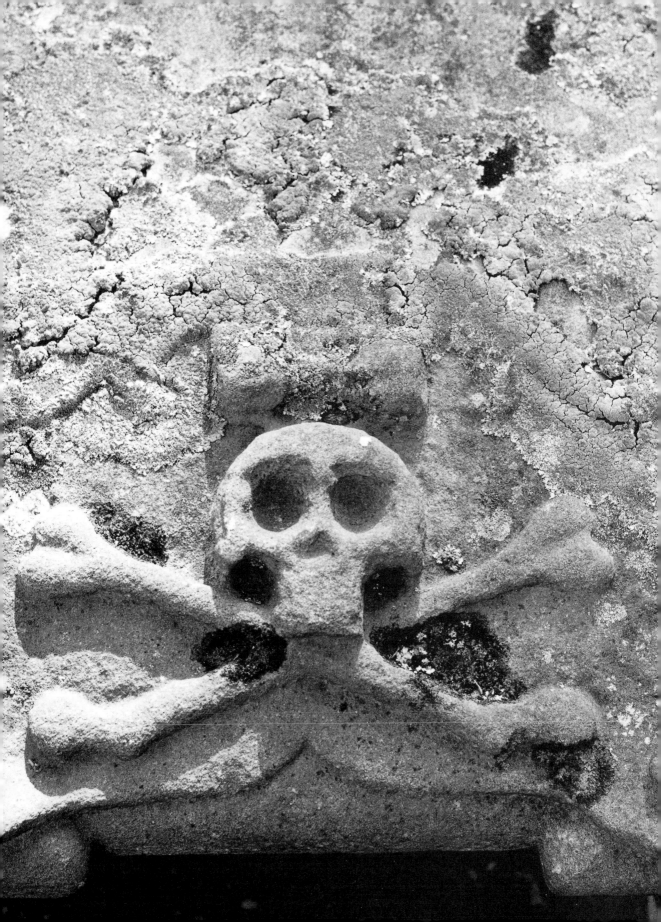

feast was celebrated in the diocese of Liège. The Cluniac feast gradually spread throughout Europe and came to involve the use of texts and formulas from the Office of the Dead, the black vestments of Good Friday, and the sequence of Dies irae.
[2]

It seems that it was Christianity that brought the dead to Hallowe'en. With first the festival of All Saints on November 1st then of All Souls on November 2nd the Church focused the attention of the living on the commemoration of the dead. The rites and services for the departed combined with the customs of divination and protection from the supernatural forces already in play and the hybrid festival of All Hallow's Eve was born.

It seems to be clear at the outset that the Christian Fête in Commemoration of the Dead, according to its history, is an adaptation from paganism; and with so many Irish ecclesiastics, or else their disciples, educated in the Celtic monasteries of Britain and Ireland, having influence in the Church during the early centuries, there is a strong probability that the Feast of Samain had something to do with shaping the modern feast... for both feasts originally fell on the first of November.
[4]

E. Wienz in his 'the Fairy Faith in Celtic Countries' is heartily in favour of a 'Celtic festival of the dead' but he does have useful things to add about the nature of remembrance and of honouring the dead.

Then, very gradually, in the course of four centuries, the character of the Christian cults and feasts of the saints and of the dead seems to have been determined. The following citation will serve to illustrate the nature of Irish Christian rites in honour of the dead - In the 'Lebar Brecc' we read: 'There is nothing which one does on behalf of the soul of him who has died that doth not help it, both prayer on knees, and abstinence, and singing requiems, and frequent blessings. Sons are bound to do penance for their deceased parents. A full year, now, was Maedóc of Ferns, with his whole community, on water and bread, after loosing from hell the soul of Brandub son of Echaid.

According to St. Augustine, the souls of the dead are solaced by the piety of their living friends when this expresses itself through sacrifice made by the Church; St. Ephrem commanded his friends not to forget him after death, but to give proofs of their charity in offering for the repose of his soul alms, prayers, and sacrifices, especially on the thirtieth day; Constantine the Great wished to be interred under the Church of the Apostles in order that his soul might be benefited by the prayers offered to the saints, by the mystic sacrifice, and by the holy communion.

Such prayers and sacrifices for the dead were offered by the Church sometimes during thirty and even forty days, those offered on the third, the seventh, and the thirtieth days being the most solemn. The history of the venerable Bede, the letters of St. Boniface, and of St. Lul prove that even in the ancient Anglican church prayers were offered up for the souls of the dead; and a council of bishops held at Canterbury in 816 ordered that immediately after the death of a bishop there shall

be made for him prayers and alms. At Oxford, in 1437, All Souls college was founded, chiefly as a place in which to offer prayers on behalf of the souls of all those who were killed in the French wars of the fifteenth century.
[4]

As well as the rites for the dead and the commemoration of the canonised and faithful dead the Church was responsible for visions of the skeletal dead dancing with the living. The 'Danse Macabre' or 'Dance of Death' was a medieval reminder that everyone, no matter how high born or lowly, will ultimately die - no flesh shall be spared. The very word 'macabre' entered the English language thanks to the French dance of death.

Macabre

1. Suggesting the horror of death and decay; gruesome: "macabre tales of war and plague in the Middle Ages."; 2. Constituting or including a representation of death.

Etymology: Ultimately from Old French (Danse) Macabre, (dance) of death, perhaps alteration of Macabe, Maccabee, from Latin Maccabaeus, from Greek Makkabios.

Word History: The word macabre is an excellent example of a word formed with reference to a specific context that has long since disappeared for everyone but scholars. Macabre is first recorded in the phrase Macabrees daunce in a work written around 1430 by John Lydgate. Macabree was thought by Lydgate to be the name of a French author, but in fact he misunderstood the Old French phrase Danse Macabre, "the Dance of Death," a subject of art and literature. In this dance, Death leads people of all classes and walks of life to the same final end. The macabre element may be an alteration of Macabe, "a Maccabee." The Maccabees were Jewish martyrs who were honored by a feast throughout the Western Church, and reverence for them was linked to reverence for the dead. Today macabre has no connection with the Maccabees and little connection with the Dance of Death, but it still has to do with death.
[5]

John Lydgate was commissioned to write a poem by the town clerk of London. This 'dance of death' was to be inscribed, with accompanying illustrations, on the walls of Old St. Paul's Cathedral in London (the Church that stood before the great Fire of London and preceded Sir Christopher Wren's building). There upon the walls of one of the most important religious buildings in Britain were dancing skeletons reminding all that saw them - Royalty, Clergy or commoner - that the same end awaited them all. The poem and the whole idea of the mural were inspired by a similar 'Dance Macabre' that already existed in Paris. The Old St Paul's 'Dance of Death' was deliberately destroyed on the orders of the Lord Protector, the Duke of Somerset, in 1549.

Europe had been gripped by the Black Death and blighted by famines. Death was part of everyday life and in a strange way there is something bizarrely comforting about the grinning skeletons dressed as preachers and ploughmen, Queens and peddlers.

above:
Vintage Halloween card.

right:
The Parish Priest
One of the 41 woodcuts which comprise Hans Holbein's *Dance of Death*. Accompanying this illustration in the original 1538 edition was the following biblical quotation: ***"I myself also am a mortal man, like to all."*** (Wisdom of Solomon vii, 1.)

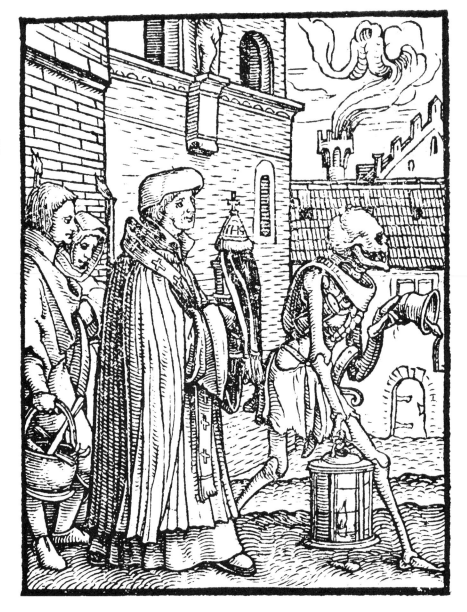

The Parish Priest

Ie porte le fainct facrement
Cuidant le mourant fescorir,
Qui mortel fuis pareillement,
Et comme luy me fault mourir.

The Holy sacrament I bear with me
To soothe the sinner in his latest hour,
I, who am mortal too, as well as he,
And can no more than he evade Death's power.
[6]

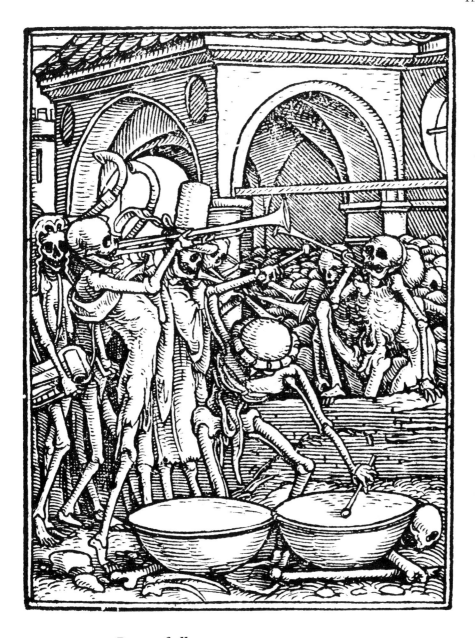

left:
Bones Of All Men
One of the 41 woodcuts which comprise Hans Holbein's *Dance of Death*. Accompanying this illustration in the original 1538 edition were the following biblical quotations:
"Woe! woe! woe! to the inhabiters of earth."
(Revelation viii, 13.)
"All in whose nostrils was the breath of life... died."
(Genesis vii, 22.)

Bones of all men

Malheureux qui uiuez au monde,
Toufiours remplis d'aduerfitez,
Pour quelque bien qui uous abonde,
Serez tous de Mort uifitez.

Woe! Woe! Inhabitants of Earth,
Where blighted cares so keenly strike,
And, spite of rank, or wealth, or worth,
Death - Death will visit all alike.
[6]

With the new technology of printing the Danse Macabre was no longer kept to Church walls and private illuminated manuscripts and books of hours. The first edition of the 'Dance Macabre' - complete with woodcut illustrations and accompanying verses - was printed in Paris by Guy Marchant, in 1485. Another edition was printed at Lyons in 1499, but they were to be outclassed about forty-five years later.

When Hans Holbein the Younger created his 'Dance of Death' he created a masterpiece that easily surpassed the earlier primitive 'Danse Macabres'. Holbein truly brings the dead to life. There is movement and freakish comedy in his contorted skeletons and death grins like a jolly pumpkin lantern.

The printing press was also vital to the wide spread distribution of the text that led to the reformation of Christianity in Europe. On 31 October 1517, Martin Luther nailed his Ninety-Five Theses on the church door of Wittenberg.

Disputation of Doctor Martin Luther on the power and efficacy of indulgences October 31, 1517
Out of love for the truth and the desire to bring it to light, the following propositions will be discussed at Wittenberg, under the presidency of the Reverend Father Martin Luther, Master of Arts and of Sacred Theology, and Lecturer in Ordinary on the same at that place. Wherefore he requests that those who are unable to be present and debate orally with us, may do so by letter. In the Name our Lord Jesus Christ. Amen...
[7]

The castle church door did, in fact, serve as the 'black-board' of the university and this was where notices were commonly displayed. Luther simply expected that the points he was raising would be debated in a public forum at the University. He never expected that they would be printed and widely distributed - let alone that they would lead to the division of the Church. Protestantism came to despise Catholicism for its 'superstitious practices' and thought it was riddled with corruption.

Christianity has often met paganism halfway and supplanted old sites and festivals gradually. The religion may have been changing but this was not a battle for land with blood and sword but a battle for hearts and minds. Such a battle is fought slowly over generations...the last faith standing is the winner.

As early as about 230 AD Christian writers were lamenting the inconsistency of early Christians in respect to pagan festivities. Tertullian tells us:

'By us who are strangers to Sabbaths, and new moons, and festivals, once acceptable to God, the Saturnalia, the feasts of January, the Brumalia, and Matronalia, are now frequented; gifts are carried to and fro, new year's day presents are made with din, and sports and banquets are celebrated with uproar; oh, how much more faithful are the heathen to their religion, who take special care to adopt no solemnity from the Christians.'

The Venerable Bede, born 672 or 673; died 735, includes among his histories and descriptions of the conversion to Christianity of England the text of a letter from Pope Gregory the Great to the missionaries. This tells us of the tactics that were employed to replace the native pagan religion.

The Letter to Mellitus of 601

When Almighty God shall bring you to the most reverend Bishop Augustine, our brother, tell him what I have, after mature deliberation on the affairs of the English, determined upon, namely, that the temples of the idols in that nation ought not to be destroyed, but let the idols that are in them be destroyed; let holy water be made and sprinkled in the said temples - let altars be erected, and relics placed. For if those temples are well built, it is requisite that they be converted from the worship of devils to the service of the true God; that the nation, seeing that their temples are not destroyed, may remove error from their hearts and, knowing and adoring the true God, may the more familiarly resort to the places to which they have been accustomed.

And because they have been used to slaughter many oxen in the sacrifices to devils, some solemnity must be substituted for them on this account, as, for instance, that on the day of the dedication, or of the nativities of the holy martyrs whose relics are there deposited, they may build themselves huts of the boughs of trees about those churches which have been turned to that use from temples, and celebrate the solemnity with religious feasting, no more offering beasts to the devil, but killing cattle to the praise of God in their eating, and returning thanks to the Giver of all things for their sustenance; to the end that, whilst some outward gratifications are permitted them, they may the more easily consent to thee inward consolations of the grace of God.

For there is no doubt that it is impossible to efface every thing at once from their obdurate minds, because he who endeavors to ascend to the highest place rises by degrees or steps and not by leaps. This the Lord made himself known to the people of Israel in Egypt: and yet he allowed them to use the sacrifices which they were wont to offer to the devil in his own worship, commanding them in his sacrifice to kill beasts to the end that, changing their hearts they may lay aside one part of the sacrifice whilst retained another: that whilst they offered the same beasts which they were wont to offer, they should offer them to God, and not to idols, and thus they would no longer be the same sacrifices.
[8]

Here we find that, as well as pagan holy sites, pagan holy days were to be rededicated to God. This conversion was a relatively gentle process but it was a long and occasionally ineffective one. Just as some churches lie with immense standing stone circles in their graveyards so the ancient pagan customs associated with these holy places were often simply transferred to the new church. Superstitions telling which way you should walk about a church or of carrying fire round a church at a baptism are clear survivals from an earlier age. We find that in the Western Isles the ancient goddess of spring who aided women in childbirth becomes the foster mother and midwife of Christ. Charms and incantations were simply

above:
The Devil at the mouth of Hell.

101

reworked to include the trinity and customs and rites survived with a thin veneer of respectable Christianity.

In Scotland we find that St. Kentigern is the son of a faithful Christian maiden named Thanew, later St. Enoch. She was the daughter of the pagan King Loth and sister to Gawain of Arthurian legend. Saints were linked in their 'lives' to British heroes and legendary figures. St. Kentigern ends up meeting and baptising an aged Druid named Lailoken - Merlin the Wild.

In Brittany there are curious traditions associated with St. Herve, a 6th century Abbot, also known as Harvey, Herveus or Huva. Saint Herve is still venerated throughout Brittany but we have very few reliable accounts of him - his life was first written down in the late medieval period. The account of his life tells us that a young British bard named Hyvarnion lived at the court of Childebert, King of the Franks. Hyvarnion desired, after four years, to return to his native home. He was travelling through Brittany when, riding through a wood, he overheard a young girl singing. He dismounted his horse and made his way through the trees towards the gentle voice. There, in a sun-dappled glade, he met a fair maiden who was gathering herbs. He asked her what they were for.

"This herb drives away sadness, that one banishes blindness, and I look for the herb of life that drives away death," she said.

Hyvarnion forgot his homeward journey and in that hour he loved the maiden and later married her. Their son was to become St. Herve. In the canticle of St. Herve we are told that as a child he went out into the night on the eve of the Fete of La Toussaint - All Saint's Eve - to 'sing the song of the souls'. He did not fear the wandering souls of the dead.

We find that the festival of All Hallow's Eve begins to appear in the medieval Saints' lives and in the verse and prose romances of Arthur and his knights.

Sir Gawain and the Green Knight is an epic told by an unknown author. This was a winter's tale to be spoken aloud by a raging fire after a hearty meal of venison and mead. It begins at Christmas-tide as Arthur holds court at Camelot and the huge Green Knight bursts into the festivities to seek a worthy challenger. Sir Gawain meets his challenge to exchange blows with the Knight's huge axe and slices the giant's head clean off with one blow. Unperturbed the Green Knight picks up his decapitated head and leaves expecting Gawain to find him in a year's time so he can return the blow. There follows a fine description of the changing season until Gawain finally prepares to leave Camelot to seek out the Green Knight and bravely face his fate.

Yet quyl All-Hal-Day with Arther he lenges,
And he made a fare on that fest for the frekes sake,
With much revel and ryche of the Rounde Table.
[9]

Sir Gawain lingered at Camelot until All Hallows day, when Arthur furnished his

knight with a feast on that festival. All Hallows was clearly an important universal festival. There may be at least two reasons why Gawain would wait and leave at this time:

The Green Knight had arrived in the dead of winter and now with the summer's end and winter's dawning it was the natural time to journey to find the Green Chapel, or...

That this was the time of the festivals of the dead - Gawain was expecting to be slain and Arthur and his court were bidding farewell to their doomed friend.

Much has been read into the tale of Sir Gawain and the Green Knight about pagan survivals and knights of the goddess. It is a miracle that we have this poem at all. It survived in a single copy that was rescued from a burning house and remained relatively intact after centuries of civil wars, religious upheavals and virulent plagues. This is a wonderful medieval verse epic of ca. 1,400 AD and should be appreciated as such - it is folly to pick it apart searching for hidden meanings or pagan secrets.

Malory also includes All Hallowmas in his 'Morte D'Arthur':

Sir Kay was made knight at All Hallowmass afore.

Kay was Arthur's foster brother. This and the following quote show that the festival of all Hallowmas was well known and was becoming the setting for heroic tales just as the feis of Samain had been the setting for adventures in ancient Ireland.

Then Sir Bors told Sir Launcelot how there was sworn a great tournament and jousts betwixt King Arthur and the King of Northgalis, that should be upon All Hallowmass Day, beside Winchester ... And then every knight of the Round Table that were there at that time present made them ready to be at that jousts at All Hallowmass, and thither drew many knights of divers countries.

And as All Hallowmass drew near, thither came the King of Northgalis, and the King with the Hundred Knights, and Sir Galahad, the haut prince, of Surluse, and thither came King Anguish of Ireland, and the King of Scots.
[10]

It seems clear that the ancient feis of Samain and the festival of All Saints did in effect merge and give birth to the curious customs of Hallowe'en. This was the night before the Catholic festival and the threshold between summer and winter. Here the faerie otherworld realm met and mingled with the veneration of the dead and departed souls flew with the faerie hordes.

We have a strange similar occurrence here in Scotland with the development of the legend of the Loch Ness Monster. It was almost certainly a pagan water monster in origin - akin to the kelpie or the stoorworm - then one day St. Columba, while converting the natives, saved a young child from the terrible creature thus proving the strength of the new religion. St. Columba was essentially a real individual so this tale in his 'life' means that the creature had to have taken actual physical form. Today

we have a wholly secular Nessie - neither the real monster of the Christian tale nor the pagan faery but a weird admixture somewhere between a legend and a very elusive physical beast. She still attracts representatives of both factions to the Loch.

Loch Ness Monster Hunter Nets Big Witch Trouble

Veteran monster hunter Jan Sundberg landed himself in hot water with a white witch on Tuesday as he began an underwater attempt to catch the most famous and elusive resident of Scotland's Loch Ness.

The Swede has sparked fury among animal lovers and witches alike with plans for Operation 'Clean Sweep', a trawl of the lake which he hopes will net Nessie, the legendary Loch Ness monster.

But Kevin Carlyon, high priest of the British White Witches, is determined to put a stop to the hunt by casting a protective spell over the loch and any monsters lurking peacefully beneath the waves.

Sundberg, who is adamant the work of his Global Underwater Research Team is legitimate scientific research, is unimpressed by the interference and plans a distinctly unscientific solution.

"It's all a lot of mumbo jumbo, so we haven't bothered with this guy," he said. "If he shows his face down here again, we'll throw him into the lake. I think he needs to be cooled off a bit."

The legend of a monster in the dark waters of Britain's largest lake dates back to 565 AD when St. Columba, the holy man who brought Christianity to Scotland, spotted a fearsome lake-dwelling beastie.
[11]

It should really be added that Mr Carlyon is most definitely not the High Priest of all British White Witches - I am reliably informed there is no such title and that Mr Carlyon is merely High Priest of his own group. Kevin has also recently appeared, dressed in his red robes with his hairy chest and gold pentagram medallion, on TV news programmes since he 'put a curse' on the 'Harry Potter' movie because he objected to the unhistorical way round that Harry et al use their broomsticks for flying. This wouldn't be so bad except that Kevin is utterly wrong – the earliest image of witches on broomsticks has the brush at the back exactly as the filmmakers do. It is my opinion that Mr Carlyon is doing nothing very positive for the image and reputation of modern witchcraft in Britain. I should also add that St. Columba was also not the first Holy Man to bring Christianity to Scotland. As the saying goes - why let the truth get in the way of a good story?

The High Priest of British White Witches, Kevin Carlyon, casts a spell to protect the Loch Ness Monster. Mr Carlyon, who travelled from his home in Hastings, east Sussex, to perform the deed, certainly worked magic for tourist chiefs. The Highland tourist trade got a much-needed boost yesterday from Mr Carlyon, who cast the spell to protect the loch and its creatures, and to bring harmless bad luck to a Swedish scientist who wanted to take a DNA sample from Nessie.

The dispute between the white witch and Jan Sundberg, the crypto-zoologist, attracted media interest from around the world. Twelve film crews

above:
This mediaeval manuscript bears the earliest depiction of witches flying on broomsticks.

turned up to see Mr Sundberg arrive to launch his two-week project, which would involve trying to temporarily trap the Loch Ness monster in a massive pot. However, Mr Sundberg said he was to use hi-tech sonar from Simrod of Aberdeen to make 3D sound pictures of the loch and anything big in it. He had to give Scottish Natural Heritage several undertakings before being allowed to use the 22ft-long cylindrical net, which was inspected by water bailiffs to ensure that trout or salmon would not be trapped. Such assurances were not enough for the high priest and Mr Sundberg threatened to throw the witch in the loch.

Unperturbed, the witch cast his spells: "Elements of earth, air, fire, and water, I summon you to Loch Ness that it may be safe and creatures here not harmed."

A delighted Willie Cameron, of the Loch Ness marketing group, said: "You couldn't buy publicity like this."

[12]

By a strange twist of fate Willie's words are quite relevant. If Christianity had not chosen November 1st for its festival of All Saints, would any remnant of Samain survive? Did they unwittingly bring the spirits of the dead to Hallowe'en and give the rites and customs of the end of summer a new life?

Truly, you couldn't buy publicity like that.

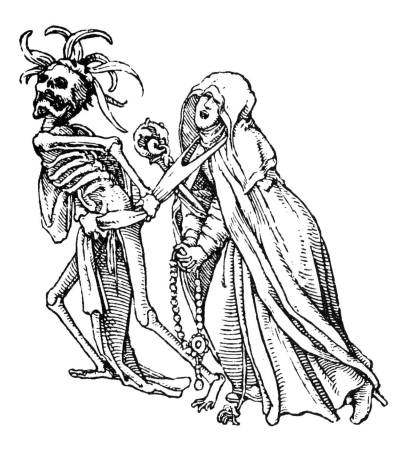

left:
The Abbess
Detail from Woodcut
by Hans Holbein.

Notes

[1] British Calendar Customs: Scotland

[2] Dictionary of the Middle Ages
 American Council of Learned Societies

[3] The meaning of All the Saints
 John Hanning, Medieval Studies journal vol. 10 1948

[4] The Fairy Faith in Celtic Countries
 Evans Wienz

[5] The American Heritage Dictionary of the English Language
 Fourth Edition. 2000.

[6] The Dance of Death
 Hans Holbein the Younger, Dover Edition

[7] Martin Luther, 1517

[8] Ecclesiastical History of the English Nation
 Bede

[9] Sir Gawain and the Green Knight
 Everyman's Library Edition 1962

[10] Le Morte D'Arthur
 Sir Thomas Malory

[11] Reuters News Agency
 Tuesday April 24 10:58 AM ET

[12] The witch, the scientist, the monster and the media
 David Ross, The Glasgow Herald Newspaper

above:
Vintage Halloween
card.

fear and Lothians

When you picture the witch hunts images of burning bodies and mediaeval tortures come to mind. Women meeting by moonlight in secret covens to work magic and sign pacts with the Devil. We imagine aged crones flying on broomsticks and dancing naked about bonfires at their gatherings. But where did this image of witch as devil-worshipper come from and why did Halloween become known as the night of the witches' greatest sabbat?

The North Berwick Witch trials saw evidence brought forth that a conspiracy had been hatched to murder the King, that a group of men and women had had traffic with the Devil and that they had gathered on Hallowe'en night to desecrate a churchyard and work their homicidal spell.

Edinburgh was a very different place at the time of the witch trials. The King, James VI of Scotland and I of England ruled a haunted, divided land. Catholicism fell and Protestantism rose. James's mother, Mary Queen of Scots, a Catholic monarch, was executed, beheaded in the red dress of martyrdom, and the country had been regular witness to the burnings and executions of both competing religious movements.

King James VI & I's birth was difficult. Mary had a long and painful labour and called on the Saints to intercede with God for her unborn child and her own life. As she lay in her room at Edinburgh Castle she called for a specific relic to aid her. A servant rode forth to recover the remains of St. Margaret from their resting place in Dunfermline. He returned and the relic was placed by Mary to watch over James' birth. It was St. Margaret's decapitated head. It is said that her pale skin was still stretched over the skull and her fine fair hair was still intact.

Different times indeed.

A monarch's position was a vulnerable one. Plots against the crown were common-place and King James must have felt threatened as the two religious groups plotted and counter-plotted. James struggled to unite the peoples of his kingdom. He authorised the first version of the Bible in English - the 'King James Bible' - and he gave his divided nation a common enemy, the witch. The most effective way to stop two opposing factions from fighting is to give them a common foe.

After all, whether Catholic or Protestant you still worshipped and feared God. These 'witches' despised your God. They mocked your sacred sites, defiled holy places, made vile pacts with the Devil and his demonic minions. They were 'the others', the 'outcasts' in your midst, in your town or village where they could bewitch your children, blight your crops and attack your cattle.

They were somehow less than human, consorts of evil, fit for burning. But most importantly - they were not powerful. A foreign nation has an army and navy to defend itself from hostility, a powerful lord has armed men under his command, but a minority community within your isle - whether Jew, gypsy or 'witch' - is relatively harmless, a soft target for a campaign of hate. The populace was superstitious, paranoid and frightened - to that dry kindling was added the spark of Royal and Clerical sanction and popular hysteria fanned the flames as more and more soft bodies were burned on the pyres.

It was of course far more complicated than that. History can't really be distilled or generalised down to bite-sized pieces. Every individual was tried for different reasons, different petty hatreds or local prejudices, envies or poisonous rumours. A myriad of little fears lit the fires and tied the nooses. Accusations of witchery were difficult to repudiate. 'Eyewitness' testimony was easy to give and impossible to disprove, confessions and condemnations extracted under days of excruciating torture were admissible as damning evidence.

But beneath all the legalese and formal court proceedings was the same fearful urge to destroy that the Romans had exhibited at Anglesey. As they slaughtered Druids and priestesses and burned their sacred groves, so 16th and 17th century Britain cleansed itself of the imaginary evil within - the witches.

The North Berwick Witch trials are justly infamous in Scottish legal history. Around seventy people in all were implicated and imprisoned. They were alleged to be a vast coven of witches who had tried and failed to assassinate their King. The King set sail from Leith in October 1589 bound for Denmark and his bride to be, Anne of Copenhagen. Two months previously Anne had attempted to sail from Denmark to Scotland but strong westerly winds had hindered her voyage and she had had to put into port at Oslo. King James arrived in Norway and the two were finally wed on the 23rd of November. By now it was too late in the year to return to Scotland. James and his young bride spent the following few months in Norway and Denmark. This time in Scandinavia was to expose James to the continental witch hunt and he returned to Scotland on 1st May 1590 well versed in the latest 'witchlore'.

I am indebted to E.H. Thompson, Director of the School of American Studies at Dundee University. Many of the following extracts are from his chronology 'Bothwell and the North Berwick witches.' He has scoured such publications as the Calendar of State Papers Relating to Scotland 1589-1593, the Warrender Papers and the History of the Kirk of Scotland to create an invaluable resource. Please note that some of the original Scots language is not terribly easy but try to read it phonetically.

above:
Newes from Scotland,
front page.

23 July 1590 News of witches arrested in Denmark; arrests in Edinburgh

"It is advertised from Denmark, that the admirall there hathe caused five or six witches to be taken in Coupnahaven, upon suspicion that by their witche craft they had staied the Queen of Scottes voiage into Scotland, and sought to have staied likewise the King's retorne."
[Bowes to Burghley]

In Scotland a maid named Gillis Duncan was working for David Seaton in the small village of Tranent. When Duncan appeared to develop a miraculous talent for healing and was suspected of sneaking out of her master's house in the dead of night Seaton accused her of diablory. He personally had her tortured: her fingers were crushed in a vice-like instrument named the 'pillwinkes' and she was thrawed - her was head bound with ropes, which were violently twisted. When her naked body was then examined a 'devil's mark' was identified on her throat. Eventually Duncan confessed to being a witch. In prison she was induced to implicate other 'witches'. Among those she named were Agnes Sampson, a respected old woman from Haddington in East Lothian, John Fian, the schoolmaster of Saltpans, and Euphemia Maclean and Barbara Napier, two much respected Edinburgh ladies.

28 November 1590 King questions witches; account to be published

"The King and Counsaill is occupied with the examinaciouns of sundry witches taken in this contrye, and confessing both great nombers and the names of their fellowes; and also strange and odiouse factes done by them; which upon the full trialls of their causes are intended to be hereafter published. And some of good qualities are like to be blotted by the dealings of the wickett sorte."
[Bowes to Burghley]

7 December 1590 Agnes Sampson confesses

The King *"by his owne especiall travell"* has drawn Sampson, the great witch, to confess her wicked doings, and to discover sundry things touching his own life, and how the witches sought to have his shirt or other linen for the execution of their charmes. In this Lord Claud and other noblemen are evill spoken of. The witches known number over thirty, and many others accused." *"Their actes are filthy, lewde, and phantasticall."*
[Bowes to Burghley]

7 December 1590 King questions witches

We are now busy examining witches, who confess many strange things.
[Roger Aston to James Hudson]

Agnes Sampson when she was brought before the King and a council of nobles initially refused to confess. She was stripped naked and her body was completely shaved. When a 'devils' mark' was found on her genitals she was taken away and tortured. She had a witch's bridle forced upon her head. Its four sharp prongs cut into her tongue and cheeks and her head was thrawed. She was deprived of sleep until she too broke and confessed to various crimes of witchcraft.

above:
Newes from Scotland,
the North Berwick
witch trial.

109

John Fian, the schoolmaster was to be the most terribly tortured of all. It is in his trial that we find that the North Berwick Witches confessed to a meeting on Hallowmas eve. From this account comes the notion that Halloween was the night of the great sabbat, that across Europe covens of witches and warlocks would gather to meet with and pay homage to the devil, to blaspheme against God with black masses then fall into drunken diabolical orgies.

26 December 1590 Trial of Fian

Johnne Feane alias Cwninghame, last duelland in Prestoune

...was approached by the devil (dressed in white) who said: 'Will ze be my serwand and adore me and my serwandis, and ze shall never want?...

while lying in bed at Prestonpans let himself be carried to North Bewick kirk "quhair Sathane commandit him to mak homage with the rest of his serwandis; ...commands to do evil, eat, drink and rejoice;

Here we find Hallowe'en explicitly mentioned:

...being in company with Annie Sampson, Robert Grierson, Kate Gray and others on Hallowmas Eve embarked in a boat beside Robert Grierson's house in the Pans and sailed over the sea to a tryst they had with another witch, where they entered a ship and drank good wine and ale in it, thereafter causing the ship to sink with the persons in it, then returned home;

having moles' feet, given him by Satan, in his purse so as never to lack silver;

being in the North Berwick kirk where Satan made a devilish sermon, where the said "Johnne satt vpoune the left syde of the pulpett, narrest him; And the sermon being endit, he cam doune and tuke the said Johnne be the hand, and led him widderschinnis about; and thaireftir, caussit him kyse his erse,"

...receiving the directions and commandments of Satan: first to deny God and all true religion, secondly to give his faith to the Devil and adore him, thirdly he said to the Devil that he should persuade as many as he could to join his society, fourthly he dismembered the bodies of dead corpses and specially unbaptised children, fifthly he destroyed men by land and sea with corn, cattle and goods, and raised tempest and stormy weather as the Devil himself, blowing in the air etc;

guilty of being a common witch and enchanter.
Marginal jotting "Convict of diuers poyntis of Wichcraft, and brynt"
[1]

A contemporary chapbook, Newes from Scotland (1591) describes the torture of John Fian. "First by thrawing of his head with a roape, whereat he would confesse nothing. Secondly he was perswaded by faire means to confesse his follies, but that would preuaile us little. Lastly he was put to the most seuere and cruell paine in the world, called the bootes, who after he had recieued three strokes, being enquired if he would confesse his damnable acts and wicked life, his tung would not serve him to speak."

above:
Newes from Scotland,
Dr. Fian and his 'most
ungodly lyfe'.

Dr. Fian lost consciousness. The court officials saw his silence as a trick of the devil; they searched his mouth for some charm, and found two pins "thrust up into the head." The chapbook clearly reverses the facts: John Fian's torturers stuck two pins into his tongue. After this torture, in the presence the King, he confessed to all that was suggested to him as "most true, without producing any witness to justify the same," and renounced "conjuring, witchcraft, enchantment, sorcery and such like."

When he was next brought before the King and his council John Fian recanted his confession. His body was examined for devil's marks in case he might have "entered a new conference and league with the Devil." No marks were found. Fian was then taken and "commanded to have a most strange torment" so that he would return to his original confession.

His nails upon all fingers were riven and pulled off with an instrument called in Scots a turkas, which in English we call a pair of pincers, 'and under every nail there was thrust in two needles over even up to the heads. At all which torments notwithstanding, the doctor never shrunk any whit, neither would he then confess it the sooner for all the tortures inflicted upon him.'

Despite these tortures Fian refused to confess. In time his torturers brought out the "Spanish boots". Dr. Fian withstood so many blows in them that, "his legges were crushte and beaten, the bloud and marrowe spouted forth in great abundance... and notwithstanding all these grieuous paines and cruell torments hee would not confesse anie thing, so deeply had the devill entered into his heart, that hee utterly denied all that which he had before auouched..."

Dr. John Fian steadfastly refused to confess and maintained that his original confession was only done and said for fear of pains that he had endured. Despite his denials and even without a confession the King's council decided to execute him for example sake, 'to remain a terror to all others hereafter, that shall attempt to deal in the like wicked and ungodly actions, as witchcraft.'

End January 1591 Execution of Fian

"the saide Doctor Fian was soon after araigned, condemned and adjudged by the law to die, and then to be burned according to the lawe of that lande provided in that behalfe. Whereupon hee was put into a carte, and beeing first strangled, hee was immediately put into a great fire, being readie provided for that purpose, and there burned in the Castle Hill of Edenbrough, on a Saterdaie, in the ende of Januarie last past, 1591. The rest of the witches which are not yet executed, remayne in prison till farther triall and knowledge of his Majesties pleasure"
[Newes from Scotland]

...Many things they told which they recanted at their execution. John Fianne, executed in Edinburgh, at his death denied all he had acknowledged, saying he had told those tales by fear of torture and to save his life.
[Bowes to Burghley]

above:
Newes from Scotland, description of the torture of Dr. Fian.

When Agnes Sampson came to trial there were over fifty separate counts against her. Among them was the accusation that she had cured the wife of Johnne Cokburn, the sheriff of Hadingtoun, who had been bewitched "be the wich of Mirrielawis, be the blast of ewill wind, one Hallaw-ewin."

Again we find that a witch was seen to be working dark magic on the night of Halloween. The following is a description of the gathering of the witches in North Berwick kirkyard from the trial.

27 January 1591 Trial of Agnes Sampson

...Confessed before his Majesty that the Devil in the likeness of a man met her going out in the fields from her own house at Keith between five and six in the evening when she was alone, and commanded her to be at North Berwick kirk the next night.

...with the rest of their accomplices, above a hundred persons of which there were six men and all the rest women. The women first made their homage, and next the men. The men were turned round nine times widdershins, and the women six times. Johnne Fien 'blew vp the duris, and blew in the lychtis' which were like big black candles sticking round about the pulpit.

The Devil started up himself in the pulpit, like a big black man, and called every man by his name, and every one answered 'Here, master'. When Robert Greirsoune was named they all ran to and fro and were angry, for it was promised that he should be called 'Rot the Comptroller aliam Rob the Rowar' for expressing his name.

The first thing he asked was 'If they had kept all their promises and had been good servants?' and 'What had they done since the last time they convened?'

On his command they opened up the graves, two within the kirk and one outside, and took off the joints of their fingers, toes and knees and divided them up amongst them; and the said Agnes Sampson got for her part a winding sheet and two joints, which she kept negligently. The Devil commanded them to keep the joints upon them until they were dry, and then to make a powder of them with which to do evil. Before they departed they kissed his arse. He had on a gown and a hat, which were both black; and those that were assembled, partly stood and partly sat. Johnne Fiene was always nearest to the Devil, at his left elbow. Gray-meill kept the door....

[1]

She was duly sentenced.

For this cause the said Agnes was ordained by the Justice, pronounced by the mouth of James Scheill, Dempster, to be taken to the Castle of Edinburgh, and there bound to a stake and strangled until she was dead, and thereafter her body to be burned to ashes; and all her moveable goods to be forfeit and brought in to the use of our sovereign lord, etc.

[1]

Barbara Napier was a respectable Edinburgh lady. The dramatic nature of her trial goes someway to showing the severity of King James's judgement.

9 May 1591 Barbara Napier charged

[Bowes] was informed this morning that Barbara Naper, arraigned yesterday, was charged with practice for the destruction of the King, to have been done by the devil and the other witches, at the motion of Bothwell, as Graham affirms; as also for the death of the late Earl of Angus, and many other sorceries, witchcrafts. and consulting with witches.
[Bowes to Burghley]

She was found guilty of consulting with witches but not of seeking the death of the King.

May 1591 Barbara Napier condemned

Upon Saturday, the 8th of May, Barbara Naper, sister to William Naper of Wright's Houses, was convicted by an assise for art, part, and consulting with witches. The nixt Tuisday she was condemned to be wirried till she were dead, and thereafter to be burnt. When the staike was sett in the Castell Hill, with barrells, coales, heather, and powder, and the people were looking for present executioun, her freinds alledged she was with child, wherupon the executioun was delayed, till that alledgance was tryed. In the meane tyme, these that were upon her assise were summouned to underly the law upon Moonday, the seventh of June, for wilfull errour, in cleanging her in treasoun against the king's persoun. The jurie men came in the king's will. [...]Barbara Naper was convicted onlie of consulting with Richard Graham and Agnes Sampsoune. That she consulted for the death of the king or the Erle of Angus she denied. In respect of the Act of Parliament against naiked consultatioun was not putt into executioun, it was thought hard to execute her.
[2]

When Barbara Napier escaped the flames due to her pregnancy King James was furious. He condemned the decision to stay her execution and personally interceded to have the decision reversed.

James had the jury brought before him and tried them for their 'error'.

7 June 1591 King James's speech to accused jurors

"For witchcraft, which is a thing growen very common amongst us, I know it to be a most abhominable sinne, and I have bene occupied these three quarters of this yeere for the siftyng out of them that are guylty heerein. We are taught by the lawes both of God and men that this synne is most odious, and by Godes law punishable by death: by man's lawe it is called maleficium or venificium, an ill deede or a poysonable deede, and punishable likewise by death. Now yf it be death being practised against any of the people, I must needes thinke it to be - at least - the like yf it be agaynst the King [...] As for them who thinke these witchcraftes to be but

fantacyes, I remmyt them to be catechised and instructed in these most evident poyntes. [...persona intervention] because I see the pride of these witches and their freendes, which can not be prevented but by myne owne presence. And for these witches, whatsoever hath bene gotten from them hath bene done by me my selfe; not because I was moe wise then others, but because I was not partiall, and belefte that such a vice did reigne and ought to be repressed [...testimony of witches admissible] fyrst, none honest man can know these matters; secondly, because they will not accuse themselves; thirdly because no acte which is done by them can be seene. Further, I call them witches which doe renounce God and yeld themselves wholely to the devill; but when they have recanted and repented, as these have done, then I accompt them not as witches, and so their testymony sufficient. In this I refer myself to the ministers. Besides, the inquest is to judge of the qualitie of the testymony and circumstances concernyng the same. Also it may be observed that never any of good lyfe were chardged with that cryme."
[Report of King James's speech. Enclosed with Bowes to Burghley]

The King ordered a medical determination to discover whether Barbara Napier was or was not pregnant.

14 -19 June 1591 King to Maitland on Napier
"Trye by the medicinairis aithis gif Barbara Nepair be uith bairne or not. Tak na delaying ansour. Gif ye finde sho be not, to the fyre uith her presesentlie [sic], and cause bouell her publicclie..."
[King James to Maitland; misdated April 1591]

For once an accused 'witch' managed to escape execution.

23 February 1592 Release of Barbara Napier
Ordanet upoun ane warrand direct fra the Kingis Matie, that Barbara Naper, spous to Ard. Douglas, be putt to libertie furth of waird, and William Naper of Wrichtishoussis, hir brother, is becum souertie for her reentrie.
[Burgh of Edinburgh Records]

The general statistics lose their ability to touch us. Thousands of men and women were executed for 'witchcraft.' It is only when we narrow our focus down to one individual, one soul, that we can put ourselves in their place, imagine their torments as our own. The question is whether you could withstand torture. If you were denounced by friends, family or neighbours would you continue to stand by your innocence? Beaten, half drowned, strung up so your muscles tore, broken by blows that cracked your bones and mangled your limbs - could you withstand these agonies and not confess? At what point do you forget what life feels like without pain - how long till death would be a mercy, until you would say anything, condemn anyone, just to make them stop. Courage fades and fails. The stoutest heart will break. How long would you last until you swore and signed any confession and implicated your best friend or dearest love? It is in the actual testimony of the individual that we can see ourselves.

above:
Woodcut illustration of familiars and demonic creatures frolicking as a Witch makes magic over a spellbound victim.

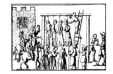

King James defined what he believed the witches to be.

"There are principalle two sortes, whereunto all the partes of that unhappie arte are redacted; whereof the one is called Magic or Necromancie, the other Sorcerie or Witch-craft. The Witches as Servantes onelie, and slaves to the Devil; but the Necromanciers are his maisters and commanders." On 26 October 1591 he had a commission set up for the discovery of witches.

...alsweill thame quhilkis ar already convict, or utheris quhilkis ar detenit captive and hes confessit, and sum that hes not confessit, as alswa all sic utheris as ar dilatit, or that heireftir salbe acused and dilaitit, off committing, using and practizing of witchcraft, sorcherie, inchantment, and utheris divilish divysis... [to try and examine, and report to his Highness and his Council] ...the personis wilfull or refusand to declair the veritie to putt to the tortour, or sic uthir punishement to use and caus be usit as may move thame to utter the treuth ...
[3]

In 1597, few short years after the North Berwick witch trials, King James produced a book entitled 'Daemonologie'. Truly James believed that he was carrying out his plain duty towards God and was himself the personal enemy of the Devil. In 1604, a short time after he ascended to the English throne 'Daemonologie' was republished in London. It takes the form of a dialogue and the King is quoted in his own words throughout.

"The fearfulle aboundinge at this time in this countrie, of these detestable slaves of the Devill, the Witches or enchanters, hath moved me... to... this following treatise of mine... to resolve the doubting harts of many; both that such assaultes of Sathan are most certainly practized, & that the instrumentes thereof, merits most severly to be punished."

It is hard for us to imagine how dreadful being condemned as a witch would be. There survives a single letter written in 1628 by Johannes Junius to his daughter shortly before his execution. This unique document gives us an insight into his torment and of the injustice suffered throughout Europe and America during the times of the witch hunts.

The Johannes Junius Letter
Many hundred thousand good-nights, dearly beloved daughter Veronica. Innocent have I come into prison, innocent have I been tortured, innocent must I die. For whoever comes into the witch prison must become a witch or be tortured until he invents something out of his head and - God pity him - bethinks him of something. I will tell you how it has gone with me. When I was the first time put to the torture, Dr. Braun, Dr. Kotzendorffer, and two strange doctors were there.

Then Dr. Braun, asks me, "Kinsman, how come you here?", I answer, "Through falsehood, through misfortune." "Hear, you," he says, "you are a witch; will you confess it voluntarily? If not, we'll bring in witnesses and the executioner for you." I said "I am no witch, I have a pure conscience in the matter; if there are

above:
The execution by hanging of witches in Scotland.

a thousand witnesses, I am not anxious, but I'll gladly hear the witnesses."

Now the chancellor's son was set before me... and afterward Hoppfen Elss. She had seen me dance on Haupts-moor... I answered: "I have never renounced God, and will never do it- God graciously keep me from it. I'll rather bear whatever I must."

And then came also- God in highest Heaven have mercy - the executioner, and put the thumb-screws on me, both hands bound together, so that the blood ran out at the nails and everywhere, so that for four weeks I could not use my hands, as you can see from the writing... Thereafter they first stripped me, bound my hands behind me, and drew me up in the torture. Then I thought heaven and earth were at an end; eight times did they draw me up and let me fall again, so that I suffered terrible agony...

And this happened on Friday, June 30, and with God's help I had to bear the torture. When at last the executioner led me back into the prison, he said to me:

"Sir, I beg you, for God's sake confess something, for you cannot endure the torture which you will be put to; and even if you bear it all, yet you will not escape, not even if you were an earl, but one torture will follow after another until you say you are a witch. Not before that," he said, "will they let you go, as you may see by all their trials, for one is just like another."...

And so I begged, since I was in a wretched plight, to be given one day for thought and a priest. The priest was refused me, but the time for thought was given. Now, my dear child, see what hazard I stood and still stand. I must say that I am a witch, though I am not, must now renounce God, though I have never done it before. Day and night I was deeply troubled, but a last there came to me a new idea. I would not be anxious, but, since I had been given no priest with whom I could take counsel, I would myself think of something and say it. It were surely better that I just say it with mouth and words, even though I had not really done it'; and afterwards I would confess it to the priest, and let those answer for it who compel me to do it... And so I made my confession, as follows; but it was all a lie.

Now follows, dear child, what I confessed in order to escape the great anguish and bitter torture, which it was impossible for me longer to bear...

Then I had to tell what people I had seen [at the witch-sabbath]. I said that I had not recognized them. "You old rascal, I must set the executioner at you. Say - was not the Chancellor there?" So I said yes. "Who besides?" I had not recognized anybody.

So he said: "Take one street after another; begin at the market, go out on one street and back on the next." I had to name several persons there. Then came the long street. I knew nobody. Had to name eight persons there. Then the Zinkenwert- one person more. Then over the upper bridge to the Georgthor, on both sides. Knew nobody again. Did I know nobody in the castle - whoever it might be, I should speak without fear. And thus continuously they asked me on all the streets, though I could not and would not say more. So they gave me to the executioner, told him to strip me, shave me all over, and put me to the torture.

"The rascal knows one on the market-place, is with him daily, and yet won't know him." By that they meant Dietmery: so I had to name him too.

Then I had to tell what crimes I had committed. I said nothing. ..."Draw the rascal up!" So I said that I was to kill my children, but I had killed a horse instead.

It did not help. I had also taken a sacred wafer, and had desecrated it. When I had said this, they left me in peace.

Now dear child, here you have all my confession, for which I must die. And they are sheer lies and made-up things, so help me God. For all this I was forced to say through fear of the torture which was threatened beyond what I had already endured. For they never leave off with the torture till one confesses something; be he never so good, he must be a witch. Nobody escapes, though he were an earl...

Dear child, keep this letter secret so that people do not find it, else I shall be tortured most piteously and the jailers will be beheaded. So strictly is it forbidden... Dear child, pay this man a dollar... I have taken several days to write this: my hands are both lame. I am in a sad plight....

Good night, for your father Johannes Junius will never see you more.
July 24, 1628.

[And on the margin of the letter he added:]

Dear child, six have confessed against me at once: the Chancellor, his son, Neudecker, Zaner, Hoffmaisters Ursel, and Hoppfen Else - all false, through compulsion, as they have all told me, and begged my forgiveness in God's name before they were executed... They know nothing but good of me. They were forced to say it, just as I myself was.
[3]

They say that Guy Fawkes was the only man to ever enter parliament with honest intentions. He was part of the Gunpowder plot to assassinate King James VI & I and his government at Westminster Palace in London. This was a Catholic conspiracy which involved loading the cellars beneath the Parliament with barrels of gunpowder then detonating it as the King sat in attendance. Guy Fawkes was captured on the night of 4th November - the night before the regicide was scheduled.

Remember, remember, the fifth of November,
Gunpowder, treason and plot,
Pray tell me reason why Gunpowder treason,
Should ever be forgot.

The survival of the King and his government was to henceforth to be officially celebrated annually on the 5th November. The marking of this day evolved from simple church services to today's Bonfire nights. Effigies of Guy Fawkes are still burned on pyres and tons of fireworks are detonated. It has been suggested that the November 5th celebrations were in fact a survival of ancient Samhain fire rites but as this was a historical anniversary the argument is unconvincing.

Curiously, in 1655, in his book 'The Church History of Britain: from the Birth of Christ until the year 1648' Dr Thomas Fuller tells us that King James VI & I had a final change of heart following numerous cases where people bore false witness and faked demonic possession.

'...the frequency of such forged Possessions wrought such an alteration upon the judgement of King James that he, reading from what he had written in his Daemonologie, grew first diffident of, and then flatly to deny the workings of Witches and Devils, as but falsehoods and delusions.'

It should be stated that, just as King James VI & I was the VI of Scots and I of England, our current monarch is Queen Elizabeth II of England and I of Scotland. Her namesake Queen Elizabeth I was never Queen of Scots and had Mary, the Scots monarch, beheaded. Elizabeth I died childless and Mary's son James succeeded to the throne becoming VI & I. He lived long and died in his bed at the age of fifty-eight. His one surviving son, King Charles I, was not so lucky. His English subjects rose up against him, put him on trial and executed him. 'For all the treasons and crimes this Court doth adjudge, that the said Charles Stuart, as a tyrant, traitor, murderer, and a public enemy, shall be put to death, by the severing his head from his body.'

In the last few years historians and scientists working together have deduced that the cases of physical 'bewitchment' that plagued Europe and America at the times of the witch hunts were almost certainly the result of 'ergotism'.

The Ergot of Rye is a plant disease that is caused by the fungus Claviceps purpurea. The so called ergot of the fungus is a resting stage called the sclerotium that overwinters and is where the sexual stage of the lifecycle will form. The sclerotium is a dark purplish structure that replaces the grain in the rye plant.
[4]

In her book 'Molds, Epidemics and History' (New Haven, Yale University Press, 1989), Mary Matossian makes a convincing case linking the occurrence of ergotism in the rye harvest with periods where there were high numbers of witchcraft prosecutions. When the infected rye was harvested, milled and used in baking bread for a community, people and animals ingested it; all began to suffer from strange and inexplicable afflictions.

A person who had consumed ergot in their daily bread could suffer from a number of symptoms: Their muscles spasmed, their body shook and writhed uncontrollably; they could witness vivid nightmarish hallucinations or feel as though insects were crawling beneath their skin or wild animals were scratching at their flesh. It was from ergot that the psychoactive drug LSD was first isolated. Doctors who had never encountered such an affliction were without a treatment or cause and diagnosed 'bewitchment'.

above:
Outlook Press bookpiece
The Outlook Tower was built on Castlehill where executions for witchcraft were carried out.

About a hundred years ago Castle Hill in Edinburgh was cleared to make way for the building of the Outlook Tower. A thick layer of black ashes was discovered. Here, within sight of Edinburgh Castle, hundreds of individuals had been put to death, their bodies burned and left scattered on unhallowed ground. A bronze fountain was commissioned and the Celtic renaissance artist John Duncan sculpted the monument which is to this day known simply as 'the Witches' Well'.

Notes

[1] Dittay Pitcairn

[2] Historie of the Kirk of Scotland
 Calderwood

[3] European Witchcraft
 E. William Monter, Department of History, Northwestern University, John Wiley & Sons, Inc.

[4] http://www.botany.hawaii.edu/faculty/wong/BOT135/LECT12.HTM

above:
Vintage Halloween
card.

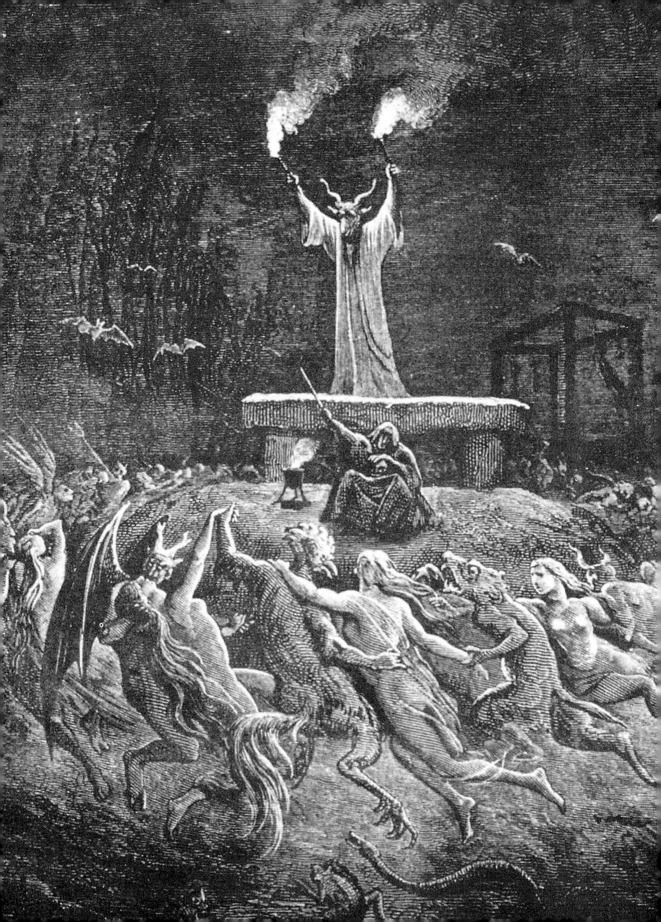

Season of the Witch

Halle'en! Halle'en! This nicht at e'en
Three witches on the green,
Ane black, ane green,
Ane playing the tambourine.
[1]

Today when we think of witches our heads are filled with images of slightly green ugly old hags, dressed in ragged black frocks with pointy hats and pointy noses. They tend to cackle a lot. They stick out their warty chins and grin madly while stroking their black cats. They tend to live in tumbledown cottages and mix noxious potions in bubbling cauldrons and fly out of their chimneys on broomsticks.

Our ideas about what makes an archetypal witch is filtered through centuries of folktales and superstitions, fireside songs and fairy stories. We have grown up with the wicked witches of Disney and the Wizard of Oz, Technicolor crones brought to life on the big screen, but their roots lay in the wealth of old folklore that sailed into New York harbour with America's immigrants.

In the confusion of history many writers have confused the 'real' witches with their fanciful weird sisters. Folklorists have in the past tried to prove their theories that there was a hidden underground tradition of witchcraft that was persecuted in the Burning Times. Confessions extracted under excruciating torture should not be taken at face value - if it might have spared them further pains the accused would have happily confessed to being the tooth fairy. But the details of these confessions were published in chapbooks and lived on to mix and mingle with tales of giantesses and hags till the archetypal witch was created.

Witchcraft was unknown in the ancient Highlands. The Gaelic word buidseachd (witchcraft) was borrowed from English. As Lord Hailes pointed out long ago, we find in the ancient history of Scotland as a whole "scarcely any vestiges of witchcraft". There are no meetings with the devil or any broom riding in Gaelic folklore, a fact that betrays the influence of the imported ideas about witches. The Scottish folk-lore embedded in the accounts of our witch trials may impart some "local colour" to them, but affords no proof of the antiquity of a witch cult on

opposite:
Satan at Sabbat
A vivid picture of the imagined diabolic revels of Satan and his hosts of witches and demons meeting for the grand sabbat.

Scotland. When the craze for witch finding became prevalent, the "searchers" read out certain charges, which their demented and tortured victims admitted as correct, but we cannot regard the records of trials as good folk-lore evidence. In genuine folk-tales certain female figures are "wise women" who are possessed of charms and magic wands, but they are neither hated nor feared. They are invariably protectors of their kind against evil influences and especially the numerous demons of earth, air, and water. Some are healers, "blood stoppers", and foretellers, as are also certain "wise men". The supernatural powers were supposed to be passed down through the generations from a woman to a man and a man to a woman, usually, but not always, relatives of one another.
[2]

Imagine a black cast iron cauldron. It sits on a glowing fire, flames licking at its sides. A witch's brew bubbles and reeks of pond slime and sulphur. Into the cauldron go all the ingredients that make our modern image of the witch: a confession or three, a island folktale of a magical Carlin, the Night Mara that haunts your sleep, the German Hexen on their way to the sabbat, Macbeth's three weird sisters on a lonely moor, the wicked stepmother with her poisoned apple and a thousand tales told on dark nights.

Today when we wake with a fright in the wee small hours we call our bad dream a 'nightmare'. The word descends from the Anglo-Saxon and Old Norse name for a fearsome night demon, the 'mara'. The dreamer lay in bed with the demon sat upon their chest giving them vivid disturbing dreams. To the Anglo-Saxon this was a martrö (mare-ride), in Norway - a mareritt, in Denmark - a mareridt. In Germany, the demon is often known as an Alp, a word closely related to elf, a nightmare was an Alptraum. (alp-dream)

A cabinetmaker in Bühl slept in a bed in his workshop. Several nights in a row something laid itself onto his chest and pressed against him until he could hardly breathe. After talking the matter over with a friend, the next night he lay awake in bed. At the strike of twelve a cat slipped in through a hole. The cabinetmaker quickly stopped up the hole, caught the cat, and nailed down one of its paws. Then he went to sleep.

The next morning he found a beautiful naked woman in the cat's place. One of her hands was nailed down. She pleased him so much that he married her.

One day, after she had borne him three children, she was with him in his workshop, when he said to her, "Look, that is where you came in!" and he opened the hole that had been stopped up until now.

The woman suddenly turned into a cat, ran out through the opening, and she was never seen again.
[3]

The idea that these bad dreams were the workings of some foul 'female' creature was evident throughout Europe and the folk protected themselves with charms.

English charm to control the Night-Mare:

S. George, S. George, our ladies knight,
He walkt by daie, so did he by night.
Untill such time as he her found,
He hir beat and he hir bound,
Untill hir troth she to him plight,
She would not come to him that night.
[4]

Nightmare charm or Spell against the Mara from the Shetland Islands:

Pulling from my head the longest hair it possessed, and then going through the
pantomime of binding a refractory animal, the nurse slowly chanted this spell:
De man o' meicht
He rod a' neicht
We nedder swird
Nor faerd nor leicht,
He socht da mare,
He fand da mare,
He band da mare
Wi' his ain hair,
An' made her swear
By midder's meicht,
Dat shö wad never bide a neicht
What he had rod, dat man o' meicht.
[1]

In Britain this sleep paralysis was known as being 'Hag-ridden'. It could be prevented
with the protection of a stone with a hole naturally worn through it – a 'Hag stone'.
Here is another charm of protection from the Shetland Islands:

Arthur Knight
He rade a' night,
Wi' open swird
An' candle light.
He sought da mare;
He fan' da mare;
He bund da mare
Wi' her ain hair.
And made da mare
Ta swear:
'At she should never
Bide a' night
Whar ever she heard
O' Arthur Knight.
[1]

above:
Vintage Halloween
card.

Protection from evil forces was a necessity of everyday life and there were numerous defences against witches and witchcraft.

To counteract... witchcraft, nail a horse-shoe on the stable door, put a piece of iron in the kirn, and sprigs of rowan, not allowed to touch the ground, above the byre door-head or sewn into the seams of children's clothing (advised after Hallowmas raids).

A relic of superstition also existed in this district in the person of an old Highland dame, who used to burn rowan-tree branches in front of her house every Hallowe'en night to keep the witches away.
[1]

Such safeguards were vital as it was thought that, like the magical Hags and Carlins, the witches had the power to transform themselves into the shape of birds and beasts. They could be anywhere, disguised and concealed.

...her transformation into the shape of a raven; which now, in a great measure, supersedes the use of her ancient and renowned hobby-horse, the Broom, on which she formerly walloped with such surprising velocity. This similitude is commonly assumed by her when on excursions to any distance, to attend the counsels of Satan - to hold communion with the sisterhood - or to attend some important enterprise.

The witch likewise assumes the character of a magpie on occasions of sudden emergency, which require immediate conference with a number of members of the craft. The likeness of this bird, which is of a domestic character, and fond of hopping and picking about the doors, screens the witch from suspicion, as she visits another witch's dwelling. Hence, when a number of magpies convene together side by side on a house top, it is no wonder that their appearance should occasionally excite suspicion. But we humbly think that mere suspicion by no means justifies that hostility of temper which in several districts the inhabitants are led to entertain against the whole race of magpies, merely because the witches sometimes assume their similitude...
[5]

Fence, Lancashire, England.
On the night of Hallowe'en, 1632, a young boy named Edmund is supposed to have had an encounter with witchcraft. It seems that he came across two greyhounds on Pendle, both of which had chains trailing from their collar. For some reason Edmund decided to use them to hunt for hares (locally called 'malkins', somewhat reminiscent of the local Malkin Tower). A hare started nearby, but the dogs refused to chase it. The boy tied up the animals and started to thrash them with his stick. As the stick fell, the dogs were transformed into humans, one of whom was his neighbour Frances Dickenson, the other a boy he did not know. The woman seized hold of Edmund and promised him money if he would keep the secret of their transformation; however, the bot refused, recognizing her for a witch. The transformation scene was not complete, however, for she then changed the uniden-tified boy into a white horse by placing a bridle over his head, and then forced

Edmund to ride alongside her. The unlikely pair rode to the house called Hoarstones at Fence, where Edmund saw witches and warlocks feasting. He escaped, and when eventually his story came out, he was taken to local magistrates.

Such was the witchcraft hysteria of the time that the boy's imaginative tale was taken seriously, and a large number of men and women were arrested and sent for trial at Lancaster. They were all found guilty of witchcraft and sentenced to death by hanging, but fortunately the judge ordered a stay of execution. The case became very famous, and eventually a sensational play, The Late Lancashire Witches, was a London success. For some months Edmund was in demand as a witch-hunter, for he claimed to be able to identify witches merely by sight. However, he was soon proved to be a liar - his tale being an adventure yarn invented by his father, who recognized the business of witch-hunting as being financially sound. One of the people aware of the extent to which Edmund was lying, and causing acute distress to the neighbourhood, was John Webster, the vicar of Mytton, whose book Displaying of Supposed Witchcraft (1677) was based upon his experiences with Edmund. This batch of Lancashire witches was later reprieved by Charles I.
[6]

Another notorious case of 'witchcraft' that had elements of Hag folklore was that of Major Weir and his sister, Jane. Major Thomas Weir had been a lieutenant in the Scottish Puritan Army and was later appointed Major in command of the Edinburgh city guards. He was deeply religious, '...so notoriously regarded among the Presbyterian strict sect, that if four met together, be sure Major Weir was one...' When he retired in 1650 after many years of service it was expected he would spend his remaining years living quietly in his home in the West Bow with his spinster sister Jane.

Throughout the narrow cobbled streets, wynds and closes of Edinburgh, Major Thomas Weir was a well-known figure. 'His garb was still a cloak, and somewhat dark, and he never went without his staff. He was a tall black man, and ordinarily looked down to the ground; a grim countenance and a big nose.' Then, suddenly in the spring of 1670, when Major Weir was 76 years old, he began to confess to a catalogue of horrendous crimes to the elders of his church. When city officials were called in they decided the Major had lost his mind, grown senile in his decrepitude but Weir insisted his confession was true.

Weir claimed that he had had incestuous relations with his sister since she was ten years old. He confessed to having relations with his stepdaughter, Margaret Bourdon, and numerous illicit affairs with servant girls. It was recalled that back in 1651 a woman in Lanark reported seeing the Major engaged in sexual congress with a mare. She was, at the time, not believed and was publicly whipped for lying. Now Major Weir openly admitted to bestiality with both mares and cows.

The shocked officials were then told by the Major why he had led a life of debauchery and perversion. He confessed that he was in fact a witch: a sorcerer who, along with

his sister, worshipped the Devil. When Jane Weir was questioned, to the horror of the officials, she too confessed and spoke at length about her meetings with the Devil in the guise of a tiny woman. She also explained that her brother's staff was actually a magical wand. Brother and sister were soon brought to trial and found guilty.

On April 11 1670, Major Thomas Weir was taken to the place of execution where he was duly strangled and his was body was burned. The following day Jane Weir was burned at the stake at Grass Market. The story of their case was recounted in pamphlets and books and its fame lasts to this day. Their home in the West Bow was forever after thought to be a haunted house till its eventual demolition and on some dark nights a fiery black coach and horses is still seen tearing down the Royal Mile taking the Weirs to hell.

A short time ago I was fortunate enough to examine a fine old book at the National Library of Scotland. (I have changed the old spellings where 'f's are used for 's's to protect the innocent...)

The history of witches, ghosts, and Highland seers:
containing many wonderful well-attested Relations
of SUPERNATURAL APPEARANCES
Not published before in any similar collection.

Designed
For the conviction of the unbeliever,
and the Amusement of the Curious.

Somnia, terrores Magicos, miracula. Sagas,
Nocturnos Lemures, portentaque, Theffala rides?

Say, can you laugh indignant at the schemes
Of magick terrours, visionary dreams,
Portentous wonders, witching imps of Hell,
The mighty goblin and enchanting spell?

There is the following eyewitness account ("take this notable remark from two persons yet alive...") of a curious incident said to have taken place shortly before the Weir's confessions.

...this gentlewoman coming from the Castle-hill, where her husband's niece was lying in of a child, about midnight, perceived about the Bow-head three women in windows shouting, laughing and clapping their hands. The gentlewoman went forward, till just at Major Weir's door, there arose as from the street, a woman about the length of two ordinary females, and stepped forward. The gentlewoman, not as yet excessively feared, bid her maid step on, if by the lantern they could see what she was; but haste what they could, this long-legged spectre was still before them, moving her body with a vehement cahination, a great unmeasurable

laughter. At this rate the two strove for place, till the giantess came to a narrow lane in the Row, commonly called the stinking close, into which she turning, and the gentlewoman looking after her, perceived the close full of flaming torches, (she could give them no other name) and as it had been a great number of people, stentoriously laughing, and gaping with tahees of laughter. This sight, at so dead a time of night, no people being in the windows, belonging to the close, made her and her servant haste home, declaring all what they saw to the rest of the family, but more passionately to her husband. And though sick with fear, yet she went the next morning with her maid, to view the noted places of her former night's walk, and at the close inquired who live there? It was answered, Major Weir.

Here we have a dark giantess walking the streets of old Edinburgh. She appears from nowhere and nothingness like some supernatural hag goddess and vanishes in a confusion of fiery torches. Jane Weir also confessed to having entertained a faery emissary and we can see in the tales that surround their case elements of indigenous folklore.

It is also interesting that there are in the eyewitness's story three women, like the three weird sisters, leaning, laughing and clapping from their windows. While a coven of witches was widely thought to be thirteen, in mockery of Christ and his twelve disciples, witches were often thought to work in threes.

William Shakespeare was nothing if not a good judge of popular contemporary tastes. It was only a few short years after the trial of the North Berwick witches and the ascension of King James VI & I to the English throne that he wrote 'Macbeth'. The exact date of its writing and first performance remain controversial, thought to be some time between 1601 and 1610, but the earliest text we have dates from 1623. 'Macbeth' or as it is commonly known by theatrical types 'the Scottish Play' has been said to be cursed by its authentic depiction of witchcraft rites. Superstitious thespians will not name it for fear of accidents and misfortune. The best explanation for the supposed 'curse' that I've heard is that 'Macbeth' is such a popular play that it is the last resort of struggling companies on the edge of bankruptcy. I've also heard that in an outdoor production of 'Macbeth' staged in Bermuda in 1953, Charlton Heston suffered severe burns in his groin and leg area from tights that were accidentally pre-soaked in kerosene. Cursed or not - that's got to hurt...

Act 1, Scene 1. *A desert place.*
 Thunder and lightning. Enter three Witches

First Witch *When shall we three meet again*
 In thunder, lightning, or in rain?

Second Witch *When the hurlyburly's done,*
 When the battle's lost and won.

Third Witch *That will be ere the set of sun.*

First Witch	*Where the place?*
Second Witch	*Upon the heath.*
Third Witch	*There to meet with Macbeth.*
First Witch	*I come, Graymalkin!*
Second Witch	*Paddock calls.*
Third Witch	*Anon.*
ALL	*Fair is foul, and foul is fair:*
	Hover through the fog and filthy air.
Exeunt	

Now when we read Shakespeare or watch a movie we don't really see the plays in their proper context. Macbeth was written with the intention that it should be performed in a large theatre for a large crowd. It had to compete for an audience with bear baiting and public executions. Its themes of Scottish monarchy, royal assassination and witchcraft were all hot topics at the time. The weird sisters let a company of players employ all the latest tricks and technologies of the theatre from flying effects and trap doors to thunderous storms and thick fogs. This was witchcraft as thrilling entertainment, a chance to see the supernatural wonders of folktales in the flesh.

Act 4, Scene 1.	*A cavern. In the middle, a boiling cauldron.*
	Thunder. Enter the three Witches
First Witch	*Thrice the brinded cat hath mew'd.*
Second Witch	*Thrice and once the hedge-pig whined.*
Third Witch	*Harpier cries 'Tis time, 'tis time.*
First Witch	*Round about the cauldron go;*
	In the poison'd entrails throw.
	Toad, that under cold stone
	Days and nights has thirty-one
	Swelter'd venom sleeping got,
	Boil thou first i' the charmed pot.
ALL	*Double, double toil and trouble;*
	Fire burn, and cauldron bubble.
Second Witch	*Fillet of a fenny snake,*
	In the cauldron boil and bake;

Eye of newt and toe of frog,
Wool of bat and tongue of dog,
Adder's fork and blind-worm's sting,
Lizard's leg and owlet's wing,
For a charm of powerful trouble,
Like a hell-broth boil and bubble.

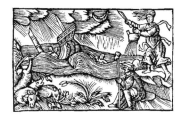

ALL *Double, double toil and trouble;*
 Fire burn and cauldron bubble.

It is thought that Shakespeare's source for the three witches of Macbeth was Holinshed's 'Historie of Scotland.':

...there met them three women in strange and wild apparell, resembling creatures of elder world... afterwards the common opinion was, that these women were either the weird sisters, that is (as ye would say) the goddesses of destinie, or else some nymphs or feiries, indued with knowledge of prophesie by their necromanticall science...
[7]

Witches took to the stage, to the pages of books and pamphlets and into the popular imagination.

There, in a gloomy hollow glen, she found
A little cottage built of sticks and weeds,
In homely wise, and walled with sods around,
In which a witch did dwell in loathly weeds
And willfull want, all careless of her needs;
So choosing solitary to abide,
Far from all neighbors, that her devilish deeds
And hellish arts from people she might hide,
And hurt, far off, unknown, whomever she envied.
[Edmund Spenser, 'The Faerie Queene', 1590]

They were less creatures of flesh and blood than half human members of the faeries' Unseelie Court, stealing mortals and taking to the night skies on All Hallows' Eve. In the ballad of Alison Gross from the Scots border country we meet a particularly loathsome old hag who holds a man captive and tries to persuade him to be hers till he is finally set free by some kind Seelie faeries as they ride by at Halloween. In its thirteen verses its witch is less a figure of fear and more a figure of fun.

Alison Gross

1 *O Alison Gross, that lives in yon tow'r,*
 The ugliest witch in the north countrie,
 She trysted me ae day up till her bow'r,
 And mony fair speeches she made to me.

above:
A witch raising a storm.

2 *She straik'd my head, and she kaim'd my hair,*
And she set me down saftly on her knee;
Says - "If ye will be my leman sae true,
Sae mony braw things as I will you gi'e."

3 *She shaw'd me a mantle of red scarlet,*
With gowden flowers and fringes fine;
Says - "If ye will be my leman sae true,
This goodly gift it shall be thine."

4 *"Awa, awa, ye ugly witch,*
Haud far awa, and let me be;
I never will be your leman sae true,
And I wish I were out of your company."

5 *She neist brocht a sark of the saftest silk,*
Weel wrought with pearls about the band;
Says - "If ye will be my ain true love,
This goodly gift ye shall command."

6 *She show'd me a cup of the good red gowd,*
Weel set with jewels sae fair to see;
Says - "If ye will be my leman sae true,
This goodly gift I will you gi'e."

7 *"Awa, awa, ye ugly witch,*
Haud far awa, and let me be;
For I wadna ance kiss your ugly mouth,
For all the gifts that ye cou'd gi'e."

8 *She's turn'd her richt and round about,*
And thrice she blew on a grass-green horn;
And she sware by the moon and the stars aboon,
That she'd gar me rue the day I was born.

9 *Then out has she ta'en a silver wand,*
And she turn'd her three times round and round;
She mutter'd sic words, that my strength it fail'd,
And I fell down senseless on the ground.

10 *She turn'd me into an ugly worm,*
And gar'd me toddle about the tree;
And aye on ilka Saturday night,
Auld Alison Gross she came to me,

11 *With silver basin, and silver kame,*
To kame my headie upon her knee;

But rather than kiss her ugly mouth,
I'd ha'e toddled for ever about the tree.

12 *But as it fell out on last Hallow-e'en,*
When the seely court was ridin' by,
The queen lighted down on a gowan bank,
Near by the tree where I wont to lye.

13 *She took me up in her milk-white hand,*
And she straik'd me three times o'er her knee;
She chang'd me again to my ain proper shape,
And nae mair do I toddle about the tree.'

Jamieson gave this ballad from a manuscript, altering the spelling in conformity with Scots orthography.

> *This is the nicht O' Hallowe'en,*
> *A' the witches are to be seen,*
> *Some o' them black, an' some o' them green,*
> *And some o' them like a randy quean.*
> [1]

Witches have long been associated with Halloween night. It is thought to be the night of one of their great sabbats: strange nocturnal gatherings of witches and warlocks held on desolate hilltops or in quiet churchyards. It was a night when travel was best avoided by decent folks and children had to be tucked soundly in their beds.

> *Hallowe'en will come, will come,*
> *Witchcraft (divination) will be set agoing,*
> *Fairies will be at full speed*
> *Running in every pass;*
> *Avoid the road children, children!*
> [1]

Mony a ane has met with things on Hallowe'en that they never after forgot.... O, Sir, Hallowe'en among us is a dreadful night! Witches and warlocks, and a' lang-nebbit things, hae a power and a dominion unspeakable on Hallowe'en. The de'il at other times gi'es, it's said, his agents a mutchkin o' mischief, but on this night it's thought they hae a chappin....
[1]

Such grand gatherings of witches were said to be common across the whole of Europe. In Germany the witches were thought to hold their yearly sabbat half a year before, on Walpurgis Night - May eve. From across the country the hexen flew to the Brocken, the highest peak in the Harz mountains of central Germany.

above:
The witches sabbat
at the Brocken.

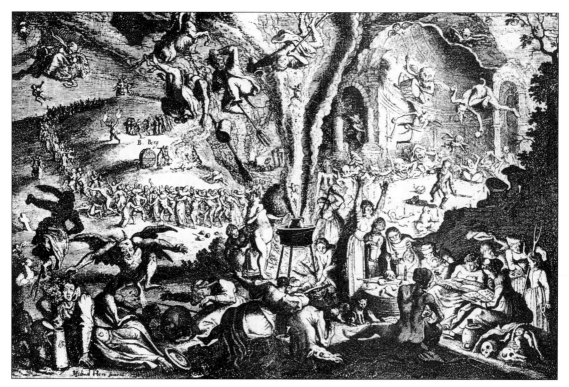

above:
Panorama of the Witches' Sabbath
Witches carelessly ignore the no-fly zone notices as a full blooded fictional sabbat is in rampant demonic swing.

opposite:
'Shakespeare's Globe'
The reconstructed Globe Theatre on the South Bank of the Thames, London.
http://www.shakespeares-globe.org/

A German folktale tells how a young man learned his bride to be was in fact a witch. He had had his suspicions for quite some time that his potential mother in law was a witch (I am told this is fairly common...) but was less sure about his fiancé. When Walpurgis Night came he followed the pair as they crept into a hayloft. There they drank from a small glass and promptly vanished. The man picked up the glass and after a moment's hesitation he took a sip. Instantly he found himself transported to the Brocken. There on the cold mountaintop umpteen dancing witches surrounded him. When the dance ended he saw the Devil stood in their midst. At his command the witches all drank from their glasses and flew off back home. There stood the man, alone on the mountain, without the glass. With no other choice he began the long trek home on foot.

Eventually he finally made it back to his home only to be met by his fiancé and her mother in foul temper. For drinking from their magic glass they transformed him into a donkey. Life as a donkey didn't really agree with the man and he wandered, forlornly refusing hay and feeling sorry for himself. In time he went home and was met by his bride to be. She looked at him with his long ears and his sad eyes and took pity on him. She told him to go to the church and as a child was baptised to stand by the church door and let the holy baptismal water fall upon his back.

The following Sunday a baby was baptised at the church and the donkey waited by the door. After the service the sexton went outside to pour away the holy water but found a filthy great big donkey stood in his way. He told the donkey to move but it stubbornly stayed put. Angrily the sexton threw the holy water over the donkey,

which was instantly transformed back into a man. Thus restored the man rushed home and was reunited with his fiancé. In time they were married and lived happily from that time forth. (I don't know quite how his mother in law took it...)

Robert Burns gives us a wild earthy tale of a witches' sabbat in his famous poem 'Tam O' Shanter'.

...And, wow! Tam saw an unco sight!
Warlocks and witches in a dance;
Nae cotillion brent-new frae France,
But hornpipes, jigs, strathspeys, and reels
Put life and mettle in their heels.
A winnock bunker in the east,
There sat Auld Nick in shape o' beast:
A towzie tyke, black, grim, and large,
To gie them music was his charge;
He screw'd the pipes and gart them skirl,
Till roof and rafters a' did dirl.—
Coffins stood round like open presses,
That shaw'd the dead in their last dresses;
And by some devilish cantraip sleight
Each in its cauld hand held a light,
By which heroic Tam was able
To note upon the haly table
A murderer's banes in gibbet airns;
Twa span-lang, wee, unchristen'd bairns;
A thief, new-cutted frae the rape—
Wi' his last gasp his gab did gape;
Five tomahawks, wi' blude red-rusted;
Five scimitars, wi' murder crusted;
A garter, which a babe had strangled;
A knife, a father's throat had mangled,
Whom his ain son o' life bereft—
The grey hairs yet stack to the heft;
Wi' mair o' horrible and awfu',
Which ev'n to name wad be unlawfu'.

As Tammie glowr'd, amaz'd and curious,
The mirth and fun grew fast and furious:
The piper loud and louder blew,
The dancers quick and quicker flew;
They reel'd, they set, they cross'd, they cleekit
Till ilka carlin swat and reekit
And coost her duddies to the wark
And linket at it in her sark!

Now Tam, O Tam! had thae been queans,
A' plump and strapping in their teens!
Their sarks, instead o' creeshie flannen,
Been snaw-white seventeen hunder linen!—
Thir breeks o' mine, my only pair,
That ance were plush, o' gude blue hair,
I wad hae gien them aff y hurdies,
For ae blink o' the bonie burdies!

But wither'd beldams, auld and droll,
Rigwoodie hags wad spean a foal,
Lowping and flinging on a crummock.
I wonder didna turn thy stomach.

But Tam ken'd what was what fu' brawlie;
There was ae winsom wench and walie,
That night enlisted in the core
(Lang after ken'd on Carrick shore.
For mony a beast to dead she shot,
And perish'd mony a bonie boat,
And shook baith meikle corn and bear,
And kept the country-side in fear);
Her cutty sark o' Paisley harn,
That while a lassie she had worn,
In longitude tho' sorely scanty,
It was her best, and she was vauntie.
Ah! little ken'd thy reverend grannie,
That sark she coft for her wee Nannie,
Wi' twa pund Scots ('twas a' her riches),
Wad ever grac'd a dance of witches!...

Robert Burns wrote 'Tam o' Shanter' in one fevered night of inspiration. It was written in 1790 for, and duly appeared in, Captain Grose's 'Antiquities of Scotland', a book 'chiefly meant to illustrate and describe the ancient castles and monasteries of Scotland.' The poem tells of Tam bumbling upon a witches' sabbat at Alloway Kirk in Ayrshire. Burns had in fact asked to come to Ayrshire and make a drawing of Kirk Alloway for his book. The church was the burial-place of Burns's father. Grose agreed, provided that Burns would furnish a story of witches to go along with it.

Captain Grose here describes of Alloway Kirk:
'This church, is also famous for being the place wherein the witches and warlocks used to hold their infernal meetings, or sabbaths, and prepare their magical unctions; here too they used to amuse themselves with dancing to the pipes of the muckle-horned Deil. Diverse stories of these horrid rites are still current: one of which my worthy friend Mr. Burns has here favoured me with in verse ... This poem is founded on a traditional story...'

Burns himself gave the following prose summary in his letter to Captain Grose.

On a market-day, in the town of Ayr, a farmer from Carrick, and consequently whose way lay by the very gate of Alloway kirk-yard, in order to cross the river Doon, at the old bridge, which is about two or three hundred yards farther on than the said gate, had been detained by his business till by the time he reached Alloway it was the wizard hour, between night and morning. Though he was terrified with a blaze streaming from the kirk, yet as it is a well-known fact, that to turn back on these occasions is running by far the greatest risk of mischief, he prudently advanced on his road. When he had reached the gate of the kirk-yard, he was surprised and entertained, through the ribs and arches of an old gothic window which still faces the highway, to see a dance of witches merrily footing it round their old sooty blackguard master, who was keeping them all alive with the power of his bagpipe. The farmer stopping his horse to observe them a little, could plainly descry the faces of many old women of his acquaintance and neighbourhood. How the gentleman was dressed, tradition does not say, but the ladies were all in their smocks; and one of them happening unluckily to have a smock which was considerably too short to answer all the purpose of that piece of dress, our farmer was so tickled that he involuntarily burst out, with a loud laugh, "Weel luppen, Maggy wi' the short sark!" and recollecting himself, instantly spurred his horse to the top of his speed. I need not mention the universally known fact, that no diabolical power can pursue you beyond the middle of a running stream. Lucky it was for the poor farmer that the river Doon was so near, for notwithstanding the speed of his horse, which was a good one, against all odds he reached the middle of the arch of the bridge, and consequently the middle of the stream. The pursuing, vengeful hags were so close at his heels, that one of them actually sprung to seize him: but it was too late; nothing was on her side of the stream but the horse's tail, which immediately gave way to her infernal grip, as if blasted by a stroke of lightning; but the farmer was beyond her reach. However, the unsightly tailless condition of the vigorous steed was to the last hours of the noble creature's life, an awful warning to the Carrick farmers, not to stay too late in Ayr markets.

'Tam O' Shanter' was not a work designed to strike fear in to folks' hearts; the intention was not that it should be read from a pulpit as a dire warning against the dark arts. The world was by that point a bit more rational and considerably less superstitious. 'Tam O' Shanter' is a wild bawdy tale at home in a tavern with a whisky or three and a warm fire roaring in the hearth. In good company witches were highly entertaining but on a lonely dark road they might still be lurking behind gnarled trees.

The lower class in general were strongly tainted with superstitious sentiments and opinions, which had been transmitted... from one generation to another by tradition. They firmly believed in ghosts, hobgoblins, fairies, elves, witches and wizards. These ghosts and spirits often appeared to them at night. They used many charms and incantations to preserve themselves, their cattle and houses from the malevolence of witches, wizards and evil spirits, and believed in the beneficial effects of these charms... They frequently saw the Devil, who made wicked attacks

upon them when they were engaged in religious exercises... They fixed branches of mountain ash or narrow leaved service-tree above the stakes of their cattle, to preserve them from the evil effect of elves and witches. All these superstitious opinions... which they firmly believed... are of late years almost obliterated among the present generation.
[1]

Though witches may not have been a constant fear there were certain nights when they were thought to be most active. Chief among these was All Hallows' Eve. That night, more than any other, was haunted by clouds of black clad witches flying like a murder of crows to their appointed gatherings. No one was safe on the open road that night as the Hallowmas Rade went by.

Hallowmass Rade, the name given to a general assembly of warlocks and witches, formerly believed by the vulgar to have been held at this season... The term Rade evidently refers to their riding by virtue of their enchantments to these meetings. It is borrowed from a military expedition.
[1]

Flyting betwixt Montgomery and Polwart

In the hinder end of haruest, on Allhallow euen,
...
The Weird Sisters wandring, as they were wont then,
(leave the child lying by a dyke).
Then a cleir companie came soone after closse,
Nicneven with her nymphes, in number anew,
With charmes from Caitness and Chanrie of Rosse,
Whose cunning consists in casting of a clew;
Thir venerable virgines whom the world call witches,
Some backward raid on brod sows, and some on black bitches;
With their mouthes to the moone, murgeons they maid.
Some, be force, the four windes fetches;
And nyne times, withershins, about the thorne raid.
Be ane after mid-night their office was ended:
At that tyd was na time for trumpers to tarie.
[8]

This 'Flyting', already quoted in relation to the faery folk, was a form of literary duel. Alex Montgomery, the Scottish poet depicts Polwart, another poet, as being born on Halloween and attended by troops of faeries and witches. Flyting was the literary equivalent of 'your mamma...' with two opponents writing florid insults back and forth, heaping on more ridiculous and lurid details with every verse.

Away from the literary elite the Hallowmass Rade was a matter to be taken much more seriously.

above:
Vintage Halloween card.

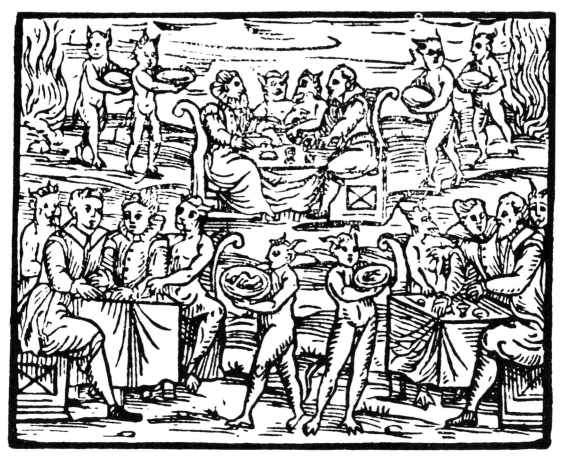

Trystes, where the whole warlocks and witches of a country were assembled, are yet remembered among the peasantry with terror; they were wont to date their age from them; thus - 'I was christened o' the Sunday after Tibbie Fleucher's Hallowmass rade.' Apart from these general meetings, or 'Hallowmass Rades', as they are yet called, there were trystes of friendly converse and of consultation, held between a few of the presiding carlins, where the private emoluments of the parties, or the revenge offered them, was amply discussed.
[9]

Throughout Scotland the witches flew and met on every weird and haunted hill.

These Hallowmass Raides, annual procession of witches, held a noted tryste at Lochenbrigg hill, in the Stewartry of Nithsdale, 5 miles N.E. of Dumfries, at Hallowe'en. Their principal steeds were broomsticks, thrice warped in the ween' (wind), virl'd wi' a dead man's banes, their chariots were of hemlock, the saddle-laps of the scalps of unchristened bairnes. The bridle-reins were tassels of the moon, and their stirrup-irons the collar-bones of a she-wolf, 'worried i' the birth'; the bridle-bits were forged by Satan and had power over any living thing. The 'weird coat' was woven from skins of shelly-cows (monsters, half fish, half cow).
[1]

With time and technology the fear of witches dwindled away but the tales and songs lived on and were passed on through families till eccentric country Reverends and folklore collectors began to wander into cottages and blackhouses and finally wrote down the stories of witches and their exploits at Halloween. We'll leave the weird sisters with this enchanting little tale, which conjures a strange image of the Devil that Kings and Clergy had so long feared.

In Clackmannan, on the confines of the parish of Dollar, lies a glen called Burngrens. In this glen there is a large stone shaped like a cradle. It is believed in the neighbourhood that the stone, every Hallowe'en night, is raised from its place and suspended in the air by an unseen power, while 'Old Sandy', snugly seated upon it, is swung backwards and forwards by his followers, the witches, until daylight warns them to decamp.
[1]

Notes

[1] British Calendar Customs: Scotland

[2] Scotland: The Ancient Kingdom
 Donald A. Mackenzie, Blackie, 1930

[3] 'Alp' Volkssagen aus dem Lande Baden und den angrenzenden Gegenden, Bernhard Baader,
 Karlsruhe: Verlag der Herder'schen Buchhandlung, 1851

[4] Discoverie of Witchcraft
 Reginald Scot, 1584

[5] Popular Superstitions and festive amusements of the Highlanders of Scotland
 William Grant Stewart, Edinburgh, 1823

[6] Strange Britain
 Charles Walker, Brian Trodd Publishing House ltd, 1989

[7] Historie of Scotland
 Holinshed

[8] Flyting betwixt Montgomery and Polwart
 Scottish Text Society

[9] Remains of Nithsdale and Galloway Song
 R.H. Cromek, 1810

opposite:
The Witches' Well
Bronze fountain,
Castlehill, Edinburgh.

(image © Mark Oxbrow)

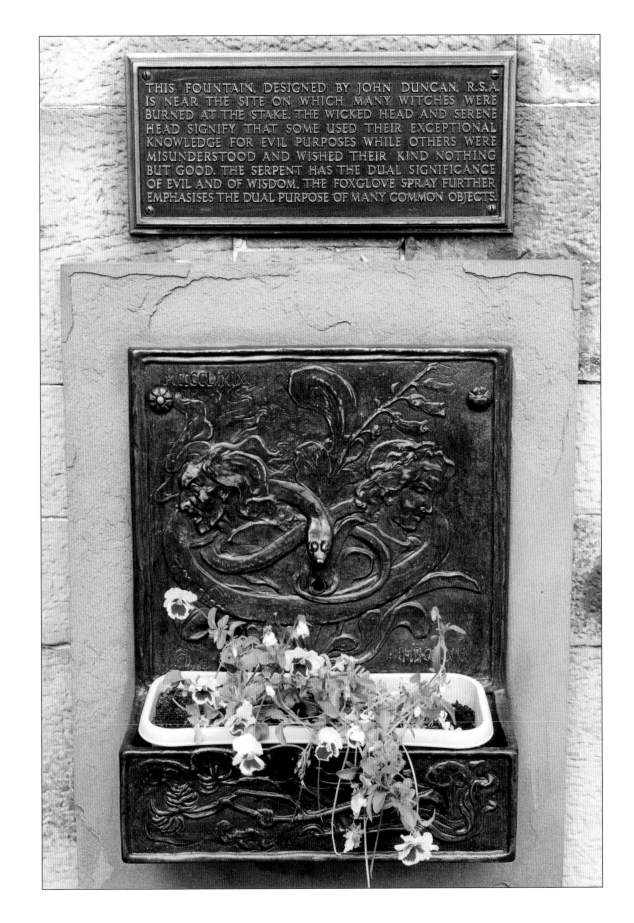

THIS FOUNTAIN, DESIGNED BY JOHN DUNCAN, R.S.A. IS NEAR THE SITE ON WHICH MANY WITCHES WERE BURNED AT THE STAKE. THE WICKED HEAD AND SERENE HEAD SIGNIFY THAT SOME USED THEIR EXCEPTIONAL KNOWLEDGE FOR EVIL PURPOSES WHILE OTHERS WERE MISUNDERSTOOD AND WISHED THEIR KIND NOTHING BUT GOOD. THE SERPENT HAS THE DUAL SIGNIFICANCE OF EVIL AND OF WISDOM. THE FOXGLOVE SPRAY FURTHER EMPHASISES THE DUAL PURPOSE OF MANY COMMON OBJECTS.

left: **Doon Hill**. The Faery Hill at Aberfoyle where the Reverend Robert Kirk is said to still dwell, ministering to a faery congregation.

above: Today the trees at the top of the hill are hung with ribbons and little messages from children asking the faeries to look after the spirits of their deceased pets.

(images © Mark Oxbrow)

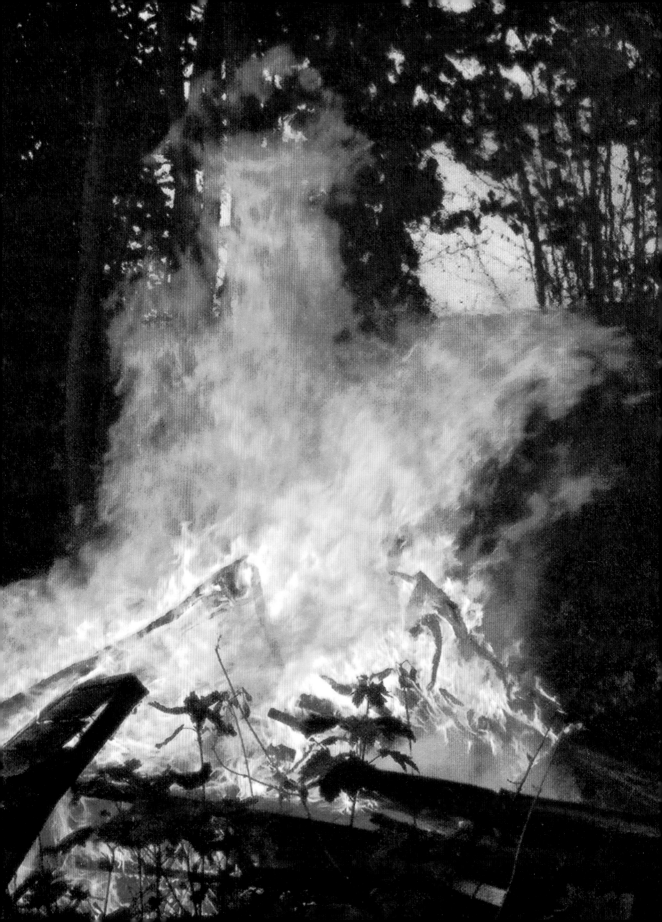

the hallowmas fire

Brave bonefire, burn á,
Keep the fairies á awá.

There is nothing quite as satisfying as gathering together a vast pyre of fallen wood, setting it alight, and watching it burn. One year in Edinburgh the task of organising the Beltane bonfire fell to me. It had been a stormy April and many old trees had lost huge branches to the strong winds. We piled a trailer high with wood from the Inverleith sawmill, where the city's dead wood is taken, and started to build the bonfire. That year we were also given a rather special piece of firewood: a rowan, most magical of trees, had come down and was chopped up and waiting for us. Whole branches of it still bore green leaves and we stacked then high on the top of the pyre. That night the May Queen circled the pyre and lit the fire. In a short while the bonfire raged and flames leapt into the night sky. It crackled like firecrackers and a million tiny sparks were caught by the wind. That year the fire smelt sweet and rich - magic wafted and danced in the smoke.

A relic of superstition also existed in this district in the person of an old Highland dame, who used to burn rowan-tree branches in front of her house every Hallowe'en night to keep the witches away.
[1]

While we were at Mrs. Grant's we saw the common cement of the keeping of Hallowe'en. All the children came out with burning torches, shouting and jumping The protestants generally keep Hallowe'en on the old day, November 12, and the Catholics, on this day; but hearing I had wished to see it two years ago, they all decided to keep it to-day.

We went upstairs to look at it from the windows, from whence it had a very pretty effect. When we drove home we saw all the gillies coming along with burning torches, and torches and bonfires appeared also on the opposite side of the water.
Hallowe'en, October 31st 1866-7
[Queen Victoria - 'Leaves from the Journal of our Life in the Highlands' 1868]
[2]

opposite:
Brave bonfire

(image © Deborah Bacci)

Across the Highlands of Scotland huge bonfires were kindled at Halloween. This was not a grim reminder of dead friends or a harsh winter to come but a vibrant carnival affair – a community celebrating with music, dancing, drinking and more drinking.

...a glamour of mystery and awe has always clung to Hallowe'en in the minds of the Celtic peasantry, the popular celebration of the festival has been, at least in modern times, by no means of a prevailingly gloomy cast; on the contrary it has been attended by picturesque features and merry pastimes, which rendered it the gayest night of all the year. Amongst the things which in the Highlands of Scotland contributed to invest the festival with a romantic beauty were the bonfires which used to blaze at frequent intervals on the heights." On the last day of autumn children gathered ferns, tar-barrels, the long thin stalks called 'gàinisg,' and everything suitable for a bonfire. These were placed in a heap on some eminence near the house, and in the evening set fire to. The fires were called 'Samhnagan.' There was one for each house, and it was every child's ambition to have the biggest. Whole districts were brilliant with bonfires, and their glare across a Highland loch, and from many eminences, formed an exceedingly picturesque scene.
[3]

But let us begin with the smaller fires that filled Halloween night: the fire torches. You might be surprised how warm a large chunk of wood with some burning hessian at one end can keep you. Even painted red in only a wee loincloth you still feel quite cosy with a blazing fire torch on a chill night. These little fires served a magical as well as a practical function: their circling flames protected fields and homes for the coming winter.

On the evening of the 31st of October, among many others, one remarkable enough ceremony is observed. Heath, broom, and dressings of flax, are tied upon a pole. This faggot is then kindled; one takes it upon his shoulders, and running, bears it round the village; a crowd collecting where the first faggot is hurled out, a second is bound to the pole, and kindled in the same manner as before. Numbers of these blazing faggots are often carried about together... This is Halloween, and is a night of great festivity.

Hallow Eve is kept sacred; as soon as it is dark, a person sets fire to a bush of broom fastened round a pole, and, attended with a crowd, runs round the village. He then flings it down, keeps a great quantity of combustible matters in it, and makes a great bonfire. A whole tract is thus illuminated at the same time...

The... solemnity of kindling fires near their corn fields and walking round them with burning torches was kept on the eve of the first of November as a thanksgiving for the safe ingathering of the produce of the fields.

Another custom in which boys indulged themselves on Hallowe'en night was to go about in companies with lighted torches. These torches were made of a kind of long coarse grass, which they gathered in autumn and dried for the occasion.
[4]

As you can see, all manner of combustibles were used and torches were usually brought by folk to a communal bonfire to light it en masse.

Before Halloweven torches and bonefires [sic] were made ready. The torches went by the name of 'sowmacks'. They were made of pieces of split bog-fir, tied together with 'streh-rapes' (straw ropes), with one end small by which to carry them. They were of various lengths, reaching up to seven feet, according to the age and strength of the one that carried. Each member of the household had one and took part in the ceremony. About 'sky-set' all the members of the household set out, carrying each a 'sowmack', to the farthest corner of arable land on the farm. On reaching that point the torches were lighted from a live 'peat coal' that had been taken from the hearth; tightly wrapped up in straw-rope to prevent the ingress of air, and carried by one of the family. When the torches were all kindled the processionists started and went round all the tilled land. After the procession was finished, all went to the bonefire which, if possible, was on a knoll or high spot, and threw the blazing remains of the 'sowmacks' on it to kindle it, shouting:

> *Brave bonefire, burn a',*
> *Keep the fairies a' awa'.*

They then joined hands and danced round the burning pile.

 The torches carried sunwise. Perhaps there is no part of the Highlands of Scotland where the practice of using the flaming torches of Halloween is so much observed, even still, as in the braes of Aberdeenshire. Not later than last year, our Gracious Majesty, no doubt in order to preserve those relics of ancient times, caused these blazing torches to be kindled by the youth of the place, around Balmoral Castle. The torches are considered by the natives to be the means of protecting, not only their farms and other possessions from the ravages of the fairies, but likewise mothers and newly born infants. While the landed possessions were duly surrounded that evening by the torch-bearers, the dwellings where children had been born were encompassed with still greater care, for the safety of the mothers and their young offspring, which the fairies were on the watch to snatch away. The torch-bearers used great care in carrying their fire in the right-hand, and therewith running around their premises from right to left, thus observing the 'Deas-iuil' [deiseal], or the right-hand direction. The 'Tuath-iuil' [tuathal], being the left-hand, or wrong direction, would render their precautions entirely abortive. In this manner they protected their properties, and prevented the fairy thieves from snatching away the unbaptized infants from their mothers' bed, placing in their room their own ugly and deformed children. Martin, in his History of the Western Isles, informs us, 'That this was considered an effectual means to preserve both the mother and infant from the power of evil spirits, who are ready at such times to do mischief, and sometimes carry away the infants and return poor, meagre skeletons; and these infants have voracious appetites.
[4]

These firelight wanderings could be many hundreds strong or a small family custom.

above:
Vintage Halloween card.

Fifty years ago the Braemar Highlanders made the circuit of their fields with lighted torches at Hallowe'en to ensure their fertility in the coming year. At that date the custom was as follows: Every member of the family... was provided with a bundle of fir 'can'les' with which to go the round. The father and mother stood at the hearth and lit the splints in the peat fire, which they passed to the children and servants, who trooped out one after the other, and proceeded to tread the bounds of their property, going slowly round at equal distances apart, and invariably with the sun. When the fields had thus been circumambulated the remaining spills were thrown in a heap and allowed to burn out. In this way the 'faulds' were purged of evil spirits.
[4]

Boys 'ding' either side of the road, from one side to the other, quite systematically, carrying not faggots, but blazing rolls of rag which have been dipped in paraffin and bound on a piece of wire from ten to fifteen feet in length.

'It is great fun for the performers,' writes a friend of the present writer who witnessed it in 1932, ' but less so for the onlookers, as when the whirling mass hits the ground it throws off more than sparks. But no one interferes with the bounds-to-bounds fire, however dangerous it may appear. A huge bonfire goes on at the same time, and the blackening of faces - the blacker the better.
[5]

The burning of a sacred bonfire is an ancient tradition. Fire is a sacred thing. It fascinates and bewitches as it dances, seemingly alive. It breathes and eats, grows from a mere spark to a vast inferno. It moves, consuming as it goes, seeking fresh fuel. Fire can warm and nurture, cook our raw food and keep us comfortable on a cold night but it can also break loose and destroy: burning forests and cities to the ground. Fire is in essence a living entity and as all living things it eventually dies leaving nothing but ashes in its wake.

It is thought that the lighting of sacred fires is a tradition that stretches back to the Druids. Having said that there was a time when Stonehenge was said to belong to the mystical orders of Druids as well. It appears sometimes that anything that is very old and has lost its origins is said to be Druidical - whether it is far older or far younger than that priesthood.

The only other season noted for superstitious observances is that of Hallowe'en. Hallowe'en in Gaelic means "Samhuinn," that is "Samhtheine," the fire of peace. It is a Druidical festival, at which the fire of peace was regularly kindled. There is no night in the year which the popular imagination has stamped with a more peculiar character than Hallowe'en. It was the night, above all others, when supernatural influences prevailed. It was the night for the universal walking abroad of all sorts of spirits, fairies, and ghosts, all of whom had liberty on that night. It was customary in many parts of Scotland to have hundreds of torches prepared in each district for weeks before Hallowe'en, so that, after sunset on that evening, every youth able to carry a blazing torch, or "samhnag," ran forth to surround the

above:
Vintage Halloween
card.

boundaries of their farms with these burning lights, and thereby protect all their possessions from the fairies. Having thus secured themselves by these fires of peace, all the households congregated to practice the various ceremonies and superstitious rites of that eventful evening.
[6]

The image of our archetypal Druid - all long white robes and beard with a golden sickle and some nice sandals - standing about selling bits of fire on sticks is pretty surreal. Please note that Druids weren't really like this...

When the first night of winter came, the people would gather fuel and make blazing fires for to keep away the witches, or at least to deprive them of the power of taking away the produce of the farm, and they would go to the Druid and buy a kindling of what was called the holy fire.
[7]

This 'holy fire' was the 'need fire' - 'neid fire' - 'Tein'eigin'. The idea was that all fires were extinguished and a brand new fire had to be kindled from scratch without the aid of flints or matches.

All household fires to be extinguished and relighted on Hallowmas morning from ritual or, at the first, neid fire (Tein'eigin). These sacred fires were commonly lighted on cairns and none could obtain fresh kindling whose dues were unpaid or who had been disturbers of the peace.
[8]

Lucifer matches are used only by the minister and there is no flint or steel on the island.
[4]

To extinguish all fires was an important event. Fires were not just allowed to go out at night to be relit in the morning - they were kept alight continually.

In one of the islands of St Kilda... turf fires are always kept burning, if one happens to go out a live turf is borrowed from a neighbour. The fires of St Kilda have probably been burning for centuries. [This rule of lighting would of course apply also to the Hallowtide fire.]
[4]

So, armed only with pointy sticks and pieces of wood you have to create a forced fire with friction alone. At the Crannog centre on Loch Tay I got to have a go at this. They have a notched baseboard and a pointed stick that you turn with a bow. You drag the bow sting back and forth spinning the stick and a little twist of smoke rises from the point of friction. A tiny pile of black burnt ash forms and with a bit of luck you find a minute smouldering ember in the heart of the ashes. They found that dried out fungi made the best dry kindling to get a flame alive. We have descriptions of vast numbers

of men gathering to turn poles the size of tree trunks but with some practice anyone could master this skill.

Sir James Frazer had rather a lot to say about need fires.

The Need-fire, - The fire-festivals hitherto described are all celebrated periodically at certain stated times of the year. But besides these regularly recurring celebrations the peasants in many parts of Europe have been wont from time immemorial to resort to a ritual of fire at irregular intervals in seasons of distress and calamity...

...they may perhaps be regarded as the source and origin of all the other fire-festivals; certainly they must date from a very remote antiquity. The general name by which they are known among the Teutonic peoples is need-fire. Sometimes the need-fire was known as "wild fire," to distinguish it no doubt from the tame fire produced by more ordinary methods. Among Slavonic peoples it is called "living fire."

The history of the custom can be traced from the early Middle Ages, when it was denounced by the Church as a heathen superstition, down to the first half of the nineteenth century, when it was still occasionally practised in various parts of Germany, England, Scotland, and Ireland. ...In some parts of the Highlands of Scotland the rule was that all householders who dwelt within the two nearest running streams should put out their lights and fires on the day appointed. ...In the Highlands of Scotland the proper places for performing the rite seem to have been knolls or small islands in rivers.

The regular method of producing the need-fire was by the friction of two pieces of wood; it might not be struck by flint and steel. ... Where the wood to be employed is specified, it is generally said to be oak; but on the Lower Rhine the fire was kindled by the friction of oak-wood or fir-wood. In Slavonic countries we hear of poplar, pear, and cornel wood being used for the purpose. Often the material is simply described as two pieces of dry wood. Sometimes nine different kinds of wood were deemed necessary, but rather perhaps to be burned in the bonfire than to be rubbed together for the production of the need-fire.

The particular mode of kindling the need-fire varied in different districts; a very common one was this. Two poles were driven into the ground about a foot and a half from each other. Each pole had in the side facing the other a socket into which a smooth cross-piece or roller was fitted. The sockets were stuffed with linen, and the two ends of the roller were rammed tightly into the sockets. To make it more inflammable the roller was often coated with tar. A rope was then wound round the roller, and the free ends at both sides were gripped by two or more persons, who by pulling the rope to and fro caused the roller to revolve rapidly, till through the friction the linen in the sockets took fire. The sparks were immediately caught in tow or oakum and waved about in a circle until they burst into a bright glow, when straw was applied to it, and the blazing straw to kindle the fuel that had been stacked to make the bonfire.

Often a wheel, sometimes a cart-wheel or even a spinning-wheel, formed part of the mechanism; in Aberdeenshire it was called "the muckle wheel"; in the

island of Mull the wheel was turned from east to west over nine spindles of oak-wood. Sometimes we are merely told that two wooden planks were rubbed together. Sometimes it was prescribed that the cart-wheel used for fire-making and the axle on which it turned should both be new. Similarly it was said that the rope which turned the roller should be new; if possible it should be woven of strands taken from a gallows rope with which people had been hanged, but this was a counsel of perfection rather than a strict necessity.

Various rules were also laid down as to the kind of persons who might or should make the need-fire. ...In the western islands of Scotland the fire was kindled by eighty-one married men, who rubbed two great planks against each other, working in relays of nine; in North Uist the nine times nine who made the fire were all first-begotten sons, but we are not told whether they were married or single.
[3]

They had made a fire... Which from the feast was called Samh-nag or Savnag. Around it was placed a circle of stones, one for each person of the families to whom they belonged. And when it grew dark the bonfire was kindled, at which a loud shout was set up. Then each person taking a torch of ferns or sticks in his hand, ran round the fire exulting; and sometimes they went into the adjacent fields where, if there was another company, they visited the bonfire, taunting the other if inferior in any respect to themselves. After the fire was burned out they returned home, where a feast was prepared, and the remainder of the evening was spent in mirth and diversion of various kinds. Next morning they repaired betimes to the bonfire, where the situation of the stones was examined with much attention. If any of them were displaced, or if the print of a foot could be discerned near any particular stone, it was imagined that the person for which it was set would not live out the year. Of late years this is less attended to, but about the beginning of the present century it was regarded as a sure prediction. The Hallowe'en fire is still kept up in some parts of the Low Country; but on the western coasts and in the Isles it is never kindled, though the night is spent in merriment and entertainments.
[9]

In the Isle of Man also, another Celtic country, Hallowe'en was celebrated down to modern times by the kindling of fires, accompanied with all the usual ceremonies designed to prevent the baneful influence of fairies and witches.
[3]

These fires lit up glens and mountains across the Highlands.

Sheriff Barclay tells us that, while travelling from Dunkeld to Aberfeldy, about seventy years ago, he saw thirty fires blazing on the hill-tops, each having a ring of people dancing round it.

Hallow Fires are still kindled on the Eve of All Saints by the inhabitants of Buchan, and present a singular and animated spectacle, from sixty to eighty being frequently seen from one point.
[4]

Once you have a raging bonfire to keep the chill night air at bay and illuminate your gathering you can get down to the serious business of enjoying yourself.

One after another of the youths laid himself down on the ground as near to the fire as possible so as not to be burned, and in such a position as to let the smoke roll over him. The others ran through the smoke, and jumped over him.
[10]

After making the round of the village (as guisers), the lads climbed a hill near, called in English, Stormy Hill, and there they lit a bonfire. For weeks before, they collect materials for this fire, here again exercising great licence, taking barrels, and even doors, wheelbarrows or carts. No one's coal cellar is safe. After the fire is lit and burning well, the lads run round and leap through it, doing this until all has been burnt away.

A native of the parish of Fortingall, Pth., who is almost seventy years of age, says that the Bonfire was a prominent part of Hallowe'en amusements in his young days, and that part of the performance consisted in rushing through the ashes, as soon as that became possible by the subsidence of the flames. He says he has done it himself often.

The young people gathered in large companies, and, having prepared a very large bannock, they took it with them to a place where they made a bonfire, and when they got the bonfire ablaze they ate their bannock and danced round the fire. The reciter says she has herself engaged in this custom.
[4]

Not content with eating bannocks and risking life and limb leaping the flames folk also used the bonfires for divination.

The day before Hallowe'en the young women of the place collected material for a bonfire which they piled up in a quiet spot and waited till night came. They then gathered at the spot, each provided with a nice round stone, which they marked, then placed them in the firewood and set fire to the whole, each taking care that her stone was in the full heat. When all was well alight they went home leaving it to burn out. Early next morning each examined her stone to see if it was without a crack, if so, the one it represented would live another year, if it was cracked she would die before the year was out. It is true that one woman who tried this and found her stone imperfect did die within the year
[4]

In the northern part of Wales it used to be customary for every family to make a great bonfire called Coel Coeth on Hallowe'en. The fire was kindled on the most conspicuous spot near the house; and when it had nearly gone out every one threw into the ashes a white stone, which he had first marked. Then having said their prayers round the fire, they went to bed. Next morning, as soon as they were up, they came to search out the stones, and if any one of them was found to be missing, they had a notion that the person who threw it would die before he saw another Hallowe'en.

above:
Vintage Halloween card.

*According to Sir John Rhys, the habit of celebrating Hallowe'en by
lighting bonfires on the hills is perhaps not yet extinct in Wales, and men still living
can remember how the people who assisted at the bonfires would wait till the last
spark was out and then would suddenly take to their heels, shouting at the top of
their voices, "The cropped black sow seize the hindmost! " The saying, as Sir John
Rhys justly remarks, implies that originally one of the company became a victim
in dead earnest. Down to the present time the saying is current in Carnarvon-
shire, where allusions to the cutty black sow are still occasionally made to frighten
children...*
[3]

Just because you had spent most of the last few days building a dirty great big bonfire
and you'd carried your fire torches and set the whole thing ablaze it didn't mean your
creation was going to survive for long.

*The old observance of Hallowe'en, kindling a fire on some conspicuous place... the
destroying of such fires by bands of boys was often a hazardous undertaking. The
method of attack was by approaching the opposite fire stealthily armed with sticks
and caps or bonnets filled with stones; a rush was made on the weakest point... and
on the dispersal of the attacked party, the fire was destroyed and the victors fixed
burning peats on pointed sticks and returned home in triumph to their own ground.
A return visit was seldom made. In small towns and villages the material for the
Hallowe'en fire was begged from door to door.*

*The Hallowe'en fire... was kindled in Buchan. Various magic ceremonies
were then celebrated to counteract the influence of witches and demons, and to
prognosticate to the young their success or disappointment in the matrimonial
lottery. These being devoutly finished, the Hallow fire was kindled, and guarded by
the male part of the family. Societies were formed, either by pique or humour, to
scatter certain fires, and the attack and defence were often conducted with art and
with fury... But now the Hallow fire, when kindled, is attended by children only.*
[4]

Building the bonfire was often the job of boys and the fires became a custom
associated with children.

*At Hallowe'en each house has a bonfire. They do not dance round the fires. The
custom is chiefly observed by children. The fires are lighted on any high knoll near
the house.*
[4]

*On the last day of autumn children gathered ferns, tar-barrels, the long thin stalks
called gainisg [gainnisg], and everything suitable for a bonfire. These were placed
in a heap on some eminence near the house and in the evening set fire to. The fires
were called samhnagan. There was one for each house and it was an object of
ambition who should have the biggest.*
[11]

Sept. 1826. The river White Cart, on which Paisley stands... is often remarkably shallow at low water. This is especially the case between the highest and the lowest of three stone bridges, by which the old town or burgh is connected with the new town. In this shallow part of the stream, parties of boys construct, on Hallow-eve... circular raised hearths, if I may so term them, of earth or clay; bordered by a low round wall composed of loose stones, sods, &.c. Within these enclosures, the boys kindle on their hearths, bonfires, often of considerable size. From the bridges, the appearance of these bonfires, after nightfall, is singular... The number and glare of the fires, their tremulous reflection in the surrounding water, the dark moving figures of the boys that group around them, and the shouts and screams set up by the youthful urchins in testimony of enjoyment, might almost make one fancy that the rites and incantations of magic, or of wizardry, were taking place before one's very eyes.

In 1860 I was residing near the head of Loch Tay during the season of the Hallowe'en feast. For several days before Hallowe'en, boys and youths collected wood and conveyed it to the most prominent places on the hillsides in their neighbourhood. Some of the heaps were as large as a corn-stack or hay-rick. After dark on Hallowe'en, these heaps were kindled, and for several hours both sides of Loch Tay were illuminated as far as the eye could see. I was told by old men that at the beginning of this century men as well as boys took part in getting up the bonfires, and that, when the fire was ablaze, all joined hands and danced round the fire and made a great noise; but as these gatherings generally ended in drunkenness and rough and dangerous fun, the ministers set their faces against the observance, and were seconded in their efforts by the more intelligent and well-behaved in the community; and so the practice was discontinued by adults and relegated to schoolboys.
[4]

As is often the case, when too many people are having too much fun, someone tends to decide that this is a bad thing and should be snuffed out.

The Hallowe'en blaze or bleese, Gael. samhnag, was seen burning in almost every part of Scotland. From the end of the 17th century many attempts were made to suppress these 'superstitious' fires, but they were continued in some places for two hundred years.

The practice of lighting bonfires (on cairns) on the first night of winter, accompanied with various ceremonies, still prevails in this and the neighbouring Highland parishes.
[4]

Attempts to stop the fires were pretty unsuccessful and then Queen Victoria's participation gave the proceedings an air of respectability.

On the same day the following year, viz., Thursday, October 31st 1867, we had an opportunity of again seeing the celebration of Hallowe'en, and even of taking part in it. We had been out driving, but we hurried back to be in time for the celebration.

Close to Donald Stewart's house we were met by two gillies bearing torches. Louise got out and took one, walking by the side of the carriage, and looking like one of the witches in Macbeth. As we approached Balmoral, the keepers and their wives and children, the gillies and other people met us, all with torches; Brown also carrying one. We got out at the house, where Leopold joined us, and a torch was given to him. We walked round the whole house, preceded by Ross playing the pipes, going down the steps of the terrace. Louise and Leopold went first, then came Janie Ely and I, followed by everyone carrying torches, which had a very pretty effect. After this a bonfire was made of all the torches, close to the house, and they danced reels whilst Ross played the pipes.
[Queen Victoria - 'Leaves from the Journal of our Life in the Highlands' 1868]
[2]

Victoria's beloved husband had died in 1861, just a few short years before. She found solace at her Highland estate and spent many happy holidays at Balmoral. The now famous gillie John Brown had, in 1865, been promoted to an upper servant and was the Queen's personal attendant. Victoria's Highland Journals were published in 1867 entitled 'Leaves from the Journal of our Life in the Highlands' (known simply as 'Leaves') in a limited print run for private circulation only. The following year a public edition was printed and the title became an immediate bestseller. The Highlands became a fashionable and romantic holiday destination and there was a newfound interest in all things Scottish. In time the princess Louise, here brandishing a fire torch and looking like one of Macbeth's witches, was married to 'Macduff', sixth Earl of Fife, whose family had been former owners of Balmoral. It was said that the match delighted The Queen.

During Her Majesty's long sojourn in the autumn of each year, there was observed in Crathie, at Hallowmas, the ancient practice of burning the witch. The ceremony began with the building of a huge bonfire in front of the castle just opposite the principal doorway. On Hallowe'en there was a mustering of the clansmen, who met, dressed in the Highland costume, at the upper end of the West Avenue, and, on a signal given by the firing of a gun, headed by a band, began to march towards the palace. At the salute, the bonfire was lit so as to be in full blaze when the procession reached the castle door. The interest of the promenade was centred in a trolly, on which there sat the effigy of a hideous old woman or witch, called the Shandy Dann. Beside her crouched one of the party, holding her erect, while the march went forward to the bagpipe's strain. As the building came in sight, the pace was quickened to a run, then a sudden halt was made a dozen yards or so from the blaze. Here amid breathless silence, an indictment is read why this witch should be burned to ashes, and with no one to appear on her behalf - only this advocatus Diaboli, paper in hand, she is condemned to the flames. With a rush and a shout, and 'skirling' of bagpipes, the sledge and its occupant are hurled topsy-turvy into the fire, while the mountaineer springs from the car at the latest safe instant. Then follow cheers and hoots of derisive laughter as the in-flammable wrappings of the Shandy Dann crackle and sputter out. All the while the residents of the castle stand on the perron enjoying the curious rite, and no one there entered more heartily into

it than the head of the empire herself.
[M. 'who has witnessed it a score of times - a native and tenant of the royal property for all but the last ten years of the Queen's occupation.']
[12]

As the night wore on the fire burned down and on the wee small hours the dull glow of the dying pyre faded to nothing. All that remained was for the ashes to be spread.

The ashes were scattered as far as possible. In north-eastern districts the ashes of the Hallowe'en bonfires were scattered, all who took part in kindling them vying with each other who should spread abroad the greatest quantity.

When the heap was burned down, the ashes were scattered. Each one took a share in this part of the ceremony, giving a kick first with the right foot, and then with the left; and each vied with the other who should scatter the greatest quantity. When the ashes were scattered, some still continued to run through them, and to throw the half-burned peats at each other, and at times with no small danger.

At each farm, as high a spot as possible, not too near the steading, was chosen for the fire. Much the same process was gone through as with the villagers' fire. The youths of one farm, when their own fire was burned down, and the ashes of it scattered, sometimes went to the neighbouring fire, and lent a hand in the scattering of its ashes.
[4]

This seems like a fine place to say a few words regarding the theory of the 'Celtic Fire Festivals.' These days when a large group of folk are gathering at night we tend to illuminate them with the aid of floodlighting or numerous streetlights. Being able to see where you are going and where you are stops you bumping into other folk and tripping over things in the dark. If you've ever camped out in the woods then you'll probably know the value of a decent torch with fully charged batteries. These wholly practical considerations were just as important in previous centuries. Stumbling up a wet hillside in the pitch dark, trying to avoid rocks and rabbit holes, was no fun without the aid of a fire torch to light your way. Equally bad is the prospect of standing about on a rainy windswept hilltop for hours without a great big burning bonfire to keep out the cold and light up the night.

Past writers have developed the notion that there were a series of festivals of Celtic origin that neatly divided the year and formed their ancient seasonal calendar. This Celtic year was thought to consist of the four 'great Celtic Fire festivals': Samhain, Imbolc, Beltane and Lughnasadh. At the end of summer was Samhain and at the end of winter came Beltane. These two nights split the year into two equal halves with the other two festivals fitting snugly at the mid points between them. Thus the 'quarter-days' of a four fold year.

The importance of the quarter-days in medieval Irish literature was noticed in the first systematic treatment of those texts, such as the works of Charles Vallancey in the eighteenth century. By the second half of the nineteenth, it had become assumed

by English folklorists that they were observed in ancient Britain as well. One of these writers, Charles Hardwick, either borrowed, or made himself, a misreading of the description of the fire rite of Beltane in 'Sanas Chormaic' which caused him to believe that it was carried out at all four feasts. From this error sprang the characterization of them as 'the fire festivals', which was never taken into academe but has persisted in popular works to the present day.
[14]

Simple ideas about the past are often appealing. It's nice and easy to think of the Celts as a jolly bunch of savages meeting up four times a year to light raging bonfires and drink in the new season. It is simpler to take a custom from one region and apply it to a whole country or a whole culture. The past was, however, just as complicated and diverse as the present. It refuses to be neatly pigeonholed and described in sound bites.

The concept of these Celtic fire festivals has made its way into the works of modern popular academics as well as the mountain of Celtic new age, Druid and wiccan publications. To these four festivals have been added four more. The spring and autumn (fall) equinoxes and the summer and winter solstices. These four interlopers also fit beautifully in between the original festivals to create the popular 'eight-fold year'. As the foundation for the modern pagan religious movements this is an elegant and attractive system of celebrations. A chance for groups to come together and bond eight times a year. Each festival is endowed with its own meanings and stories and has different ritual elements. As the basis of a modern pagan calendar this works beautifully but to claim this is an ancient authentic Celtic calendar of fire festivals is, to be blunt, nonsense. Sorry to sound so harsh but I believe it is better to be accurate and honest.

Modern paganism should be unapologetically modern without reliance of pseudo-ancient 'knowledge' to lend it authenticity. It may be growing like a tiny acorn from an ancient oak but it is a vibrant new tree in its own right that does not need to point to the imagined roots of its ancestor to thrive and grow.

above:
Halloween Bonfire

Notes

[1] The Weekly Scotsman
 T. A. Carlton, 3rd September 1898

[2] Queen Victoria's Highland Journals
 Edited by David Duff, Exeter Webb & Bower 1980

[3] The Golden Bough 'The Hallowe'en Fires'
 Sir James Frazer

[4] British Calendar Customs: Scotland

[5] The Silver Bough
 F. Marian McNeill

[6] Highland Superstitions
 The Rev. Alexander MacGregor, M.A.

[7] Popular Tales of the West Highlands
 Letter from J. Dewar quoted by J. F. Campbell 1895

[8] Celtic Mythology and Religion
 Alexander MacBain, Inverness, 1885

[9] Scotland and Scotsmen in the Eighteenth Century
 John Ramsay of Ochtertyre - Alexander Allardyce, ed. 1888

[10] Notes on the Folk-Lore of the North-East of Scotland
 Walter Gregor, Folk-Lore Society, 1881

[11] Witchcraft and the Second Sight in the Highlands and Islands of Scotland
 John Gregorson Campbell. 1902

[12] Scottish Notes and Queries
 Alexander MacDonald, 2nd Series, III

[13] Chambers' Scots Dialect Dictionary

[14] Stations of the Sun
 Ronald Hutton, Oxford University Press, 1996

Mischief Night

This is Hallowe'en,
An the morn's Hallowday;
Gin ye want a true love,
It's time ye were away.

Tally on the window-brod,
Tally on the green,
Tally on the window-brod,
The morn's Hallowe'en.
[1]

I grew up with old Scots customs. My mother had run a folk music club in the sixties and there was no escaping her enthusiasm for seasonal traditions. When I was little, I didn't go out with a pumpkin Jack O' Lantern and simply say 'Trick or Treat'. The children in Scotland went out guising at Hallowe'en. The day was spent trying to cut the rock hard innards out of a turnip then carving a jagged face on it. I still remember switching the kitchen light out and the satisfaction of seeing the lantern's face lit up by a wee candle. We'd dress up in the best costume we could muster out of old clothes and whatever we could lay our hands on. While you were still getting ready there would be a knock at the door and a motley group of little witches and vampires would sing a wee song or tell a joke or two. There was a big bowl of sweets waiting and everyone got a handful in their bags. Eventually we set out into the chill night to knock on folks' front doors and do our own little performance.

Traditions develop and change with the centuries. America's 'Trick or Treat' grew from the immigrant guising customs of Scotland and Ireland. Scots Hallowe'en guising has its roots in a host of earlier gatherings and folk plays. There in the records of past deeds and misdeeds we can find all the elements that make up modern 'Trick or Treating': This was 'mischief night' - a time when the normal rules don't quite seem to apply - a night when the world was turned upside down and inside out and pranks were played. It was a time to disguise yourself - hide your features and become someone or something else for an evening. The one night where you could take to the streets and knock on doors seeking payment for your performance. Across the land innocent turnips were being sliced and diced and

disembowelled for lanterns. This was Hallowe'en - but where did its customs come from?

Night is the prime time for nefarious activities. Darkness has long been good a friend to highwaymen, smugglers, body snatchers, burglars and illicit lovers. When the sun goes down, it's time to get up to no good. Add into that equation a celebration involving copious amounts of strong alcohol and you have the formula for mischief night.

The Hallows Fair was an important annual feature of the Edinburgh calendar since it was granted a Royal Charter in 1477. Indeed, the direct descendant of these yearly cattle markets is still held out at Gorgie today. But centuries ago the year's largest cattle market was held in the heart of the old town at the Grassmarket. The Grassmarket sat next to the King's stables at the foot of the Castle. It was a large open space surrounded by high tenement houses. Here livestock were driven from across Scotland and over from Ireland along the old drove roads to be sold at the end of summer. The Hallows Fair was a rather lively event. Cattle, horses and sheep shared the space with stalls and stages featuring companies of players and performers. Army recruiters tried to tempt the men into conscripting, fortune-tellers and peddlers plied their trade and gingerbread men sat in rows.

Walter Geikie, the deaf and dumb artist who died in 1837, is another who has depicted the fair. One of his etchings features the gingerbread stall, thronged by eager buyers. The "gingerbread man" was a regular figure at the fair. A writer in 1909 records that some old Edinburgh people could then still remember Robbie Salmond, "the gingerbread weaver of Kirkcaldy," who appeared annually at Hallow Fair and "to encourage his patrons occasionally tossed some gingerbread amongst the crowd, crying Feed the ravens."
[2]

With cattle come cattlemen and the scores of cattlemen had most of their year's earnings in their pockets by the end of the Hallows Fair. Parts of Edinburgh's Old Town had long been dens of vice and iniquity. There were plenty of inns and taverns and after a few jars of ale and a few drams of whisky the cattlemen kept the local brothels busy. Drunken revellers spilled out into the streets and things tended to get out of hand. In 1528 the Town Council decreed that, '...no manner of persons coming to the said fair shall molest or trouble one another...'

The fair, with its colourful characters and reputation, became the subject of painters and poets.

> *There's mony braw Jockies and Jennies*
> *Comes weel-buskit into the fair,*
> *Wi' ribbons on their cockermonies*
> *And fouth o' braw flo'er i' their hair.*
> *Maggie sae brawly was byskit*

When Jockie was tied to his bride.
The pownie was ne'er better whiskit
Wi' a cudgel that hung by his side
Sing fal re ral, la de.

Buskit: dressed, adorned;
fouth: abundance;
cockermonie: coiffure, the gathering of a woman's hair into the snood or fillet;
flo'er: flower;
powny: pony;
whiskit: lashed.
[3]

In time the level of drunken rioting prompted city officials to have the whole Fair moved out of the city to the confines of Calton Hill. A few years ago I had the good fortune to drink regularly with an Irishman in the pubs of Grassmarket and the nearby Cowgate. We also had a habit of drinking too much and getting into trouble but fortunately no one ever sought to eject us to Calton Hill - though the poor soul did in time become the sound engineer for Daniel O'Donnell.

Another group of Irishmen that I shared a few pints with were the Armagh Rhymers. They are a fine troupe of traditional performers who tell old Irish stories, sing songs and play a variety of instruments. They were playing at the Edinburgh International Children's Festival one year, and so was I. It was a dire rain soaked week that prompted the festival to move from the boggy marsh of Inverleith Park into the city's many theatres. The Rhymers wear hessian suits, big black boots and a dizzying array of huge wickerwork masks. With a few tunes and wild stories they captivated audiences full of schoolchildren. As evening came I ended up with them and my then girlfriend, a lovely Australian lass, in the Tron bar drinking ciders and Guinness and talking about wassailing.

The Armagh Rhymers troop off on May morning at dawn to play on the hills near their hometown. Six months later they spend the evening wassailing in an apple orchard. Wassailing is usually a midwinter pastime with companies of mummers journeying to pubs and apple trees to toast the health and fruitfulness of the trees, pour some cider on their roots, fire shotguns into their branches and drink a lot of string cider. Wæs hal! was an everyday Anglo-Saxon greeting that means 'be healthy' or more literally, 'Wæs' - 'to be' and 'Hal' - 'whole'. The modern English words 'was' and 'whole' descend from these roots. When the Vikings arrived they brought the similar expression, 'Ves heill'. Wassailing is still an active part of country life with many wassailing songs still being sung and many wassailing bowls full of cider or spiced ale being drunk.

Here's to thee, old apple tree,
Whence thou mayst bud
And whence thou mayst blow!

And whence thou mayst bear apples enow!
Hats full! Caps full!
Bushel—bushel—sacks full,
And my pockets full too! Huzza!
[4]

In the Hebrides there was a tradition of offering ale to an ancient sea god 'Shony'.

Sacrifice to Shony: late as third quarter 17th c.

The inhabitants of Bragar had an ancient custom of sacrifice to a sea-god called Shony at Hallowtide... The inhabitants of the island came to the church of St. Malvay, having each man provision along with him; every family furnished a peck of malt, and this peck was brewed into ale; one of their number was picked out to wade into the sea up to the middle, and, carrying a cup of ale in his hand, standing still in that posture, cried with a loud voice, saying "Shony I give you this cup of ale, hoping you will be so kind as to send us plenty of sea-ware for enriching our ground for the ensuing year," and so threw the cup of ale into the sea.

...Dr George Henderson suggests that Shony may be identified with Sjofn, one of the goddesses of the Edda. In any case, he says, the word is Norse, and was adopted by the Celtic stock of Lewis.
[5]

On the Isle of Man mumming was an integral part of Hallowe'en celebrations.

New Year: 'In the Isle of Man, one of the fortresses in which the Celtic language and lore longest held out against the siege of the Saxon invaders, the first of November, Old Style, has been regarded as New Year's Day down to recent times. Thus Manx mummers used to go round on Hallowe'en (Old Style), singing, in the Manx language, a sort of Hogmanay song which began, 'To-night is New years Night, Hogunna!'
[6]

The Isle of Man still has Hollantide celebrations. (Halloween old style - 12th November) Children with turnip lanterns sing, 'Jinnie the witch goes over the house to fetch a stick to leather the mouse, Hop-tu-naa.' It is this 'Hop-tu-na' that is metamorphosed into 'Hogunna'.

The Armagh Rhymers are, with their costumes, masks and plays, a modern incarnation of mummers and travelling players. Dancers, maskers and jugglers were singing similar songs and telling similar tales hundreds of years ago.

...naturally, the less sophisticated versions remain unchronicled until the kirk sessions bestir themselves to stamp out such 'superstitious' practices. In December 1605, five men were summoned at Aberdeen for going through the town 'maskit and dansing wits bellis' at Yule. - App. I, s.v. Aberdeen - Kirk Session Records. Also Jan. 1606.

above:
Notice the ever so slightly Scottish feel of this card...

At Elgin, in January 1623, certain 'gwysseris' were censured by the Session for having 'past in ane sword dance in Paul Dunbar his closs and in the kirkyeard.' - lbid., s.v. Elgin - Kirk Session Records.

The fact that they wore 'maskis and. wissoris' is interesting, as is the gravitation to the kirkyard...

At the 'triumph' prepared by the town of Edinburgh in 1558, thirty-one dozen bells were provided for the six dancers, and there was a fool clad in a coat of 'syndrie howis.'

[7]

Masquerades and folk plays were highly popular entertainments in the Middle Ages with court and commoner alike wearing masks and elaborate headdresses and leaving their real lives behind for the duration of the revels. These masques and seasonal plays eventually died out with a few notable exceptions. The Scottish folk plays that survived and which were a lively part of both Hogmanay and Hallowe'en celebrations were the Galoshins plays.

The most fully developed form of folk representation of mock death and resurrection, symbolising the victory of summer over winter, is to be found in the Mummers' Play; which, in accordance with the tendency of folk customs to follow the Christian calendar, has shifted to Christmas or the New Year. Fragments of the play of Galatians or Goloshans... are still recited in various parts of Scotland, and I have myself collected several new versions from oral sources.

[7]

Hallowe'en, Hallowe'en comes but once a year,
And when it comes we hope to give all good cheer,
Stir up your fires, and give us light,
For in this house there will be a fight
[8]

In his book 'Galoshins - a Scottish Folk Play' Brian Hayward brought together dozens of texts of these plays and examined the custom across Scotland. At Hogmanay and Halloween bairns would gather and soot their faces, dress up with white overgarments and go round houses. Throughout central Scotland these small groups of players were 'in character' as variously: 'Galoshin', 'the Black Knight', 'the Doctor', 'Johnny Funny', 'Beelzebub', 'William Wallace', 'Farmer's Son', 'Alexander', 'Bessy' and many others. Each child had their part to play and recited their lines. The hero, Galoshin, introduces himself and is challenged by a knight. They fight and the hero is slain. A Doctor is called for who proceeds to make wild claims about his abilities. A price for a cure is agreed and the hero is resurrected. Then a fool makes a final speech and collects money from the audience.

"I was six years of age...There would only be about five of us and we were told that we would get in five houses including my own. We had to disguise ourselves as much as possible with clothes, also our manner of speaking, so as to deceive the

people in the houses. On Hallowe'en night we all met in a sort of harness room attached to Renfrew's Cartwright and Smithy...There we dressed, and in a little fire we burned a lot of corks which were used to colour our hands, legs and faces. Two big girls helped to dress us....We all had our wee part to play"
[9]

Here is one example of the text from a Galoshins play. This was performed at Halloween in Clarebrand, Dumfries and Galloway.

"Here come I bold Hector
Bold Slasher is my name,
With sword and pistol by my side
I'm sure to win the game.

You sir?

I, sir.

Take out your sword and try, sir.

Die, sir.

(He 'dies'.)

Oh, what is this that I have done?
I've slain my father's only son.
Is there a doctor in the town?

Here comes I old Doctor Brown,
The best old doctor in the town.

What can you cure?

The rout, the gout, the broken snout.
If the devil's in a man, I knock him out.
Get up, Jack, and sing a song.

Oh, once I was dead, and now I'm alive
God bless the old doctor that made me survive.

Here comes I, wee Johnny Funny,
I'm the wee boy to gather the money.
Big lang pouches doon tae my knees
I'm the wee boy to gether bawbees."
[10]

Even Sir Walter Scott recollected playing his part in a Galoshins play in his youth. He also recalls that at that time the plays and guisings were not just a custom of small boys politely performing in people's homes.

"I remember in childhood playing Judas and bearing the bag....

...In Edinburgh these Exhibitions have been put down by the police in a great measure the privilege of going disguised having been of late years so much abused that one party in particular who call'd themselves Rob Roy's gang went so far into the spirit of their part as actually to commit theft."
[11]

There is a fundamental difference between 'guising' and 'disguising'. A guise is a whole other identity that you take on instead of your own - like an actor in a play. A disguise is simply a thing that hides your face so folk can't tell who you are. There is something about being masked that can turn you into someone else. You may not feel particularly different but others perceive you as the character of your mask. A man in a gorilla suit is far more likely to 'monkey around' than a man in a T-shirt and jeans. While others see only this outer mask they are unaware of who is behind it. This anonymity is attractive whether you are a Highwayman or Zorro. Furthermore a mask also allows you to be more bold and adventurous that you might be as just yourself. There are three practical things that came together on Halloween night that made it a night of mischief: Folk in 'disguise', lots of people out under the cover of night and finally, lots of alcohol.

Once, when I was working in schools up around Aviemore on a Midsummer festival, I had the chance to visit the Highland Folk Museum in Kingussie. This is a wonderful place where history is truly brought to life: you can explore a Highland blackhouse and time travel back into Scotland's past. There I met Ross Noble, the Museum's Director and a fine storyteller, who let me loose on the folklore resources in the library. I found local court records that described one particular All Hallows night of mayhem. One year the local men were out and about as usual with more than a little drink inside them. They were taking folks' gates off their hinges, swapping sheep round, cow tipping and causing minor havoc when a policeman came to politely move them on. A wee scuffle broke out and in the ensuing fight the policeman was floored and injured. The locals were later dragged into court and fines were levied against the miscreants. With a big grin on my face I recognised the surnames of the revellers as ancestors of the local schoolchildren and even one of the Headmasters! It only remains to add that that Midsummer held more than its fair share of magic and mischief...

Unwilling to let their elders have all of the fun the youngsters had a repertoire of pranks.

Malicious mischief was barred... Crofters who took the lads' pranks badly had extra attention the following year. Two oppressors not on speaking terms gave a heaven-sent opportunity for the mixing-up of cart-wheels, axles, ploughs, socks and swingle-trees, which took its owners weeks to unravel.

Neighbours who did not resent such tricks were seldom molested. There was no fun, for instance, in running off with anything belonging to Uileam Ruaridh, for Uileam left his gear unchained and unprotected, and would never say an angry

above:
Vintage Halloween card depicting the theft of cabbages.

165

word if we went off with the lot. So instead of stealing Uileam's gear, fantastically dressed, with blackened faces, we would pay a friendly call, announcing our arrival with a fusillade of turnips on the door.

One morning after Hallowe'en, Eilidh Dhonn's chimney would not draw. Maillean's washing-pot had been places upside down on the lum. Two of us climbed up and removed the obstruction. We had the grace to feel a little guilty on receiving much praise and a handful of "lozenges" from dear old Eilidh, for we knew how the pot had got there.

(Then there was the day the Taillear Fada and his wife 'slept in'.) It took a lot of doing, but we did manage without being discovered to plug up the windows and round the Taillear's door with a plaster of soft peat so that not a dideag (peep) of light could enter the house. As the Taillear never possessed a clock, but regulated his rising by the light of the sun, the ruse succeeded beyond our brightest expectations. It was the persistent ranail of the beasts in the byre that at last impelled the Taillear to open the door - and there, to his astonishment, was the sun at twelve o'clock!

[12]

Turnips were in ample supply in late October and when I was starting this book and I asked my grandmother about her own Halloween experiences she vividly remembered 'pinching tumshies' from the great piles of cattle fodder in the nearby farmyard – 'he had so many we did nae think he'd miss one or two...' I am reliably informed that the British turnip or 'tumshie' is known in America as a rutabaga (swede). It was not just turnips that rested uneasily in their fields. Night time Hallowe'en raids on cabbage fields were extremely common. These descriptions are from the Isle of Lewis.

Immediately after nightfall, the village youths make a raid on cabbage fields and turnip fields. If the turnips have been harvested and removed to the cornyard, spades are taken to tap the pit where they are enclosed. Sometimes the crofters keep a strict watch over their property, but often the vegetables disappear in spite of their vigilance. There is a story told of some youths who were employed during the day in a farmer's cornyard and secretly tied strings to scores of his cabbages. They took the leads over the wall, pulled, and uprooted the cabbages. The farmer, who was patrolling the yard, saw his cabbages walking off before his very eyes.

These vegetables are used as ammunition. The youths spread themselves over the village and begin a systematic attack on the houses. The attack comes from the house-tops. Some daring youth climbs up and over the thatch, and, taking good aim, drops a cabbage or turnip down the chimney so that it lands on the hearth. The householders then know that mischief is afoot. The crofter himself rushes out and tries to rout the besiegers. The youths retreat, and the chase that follows is reckoned the best part of the game.

If the crofter does not rise to the occasion, the attack proceeds from other fronts. Missiles are fired from the open doorway and aimed at any article that rests on the hearth. Sometimes teapots are smashed, pots capsized, and cinders scattered over the clay floor.

No harm is intended, however, and if the householder rushes out and gives the boys a good run for their money, he is no longer molested. And as payment for the trouble given him, the vegetables with which he was attacked are left in his possession, whether they came from his own yard or not.

The game continues far into the night, for doors are never locked in the country parts of Lewis; and when the sport is over, the remaining vegetables are divided and given to the poorest households of the village.

[12]

above:
Vintage Halloween card depicting the theft of gates.

Tricks were mischievous rather than malicious. These were close-knit communities and you had to live alongside your neighbours for the rest of the year. The origins of the American customs are gradually becoming clear but it is in 'guising' that we have the clear precursor of 'Trick or Treating'.

...the guisard is a familiar personage in sixteenth-century Scotland. Whether 'guisard' was applied exclusively to these folk mummers or was a general term synonymous with 'player' is not clear. The 'thre gysaris that playit the play' at the Scottish court in August 1503 may have been none other than John English and his companions, who, according to a contemporary account, acted a 'Moralite' at the time of the royal marriage. On the whole, however, the term does seem to have been reserved for those groups of local revellers who claimed the right of entry at the festive season - a right handed down from their pagan ancestors...

[7]

We find the guiser appearing not only in the Lowlands but also in the furthest North of Scotland.

Hallowmas Foy (Feast)

Shetland Grülacks - young men in costumes. Tall, graceful hats, woven by themselves out of straw, and adorned with many-coloured ribbons gifted by sweethearts and sisters, were the indispensable headgear. Their faces were concealed by veils. Their leader was called the Skuddler; another carried a fiddle and was nicknamed the Reel-Spinner. One of their number carried a buggie, a bag formed from the skin drawn intact off the carcase, cleaned and dried, and forming a water-tight bag.

They went masked from house to house, entertaining the company with singing and dancing; and having their buggie filled with such traditional dainties as burstin brunies (cakes made with a mixture of toasted oatmeal and beremeal), legs of vivda (wind-dried mutton), and sparls (Shetland sausages), beside butter, cheese and money. Next evening they went to the house, or barn, of one of their number, where they were joined by their sisters and sweethearts, and here they held a feast and spent half the night in games, singing and dancing. What remained of

their viands was bestowed on some "puir awmous peerie lads" (poor, deserving little boys), or needy old folk in the community.

On Hallow morning, every beast in the byre got a whole "Hallow" (sheaf of corn) for breakfast in addition to the usual allowance; but in the household was preserved as a "fanteen" (fast) until the evening.
[13]

Hallowe'en was a time when communities came together not to work or grieve but to revel in good-natured mischief and homemade entertainment. The roots of guising in Scotland go deep underground. Mediaeval folk plays, like the Robin Hood plays of May, lie down beneath the Galoshins plays and both have at their heart the same idea. These were customs where you don't just sit and watch the entertainment - you are the entertainment. Rather than being a passive consumer you are an active participant. This is not a group of professional actors putting on a play but your community dressing up and singing a song - acting their parts - doing a dance. Hallowe'en is cultural D.I.Y.

...contemporary Hallowe'en guising, at least in Glasgow, is the natural development from this re-formed custom. (The Galoshin plays) Small groups of children, aged from perhaps four to twelve, dress up and visit the houses of their friends' parents to give solo performances, usually of music, dance, joke-telling or recitation. The reward is preferably fruit, nuts and sweets, which the children collect in the plastic shopping bag which each carries. So traditional is the custom that the supermarkets sell pre-packaged apples and peanuts especially for this occasion. Money is frowned upon by parents for a reward; it carries the implication of laziness on the part of the householder in not being prepared with the correct response.
[14]

Guising is not a simple plea for 'treats.' When you turn up on a doorstep you have to work for your just rewards. As an old Scottish rhyme puts it:

> *Tell a story,*
> *Sing a sang ;*
> *Dae a dance,*
> *Or oot ye gang.*
> [1]

To be a guiser is to be a pint-sized performer. You can look forward to your bag of sweets but always there is the nagging suspicion that your parents will be trying to feed you mashed turnips for days as well. I've never been terribly partial to pumpkin pie either but a few days of odd vegetables at dinner is worth it for a fine Jack O' Lantern. It's hard to imagine Hallowe'en without its turnip and pumpkin lanterns. The night needs their strangely lit grinning faces to be complete. Christmas has its trees, birthdays have their cakes and Hallowe'en has curiously carved vegetables illuminated by candlelight.

above:
Vintage Halloween
card.

Like a particularly unconvincing cover-up story for UFO sightings the origins of Jack O' Lanterns has been attributed to exploding marsh gas.

Will-with-a-wisp, or Jack-with-a-lanthorn, a meteor known among the people under these names but more usually among authors under that of ignis fatuus.

This meteor is chiefly seen in summer-nights, frequenting meadows, marshes, and other moist places. It seems to arise from a viscous exhalation, which being kindled in the air, reflects a sort of thin flame in the dark, without sensible heat.

It is often found flying along rivers, hedges, etc. by reason it there meets with stream of air to direct it. The ignis fatuus, says Sir Isaac Newton, is a vapour shining without heat; and there is the same difference between this vapour and flame, as between rotten wood shining without heat and burning coals of fire.
[15]

This colourful description comes from the first edition of the Encyclopaedia Brittanica, which was 'illustrated with one hundred and sixty copper plates' and was produced 'by a Society of Gentlemen in Scotland.' The 'Jack-with-a-lanthorn' is one of many folk names for the mysterious glowing balls of light seen hovering over marshes across Britain. In Somerset they are known to locals as a 'spunky'. This in turn gave rise to the 'punky' - the mangle-wurzel (large rooted beet) Jack O' Lantern.

A 'spunky' is not simply ascribed to fiery methane marsh gases.

Will o' the Wisps in Somerset are called 'Spunkies' and are believed to be the souls of unbaptised children, doomed to wander until Judgement Day. These are sometimes supposed to perform the same warning office as the corpse candles.

Stoke Pero Church is one of the places where 'they spunkies do come from all around' to guide this year's ghosts to their funeral service on Hallowe'en. One St John's Eve, an old carter called me to watch from Ley Hill. The marsh lights were moving over by Stoke Pero and Dunkery. 'They'm away to church gate, zo they are. They'm gwaine to watch 'tis certain, they dead cannies be.
[16]

The fact that Will O' the Wisps are seen to hover above the ground may well prove it was the original inspiration for the Jack O' Lantern. Pumpkin lanterns are set static on windowsills and porches but in Britain the turnip lantern is attached to a length of string and is carried by the guisers. On a dark night a figure dressed in dark clothes would vanish in the darkness and only the weird disembodied glowing face of their lantern would be seen - a mysterious light that hovered and moved by itself over the ground.

At the village of Hinton St. George Punky Night still sees the locals gathering to process with their illuminated mangle-wurzles and sing the Punky Night song.

It's Punky Night Tonight
It's Punky Night Tonight
Give us a Candle, give us a light
It's Punky Night Tonight
It's Punky Night Tonight
It's Punky Night Tonight
Adam and Eve won't believe
It's Punky Night Tonight
[Traditional words according to Cecil Gillman]

Punky Night at Hinton St. George is one of the gentlest, cosiest customs of the year even though it can be pretty cold on the last Thursday in October,
Local legend relates the date, and the whole business to the fair which once flourished in Chiselborough, three and a half miles to the east. Hinton men always went to this fair; inevitably they failed to return home at the end of the day. The women had to go out looking for them carrying their home-made lanterns, known locally as 'punkies'. This annual round-up of drunken husbands became jocularly known as 'Punky Night'. It is certainly a good story, showing a fine disregard for all the similar traditions which attend Hallowe'en all over the country, if not the entire world.
[17]

We find ourselves coming full circle with a tale of local village men out drinking and staying up late.

Hallowe'en has long been a night 'between the worlds' where a little harmless shenanigans and high spirits can only be expected. Today Hallowe'en is, as most old folk festivals become, a night for small children. Whether they are guising or Trick or Treating, at the end of the night the result is the pretty much the same. Little folk in costumes stagger wearily home and spill out their bags of sweets and fruit. Their parents wash their faces and brush their teeth. Then with bellies full of candy they finally get off to bed to dream of ghosts in sheets, witches on broomsticks and things that go bump in the night.

above:
Vintage Halloween
card.

Notes

[1] Chambers Traditional Scottish Nursery Rhymes

[2] The Scotsman, Thursday, September 17, 1964

[3] Hallowmas Fair
 Robert Semple of Beltrees

[4] From the South Hams of Devon, recorded 1871

[5] The Silver Bough, A Calendar of Scottish National Festivals,
 Vol. Three Hallowe'en to Yule, F. Marian McNeill , Stuart titles, ltd. Glasgow, 1961

[6] The Golden Bough: a study in magic and religion
 Sir James George Frazer, London : Macmillan, 1911-15

[7] Mediaeval Plays in Scotland: thesis submitted for the degree of PhD of the University of St.
 Andrews
 Anna Jean Mills, Edinburgh, 1927

[8] Laurieston, Dumfries and Galloway
 Rev. Walter Gregor, Further Report on Folklore in Scotland 1898

 Brain Hayward, Galoshins - The Scottish Folk Play, Edinburgh University Press, 1992

[9] J. Braidwood quoting Alexander Braidwood of Barrhead
 Scottish Studies, the Journal of the School of Scottish Studies 14, 1970

 Brain Hayward, Galoshins - The Scottish Folk Play

[10] Clarebrand District: A History (for Scottish Rural Women's Institutes)
 Clarebrand Women's Rural Institute (Castle Douglas 1965)

 Brain Hayward, Galoshins - The Scottish Folk Play

[11] The Letters of Sir Walter Scott, ed H.J.C. Grierson, 1825-6

 Brain Hayward, Galoshins - The Scottish Folk Play

[12] British Calendar Customs: Scotland
 Mary Macleod Banks, London : W. Glaisher for the Folk-Lore Society, 1937-1941

[13] Shetland Traditional Lore
 Jessie Margaret Edmondston Saxby, Edinburgh, 1932

[14] Galoshins - The Scottish Folk Play
 Brain Hayward, Edinburgh University Press, 1992

[15] Encyclopaedia Brittanica, 1771

[16] County Folklore
 Ruth Tongue, vol. VIII, Folklore Society

[17] The National Trust Guide to Traditional Customs of Britain
 Brian Shuel, Exeter Webb & Bower 1985

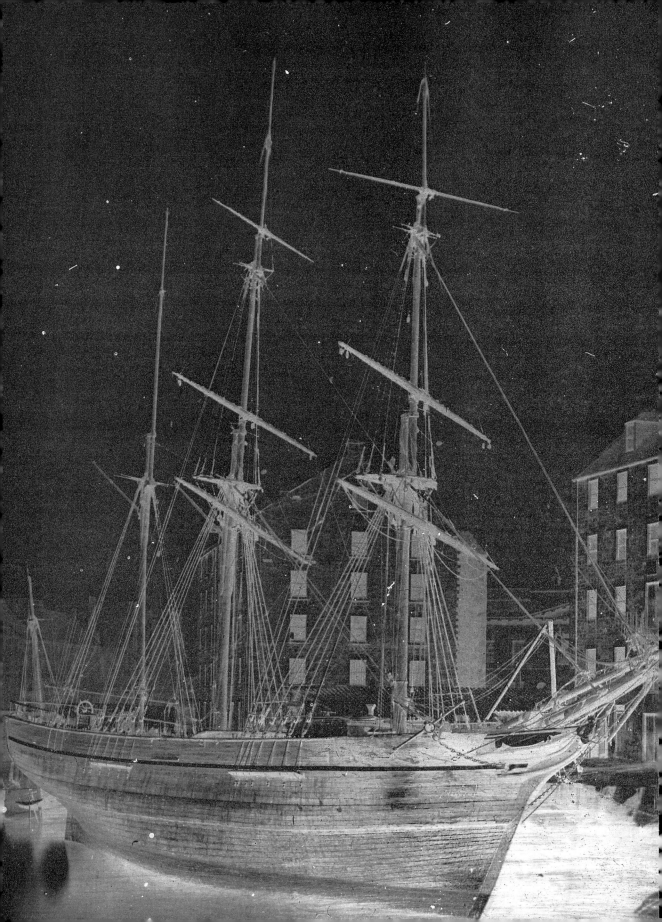

Wandering Spirits

In eighteenth century Scotland All Hallows' Eve was not a night to be out and about on the lonely moonlit highways and byways. There was mischief afoot and bogles, bad faeries and the pale ghosts of the dead haunted the shadows. Clever folk stayed in that night and gathered their friends and family together to perform rites of divination - to attempt to foretell future events. Today we still dook for apples and crack hazel nuts in the fire but two hundred and fifty years ago there were many curious Hallowe'en divination customs. Many of these would have been lost to us if not for the poet Robert Burns who faithfully recorded the rites in his poem 'Hallowe'en'.

Is thought to be a night when witches, devils, and other mischief-making beings are abroad on their baneful midnight errands; particularly those aerial people, the fairies, are said on that night to hold a grand anniversary.
[Burns]

Burns was born on the 25th of January 1759. He grew up amid a wealth of Ayrshire folktales and ballads. Witches, faeries and folk devils fuelled his imagination. Burns was good enough to leave us explanations of the various divination rites and I have occasionally added to his original notes.

The following poem will, by many readers, be well enough understood; but for the sake of those who are unacquainted with the manners and traditions of the country where the scene is cast, notes are added to give some account of the principal charms and spells of that night, so big with prophecy to the peasantry in the west of Scotland. The passion of prying into futurity makes a striking part of the history of human nature in its rude state, in all ages and nations; and it may be some entertainment to a philosophic mind, if any such honour the author with a perusal, to see the remains of it among the more unenlightened in our own.
[Burns]

> *Yes! let the rich deride, the proud disdain,*
> *The simple pleasure of the lowly train;*
> *To me more dear, congenial to my heart,*
> *One native charm, than all the gloss of art.*
> [Goldsmith]

opposite:
Sailing Boat in Leith Harbour
Negative print of vintage photograph by Hill and Adamson.

(Courtesy of City of Edinburgh Museums and Art Galleries. With thanks to David Patterson.)

Hallowe'en

Upon that night, when fairies light
On Cassilis Downans [i] dance,
Or owre the lays, in splendid blaze,
On sprightly coursers prance;
Or for Colean the rout is ta'en,
Beneath the moon's pale beams;
There, up the Cove, [ii] to stray an' rove,
Amang the rocks and streams
To sport that night;

[i] Certain little, romantic, rocky, green hills, in the neighbourhood of the ancient seat of the Earls of Cassilis.- Burns

[ii] A noted cavern near Colean house, called the Cove of Colean; which, as well as Cassilis Downans, is famed, in country story, for being a favourite haunt of fairies.- Burns

Amang the bonie winding banks,
Where Doon rins, wimplin, clear;
Where Bruce [3] ance rul'd the martial ranks,
An' shook his Carrick spear;
Some merry, friendly, countra-folks
Together did convene,
To burn their nits, an' pou their stocks,
An' haud their Halloween
Fu' blythe that night.

[iii] The famous family of that name, the ancestors of Robert, the great deliverer of his country, were Earls of Carrick.- Burns

The lasses feat, an' cleanly neat,
Mair braw than when they're fine;
Their faces blythe, fu' sweetly kythe,
Hearts leal, an' warm, an' kin':
The lads sae trig, wi' wooer-babs
Weel-knotted on their garten;
Some unco blate, an' some wi' gabs
Gar lasses' hearts gang startin
Whiles fast at night.

Then, first an' foremost, thro' the kail,
Their stocks [iv] maun a' be sought ance;
They steek their een, and grape an' wale
For muckle anes, an' straught anes.
Poor hav'rel Will fell aff the drift,
An' wandered thro' the bow-kail,

above:
Vintage Halloween
card.

An' pou't for want o' better shift
A runt was like a sow-tail
Sae bow't that night.

[iv] The first ceremony of Halloween is pulling each a 'stock,' or plant of kail. They must go out, hand in hand, with eyes shut, and pull the first they meet with: its being big or little, straight or crooked, is prophetic of the size and shape of the grand object of all their spells - the husband or wife. If any 'yird,' or earth, stick to the root, that is 'tocher,' or fortune; and the taste of the 'custock,' that is, the heart of the stem, is indicative of the natural temper and disposition. Lastly, the stems, or, to give them their ordinary appellation, the 'runts,' are placed somewhere above the head of the door; and the Christian names of the people whom chance brings into the house, are, according to the priority of placing the runts, the names in question.- Burns

'Kail' is a type of cabbage and a 'kailyard' was therefore a cabbage patch. It was sometimes thought that the kail had to be carried home backwards...
Unless the plants are pulled surreptitiously, without the knowledge and consent of their owner, they are no use for the purpose of divination.'
[1]

'An old man, a native of Islay, says that when he was young it was a common Hallowe'en custom to steal kail (gaisean càil) from which to have their future read; and he tells of one time he and several others tried it. Each pulled his stock, and away they went in company to an old woman who lived near to where he was brought up, and who had the credit of being a good hand at 'reading kail stocks'. They all knew each other's stock, but agreed to present them as a lot to the woman without letting her know which was which. And he declares that when she carne to his geas, she read his future as truly as it could be read.'
[2]

Then, straught or crooked, yird or nane,
They roar an' cry a' throu'ther;
The very wee things toddlin' rin -
Wi' stocks out-owre their shouther;
An' gif the custock's sweet or sour;
Wi' joctelegs they taste them;
Syne coziely, aboon the door,
Wi' annie care they've plac'd them
To lie that night.

The lasses staw frae 'mang them a'
To pou their stalks o' corn;[v]
But Rab slips out, an' jinks about,
Behint the muckle thorn:
He grippit Nelly hard and fast:
Loud skirl'd a' the lasses;

But her tap-pickle maist was lost,
Whan kiutlin i' the fause-house [vi]
Wi' him that night.

[v] They go to the barnyard, and pull each, at three different times, a stalk of oats. If the third stalk wants the 'top-pickle,' that is, the grain at the top of the stalk, the party in question will come to the marriage bed anything but a maid.- Burns
[vi] When the corn is in a doubtful state, by being too green or wet, the stack-builder, by means of old timber, etc., makes a large apartment in his stack, with an opening in the side which is fairest exposed to the wind: this he calls a 'fause-house.'- Burns

Burns had a rather 'colourful' reputation with the maidens and no doubt volunteered to make many a corn stalk prophecy come true - in the last couple of years a collection of his more 'racy' verse came to light and was finally published...

'They next go to the barnyard and pull each a stalk of oats, and according to the number of grains upon the stalk the puller will have a corresponding number of children. It is essential to a female's good name that her stalk should have the top grain attached to it.'
[2]

The auld guid-wife's weel-hoordit nits [vii]
Are round an' round dividend,
An' mony lads an' lasses' fates
Are there that night decided:
Some kindle couthie side by side,
And burn thegither trimly;
Some start awa wi' saucy pride,
An' jump out owre the chimlie
Fu' high that night.

[vii] Burning the nuts is a favourite charm. They name the lad and lass to each particular nut, as they lay them in the fire; and according as they burn quietly together, or start from beside one another, the course and issue of the courtship will be.- Burns

There is a rhyme that is said as the nuts burn -
"If you hate me spit and fly; If you love me burn away."
Hazel nuts have long been thought to have prophetic powers and hazel wood was used to make magical wands. Calton Hill in Edinburgh, where the annual Beltane Fire Festival is now held, is said to get its name from the Gaelic for hazel - named after a grove of the trees that once grew upon that faerie hill.

Jean slips in twa, wi' tentie e'e;
Wha 'twas, she wadna tell;
But this is Jock, an' this is me,

above:
Vintage Halloween card depicting cracking nuts in the fire and dooking for apples.

She says in to hersel':
He bleez'd owre her, an' she owre him,
As they wad never mair part:
Till fuff! he started up the lum,
An' Jean had e'en a sair heart
To see't that night.

Poor Willie, wi' his bow-kail runt,
Was brunt wi' primsie Mallie;
An' Mary, nae doubt, took the drunt,
To be compar'd to Willie:
Mall's nit lap out, wi' pridefu' fling,
An' her ain fit, it brunt it;
While Willie lap, and swore by jing,
'Twas just the way he wanted
To be that night.

Nell had the fause-house in her min',
She pits hersel an' Rob in;
In loving bleeze they sweetly join,
Till white in ase they're sobbin:
Nell's heart was dancin at the view;
She whisper'd Rob to leuk for't:
Rob, stownlins, prie'd her bonie mou',
Fu' cozie in the neuk for't,
Unseen that night.

But Merran sat behint their backs,
Her thoughts on Andrew Bell:
She lea'es them gashin at their cracks,
An' slips out-by hersel';
She thro' the yard the nearest taks,
An' for the kiln she goes then,
An' darklins grapit for the bauks,
And in the blue-clue [viii] throws then,
Right fear't that night.

[viii] Whoever would, with success, try this spell, must strictly observe these directions: Steal out, all alone, to the kiln, and darkling, throw into the 'pot' a clue of blue yarn; wind it in a new clue off the old one; and, toward the latter end, something will hold the thread: demand, 'Wha hauds?' i.e., who holds? and answer will be returned from the kiln-pot, by naming the Christian and surname of your future spouse.- Burns

This 'spell' gave the other folk present an excellent opportunity to make mischief...

above:
Vintage Halloween
card depicting casting
a 'blue clue', as
described in Burns's
poem 'Hallowe'en'.

'At Hallowe'en a pot is set near the door and one takes on hand to wind the wool contained in a clue in the pot into a fresh clue; while this proceeds with accompanying chant one steals out at the other door and in the dark creeps close to the pot stealthily so as not to attract attention; the winder says:

"I'll wind the blue clue,
Fa'll haud the end o't?"
when suddenly comes the answer,
"I", quo' the deil, "wha ither wad do't?"
The end is held really by the member of the company who stole round the house, but is taken as some uncanny power.'
[2]

An' ay she win't, an' ay she swat-
I wat she made nae jaukin;
Till something held within the pat,
Good Lord! but she was quaukin!
But whether 'twas the deil himsel,
Or whether 'twas a bauk-en',
Or whether it was Andrew Bell,
She did na wait on talkin
To spier that night.

Wee Jenny to her graunie says,
"Will ye go wi' me, graunie?
I'll eat the apple at the glass, [ix]
I gat frae uncle Johnie:"
She fuff't her pipe wi' sic a lunt,
In wrath she was sae vap'rin,
She notic't na an aizle brunt
Her braw, new, worset apron
Out thro' that night.

[ix] Take a candle and go alone to a looking-glass; eat an apple before it, and some traditions say you should comb your hair all the time; the face of your conjugal companion, to be, will be seen in the glass, as if peeping over your shoulder.- Burns

Halloween fell just after the fruit harvest and apples in particular feature in many divination customs.

'Hallowe'en was the feast of ingathering, hence in the observances are used both fruit and vegetables; with these was the unseen invoked; the future anticipated.'
[3]

Ye little skelpie-limmer's face!
I daur you try sic sportin,
As seek the foul thief ony place,

For him to spae your fortune:
Nae doubt but ye may get a sight!
Great cause ye hae to fear it;
For mony a ane has gotten a fright,
An' liv'd an' died deleerit,
On sic a night.

Ae hairst afore the Sherra-moor,
I mind't as weel's yestreen-
I was a gilpey then, I'm sure
I was na past fyfteen:
The simmer had been cauld an' wat,
An' stuff was unco green;
An' eye a rantin kirn we gat,
An' just on Halloween
It fell that night.

Our stibble-rig was Rab M'Graen,
A clever, sturdy fallow;
His sin gat Eppie Sim wi' wean,
That lived in Achmacalla:
He gat hemp-seed, [x] I mind it weel,
An'he made unco light o't;
But mony a day was by himsel',
He was sae sairly frighted
That vera night.

[x] Steal out, unperceived, and sow a handful of hemp-seed, harrowing it with anything you can conveniently draw after you. Repeat now and then: "Hemp-seed, I saw thee, hemp-seed, I saw thee; and him (or her) that is to be my true love, come after me and pou thee." Look over your left shoulder, and you will see the appearance of the person invoked, in the attitude of pulling hemp. Some traditions say, "Come after me and shaw thee," that is, show thyself; in which case, it simply appears. Others omit the harrowing, and say: "Come after me and harrow thee."
- Burns

'Young women sowed hemp seed ... over nine ridges of plough land, saying
'I sow hemp seed, and he who is to be my husband, let him come and harrow it.'
On looking back they saw the figure of their future husband.'
[1]

'If hemp-seed is not at hand, let the person take the floor-besom, and ride it in the manner of a witch three times round the peat-stack, and the last time the apparition will appear to him.'
[2]

above:
Vintage Halloween card depicting dropping egg whites in water - a divination rite known as ovomancy or oomancy or ooscopy.

Then up gat fechtin Jamie Fleck,
An' he swoor by his conscience,
That he could saw hemp-seed a peck;
For it was a' but nonsense:
The auld guidman raught down the pock,
An' out a handfu' gied him;
Syne bad him slip frae' mang the folk,
Sometime when nae ane see'd him,
An' try't that night.

He marches thro' amang the stacks,
Tho' he was something sturtin;
The graip he for a harrow taks,
An' haurls at his curpin:
And ev'ry now an' then, he says,
"Hemp-seed I saw thee,
An' her that is to be my lass
Come after me, an' draw thee
As fast this night."

He wistl'd up Lord Lennox' March
To keep his courage cherry;
Altho' his hair began to arch,
He was sae fley'd an' eerie:
Till presently he hears a squeak,
An' then a grane an' gruntle;
He by his shouther gae a keek,
An' tumbled wi' a wintle
Out-owre that night.

He roar'd a horrid murder-shout,
In dreadfu' desperation!
An' young an' auld come rinnin out,
An' hear the sad narration:
He swoor 'twas hilchin Jean M'Craw,
Or crouchie Merran Humphie-
Till stop! she trotted thro' them a';
And wha was it but grumphie
Asteer that night!

Meg fain wad to the barn gaen,
To winn three wechts o' naething; [xi]
But for to meet the deil her lane,
She pat but little faith in:
She gies the herd a pickle nits,
An' twa red cheekit apples,

To watch, while for the barn she sets,
In hopes to see Tam Kipples
That vera night.

[xi] This charm must likewise be performed unperceived and alone. You go to the barn, and open both doors, taking them off the hinges, if possible; for there is danger that the being about to appear may shut the doors, and do you some mischief. Then take that instrument used in winnowing the corn, which in our country dialect we call a "wecht," and go through all the attitudes of letting down corn against the wind. Repeat it three times, and the third time an apparition will pass through the barn, in at the windy door and out at the other, having both the figure in question, and the appearance or retinue, marking the employment or station in life.- Burns

You will notice that the vast majority of Halloween divination customs are closely associated with sowing and harvesting. A good or bad harvest meant the difference between plenty or famine and the work of the fields was still accompanied by rhymed charms and magical superstitions.

She turns the key wi' cannie thraw,
An'owre the threshold ventures;
But first on Sawnie gies a ca',
Syne baudly in she enters:
A ratton rattl'd up the wa',
An' she cry'd Lord preserve her!
An' ran thro' midden-hole an' a',
An' pray'd wi' zeal and fervour,
Fu' fast that night.

They hoy't out Will, wi' sair advice;
They hecht him some fine braw ane;
It chanc'd the stack he faddom't thrice [xii]
Was timmer-propt for thrawin:
He taks a swirlie auld moss-oak
For some black, grousome carlin;
An' loot a winze, an' drew a stroke,
Till skin in blypes cam haurlin
Aff's nieves that night.

[xii] Take an opportunity of going unnoticed to a "bean-stack," and fathom it three times round. The last fathom of the last time you will catch in your arms the appearance of your future conjugal yoke-fellow.- Burns

By now even Burns was hard pushed to find another poetic phrase for 'future husband or wife' hence 'your future conjugal yoke-fellow'.

above:
A lady uses apple peel
to spell out her future
love's initial.

A wanton widow Leezie was,
As cantie as a kittlen;
But och! that night, amang the shaws,
She gat a fearfu' settlin!
She thro' the whins, an' by the cairn,
An' owre the hill gaed scrievin;
Whare three lairds' lan's met at a burn, [xiii]
To dip her left sark-sleeve in,
Was bent that night.

[xiii] You go out, one or more - for this is a social spell - to a south running spring, or rivulet, where "three lairds' lands meet," and dip your left shirt sleeve. Go to bed in sight of a fire, and hang your wet sleeve before it to dry. Lie awake, and, some time near midnight, an apparition, having the exact figure of the grand object in question, will come and turn the sleeve, as if to dry the other side of it.- Burns

This was a rite that seems fraught with danger - there are many local folktales of girls seeing a coffin in their wet shifts and dying within the year.

Whiles owre a linn the burnie plays,
As thro' the glen it wimpl't;
Whiles round a rocky scar it strays,
Whiles in a wiel it dimpl't;
Whiles glitter'd to the nightly rays,
Wi' bickerin', dancin' dazzle;
Whiles cookit undeneath the braes,
Below the spreading hazel
Unseen that night.

Amang the brachens, on the brae,
Between her an' the moon,
The deil, or else an outler quey,
Gat up an' ga'e a croon:
Poor Leezie's heart maist lap the hool;
Near lav'rock-height she jumpit,
But mist a fit, an' in the pool
Out-owre the lugs she plumpit,
Wi' a plunge that night.

In order, on the clean hearth-stane,
The luggies [xiv] three are ranged;
An' ev'ry time great care is ta'en
To see them duly changed:
Auld uncle John, wha wedlock's joys
Sin' Mar's-year did desire,
Because he gat the toom dish thrice,
He heav'd them on the fire
In wrath that night.

above:
Vintage Halloween card depicting an alternative 'apple bobbing'.

[xiv] Take three dishes, put clean water in one, foul water in another, and leave the third empty; blindfold a person and lead him to the hearth where the dishes are ranged; he (or she) dips the left hand; if by chance in the clean water, the future (husband or) wife will come to the bar of matrimony a maid; if in the foul, a widow; if in the empty dish, it foretells, with equal certainty, no marriage at all. It is repeated three times, and every time the arrangement of the dishes is altered.- Burns

If you are trying this at home don't be too revolting with the 'foul water' as your turn will come… there is an interesting parallel with the three water vessels in 'The Adventures of Nera' tale from Ireland.

> *Wi' merry sangs, an' friendly cracks,*
> *I wat they did na weary;*
> *And unco tales, an' funnie jokes-*
> *Their sports were cheap an' cheery:*
> *Till butter'd sowens, [xv] wi' fragrant lunt,*
> *Set a' their gabs a-steerin;*
> *Syne, wi' a social glass o' strunt,*
> *They parted aff careerin*
> *Fu' blythe that night.*

[xv] Sowens, with butter instead of milk to them, is always the Halloween Supper.- Burns

'Sowens' is a traditional oatmeal pudding. It is apparently also known variously as 'boighreán' in Irish, 'càbhruich' in Scots Gaelic, and 'flummery' from the Welsh 'llymru'. I'm reasonably sure that sowens may be quite palatable if made by an expert… If you are brave or foolhardy enough to attempt to make it then soak about a pound of oat bran in a gallon of water - let it sit a while then strain out the liquid and boil it with sugar or honey. It should thicken and should be left to cool off. If I was you though I'd advise you to avoid the boiling, add honey and lots of whisky to make Atholl brose… bottle it and remember to shake well before drinking - the bottle that is…

Burns saw the beginning of the mass exodus from the Highlands - the Clearances - and had at one time planned to emigrate to Jamaica, in the West Indies. Thousands of Scots were driven from their ancestral homes and left their country for the New World. Burns lived to see America gain its independence and risked imprisonment or transportation to Botany Bay when he wrote in 'an Ode for General Washington's Birthday.'

> *See gathering thousands, while I sing,*
> *A broken chain exulting bring,*
> *And dash it in a tyrant's face.*

The tyrant was the occasionally 'mad' King George the Third.

above:
Lady with three bowls
of water, as described
in Burns's poem.

There had been a heavy price to pay across the Highlands for the failure of the Jacobite rising under 'Bonnie' Prince Charlie. Rebel chiefs were executed or exiled. The Highlanders had to surrender their weapons and were forbidden to wear kilts or plaids. The Highland way of life was systematically torn apart and the clan system disintegrated. Clan Chiefs grew more concerned with what their land was worth than with the people that lived upon it. Sheep would be more profitable than crofters. Over the decades the Highlands were cleared - a blend of persuasion and force was used to make families leave their homes and seek a new life in the cities or overseas.

Donald MacLeod's book 'Gloomy Memories' along with many other eyewitness accounts speak of the horror of this ethnic cleansing as young and old were driven from their homes which were burnt to the ground.

The consternation and confusion were extreme. Little or no time was given for the removal of persons or property; the people striving to remove the sick and the helpless before the fire should reach them; next, struggling to save the most valuable of their effects. The cries of the women and children, the roaring of the affrighted cattle, hunted at the same time by the yelling dogs of the shepherds amid the smoke and fire, altogether presented a scene that completely baffles description - it required to be seen to be believed.

"I was present at the pulling down and burning of the house of William Chisholm, Badinlkoskin, in which was lying his wife's mother, an old bed-ridden woman of nearly 100 years of age, none of the family being present. I informed the persons about to set fire to the house of this circumstance, and prevailed on them to wait until Mr. Sellar came. On his arrival, I told him of the poor old woman being in a condition unfit for removal, when he replied, 'Damn her, the old witch, she has lived too long - let her burn.'

Fire was immediately set to the house, and the blankets in which she was carried out were in flames before she could be got out. She was placed in a little shed, and it was with great difficulty they were prevented from firing it also. The old woman's daughter arrived while the house was on fire and assisted the neighbours in removing her mother out of the flames and smoke, presenting a picture of horror which I shall never forget, but cannot attempt to describe. Within five days she was a corpse."
[4]

Whole communities were violently uprooted from villages that their ancestors had lived in for centuries. They lost what few possessions they had and were forced to leave the valleys they had grown up in and the graves of their loved ones to face an uncertain future.

"I spent twenty-three years on Strathnaver, in my birthplace Ceann-na-coille, and I am confident they were the happiest days I ever spent. We were very happy and comfortable on the Strath. There were seven houses in Ceann-na-coille, which I, with a sad heart, saw burnt to the ground…"
[Angus Mackay, 89 years of age Crofter, Leadnagiullan, Farr]

In time the old Highland way of life was just a treasured memory, a fond recollection of a distant childhood when the green hills were still home to thriving communities.

"...But the people of that day were strong and healthy, active and industrious, in a way that those of today are not, whether men or women. They are not, my dear; I myself draw your notice to that. A great change of life has come into the countryside - everyone observes that. Much tea is drunk and much flour eaten nowadays. There was nothing of that in my own time or in my mother's time. There was nothing but butter and cheese and crowdie, dairy-produce and milk, and beer of heather-tops, oat-bread, barley-bread and rye-bread, porridge and milk, meat and flesh, gruel and broth. That is all changed today, my dear, and this has its visible effect and its result. Everything nowadays is sold for the sake of lowland food without worth or pith. Think you is there any kind of jam in the town of Glasgow that is not found today in Uist? Not one! In my day there was no jam except the kind that we made ourselves of brambles, of blaeberries, and of our own black and red currants. The people of today have not so much as a rose-bush. The men have taken to sloth, and they have neither kail nor carrots, nor even a garden. Since the folk were cast out to the streets of Glasgow and to the woods of Canada and to the peat-hags, the gardens have stopped."
[5]

Emigration from the Highlands of Scotland to America began shortly after 1760. In a pamphlet published in 1784, we are told that between 1763 and 1775 over twenty thousand Highlanders left to settle in America. Mr Angus Mackintosh and his wife left Inverness-shire and started a new life. They felt they had everything that they could wish for - save one thing - a small patch of heather.

And as she had heard there was an island in the Gulf of St Lawrence, opposite to the mouth of the Merimashee river, where it grew, and she understood I was going that way, she earnestly entreated I would bring her two or three stalks, or cows as she called it, which she would plant on a barren brae behind her house where she supposed it would grow; that she made the same request to several going that way, but had not got any of it, which she knew would beautify the place; for, said she, "This is an ugly country that has no heather; I never yet saw any good or pleasant place without it".
[6]

The names of countless American towns are testament to the Scots settlers. The dizzying numbers of American Highland gatherings and Scots surnames bear witness to the influence that the Highland clearances and the mass emigration was to have on America's history. Tragedy then befell Ireland as the potato harvest was blighted by fungus and the people began to starve.

"I ventured through that parish this day, to ascertain the condition of the inhabitants, and although a man not easily moved, I confess myself unmanned by the

above:
A lady looks into a mirror to see the reflection of her true love.

extent and intensity of suffering I witnessed, more especially among the women and little children, crowds of whom were to be seen scattered over the turnip fields, like a flock of famished crows, devouring the raw turnips, and mostly half naked, shivering in the snow and sleet, uttering exclamations of despair, whilst their children were screaming with hunger. I am a match for anything else I may meet with here, but this I cannot stand."
[7]

Between 1845 and 1850, the Irish potato famine took over a million lives and a further one and a half million people emigrated from Ireland to America, Australia and Britain.

"Since my last report, deaths are fearfully on the increase in this locality. Four have died in the immediate vicinity of this village within the last few days. In the mountain districts they die unknown, unpitied and in most instances unburied for weeks. Yesterday a man was discovered half concealed in a pigstye, in such a revolting condition that humanity would shrink at a description of the body. It was rapidly decomposing; but no neighbor has yet offered his services to cover the loathesome remains. Death has taken forcible possession of every cabin. Poor Coughlan, of the Board of Works, was crawling home a few nights ago, when hunger and exhaustion seized him within a few yards of his house, where was found the following morning, a frightening example of road mortality. If the present system of roadmaking be obstinately perservered in, West Carbery may be properly designated a universal grave-yard. I have just learned that in the neighborhood of Crookhaven they are buried within the walls of their huts. They have in most cases forgotten the usual ceremony of interment. The living are so consumed by famine they are unable to remove the dead. The Examiner could scarcely contain the names of all who have perished for the last month. I shall trouble you with no more particulars; but send you the gross number of victims when I write again."
[8]

Yet while the native population was starving a vast quantity of food was being exported from Ireland to Britain. In 'Ireland Before and After the Famine,' Cormac O'Grada tells us that in 1845, 26 million bushels of corn and more than a quarter of a million sheep were exported to Britain. The following year almost half a million swine and 186 thousand oxen were exported.

America became home to boatloads of immigrants from Scotland and Ireland. Some fell to illness or violence but most adapted and flourished in the New World.

...the mountain people found that they loved their tangled hills. In their instincts and memory and past experiences they had been safe and free in the marches of the Rhine and Wales and northern England and Scotland, and recently in the American Piedmont. Now in interior America they could continue to develop their sense of freedom and hospitality into an art.

No more class or race or economic bars. No more monarchy, no more colonialism or imposed religion. As John C. Campbell puts it in his Southern Highlander and His Homeland, the American mountain people had an independence raised to the fourth power.
[9]

These Celtic immigrants brought with them their songs and stories, their customs and folklore. America became home to tales of witches, devils and ghostly spirits.

'There is a persistent and continuing belief in ghosts, walking spirits, haints, and revenants in the region. They are seen as shapes in the road or near graveyards, along stretches of winding creek road and at lonely spots, or where someone lost his life, or in rooms where people died. Foul play leaves the most grisly and lasting spot. Many ghosts are to be seen, some to be heard, some to be felt. Ghosts sometimes walk and have nothing to say, others tell the person that all will be well in the other world, or warn him to stop a certain way of doing, or to help a certain person, or even to go right and return to church. The longer stories of the ghost who wants to see that his murderer is brought to justice, or to see that his family gets his property, or to tell where money is hidden are from Old World archetypes. These in many versions are told throughout the mountains.'
[9]

Along with the ghosts and revenants came another kind of spirit.
Moonshine; 100% organic, homegrown, illicit malt whisky a descendant of 'aqua vitae' and poteen. [...or poitin pronounced 'pot cheen'; 'aqua vitae' was an spirit alcohol so potent that it was used in medieval Scot's theatre for making giant dragon puppets breathe fire...]

A bottle of moonshine would have gone down well with a plate of 'chitlins'. These are the small intestines of freshly slaughtered pigs; simmered till tender and served with a sauce, added to soups or battered and fried. 'Chitlins' too had a Celtic root as the 'chitterlings' to be served up at Samhain.

I relate to you, surpassing festival, the privileged dues of Bealtain;
beer, roots, mild whey, and fresh curds to the fire.
 Lugnassad, tell of its dues of every distant year, trial of every glorious fruit, food of herbs on Lugnassad day.
 Meat, beer, nut mast, chitterlings, they are the dues of Samhain; a merry bonfire on the hill, buttermilk, fresh-buttered bread.
 Trial of every food in order, this is proper at Imbolc; washing of hand and foot and head; it is thus I relate.
[10]

The mass exodus from Scotland and Ireland brought waves of new folk to American. They brought their old traditions and beliefs with them. Among the earliest America Halloween symbols are the Scottish thistle, the kail cabbages, kilted men and tartan

above:
Vintage Halloween card.

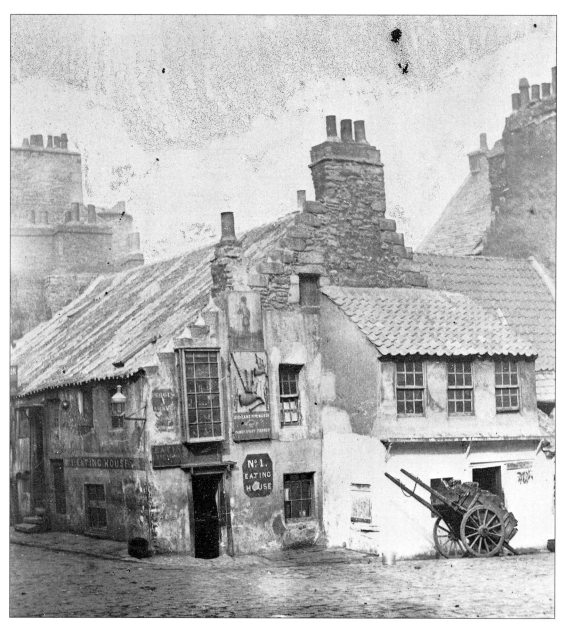

above:
West Port
Grassmarket,
in the shadow of
Edinburgh castle,
Edinburgh old town.
Vintage photograph by
Hill and Adamson.

(Courtesy of City of Edinburgh
Museums and Art Galleries.
With thanks to David
Patterson.)

patterns. Vintage American Halloween cards depict young ladies bobbing for apples, looking for their future lover's reflection in a mirror and reaching out, blindfolded, towards three bowls of water. The very divination rites that Robert Burns had written about a hundred and fifty years earlier became popular Halloween pastimes in the New World. From across the Atlantic came a wealth of seasonal rites and customs that were to shape the American celebration of Halloween.

Notes

[1] Witchcraft and the Second Sight in the Highlands and Islands of Scotland J.G Campbell

[2] British Calendar Customs – Scotland

[3] Social Life in Scotland
 Rogers

[4] Mackenzie's Pamphlet
 Alexander MacKenzie, F.S.A., Scot. 1881

[5] Catherine MacPhee, Isle of Uist
 Carmina Gadelica
 Alexander Carmichael

[6] Campbell's Travels in North America, 1793

[7] Captain Wynne, Inspecting Officer, West Clare, 1846

[8] Jeremiah O'Callaghan, Ballydehob, Cork Examiner, January 10th 1847

[9] Old Greasybeard: Tales from the Cumberland Gap.
 Leonard Roberts Ed. Detroit Michigan: Folklore Assoc. 1969

[10] Hibernica Minora
 Trans. Meyer, quoted in 'Studies in Early Celtic Nature Poetry'

above:
Vintage Halloween
card depicting dooking
for apples.

The Spook house

Every childhood town has its spooky old house - the gardens choked with weeds and overgrown with briars and dandelions, paintwork slowly peeling and boarded up broken windows. Sneak up to the front door, brush aside the dusty cobwebs, swallow your fear and step inside.

We thrive on the scary stories of secret phantoms and blood-curdling history. As a species we have a fascination for horror that has been fed by thousands of books, comics, movies and television shows. Just like the local spook house these are wonderful thrilling places to visit but you might not want to spend the whole night there.

Rusty hinges creak as you push the door slowly open. Ahead lies the dark enshrouded house. You fumble for your candles and a box of matches. A spark, a flash of light, then a gentle flickering flame and the oozing drip of hot wax. Welcome to the Spook House.

Silent shadows dance on the bare walls. Vampyr, The Golem, The Cabinet of Dr. Caligari, Dr. Jekyll and Mr. Hyde, Nosferatu, Haxan - Witchcraft through the Ages, The Phantom of the Opera. Monsters leapt from the page to the silver screen. The Cat and the Canary, Frankenstein, Boris Karloff, The Old Dark House, Freaks, Island of Lost Souls, The Mummy, Bela Lugosi, White Zombie. The silence is broken and classic monsters find a face in a host of Universal and RKO pictures.

Black and white gives way to glorious psychedelic Technicolor - saturated rainbow colours - bright red blood and glowing green skin. Christopher Lee, Vincent Price, Peter Cushing and Barbara Steele stalk the screens. Hammer pictures revitalise horror movies from darkest England.

The candle flickers and goes out. The darkness leaps out and engulfs you. You fumble for the matches and breathe again as your candle illuminates the room. In the half-light you find a wooden bookcase, clothed in cobwebs, and on its shelves lie piles of dusty books. The nightmarish works of Edgar Allan Poe and Washington Irving's 'The Legend of Sleepy Hollow.' Edward Gorey and Charles Addams - you flick through the pages and smile at the scratchy black line drawings - smudged charcoal

opposite:
Back of Unknown Woman
Vintage photograph by Hill and Adamson.

(Courtesy of City of Edinburgh Museums and Art Galleries. With thanks to David Patterson.)

and scribbled crosshatched characters. Bat-winged umbrellas and coffin shaped cookies. Generation after generation of children fed on the delights of their weird macabre worlds. Little minds full of dancing skeletons and cartoon monsters, stripy jumpers and monstrous topiary. Children who would happily sit in the pumpkin patch with Linus, waiting in vain as page after page of Charles Schultz's 'Peanuts' unfolds and Halloween and the Great Pumpkin slips by.

On the bottom shelf of the bookcase lays a moth-eaten cardboard box. You drag it to the floor and find it is surprisingly heavy. You pull it open and find a treasure trove of comic books. E.C., Atlas and Marvels. Vault of Horror, Tales from the Crypt, Eerie, Dark Mysteries, Haunted Thrills, Chilling Tales, Midnight Mystery, Phantom Stranger, Vampirella, Weird Terror and dozens more. Deliciously bizarre and outlandish picture books like medieval witch hunt chapbooks on acid. It was only a matter of time till they were blamed for the fall of western civilisation. The backlash began in England in 1949 and quickly exploded in the US. In 1954 the Comics Code Authority published its forty-point code. Among the rules: 'No comics magazines shall use the word horror or terror in its title; All scenes of horror, excessive bloodshed, gory or gruesome crimes, depravity, lust, sadism, masochism, shall not be permitted; Scenes dealing with, or instruments associated with, walking dead, torture, vampires, and vampirism, ghouls, cannibalism, and werewolfism are prohibited.' America's 'moral guardians' had struck a temporary deathblow to the horror comic and effectively censored a host of artists and writers. But the comics had already inspired a generation to come.

"...I loved E.C. comics. But you see, my parents, my dad especially, felt concerned that all of this stuff was warping me very badly - movies, comic books. He wanted me to learn the violin and stuff like that. So of course it was partially because he didn't want me to do it that I did it. And E.C. comics were the real forbidden fruit. I mean they were dangerous to the mind because they were so graphic. But they were also wonderful, so inventive. As far as I'm concerned, The Fog is an E.C. comic. It's my tribute."
John Carpenter
[1]

Halloween was a little slice of weirdness among the white picket fences and manicured lawns. Smiley happy faces and grinning carved pumpkin heads. Pipe, slippers, meatloaf on Fridays, jukeboxes, rock n' roll, baseball games, color TV and 'Bewitched' - the everyday tale of good clean all-American suburban witchcraft. Every year of its original transmission Bewitched aired a Halloween themed episode on the night it was scheduled closest to October 31st. One year the Halloween show featured Tabitha bringing all the weird things from a children's book to life to go 'Trick or Treating' with her and her mother, Samantha. Mom, dad, apple pie and baby makes three and don't forget the evangelical Christian Right backlash. Was Elizabeth Montgomery ever really going to endanger family values and the moral and religious fibre of the nation? Methinks not.

opposite and overleaf:
Resonant images from
Haxan - Witchcraft through the Ages

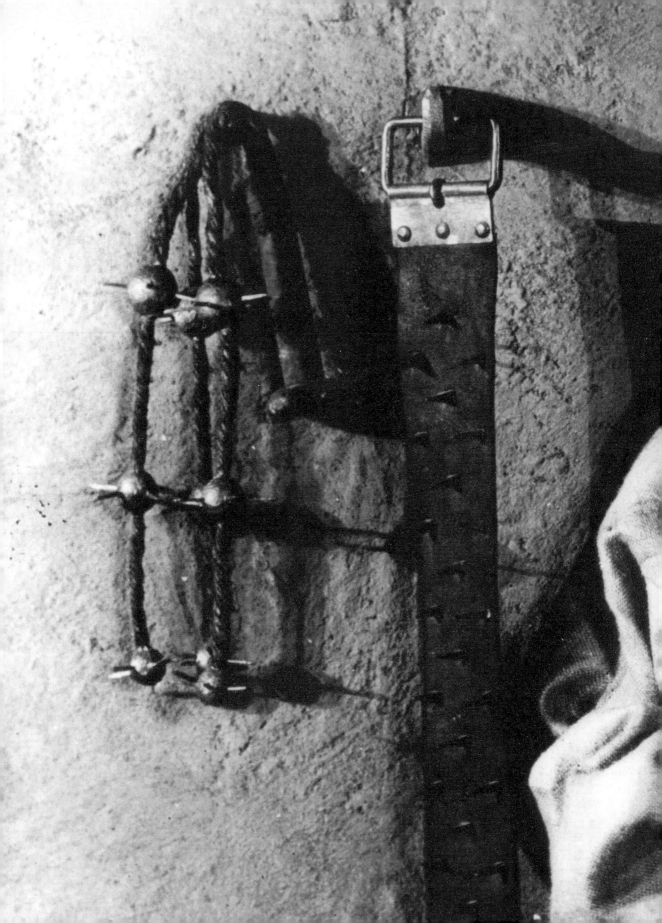

Satan is using TV, cartoons, movies, colleges, video games, card games, even religion and the US Constitution to spread this evil and send people to hell. I (and millions like me, and our parents) might have been able to slow down, or even stop this junk. When I was a kid there was a show called "Bewitched" on the TV. Millions of us thought it was a harmless TV show that was really funny. We thought séances were just for fun. We thought an Ouija board (I found a web site where over 800 people told of their experiences with this Parker Bros. game. Most were scared away from it, a lot said it helped them contact spirits easier) was a harmless toy. WRONG! And we were Christians! We could have banded together 30 years ago and stopped some of this stuff. Because we didn't our TV's are loaded with shows of immorality and witch craft. Our games are full of violence and witchcraft. Even children's books (Harry Potter) are full of this stuff, and accepted... More and more shows are coming out about witches, monsters, homosexuality, the occult, psychics, and generally bad behavior.
[2]

Freedom of Speech cuts both ways, as does Freedom of Religion. The Evangelical Conservative Right have seen the portrayal of witchcraft and other alternative lifestyles as a threat to the eternal souls of their nation. Their concerns are genuine; they believe that occult forces are real, are an ever-present danger and that their vigilance is saving souls from Satan. Their concerns are genuine, but is the threat? It seems there has been a battle raging for the hearts and minds of Americans for at least the last thirty years. The Christian Right appears to suspect a 'New Age' pagan conspiracy to corrupt the children of America with a diet of pro-witch television shows, movies and most books. They see the 1960s as an age that spawned drug-addled hippy witch movements where the Woodstock generation were writhing and fornicating in the muddy dirt one moment and worshipping the earth mother the next. As well as making exceedingly fine ice cream this generation of entrepreneurial dropouts brought their mystical beliefs to life in their creative works and in turn inspired the 'New Age movement'.

The British Witchcraft revival came hand in hand with flower power. Old orthodoxies were finally breaking down in an age that had seen Vietnam and Watergate and believed it was time to think for yourself and follow your own path. Gerald Garner thought that the witchcraft movement he had helped to forge was beginning to wane as he reached the end of his life. He thought it would soon die out and that the younger generation wouldn't find it interesting enough. He would be astonished and I suspect immensely proud to see the thriving variety of pagan faiths that flourish around the world today.

This was a time of strange coincidences and synchronicities. Just as man was walking on the moon, the moon was being worshipped as a goddess in the west for the first time in centuries. The space program sent us stunning photographs of the earth from orbit. We could see our whole bright beautiful planet shining like a tiny oasis in the immense endless void of space. The concept of the Earth as a living entity 'Gaia' was popularised and satellite communications made international broadcasting and

contact instantaneous and affordable. The end of the last century saw an upsurge in the green movement and the urgency of saving the planet was finally realised. People were turning from worshipping a creator to worshipping 'creation' - seeing the world as our mother and fighting for her survival. Modern pagans battled against the building of new roads - protesting at the destruction of the natural world and against the dominant car culture.

Rather a lot to lay at the door of 'Bewitched'. Even on a very good day Samantha's nose twitching couldn't magic up the cultural shift that was overtaking the west. Witchcraft has become a highly significant cultural entity. The media has always been quick to see a popular subject and make a good story based on it. It worked for Shakespeare with Macbeth - now we have 'The Craft' with all the special effects that Hollywood can muster but the basic logic is the same. Make something entertaining and creative from a popular contemporary subject.

In the fall season of 1997, 'Sabrina, the Teenage Witch' was viewed by approximately 7,952,000 households each week. It is very much the modern youth-oriented successor to 'Bewitched' - magical adventures in suburbia. Sabrina is a pretty average American girl who learns on her sixteenth birthday that she is a hereditary witch. There is even a talking black cat named Salem. The show has led to an animated cartoon version, computer games, a magazine and a ton of merchandise. 'The Halloween Scene,' was Sabrina the Teenage Witch's 100th episode and was a Halloween spectacular. The script, signed by the cast, was destined to be auctioned on www.allstarcharity.com with the highest bid going to benefit the Mr. Holland's Opus Foundation which promotes the importance of music in the lives of children, as well as the positive effects of music education on a child's emotional and intellectual growth, and seeks to keep music alive in schools.

"Every year the Halloween episode is the most fun. It's the most elaborate and most crazy. We are in costumes - I can't sit down or breathe in mine. We've got some fantastic outfits - all kinds of ghouls and ogres and interesting stuff. It's going to be a fun episode."
[Beth Broderick, 'Aunt Zelda' in Sabrina, the Teenage Witch.]

Not sounding terribly like a subversive plot to turn children on to the occult to me. In my more cynical moments I wonder if the Evangelists are in fact more enraged and concerned about their comparative viewing figures. Anyone watching Sabrina, Charmed or Buffy The Vampire Slayer might be missing their own broadcast Ministries and an opportunity to contribute to church funds. Heaven forbid.

Of even more concern to the religious right is another attractive blond girl with her own TV show. 'Buffy The Vampire Slayer' was initially a movie but found immense popularity on the small screen. Buffy earned a 3.7 Nielsen rating for the week of November 30 - December 6, 1998, which means that approximately 3,677,800 households watched the program that week. In the show Buffy Summers is the 'Slayer', a female warrior who is destined to battle vampires, demons and a pandemonium of

other supernatural entities. Whenever a Slayer dies, the next is chosen and a 'Watcher' trains her. With the aid of her Watcher - a British librarian named Rupert Giles - and a small circle of close friends Buffy fights to keep the suburban town of Sunnydale safe for its innocent citizens. The fact that Sunnydale is built on the Hellmouth - a gateway to Hell - tends to make life, as a Vampire Slayer, pretty hectic.

Buffy's huge success is due to a number of factors. It is excellently written and produced with consistently funny dialogue and engaging characters. The high concept idea of a blond Californian babe dealing with high school then college, grades and boyfriend troubles by day and defeating evil in its many vile guises by night offers excellent possibilities of action, comedy and romance. The cast are all excellent in their roles and each 'sidekick' is a fully rounded character in their own right. It is also one of a very tiny minority of American shows that is willing to take risks. Willow, Buffy's best friend, is not only a wiccan who practices witchcraft and spellcasting - she is also a lesbian with a regular girlfriend and they have even had a screen kiss. Buffy has featured an annual Halloween episode on the transmission date nearest October 31st. In the October 26th 1999 episode 'Fear, Itself' Buffy, Willow, Oz and Xander go to a Halloween party in a frat house.

Buffy: *"I was just thinking about the life of a pumpkin. Grow up in the sun, happily entwined with others, and then someone comes along, cuts you open, and rips your guts out."*

Xander: (about his pumpkin): *"I don't know. I was going for ferocious-scary, but it's coming out more dryly sardonic."*

Willow: *"It does appear to be mocking you with its eye holes."*

Oz: *"Yeah, its nose hole seems sad and full of self-loathing."*

The frat house seems to turn on them as they encounter all their darkest fears. Luckily Anya gets Giles and they come to the rescue. The culprit is a Fear Demon, which feeds on human fear. Once it is made flesh it turns out to be minuscule.

Xander: (taunting the fear demon): *"Who's the little fear demon? Come on, who's the little fear demon?"*

Giles: *"Don't taunt the fear demon."*

Xander: *"Why? Can he hurt me?"*

Giles: *"No, it's just... tacky."*

So, who is the diabolical mastermind behind this series, which blatantly promotes demonology, occultism, homosexuality, and the use of British swear words by peroxide punk vampires? Who has the Christian Right foaming at the mouth at its

iniquity? Joss Whedon is the guilty party. He's quite a nice man actually. Here he is interviewed in Happy Halloween Magazine.

HHM: *"How did you come up with the storyline for Buffy the Vampire Slayer?"*

Joss: *" I was tired of seeing the helpless blonde girl get cornered in the alley for sure death in horror movies. The idea was, what if that girl turned around and actually kicked some evil ass? Basically empowering that throw-away character and defeating the stereotype."*

HHM: *"Our audience are lovers of Halloween. Share with us one of your favorite Halloween memories."*

Joss: *" I never got to go trick or treating, so Halloween was fairly non-existent. I'm making up for it with the show, though."*
[3]

Proof positive that if you don't let your children go out Trick or Treating they will grow up to create a massively successful TV show with all the fun horrors you tried to keep them away from. The show's stars are taking to the big screen in American Pie, Austin Powers and the Scooby Doo movie and their celebrity is also being used to help good causes. In October 1998 Anthony Steward Head who plays Giles acted as Grand Marshall for the Hartford Halloween Parade to benefit AIDS Project Hartford. The event raised more than $30,000 for the charity.

The third show in our contemporary TV hall of Halloween is 'Charmed'. This features the Halliwell sisters: three hereditary witches who fight evil from their San Francisco family home. They have the magical Book of Shadows and each sister, Prue, Piper and Phoebe, has their own individual magical gift that can be combined in 'The Power of Three' to overcome demonic adversaries. The show comes from the stable of Aaron Spelling who also brought us 'Dynasty', 'The Love Boat', 'Charlie's Angels' and 'Beverly Hills, 90210' - again this is hardly the work of a pro-witch New Age conspiracy. The show is another success story for Spelling, netting an audience of over 3 million viewers during the week November 30 - December 6, 1998. 'Charmed's leading ladies are truly the sexy new incarnations of Macbeth's weird sisters. Rather than cackling madly and brewing noxious potions in bubbling cauldrons they wear fabulously tight clothes and somehow struggle to hang on to boyfriends. Strangely none of them are blonde.

In the 'Halloween 2000' episode aired October 26, 2000 our three heroines are transported back in time, to Virginia, circa 1670. Here they have to protect a woman who is about to give birth to Melinda Warren, their great, great,... grandmother, and the first of the Halliwell hereditary Witches. Time-travelling back to the 17th century witch hunts in the name of entertainment seems a common activity. 'The Simpsons' have had a Halloween episode in each season usually entitled 'Treehouse of Horror'. www.thesimpsons.com has a comprehensive episode guide. In season 9 the

above:
Vintage Halloween
card.

Halloween

Halloween episode first aired on October 26, 1997 was 'Treehouse of Horror VIII'. This is their description of the trilogy of mad festive tales:

Three new yucky Halloween yarns from your favorite yellow family. First, Homer seems to be the only survivor of a nuclear explosion. As the last living person on earth—literally, the Homega Man—Homer is free to do whatever he wants, specifically steal cars and crash them and dance naked in the Springfield Community Church. But Homer's revelry is cut short by a band of angry, flesh-eating mutants who survived the blast and are now hungry for Homer. Speeding in a car to Evergreen Terrace, Homer hides in his old home and discovers that his family has also survived the blast, protected by the layers and layers of lead paint in the house. Marge and kids are elated to see Homer and it's their pleasure to use their shotguns to blast holes in the mutants.

In the second story, Homer buys a matter-transporting machine from Professor Frink's yard sale. He uses it to grab beers from the fridge without getting up from the couch and to quickly go to the bathroom while watching TV. When Bart goes inside the machine with a fly, his DNA is scrambled with the insect's and two new creatures emerge: A tiny fly with Bart's head, and Bart's body with a disgusting fly's head. The family accepts the new bugged-out Bart, but when the tiny Bart tires of being a fly, it's up to Lisa to trick the big Bart back into the machine so each pest's DNA can be put back in the correct place.

The final sequence is the story of a coven of Springfield witches from 1649. As played by Marge and her sisters Patty and Selma, the witches are kindly old souls who occasionally enjoy eating children from the town. To stop the witches from eating their kids, the townspeople offer them candy and treats instead, thus initiating the tradition of Halloween.
[4]

The moment when the townsfolk, suspecting Marge of being a witch, throw her off a cliff is fantastic. One moment she is protesting her innocence the next she is flying on a broomstick and cursing the entire town with her supernatural powers.

The Salem witch trials have long been a source of inspiration for American films, plays and TV shows. They appear in works ranging from Arthur Miller's 'The Crucible' to Disney's 'Hocus Pocus' - but the original wicked old witch lurking in the broom closet was a little film called 'I Married a Witch' from 1942. Here we have the delectable Veronica Lake starring as a 17th century witch. While she is being burnt at the stake she puts a foul curse on her accuser - all of his lineage will have unhappy marriages. When a lightning strike sets her free in the present day she sets her sights on the latest descendant. This is considerably funnier than it sounds and is a fine slice of golden age Hollywood based on an unfinished novel 'The Passionate Witch' by Thorne Smith. Largely forgotten today this movie is considered by many to be the forerunner of 'Bewitched'.

above:
Vintage Halloween card.

17th century witches returning from beyond the grave to cast spells in our own time are also the leading ladies in the 1993 Disney movie - 'Hocus Pocus'.

In 1693 we meet the trio of weird Sanderson sisters: Winifred, played by the divine Ms Bette Midler, Sarah, played by the wonderfully corseted Sarah Jessica Parker who went on to star in 'sex and the city', and Mary, Kathy Najimy fresh from success as a nun in 'Sister Act'. With the aid of their spell book they prepare a potion and a spell that will give them eternal youth and immortality - by breathing in the life essences of small children. But, just before the spell is completed, the townsfolk of Salem burst in and hang them for diabolism.

Townsfolk: *"Witches, daughters of darkness, open this door!"*

Winifred: *"Hide the child..."*

Mary: *"Witches? There be no witches here, sir."*

Winifred: *"Don't get your knickers in a twist...*
...we are just three kindly old spinster ladies."

Mary: *"Spending a quiet evening at home."*

Sarah: *"Sucking the life out of little children!"*

From the scaffold the witches vow they will return upon some future All Hallows' Eve. Three centuries pass till new boy in town Max (Omri Katz of 'Eerie, Indiana'), sneaks into the derelict witches' house on Halloween night, lights the black flame candle and unleashes the Sanderson sisters. It's now up to Max with the help of a bewitched talking black cat and the girl of his dreams, Allison (Vinessa Shaw lately in 'Eyes Wide Shut'), to get rid of the witches and protect Max's little sister, Dani, a young Thora Birch many years before 'American Beauty'. Bette Midler runs riot throughout and happily chews on the scenery, Kathy Najimy spends the whole movie sniffing for children and Sarah Jessica Parker is a spellbinding mad blond nymph. 'Hocus Pocus' is set squarely on Halloween in modern day Salem and is a valiant attempt to bring the dark comedy of the night to the big screen.

Winifred: *"Sisters... All Hallow's Eve has become a night of frolic, where children wear costumes and run amok."*

Sarah: *"Amok, amok, amok, amok, amok !!"*

It has to be said that witches have, by and large, been a pretty attractive sisterhood in Hollywood movies. Sarah Jessica Parker, Veronica Lake, Nicole Kidman and Sandra Bullock (in 'Practical Magic'), Michelle Pfeiffer, Susan Sarandon and Cher (in 'The Witches of Eastwick'), Fairuza Balk, Neve Campbell, Rachel True and Robin Tunney (in 'The Craft') and not forgetting Kim Novak (in 'Bell, Book and Candle').

Halloween itself has also turned up in more than a few movies.
In 'E.T. the Extra-Terrestrial.' Elliot smuggles E.T. out of the house, as a ghost under

a white sheet, as all the local kids go Trick or Treating. They encounter all sorts of odd costumes including a kid dressed as Yoda from 'The Empire Strikes Back'. 'E.T.' was hugely successful and helped to boost Halloween's popularity.

In 'Tim Burton's The Nightmare Before Christmas' Halloween is run by the fantastical Jack Skellington and his town full of monsters. This magical movie was painstakingly created using stop motion animation - each model figure was moved a tiny amount then photographed then moved again.

"Nightmare Before Christmas is a movie I've wanted to make for over a decade, since I worked as an animator at Walt Disney Studios in the early eighties. It started as a poem I wrote, influenced by the style of my favorite children's author, Dr. Seuss. I made several drawings of the characters and the settings and began planning it as a film...

Like a lot of people, I grew up loving the animated specials like Rudolph the Red-Nosed Reindeer and How The Grinch Stole Christmas that appeared on TV every year. I wanted to create something with the same kind of feeling and warmth.

Nightmare is the story of Jack Skellington, the Pumpkin King of Halloweenland, who discovers Christmas and immediately wants to celebrate this strange holiday himself. I love Jack. He has a lot of passion and energy; he's always looking for a feeling. That's what he finds in Christmas Town. He is a bit misguided and his emotions take over, but he gets everybody excited. The setting may be odd and a little unsettling, but there are no real villains in the film. It's a celebration of Halloween and Christmas - my two favorite holidays...

I was able to entrust Nightmare Before Christmas to my friend Henry Selick, the most brilliant stop-motion animator around. We have a similar sensibility, and he was able to take my original drawings and bring them to life. He gathered together an amazing crew in San Francisco - a wonderful group of artists, all working toward the same vision. Everybody put their heart into it - Henry, the composer Danny Elfman, the screenwriter Caroline Thompson, the animators, everybody down the line - making it an incredibly challenging, and rewarding experience.

Nightmare Before Christmas is deeper in my heart than any other film. It is more beautiful than I imagined it would be, thanks to Henry and his talented crew of artists, animators, and designers. As I watch it, I know I will never have this feeling again. Nightmare Before Christmas is special. It is a film that I have always known I had to see. More importantly, it is a film I have always wanted to see. Now I can. It has been worth the wait. I think there are few projects like that in your life."
Tim Burton
[5]

Halloween has, of course, long been a favourite night for horror films. A night when the dead are thought to walk, witches abound and magic and monsters stalk is a natural for scary movies. The Granddaddy of them all is John Carpenter's 'Halloween'.

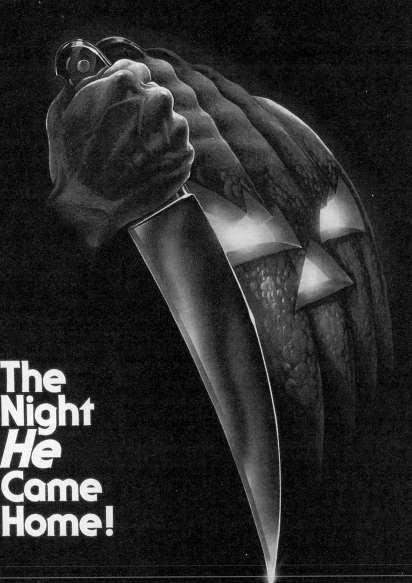

HALLOWEEN

The
Night
He
Came
Home!

MOUSTAPHA AKKAD PRESENTS DONALD PLEASENCE IN JOHN CARPENTER'S "HALLOWEEN"
WITH JAMIE LEE CURTIS, P.J. SOLES, NANCY LOOMIS · WRITTEN BY JOHN CARPENTER AND DEBRA HILL
EXECUTIVE PRODUCER IRWIN YABLANS · DIRECTED BY JOHN CARPENTER · PRODUCED BY DEBRA HILL
PANAVISION® A COMPASS INTERNATIONAL RELEASE C🅽 [R] RESTRICTED

HALLOWEEN
A screenplay by John Carpenter and Debra Hill

1 MAIN TITLE SEQUENCE
OPEN on a black screen. SUPERIMPOSE in dark red letters:

HALLOWEEN
FADE IN TO:
Darkness, with a SMALL SHAPE in the center of the screen. As MAIN TITLES CONTINUE OVER, CAMERA SLOWLY MOVES IN ON the shape.
We get closer and closer until we see that the shape is a HALLOWEEN MASK. It is a large, full-head latex rubber mask, not a monster or ghoul, but the pale, NEUTRAL FEATURES OF A MAN weirdly distorted by the rubber.
Finally CAMERA MOVES IN CLOSE on the eyes of the mask. It is blank, empty, a dark, staring socket. SUPERIMPOSE FINAL CREDIT.
FADE OUT:

FADE IN:
2 Black screen. SUPERIMPOSE:

HADDONFIELD, ILLINOIS
OCTOBER 31, 1963

"You can use the camera for manipulation. In Halloween the audience identifies with the killer because it sees things through his eyes in the opening scenes. More important that that, you can use the camera to add a three-dimensional quality to your shots. When you move the camera you create the illusion of depth...

Horror films give people an opportunity to express or to channel feelings that society frowns upon. All of us are fascinated by the forbidden, by the darkness, by monstrosity. But in our dealings with each other in society, we can't let those things out. We'd all be crazy. Film gives people the chance to be frightened, to be put through the wringer, to do go down into that forbidden area. And, of course, the great thing about movies is that they are harmless."
John Carpenter
[1]

'Halloween' was a spectacular success story. It literally came from nowhere - a tiny low budget horror movie that exploded at the box office through word of mouth. A little movie that cost $320,000 took $55,000,000. A passionate love affair between Halloween, Hollywood and horror films was begun.

"The writing of HALLOWEEN started by listing 10 Halloween scares.
Things like:
1. The ghost dressed in the bedsheet is not your boyfriend...He's the killer!
2. As you carve the jack-o-lantern in the kitchen, the sound you thought was lightning is the bad guy breaking the window.

3. The breathing sound on the telephone is really your best friend playing games...Think Again!
4. The guy in the funny Halloween costume and the William Shatner mask - is not your neighbour next door. [etc...]
And then we added character names...
1. Laurie Strode...really John Carpenter's first girlfriend.
2. Bennet Tramer...a USC friend who now writes for SAVED BY THE BELL.
3. Sam Loomis...John Gavin's character from PSYCHO who played Janet Leigh's boyfriend.
And finally...
Michael Meyers... Our UK distributor and with love 'OUR SHAPE.'"
[Debra Hill, Producer 'Halloween' at 20th anniversary showing.]

'Mother and Father stare at the POV, at first in puzzlement, then slow, growing horror.

MOTHER
Michael?

4 CLOSE SHOT - MICHAEL - CRANE
The father's hand reaches up and rips off the Halloween mask, revealing MICHAEL, 6, underneath, a bright-eyed boy with a calm, quiet smile on his face.
CAMERA PULLS BACK, revealing the bloodstained butcher knife in his hand, then further back. CRANING UP past his parents standing there, up from the neighbor's house to a HIGH SHOT of the neighborhood as the sounds of POLICE SIRENS rise in the distance.
FADE OUT:

About twenty years later another American horror movie made on a shoestring budget broke box office records and filled cinemas by word of mouth and the new medium of the Internet. 'The Blair Witch Project' tells the tale of three documentary filmmakers, Heather Donahue, Joshua Leonard and Michael Williams, who hike into Maryland's Black Hills Forest to shoot a film on the strange local legend of 'The Blair Witch'. They are never seen again. A year later, their raw footage is found. 'The Blair Witch Project' recounts their journey into the depths of the Black Hills Forest and the terrifying events that lead up to their disappearance.

October 20th 1994
Montgomery College filmmakers, Michael Williams, Joshua Leonard and Heather Donahuearrive in Burkittsville and interview local citizens.

October 21st 1994
Filmmakers head into the woods

October 25th 1994
APB is issued and Josh's car is found later in the day parked on Black Rock Road.

™

The Sheriff and police scramble to action immediately after the news spreads.
Heather age 22 Joshua 23 Michael 24
Last seen camping in the Black Hills Forrest area, near Burkittsville.
Missing persons flyer is posted by the sheriff throughout Fredericks County following the filmmakers' disappearance.

October 26th 1994
The Maryland State Police launch their search of the Black Hills area, an operation that lasts ten days and includes up to one hundred men aided by dogs, helicopters, and even a fly over by a Department of Defence Satellite.

November 5th 1994
The search is called off after 33,000 man hours fail to find a trace of the filmmakers or any of their gear.

October 16th 1995
The filmmakers' duffel was found containing film cans, DAT tapes, video cassettes, a Hi-8 video camera, Heather's journal and a CP-16 film camera. Professor David Mercer and his students from the University of Maryland's Anthropology Department discovered the bag buried under the foundation of a 100-year-old cabin.

The uncut footage was taken to Haxan films who edited together the final film.
[6]

For months an ingenious website teaser campaign fired the imaginations of America's youth. Was this actually real? Did three kids really go into the woods, shoot this movie, and then vanish leaving scarcely a trace?

A group of unknown first time filmmakers took an inventive premise, a $31,000 budget and Eduardo Sanchez and Daniel Myrick running around in the woods at night scaring the hell out of the actors. The result was 83 minutes of harrowing convincing horror and the most profitable movie in history based on return of investment: it grossed $140.5 million at the domestic US box office alone. Without a star name, a flashy soundtrack or a high body count 'The Blair Witch Project' became a cultural phenomenon.

At the core of the movie is the basic fact that Americans generally find the woods, at night, a scary place. They are mostly used to being indoors or at least in brightly lit cities. If you abandon folks in the wilds they rapidly lose the plot - lost and afraid of the dark with someone or something after them. Then there is the Blair Witch herself. An unseen supernatural force - the latest incarnation of the dark goddess - still stalking the woods two hundred years after her death.

Successful movies almost all spawn a sequel and 'Blair Witch 2: Book of Shadows' promptly appeared. It was released on Halloween night 2000 and was directed by award-winning documentary director Joe Berlinger (Brother's Keeper).

above:
The Blair Witch Project

(The "Stickman" sigil is a registered trademark of Artisan Pictures Inc.)

Everyone has his or her favourite things. A favourite hat, favourite time of year, dessert, Bond girl, song, Marx brother... My favourite movie set at Halloween?

'Nightshade. That's quite a name.'

'And only fitting,' said Will Halloway. 'I was born one minute before midnight, October thirtieth, Jim was born one minute after midnight, which makes it October thirty-first.'

'Hallowe'en,' said Jim.

By their voices, the boys had told the tale all their lives, proud of their mothers, living house next to house, running for the hospital together, bringing sons into the world seconds apart; one light, one dark. There was a history of mutual celebration behind them. Each year Will lit the candles on a single cake at one minute to midnight. Jim, at one minute after, with the last day of the month begun, blew them out.

[Ray Bradbury, Something Wicked This Way Comes, Walt Disney Picture 1983]

It's not the best movie ever but there is just something about it. Ghostly trains screeching into town in the dead of night, the oranges and reds of fiery fall leaves and the deliciously weird Dark's Pandemonium Carnival where all your forbidden desires and dreams come true. With a fine cast including Jason Robards, Jonathan Pryce, Diane Ladd and Pam Grier the director Jack Clayton creates a spellbinding work of dark fantasy where good and evil meet and fight like the Seelie and Unseelie Courts made flesh. If you haven't seen it go see it and once you have - go buy the book too.

First of all, it was October, a rare month for boys. Not that all months aren't rare. But there be bad and good, as the pirates say. Take September, a bad month: school begins. Consider August, a good month: school hasn't begun yet. July, well, July's really fine: there's no chance in the world for school. June, no doubting it, June's the best of all, for the school doors spring wide and September's a billion years away.

But you take October, now. School's been on a month and you're riding easier in the reins, jogging along. You got time to think of the garbage you'll dump on old man Prickett's porch, or the hairy-ape costume you'll wear to the YMCA the last night of the month. And if it's around October twentieth and everything smoky-smelling and the sky orange and ash grey at twilight, it seems Hallowe'en will never come in a fall of broomsticks and a soft flap of bedsheets around corners.

But one strange wild dark long year, Hallowe'en came early. One year Hallowe'en came on October 24th, three hours after midnight. At that time, James Nightshade of 97 Oak Street was thirteen years, eleven months, twenty-three days old. Next door, William Halloway was thirteen years, eleven months, twenty-four days old. Both touched toward fourteen; it almost trembled in their hands. And that was the October week when they grew up overnight, and were never so young any more...

[7]

Bradbury has long been a master of truly dark and fantastic literature. Halloween seems to be just about his favourite time of year. In 'the Hallowe'en Tree' Bradbury takes us on a strange and dangerous journey to discover the roots of All Hallows' Eve.

A thousand pumpkin smiles look down from the Halloween Tree, and twice-times-a-thousand fresh-cut eyes glare and wink and blink, as Carapace Clavicle Moundshroud leads the eight children - no nine; but where is Pipkin? - on a leaf-tossed, kite-flying, gliding, broomstick-riding trip to learn the secret of All Hallow's Eve. And they do.
[8]

Unfortunately Bradbury falls in to the trap of American misinformation about Samhain with the non-existent Celtic Druid 'lord of death' although he does an excellent job of bringing the dry and dusty bones of this fictitious deity to life. These are the type of books that plead to be read after dark - under the covers by torchlight.

I came to Bradbury's books quite late on. My childhood was full of Tolkien and C.S. Lewis - Middle Earth and Narnia. The two writers were firm friends and together with some fellow scribes they formed a writing group named 'the Inklings'. They met frequently in the smoky backrooms of pubs in Oxford to read aloud their latest works and discuss them among their peers. There Professor J.R.R. Tolkien recounted his tales of hobbits, orcs and elves - 'The Hobbit' and 'The Lord of the Rings'. The smallest, most unlikely heroes journey to a dreadful mountain to confront their darkest fears and overcome a supernatural evil. 'The Lord of the Rings' trilogy was voted the best book of the 20th century and is set to become a trilogy of blockbusting movies. Listening intently to the old Professor was Charles Williams, who in addition to being a member of the Hermetic Order of the Golden Dawn was writer of occult detective novels - including 'All Hallows' Eve'.

C.S. Lewis had lost and found his faith in Christ. His 'Chronicles of Narnia' have been interpreted as a thinly veiled Christian allegory with Aslan, the lion, as Christ who is sacrificed and rises from the dead. Lewis himself thought differently.

Some people seem to think that I began by asking myself how I could say something about Christianity to children; then fixed on the fairy tale as an instrument; then collected information about child-psychology and decided what age-group I'd write for; then drew up a list of basic Christian truths and hammered out 'allegories' to embody them. This is all pure moonshine. I couldn't write in that way at all.
[C.S. Lewis, 'Sometimes Fairy Stories may say best what's to be said.']

The creation of a fantasy is a magical process - true magic - where an idea appears from nothing and takes on an enchanted life of its own.

At first they were not a story, just pictures... a picture of a Fawn carrying an umbrella and parcels on a snowy ground. ...then suddenly Aslan came bounding into it. I think I had been having a good many dreams of lions about that time. ...I don't believe anyone knows exactly how he 'makes things up'. Making up is a very mysterious thing. When you 'have an idea' could you tell anyone exactly how you thought of it?
[C.S. Lewis, 'It all began with a picture'.]

A writer's art is in taking the pictures in their head and putting them down in words on a page. From page to printer to book shop to bookshelf and into the waiting hands of the reader. Here a second spell is cast as the story leaps from the paper to the mind's eye, and the reader's imagination takes the strings of words once again and turns them into pictures. I did not know it at the time but in the words of C.S. Lewis I was meeting the magical dark Queen of Winter for the very first time.

He looked round him again and decided he did not much like this place, and had almost made up his mind to go home, when he heard, very far off in the wood, a sound of bells. He listened and the sound came nearer and nearer and at last there swept into sight a sledge drawn by two reindeer.

The reindeer were about the size of Shetland ponies and their hair was so white that even the snow hardly looked white compared with them; their branching horns were gilded and shone like something on fire when the sunrise caught them. Their harness was of scarlet leather and covered with bells. On the sledge, driving the reindeer, sat a fat dwarf who would have been about three feet high if he had been standing. He was dressed in polar bear's fur and on his head he wore a red hood with a long gold tassel hanging down from its point; his huge beard covered his knees and served him instead of a rug. But behind him, on a much higher seat in the middle of the sledge sat a very different person - a great lady, taller than any woman that Edmund had ever seen. She also was covered in white fur up to her throat and held a long straight golden wand in her right hand and wore a golden crown on her hear. Her face was white - not merely pale, but white like snow or paper or icing-sugar, except for her very red mouth. It was a beautiful face in other respects, but proud and cold and stern.

The sledge was a fine sight as it came sweeping towards Edmund with bells jingling and the dwarf cracking his whip and the snow flying up on each side of it.

"Stop!" said the Lady, and the dwarf pulled the reindeer up so sharp that they almost sat down. Then they recovered themselves and stood champing their bits and blowing. In the frosty air their breath coming out of their nostrils looked like smoke.

"And what, pray, are you ?" said the Lady.

[9]

Lewis casts as his villain the archetypal witch - the Winter Queen - a pagan goddess who reigns over a frozen land. She is glamorous and terrible, majestic and vicious. An enchanting lady who would lure you on with soft words and sweet smiles then stab you through the heart. Was it Lewis' intention to pit Christianity versus paganism in his battle of light and darkness or did the pictures just magically appear from deep in his subconscious ?

Like many writers C.S. Lewis was very forthright in his views about what was 'healthy' reading material for children.

Those who say children must not be frightened may mean...that we must try to keep out of his mind the knowledge that he is born into a world of death, violence,

above:
Vintage Halloween
card.

wounds, adventure, heroism and cowardice, good and evil... since it is so likely they will meet cruel enemies, let them at least have heard of brave knights and heroic courage. Otherwise you are making their destiny not brighter but darker. Nor do most of us find that violence and bloodshed, in a story, produce any haunting dread in the minds of children. As far as that goes, I side impenitently with the human race against the modern reformer. Let there be wicked kings and beheadings, battle and dungeons, giants and dragons, and let villains be soundly killed at the end of the book. Nothing will persuade me that this causes an ordinary child any kind or degree of fear beyond that what it wants, and needs, to feel. For, of course, it wants to be a little frightened.

[C.S. Lewis, 'On Three ways of writing for children.']

Unfortunately, people who are neither writers nor children have always had a bad habit of expressing their own opinions on what books should be kept from children.

The Bible is clear that in the last days witchcraft and sorcery will be widespread. In fact, it even reveals that many Christians will be caught up in it!

These Harry Potter books are right on time in the end time scenario. We all know it. We all expect it. But it is so sad to watch. It is hard to watch so many young children embracing blatant witchcraft. There was a time when children's fiction stories contained dragons and witches; yet they were always evil. Then things began to change: 20th century fiction and fantasy began to divide witchcraft into the "good magic" and "bad magic". Even magnificently talented writers such as J.R.R. Tolkien (1892-1973) and C.S. Lewis (1898-1963) helped to plant the foundation for sorceries revival in our day. As wise as they were in so many things, they were often very naive in regard to evil and Satan's whole agenda. Tolkien did write about evil goblins; yet he would make the wizard to be a good guy. C.S. Lewis followed this practice by pretending that there is good and bad magic, and that God Himself used the "good" kind. He would make "magicians" (i.e. sorcerers) to be the good guys.

For these reasons, these most wonderful books, filled with deep, Christian insights, deserve to be thrown into the trashcan. What a waste. No parent should allow a child to read such books.

[10]

Few horror movies and even fewer books have ever scared me. I've slept soundly in dark woods and crept round haunted houses without a second thought. I don't particularly like heights or spiders but I can live with them.

But these people scare me.

Never in a hundred thousand years will some people lose their prejudice and fear. They seem incapable of allowing the rest of the world to make up its own mind about what it wants to do and read and see. Sometimes, when you are absolutely fundamentally convinced you are right you end up insisting that everyone else must be wrong.

These Harry Potter books are dangerous because they are ten times more blatant about the so-called wonders and glories of witchcraft and magic; yet they contain

none of the insights or Christian analogies of early children's books. We must beware. The Salem Witch Trials were caused by children playing with divination and witchcraft. The children would have "out-of-body-experiences" and be carried about by men on broomsticks with pointed hats. Many good people were murdered as a result. Sorcery brings evil wherever it goes. It is not just fantasy. We have children killing one another all across the land because they think Satan will give them power if they shed blood. J.K. Rowling needs to hang her head in shame for her irresponsibility. I hope she doesn't think that satan has allowed her to become a multi-millionaire just because she is a talented writer! She is bringing millions of young minds into the occult, and is helping to bring in the Antichrist. If you are a Christian and these words offend you, it is probably because your mind has been seduced by a devil.
[10]

It is bad enough to accuse an author of being inspired by Satan but here her name is being connected to the murder of children. Inaccuracies and misinformation are piled on to try to make a convincing argument: The Salem witch trials have been shown to be the result of ergot fungal poisoning misdiagnosed are 'bewitchment'. Children across America do not kill one another for 'power from Satan'- there are a host of psychological, sociological and developmental circumstances that lead to these murders - alienation and the easy availability of guns are the most obvious attributing factors. It is, of course, impossible to open a closed mind but it is important to let your voice be heard - to speak out against those who would condemn and censor. The same voices that would take Harry Potter out of libraries and schools would happily ban Halloween and probably be glad to see this book put to the flames.

Harry Potter's Hogwarts School of Wizardry and Witchcraft is not the first such establishment to find its way into print. Jill Murphy was only eighteen years old when she wrote 'The Worst Witch,' about Mildred Hubble and her misadventures at Miss Cackle's Academy for Witches. When she finally found a publisher the book was a runaway success leading to two sequels and a spelling book.

'Hallowe'en was celebrated each year in the ruins of an old castle quite near the school. The special fires were lit at sunset, and by dark all the witches and wizards had assembled.

As the sun set, the members of Miss Cackle's Academy were preparing to leave the school. Mildred smoothed her robes, said good-bye to her kitten, put on her hat, grabbed Ethel's broomstick and ran down to the yard. She took a quick look out of the window before leaving the room and saw the fires being lit in the distance. It was very exciting.
[11]

The underlying difference and the reason for the attacks from fundamentalists are the phenomenal success of the Harry Potter books and the accompanying media circus. The religious right have launched a sustained assault on the Harry Potter

books. Joanne Kathleen Rowling has been accused of being a witch and an occultist and of consciously and cynically teaching her black arts to America's children.

The younger generation of pagans show another side. Many dabble in black magic and the other "dark arts" that are so seductively taught at Hogwart's School of Witchcraft and Wizardry. Apart from the fantasy setting and dramatic demonstrations of magic, there is little difference between Harry's skills and the real world of the occult...

> *Among the obvious evils are the practices listed in Deuternomy 18:9-12: witchcraft, sorcery, spellcasting, divination, calling up the dead, etc. In other words, children who delight in Harry's occult world of spells and magic will naturally learn to enjoy evil and crave more. But they cannot "cling to what is good" while they love evil. The two are incompatible.*
[12]

Again we find blanket generalizations, unsubstantiated statements and the propaganda of hate. But this is the opinion of a tiny, if vocal, minority of Christians. The vast majority of Christians are perfectly rational sensible people who enjoy a good read and don't see Satan lurking round every corner.

"As far as I can tell, while no major Christian leader has come out to condemn J.K. Rowling's series, many have given it the thumbs-up. If our readers know of any major Christian leader who has actually told Christians not to read the books, I'd be happy to know about it; but in my research, even those Christians known for criticizing all that is popular culture have been pretty positive about Potter."
[Ted Olsen, ChristianityToday.com]

Joanne K. Rowling has, on occasion, answered her critics.

"On my last U.S. tour I was there over Halloween with my daughter. We were in this hotel room, and three programs in a row were concerned with the question of how we stop our children being frightened by Halloween — three in a row ... I'm sitting there thinking, you are trying to protect children from their own imaginations, and you can't do that. That's how you turn out frightened children, in my opinion. You turn out frightened children by saying, "It's not scary. There's nothing there to frighten you."

> *Kids will get scared and they've got to live through that and then deal with that... A happy child is not one who has never experienced fear or has never been allowed to experience fear."*
[13]

The simple fact is that millions of her books sell worldwide. Weighing that up against a handful of detractors puts a little perspective on their propaganda.

above:
Vintage Halloween
card.

"I am a 57-year-old clergyman and loved the series.
How do you answer fundamentalist clergy objections?"

JKR: "I am sending you a hug across cyberspace. I think you understand that these books are fundamentally moral (that is how I see them, in any case). I'm afraid there are some people who object to seeing magic in a book, per se. And therefore a debate isn't really viable."

"Ms. Rowling, did you have to do any research with real witches, or is all of your material from your imagination?"

JKR: "No, the material is almost all from my imagination. Occasionally I will use a nice, picturesque piece of folklore, which interests me. But real witches... I don't know any!"
[14]

Perhaps unsurprisingly, J.K. Rowling is a fan of Halloween.

Rowling plans to spend Halloween at home in Scotland with her daughter Jessica, 7, who wants to dress as the broomstick-riding hero.
 Says the author: "Halloween, you'd not be surprised to know, is my favourite holiday."
[15]

Things are a bit bad when your books and your motives are attacked on the internet. But when your books are being publicly burnt things have gone from bad to worse.

US church burns 'paranormal' Harry Potter books
A US religious group has burned Harry Potter books, claiming they promote sorcery and witchcraft. Members of the Harvest Assembly of God church in Pittsburgh also burned Pearl Jam and Black Sabbath CDs and videos. The group's bonfire of "paranormal" items also included the Disney videos Hercules and Pinocchio.
[16]

When I first heard about this I couldn't actually quite believe it. Visions of blackened burning pages danced in my head and I turned to Ray Bradbury's 'Fahrenheit 451'.

FAHRENHEIT 451: the temperature at which book paper catches fire and burns.

It was a pleasure to burn.
It was a special pleasure to see things eaten, to see things blackened and changed...

As I read more online articles about the burning I actually felt sick.

Citing love of God, Butler County church burns books, tapes, CDs ...
Absent was any noticeable pornography or discernible idols, unless you count a small, black and beige stuffed dragon or a coconut carved with the face of a pink pig.

Participants and spectators were limited to about 30 people, most of whom were church members. No protesters showed up to express outrage or indignation about the pyre.

And as the group stood around the well-controlled, mid-sized fire at one end of the gravel-covered church parking lot, there was more of a church camp feel to the gathering, with a guitar strumming as a group of teen-agers helped to lead songs such as "Amazing Grace," "Father of Creation" and "Lord, I Lift Your Name on High."

"I would have liked to have seen more visitors," said the Rev. George Bender as he stood and watched the flames crackle and flying embers mix with snow flurries. "But I think it worked out well. It made us pay attention to what we're doing. It made us think about how to focus on the Lord as we should. I hope people understand our intentions, though I know some won't."...
[17]

At this point I hasten to add if any right-wing fundamentalist religious groups would like to burn this book - make sure you buy it first. If you'd like to burn it by the truckload please contact our distributors for a bulk purchase at wholesale prices.

Book burning is such a strong symbolic act that a little church's action made national, then international news.

Purging Flame
Church Members Burn Harry Potter, Other Books 'Against God'
March 26 - The congregation of a church in suburban Pittsburgh gathered around a bonfire Sunday night to burn Harry Potter books, Disney videos, rock CDs and literature from other religions, purging their lives of things they felt stood between them and their faith.

"Our purpose comes out of the Bible," the Rev. George Bender of the Harvest Assembly of God Church in Butler County. "We read in the Bible how people, after they received Jesus Christ as their savior, took things out of their homes and burned them. They [the members of the congregation] received Christ and they willingly did this." The church has a regular Sunday evening service, which does not include a bonfire. But this week the congregation wanted to do a little more, and 35 people brought books, CDs and tapes that they felt were not in keeping with their faith. "We did it in the open so that people would ask why," Bender said, adding that the church has not asked that any of the material they burned be banned from bookstores or libraries, and that even among the congregation there was no pressure to participate. He pointed out that just one-third of the congregation brought things to burn. He said those who participated included a mix of new and longtime members of the church. "There's no such thing as a crusade to deal with other people's things. That's their business," he said. "We believe in the First Amendment, the Second Amendment, and the First Commandment and Second Commandment."

Animated videos such as Pinnochio and Hercules were also among the items thrown in the fire, which also included Pearl Jam and Black Sabbath CDs, and

pamphlets from Jehovah's Witnesses..

The Harry Potter books, so popular with children and parents, have drawn fire from religious leaders before for their depiction of a boy who consorts with wizards and uses magic. "We believe that Harry Potter promotes sorcery, witchcraft-type things, the paranormal, things that are against God," Bender said. "That is really bad."

A spokeswoman for Scholastic, the publisher of the books, said they are more about a child who feels powerless in the world understanding that he can take some control of his life. She said the message sent by burning books is more dangerous than any fable about sorcery could be. "I think burning books is shameful," Scholastic spokeswoman Judy Corman said. "The message is very clear by inference. I think he's saying something very strong."
[ABC news]

There was Hitler torching books in Germany in 1934, rumours of Stalin and his match-people and tinderboxes. Plus long ago, the witch hunts in Salem in 1680, where my ten-times-great-grandmother Mary Bradbury was tried but escaped the burning...it was inevitable that I would hear about the triple burnings of the Alexandrian library, two of which were accidental, one on purpose. Knowing that at nine, I wept. For, strange child that I was, I was already an inhabitant of the high attics and haunted basements of the Carnegie Library in Waukegan, Illinois.
Ray Bradbury
[18]

The spook house, for all its shadows and spectres is just all so much smoke and mirrors. Its horrors aren't really real - they're just phantasms and little frights. Movies are just strips of celluloid and books are just scraps of paper. All the characters are just actors and actresses and ordinary folk in monster suits and all the stories are just words strung together by an author on an old typewriter.

The real horrors of this world are flesh and blood and so everyday and banal that you wouldn't give them a second glance walking down the street. Movies, music, books and TV shows are a soft target for criticism. The creative industry does not have a strong political lobby to defend it like the gun companies. Thousands of children are shot every year - yet the religious right won't speak out against guns. Children starve and live homeless on the streets but you don't find fundamentalists feeding and clothing them. Any fool can destroy - burn a book or condemn a writer - but it is a noble art to create: to tell a story and spread a little joy - to make the world a brighter place than you found it.

above:
Vintage Halloween
card.

Notes

[1] John Carpenter
 Interviewed in Twilight Zone Magazine, November 1982

[2] Gene Powell Internet based Ministry –
 An Independent St Luke Evangelical Christian Church
 http://kids4god.tripod.com/id102.htm

[3] Happy Halloween Magazine Vol 2 Issue 3
 www.halloweenalliance.com/magazine

[4] Treehouse of Horror VIII
 www.thesimpsons.com

[5] Tim Burton's Nightmare Before Christmas
 The Film – The Art – The Vision
 Frank Thompson, Boxtree, 1993

[6] www.blairwitch.com

[7] Something Wicked This Way Comes
 Ray Bradbury, London Corgi 1975

[8] The Halloween Tree
 Ray Bradbury, Hart-Davis MacGibbon, 1973

[9] The Lion, the Witch and the Wardrobe
 C.S. Lewis, London, Geoffrey Bles, 1950

[10] www.daveandangel.com/CRN/Harry_Potter.html

[11] The Worst Witch
 Jill Murphy, Young Puffin Modern Classics

[12] www.crossroad.to/text/articles/Harry&Witchcraft.htm

[13] Hot Type with Evan Solomon, Interview with J.K. Rowling
 aired on CBC on Thursday, July 13th, 2000
 www.cbc4kids.ca/general/words/harrypottercontest/default.html

[14] Virtual interview with J. K. Rowling
 Barnes & Noble.com and Yahoo! Friday, October 20th,

[15] A Conversation with J.K. Rowling
 Time Canada Magazine October 30th 2000 Vol. 156 No. 18

[16] www.Ananova.com

[17] Carmen J. Lee, Education Writer
 Pittsburgh Post-Gazette Monday, March 26, 2001

[18] 'Burning Bright' a preface to Fahrenheit 451
 Ray Bradbury, London Corgi 1973

opposite:
Venetian Carnival Mask

(image © Mark Oxbrow)

above:
All Hallows Fair
A depiction of the All
Hallows cattle fair in
Edinburgh, by James
Howe.

(Courtesy of City of Edinburgh
Museums and Art Galleries.
With thanks to David
Patterson.)

right:
**A Hallow Fair
Scene**
By Walter Geikie.

(Courtesy of City of Edinburgh
Museums and Art Galleries.
With thanks to David
Patterson.)

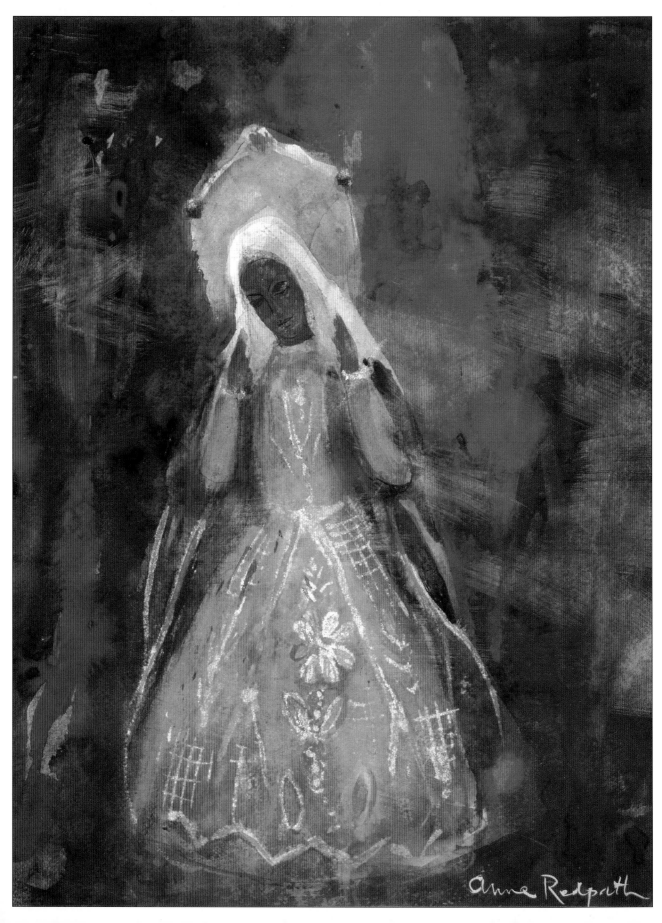

Anne Redpath

Los Dias de Muertos

We come only to sleep, only to dream
It is not true that we come to live on this earth
We become as spring weeds, we grow green and the petals of our hearts
Our body is a plant in flower, it gives flowers and it dies away
[1]

The Earth is a curious place, filled with a dizzying variety of cultures and customs. But throughout history and all around the world humankind has developed rites to deal with the dead and has often created rituals to honour the departed. As October gives way to November and summer inevitably fades to winter there are a host of festivals to mark the turning of the seasons and numerous cultures set an extra place at the table for their nearest and dearest dead relatives.

Most famous are the Mexican 'Los Dias de Muertos' – 'the Days of the Dead' – but the spirits of departed ancestors are expected in many lands: from the West Indies to Brittany in France.

It is the Black Month, the Month of the Dead, the Month of those that do not come home, the Season of widows.

Out upon the furrowed sea the wind swings in gusts and lifts the waves back into a mist of drifting spray: on the beaches the sweeping tides eat into the sand with huge devouring rushes. Sometimes there is driftwood flung ashore; sometimes, when certain currents meet and run landwards, it is other than driftwood that is flung up, pallid and terrible, a wet shapelessness upon the stretching beach, a horror dropping from the lip of the sea...
[2]

Brittany is wonderful. The people are warm and friendly. They drink excellent cider and eat endless combinations of savoury and sweet crepes. I was lucky enough to spend some time in Brittany last year – warm wet autumn days in the enchanted forest of Broceliande. The native Bretons have an active thriving Celtic culture – their own local language and a wild collection of folk songs and dances. They are a little part of France that is forever Celtic and it seems only right that they have their own traditions associated with the coming winter.

opposite:
Madonna From Mexico
by Anne Redpath. The figure of the Black Madonna appears around the world: from altars in Mexico and Haiti to cathedrals in Spain and France.

(Courtesy of City of Edinburgh Museums and Art Galleries. With thanks to David Patterson.)

And this is the Day of the Dead...

And presently there is a sound of singing that comes nearer, a grave sweet singing that is small in the large environment of air; there is a huddle of black and white (folk in mourning clothes) upon the stretching beach, the shining of taper, of swinging censer, of uplifted crucifix, and between the little burying-ground and the wide grey sea there is a kneeling crowd that prays for those that lie in either.

The night gathers early into an intolerable blackness: the wind stirs with a distant whispering, and the air is thick and wet without rain. There is no moon, no light babble of water breaking on the shore, no star answering star from sky and sea; there is no sound of life in all the small dark village, only a close unbroken blackness set interminably between earth and heaven. The people within the house have shut themselves fearfully and with prayers into their great enclosed beds: the evening-meal has been eaten in silence, the fire covered over and lights put out; but the platters are not set away, nor the food lifted from the tables. All is left for those who will enter presently by the door which to-night stands open from dusk till dawn; when in the midst of darkness and at the unspeakable hour, there comes the sound of feet, which are not feet, upon the causeway, and the touch of hands, which are not hands, upon the latch; when those that wake and pray and listen will hear about them the pale thin voices that chant the Song of the Dead...

It is the night when the Dead walk, and there is no light anywhere...

The Dead have rent their tombs and have come out from them like breath from between the lips; they have come without sound, without shape, they are but a Blackness within the blackness of the night.

...let no light wander, for the Dead are abroad; let no light stray, lest in it the Dead should see themselves!

[2]

November is the Black Month in Brittany – the Month of the Dead. As winter closed in the folk of the coastal villages looked to the sea for the return of their fishermen. They sailed off in summer, out to Iceland and deep into the Atlantic, and no word of them would have made it home. Their families waited and watched and prayed but if the boats didn't return by the Black Month they were never expected to return. *'November makes more widows than all the rest of the year.'*

It is not we, the poor and maim, we the aged and desolate, who go from door to door in the midst of the night, but the Dead; it is not we who cry unto you, but the Dead. For the Dead are come into us and we are the Dead; O ye within the houses, wake and pray, for the Dead are at your doors!

The night is black, surely the night is very black, and the wind sings about the keyholes; the night is full of fingers that touch and feet that come and go, and of voices crying upon the thresholds. Blackness within the blackness, and the graves rent open. O ye within the houses, wake and pray, and hear the Song of the Souls.

[2]

On the Eve of All Souls the spirits of the dead are thought to return home to visit their living relatives. The dead are voiceless and shapeless so they enter into the bodies of

the beggars. These poor folk are known as the 'Children of God', and they go from house to house, singing the song of the souls, eating the food set aside for them and leaving a blessing on each home.

There is a very similar festival held in Japan - it is commonly celebrated from August 13th to the 15th. 'O-bon' is a Buddhist festival where the ancestors' spirits are invited to come back home and spend some time with their living family.

Homes are cleaned in preparation for their spectral visitors and a pathway is swept between the grave and the threshold of the house. On the 13th an altar is set up with a variety of foods as offerings. Small fires are set to welcome the spirit home. They line the pathway from the grave to the house to guide them on their journey. Japanese folk who are spending 'O-bon' far from their ancestral homes will usually just make a small fire on their porch or balcony. Sometimes a priest is hired to visit and chant prayers for the dead. As night falls on the 15th fires are once more lit to send the spirits off to return to their graves.

The 'O-bon' festival is not thought of as 'spooky' or 'scary' - its religious rites are a solemn duty but they are accompanied by celebrations with festivals, food stalls and special 'bon' dances in the evenings.

In Poland there is 'Zaduszki' – the celebrations honouring the dead. The Poles have long honoured the spirits of their ancestors for their wisdom. Twice every year it is thought that the spirits of the dead have a natural gateway and an easier journey to the world of the living - just before the spring Equinox, and around the time of Hallowe'en.

In some parts of Poland candles are set adrift on the rivers to send messages from the living to the dead. Half walnut shells are filled with wax, set alight and sent floating off on the surface of the water.

'Zaduszki' is a most solemn festival. The Poles believe they must aid the souls of their dead relatives who return to visit their homes. Empty places are set around the dinner table. 'Kasza' - roasted buckwheat groats - and special rye bread, shaped in long loaves like a wrapped body are prepared and vodka is poured for the expected guest.

Candles are lit to light the spirits way and invocations are said to the dead, asking them to join in the feast and welcoming them home. As the meal is served the dead are always the first to have their plate and their glass filled. Later that evening the family walks to the graveyard with the remnants of the meal. By the graves they light candles and leave offerings of food. Here, as in Brittany, it is the beggars who would step out of the shadows to be given food and vodka in return for passing messages to the dead.

Across the world in Haiti this is the time of the Vodou rite associated with the Gede and their most famous Lwa, Baron Samedi.

above:
Vintage Halloween card.

223

Voodoo is the common English term, but contemporary authors are using Vodou to emphasise the African origins. Vodou is a religion that thrives in modern Haiti. Haiti has been falsely portrayed as a dark isle full of black magic where the dead are resurrected to walk as zombies, and Voodoo priests conduct blood sacrifices and even cannibalism. In reality Vodou is a religion born of the blending of African beliefs from Benin and Catholicism.

Beliefs and ritual hold a culture together. When a group comes under attack or is subjugated it will seek comfort and strength in its traditions. When millions of Africans were taken from their homelands and enslaved in the New World, their rites, beliefs and their spirits journeyed with them. There in the West Indies these African practises were reborn with various new names and forms: Cuba's Santeria, Trinidad's Shango cult, Brazil's Macumba, Jamaica's Obeayisne and Haiti's Vodou.

In the Fou language spoken in Benin, Vodou means an invisible force, terrible and mysterious, which can meddle in human affairs at any time. Vodou temples are decorated with murals depicting Catholic saints as evocations of Vodou spirits; so for example St. Patrick driving the snakes from Ireland evokes Dambala Wèdo symbolised as the rainbow/snake.

In Haiti, the African beliefs mingled with the Catholicism of the French colonialists to form a syncretic religion, one that combined significant elements of each religion to create a harmonious whole. The white plantation owners forbade their slaves to practice their native religions on pain of torture and death, and they baptized all slaves as Catholics. Catholicism became superimposed on African rites and beliefs, which the slaves still practiced in secret or masked as harmless dances and parties. [3]

A 'Lwa' is a spirit of the Vodou religion. The Lwa have family groups and are associated with particular natural realms (earth, air, fire and water), places (crossroads, springs, cemeteries, fields, etc.), colours, days, symbols (snake-rainbow, black cross, heart, mirror. etc.), trees (citron, cotton, calabush, cherry, banana, etc.) and types of possession (violent, obscene, dressed as peasant, imitating a snake, seductive, etc.).

One of these family groups is the Gede - the spirits of the Dead. In November the Gede dance in Haiti. The first and second of November are practically considered a national holiday. At the head of the family is the most famous Vodou Lwa of all – Baron Samedi.

My introduction to Vodou is identical to most folks – when I was a child I saw the James Bond movie 'Live and Let Die' on the TV. 'Live and Let Die' has many delights - a kick ass theme tune from Paul McCartney's Wings, a young Jane Seymour as the voodoo priestess Solitaire, the Tarot of the Witches and of course Baron Samedi. The Baron was ably played by a madly cackling Geoffrey Holder, who manages to be simultaneously sinister, manic, magical and licentious. As an aside – the Tarot of the

above:
Vintage Halloween card.

Witches was painted by the Scottish artist Fergus Hall, and according to the box they are 'Ideal for tarot readings in covens and private meetings by Witches, Warlocks and followers of the Occult.' Not exactly a sympathetic and historically accurate portrayal of the Vodou religion but hey – it's lots of fun nonetheless.

Baron Samedi is always a well-dressed dandy, resplendent in his top hat, black undertaker's tailcoat and dark sunglasses. He twirls a cane, has a legendary fondness for rum and smokes cigars. His symbol is the cross upon a tomb. He is the guardian of the crossroads and the cemetery; he knows the secrets of magic and has power over zombies. He is also a bawdy Lwa who performs the sexually explicit 'banda' dance and speaks in obscenities.

Among my friends is the film director Richard Stanley who travelled to Haiti last year to film 'Last of the Medicine Men' for the BBC. He recounted his adventures for Fortean Times magazine.

The importance of respecting the dead is evident here at every turn. Funerals are held on a lavish and costly scale complete with professional mourners whose wailing cries only add to the pervading sense of anguish as we thread our way deeper into the necropolis to light our candles and pour water three time before a blackened cross, the seat of Baron Samedi, a guardian of the graveyard and head of the Gede spirit family, the spirits of the dead, associated with the colours of black and purple.
[4]

On November 2nd candles are lit in graveyards to Baron Samedi and he eats his favourite foods – hot peppers, salt herrings and roasted bananas. He is a dark and ludicrous clown whose erotic dances and rude words bring laughter and merriment. Among the peasant class the Baron is a welcome presence and he has travelled with the Haitians to America – to New Orleans, Miami, Galveston, Charleston and New York City. Around the world the Vodou religion has well over fifty million followers.

One of the really excellent things about writing a book is you get to make contact with all sorts of wonderfully interesting people. One of these is Brandi C. Kelley from Voodoo Authentica of New Orleans. She was kind enough to fill me in on her own story and VOODOOFEST:

After a lifelong interest in Voodoo, which began at the age of 4, I started working at the Voodoo Museum when I was around 15 and participated in all of the rituals and re-enactments there as a snake dancer. I began to long for more authenticity in these programs and ceremonies. So, I did the research on African, Haitian and early New Orleans Voodoo Rituals, involved authentic Priests and Priestesses from the area and on Halloween, in 1990, while still at the Museum, organized a large public ritual at Congo Square in Armstrong Park to honor the Ancestors.

Congo Square is significant as it has been a ritual gathering space for hundreds of years. Under the Napoleonic Code, the slaves here had a 'Free Day' -

Sunday, and would gather together at Congo Square to sing, dance, congregate & worship. These gatherings turned into tourist attractions, even back then. People would come from all over to watch (to 'gawk' really at) the ritual dances, such as the Calinda and Yanvalou (the snake dance) and to hear the beautiful, creative music that was so foreign to them. Many people say that the Square is the birthplace of Jazz. So, the Halloween rituals I put together at Congo Square are truly done in honor of them and all the Benevolent Spirits and Ancestral Forces. We give special high praise to the "Spiritual Mother of New Orleans," the great Voodoo Queen Marie Laveau.

In 1996, I left the Museum to begin my business Voodoo Authentica, but have always continued the rituals. I began to have the idea for an evolution of the Halloween ritual into a whole day and evening festival at Congo Square that would be free to the public and VOODOOFEST was born. The first one was in 1999 and began with a ritual in which libations were poured to the Spirits and Ancestors to give thanks for all of their blessings and to ask for their continued support. Booths manned by local practitioners, spiritualists, psychics and artisans greeted people with a variety of unique local folkart, potions, gris gris, Voodoo dolls, incense, drums, music and other exotic items. Our educational corner offered lectures, programs and question & answer sessions with some of the city's and nation's leading Voodoo practitioners, artists & historians. The food can't go without mentioning — lots of delicious homemade local delicacies like Jambalaya, Gumbo, pralines and sweet potato pies, to mention a few, tempted our visitors, who came from all over the city, country and world. On the main stage, there was entertainment all day - Presentations of African Dance, Stiltwalking, Brazilian Dance and of course, lots of Blues & Soul music. Internationally renowned locals like Jazz & Blues great Harold Batiste & Coco Robicheaux were true highlights. At 7 PM, our closing Ancestral ritual begins - offerings are made to the Spirits, including beautiful song & dance. The ritual closes with a snake dance, done in honor of the great Marie Laveau & Damballah, the ancient serpent Spirit of balance & wisdom.

It was a beautiful event and VOODOOFEST 2000 went even better; many of the previous year's visitors from around the globe joined us again in celebration. We hope VOODOOFEST 2001 will be the best yet – it is free to the public and held annually at Congo Square in Armstrong Park on Halloween, October 31st, from 12 Noon-7pm.
[5]

At the beginning of November the cemeteries are full of life in Mexico. Family graves are carefully cleaned, weeded and repaired. Brightly painted crypts and graves are decorated with rainbows of paper streamers and 'cempazuchiles' - golden marigolds – till the cemeteries are a riot of colours. For these are los Dias de Muertos – the Days of the Dead.

On the nights of October 31st and November 1st the streets are filled with the sounds and spectacle of the 'comparsas'. Masked mummers, accompanied by musicians, enact comic plays and walk from house to house performing for a little food or drink.

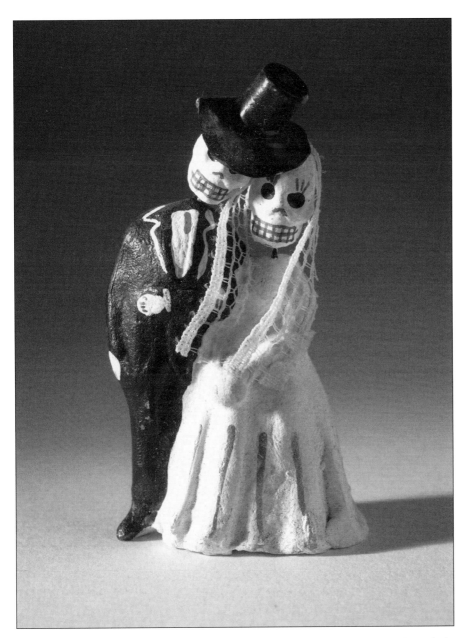

left:
'Calaca'
Handmade Mexican figures. From the exhibition 'Heaven and Hell and Other Worlds of the Dead'.

(Courtesy of City of Edinburgh Museums and Art Galleries. With thanks to David Patterson.)

In homes throughout Mexico families construct private altars dedicated to their departed loved ones. These may be anything from a simple table with a few of the deceased's personal possessions to a hugely elaborate and expensive display that has been handmade by professionals.

The altars or 'ofrendas' as they are called, also usually contain objects made from sugar or sugar sculpture known as 'alfenique.' These objects may be small animals, such as lambs, miniature plates of food (enchiladas with mole), small coffins, often with pop-up skeletons, and of course, the sugar skull or 'calavera.'
[6]

below:
'Calavera's.
Illustrations by the
mexican artist Jose
Guadalupe Posada.

bottom left:
Calavera depicting
contemporary
newspapers as
skeleton cyclists,
c. 1889-1895.

bottom right:
Calavera of Don
Quijote.

Pictures of the deceased family members are surrounded by flowers, fruit, 'pan de muerto' - bread of the dead, sugar skulls and 'papel picado' - Mexican cut-paper - and eventually illuminated by slow burning candles. The smell of their favourite foods guides the family spirits back to their former homes. November 1st is dedicated to the memory of deceased infants and children. The souls of departed children, often known as 'angelitos' - little angels, are offered toys and candy. The adult dead are honoured on November 2nd and given 'pulque' or 'aguardiente' - traditional Mexican alcohol.

On the morning of November 2nd families gather in the cemeteries for a traditional feast. This is El Dias de los Muertos – the Day of the Dead – when the spirits of family members are honoured and remembered. But this is not a mournful time – these are festive gatherings with eating and drinking, music and laughter – this is a time to celebrate the lives of the departed.

The Day of the Dead can range from a very important cultural event, with definite social and economic responsibilities for participants (exhibiting the socially equalizing behavior that social anthropologists would call redistributive feasting, e.g. on the island of Janitzio in Michoacan state), to a religious observance featuring actual worship of the dead (whether Catholic priests recognize/approve of it or not, e.g., Cuilapan, Oaxaca), to simply a uniquely Mexican holiday characterized by special foods and confections (the case in all large cities.)
[7]

'Calavera' means simply skull in Spanish. Of all the calaveras the most famous is Catrina, the Elegant Lady. She was created by the painter and illustrator José Guadalupe Posada, who lived at the beginning of last century. Calavera Catrina is a most elegantly dressed skeleton, she was based upon the ladies who were imitating French fashions and she is easily recognized by her great feathered hat.

Mexico seems to dance with death - writer Octavio Paz notes that a Mexican does not fear death. He "...chases after it, mocks it, courts it, hugs it, sleeps with it; it is his favorite plaything and his most lasting love." Market stalls are filled with sugar skulls and little 'calaca' figures - miniature handmade models of living skeletons in everyday life: as musicians or pool players, married couples or masked Mexican wrestlers...

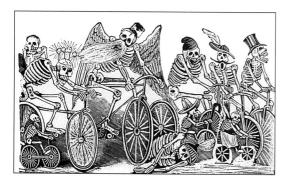 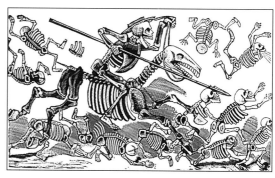

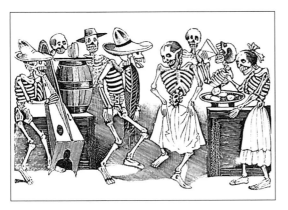 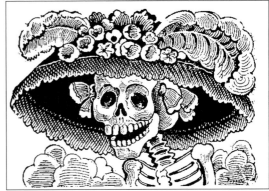

The Days of the Dead allow young and old to come together and remember their friends and relatives who have passed on. As a community they celebrate the lives of their loved ones rather than mourn their passing. They have an annual festival that allows them to face up to death and turn the skull and bones of the reaper into masks, toys and sugar candy. Mortality is not a taboo subject to be feared and avoided – it is faced head on and turned into a vibrant affirmation of life. Would any of us really want our loved ones to grieve without end at our passing? Would you not prefer that they came together to drink, dance and revel in the life that you had and the way that your existence touched their hearts?

above:
'Calavera's.
Illustrations by the mexican artist Jose Guadalupe Posada.

top left:
Gran fandango y francachela de todas las calaveras.
(Happy dance and wild party of all the skeletons.)

top right:
La calavera catrina.
The calavera of the fashionable lady.

Notes

[1] Netzahualcoyotl, poet-king of Texcoco, 13th century, trans.
The Days of the Dead
John Greenleigh and Rosalind Rosoff Beimler, Pomegranate, 1998

[2] The Black Month
M. Clothilde Balfour, The Evergreen – Winter 1896-7

[3] Do You Do Voodoo?
Shannon R. Turlington, Garnet Publishing, 1999

[4] The White Darkness
Richard Stanley, Fortean Times Magazine, November 2000 FT140
http://www.forteantimes.com/articles/140_voodoo.shtml

[5] Brandi C. Kelley, Voodoo Authentica of New Orleans
WWW.VOODOOSHOP.COM

[6] El Dias de los Muertos
Alexis Ciurczak and José Range, http://muertos.palomar.edu/

[7] What do Mexicans celebrate on the "Day of the Dead?"
Rhicardo J. Salvador
http://www.public.iastate.edu/~rjsalvad/scmfaq/muertos.html

Treat or Trick?

New Jersey. The night before Halloween, 1938.
Imagine if you will, sitting in a comfy armchair with a nice cup of tea and a cookie. You're having a quiet night in with some soothing music on the radio. You tune in to WABC, smile, sit back and relax. The song is suddenly interrupted and as you listen to the News broadcasters you splutter into your teacup. Martians are invading Earth - an alien object has landed in Grover's Mill, New Jersey...

"Good heavens, something's wriggling out of the shadow like a gray snake. Now it's another one, and another. They look like tentacles to me. There, I can see the thing's body. It's large as a bear and it glistens like wet leather. But that face. It... it's indescribable. I can hardly force myself to keep looking at it. The eyes are black and gleam like a serpent. The mouth is V-shaped with saliva dripping from its rimless lips that seem to quiver and pulsate... The thing is rising up. The crowd falls back. They've seen enough. This is the most extraordinary experience. I can't find words. I'm pulling this microphone with me as I talk. I'll have to stop the description until I've taken a new position. Hold on, will you please, I'll be back in a minute."
[1]

Orson Welles had told listeners at the start of the broadcast that they were listening to a fictional radio drama. Unfortunately the thousands of listeners who tuned in late believed their ears and thought that New Jersey was indeed being decimated by an alien attack. Welles simply said that this was "the Mercury Theater's own radio version of dressing up in a sheet and jumping out of a bush and saying 'boo!'"

The October 31st New York Times reported on the chaos the dramatisation inspired:

Radio Listeners in Panic, Taking War Drama as Fact
Many Flee Homes to Escape 'Gas Raid From Mars'
Phone Calls Swamp Police at Broadcast of Wells Fantasy
A wave of mass hysteria seized thousands of radio listeners between 8:15 and 9:30 o'clock last night when a broadcast of a dramatization of H.G. Wells's fantasy, "The War of the Worlds," led thousands to believe that an interplanetary conflict had started with invading Martians spreading wide death and destruction in New Jersey and New York.

The broadcast, which disrupted households, interrupted religious services, created traffic jams and clogged communications systems, was made by Orson Welles, who as the radio character, "The Shadow," used to give "the creeps" to countless child listeners. This time at least a score of adults required medical treatment for shock and hysteria...

...Throughout New York families left their homes, some to flee to near-by parks. Thousands of persons called the police, newspapers and radio stations here and in other cities of the United States and Canada seeking advice on protective measures against the raids....The radio play, as presented, was to simulate a regular radio program with a "break-in" for the material of the play. The radio listeners, apparently, missed or did not listen to the introduction, which was: "The Columbia Broadcasting System and its affiliated stations present Orson Welles and the Mercury Theatre on the Air in 'The War of the Worlds' by H.G. Wells."

They also failed to associate the program with the newspaper listing of the program, announced as "Today: 8:00-9:00—Play: H.G. Wells's 'War of the Worlds'—WABC." They ignored three additional announcements made during the broadcast emphasizing its fictional nature.

Mr. Welles opened the program with a description of the series of which it is a part. The simulated program began. A weather report was given, prosaically. An announcer remarked that the program would be continued from a hotel, with dance music. For a few moments a dance program was given in the usual manner. Then there was a "break-in" with a "flash" about a professor at an observatory noting a series of gas explosions on the planet Mars...

The level of public concern prompted messages to the New York and New Jersey Police.

"To all receivers: Station WABC informs us that the broadcast just concluded over that station was a dramatization of a play. No cause for alarm."

The New Jersey State Police teletype:
"Note to all receivers—WABC broadcast as drama re this section being attacked by residents of Mars. Imaginary affair."

CBS - the Columbia Broadcasting System issued a statement saying that the broadcast was an adaptation of H.G. Wells's 'War of the Worlds' which 'followed the original closely, but to make the imaginary details more interesting to American listeners the adapter, Orson Welles, substituted an American locale for the English scenes of the story.'

Naturally, it was neither Columbia's nor the Mercury Theatre's intention to mislead any one, and when it became evident that a part of the audience had been disturbed by the performance five announcements were read over the network later in the evening to reassure those listeners.

Orson Welles himself expressed regret and said, "It was our thought that perhaps people might be bored or annoyed at hearing a tale so improbable."

The reputation of Halloween as mischief night had been spectacularly underlined.

Only two years before the 'War of the Worlds' broadcast there had been a very strange and solemn event - a final séance to try to contact the departed spirit of Harry Houdini. Houdini was the greatest escapologist and magician of his age. He was an international star who had astonished audiences around the globe on stage and on screen. Off stage he had been bitterly hurt by the death of his mother and had sought the comfort of spiritualism only to find its practitioners were bogus.

Spiritualism is nothing more or less than mental intoxication, the intoxication of words, of feelings and suggested beliefs. Intoxication of any sort when it becomes a habit is injurious to the body but intoxication of the mind is always fatal to the mind. We have prohibition of alcohol, we have prohibition of drugs, but we have no law to prevent these human leeches from sucking every bit of reason and common sense from their victims. It ought to be stopped, it must be stopped, and it would seem that the multiplicity of exposures and the multitude of prosecutions that have followed rational investigation should be sufficient to justify, yes, demand legislation for the complete annihilation of a cult built on false pretence, flimsy hearsay evidence, and the absurdity of accepting an optical illusion as fact.
Harry Houdini
[2]

Houdini was a man of action and testified against mediums in Washington D.C.

On 26 February 1926 the bill (forbidding fortune telling in the District of Columbia) came up for hearing before a House of Representatives committee and Houdini travelled to Washington to testify. The public gallery was crowded with mediums, palm readers, astrologers, crystal gazers and lucky charm sellers... Houdini took the stand; he gave his occupation as author, psychic investigator, and mysterious entertainer. In his evidence he gave details of his investigations, saying that in thirty-five years he had never found a genuine medium and now did not believe that one existed.
[3]

Harry Houdini died two and half years later at 1.26 a.m. 31st October 1926 - Halloween.

Before his death he made a solemn pact with his wife Beth that whichever of them died first would come back to the other with a message if they could. They agreed on some secret words that would confirm it was real. Each year she held a séance on Halloween, the anniversary of Houdini's death. The last séance was held on 31st October 1936, the tenth anniversary. She maintained, to the end of her life, that she had never received a communication from Houdini after his death.

By the end of the 1930s towns were holding Halloween parades and mischief could mean quite expensive vandalism. Halloween greetings cards with seasonal figures of

witches, black cats and pumpkins were stocked in the five and dime stores and the practice of Trick or Treating and carving Jack O' Lanterns were encouraged. In time they became firmly embedded in American culture and as Halloween became more and more a festival for children the pranks were reduced to toilet paper strewn trees and bananas in tail pipes. World War Two brought American GIs to Great Britain. 'Over-sexed and over here.' They brought with them American Halloween customs and very soon the British Wrens were helping US Airmen to carve grinning faces into pumpkins.

Halloween has steadily increased in popularity over the decades. The baby boom created a vast generation of Trick or Treaters. By the time the baby boomers had grown up to be parents themselves Halloween was a boom time for business as well. Halloween has become second only to Christmas in dollars spent. It is estimated that Americans spent over $6 billion celebrating Halloween last year

The National Confectioners Association expected Americans to spend about $1.93 billion on candy for Halloween. A quarter of all the candy sold in America each year is purchased between September 15th and November 10th. Halloween has the highest candy sales of any US holiday.

Hersheys are a huge American candy manufacturer. They have a special Halloween website at - http://www.trickortreats.com/ - and the festival even turns up in the company's annual report.

Seasonal Sales ... A Growing Trend

Seasonal confectionery items, including such products as Valentine hearts, chocolate Easter bunnies, Halloween Trick-or-Treat candy and Christmas novelties, had a great year in 2000. In fact, looking at the total confectionery industry, seasonal sales grew 8 percent at retail last year, more than twice the rate of the confectionery category as a whole, and accounted for 34 percent of total industry sales.

Halloween

The trend in Halloween sales continues to shift toward bigger bags of branded items as well as snack-size items (both branded and assortments). The Halloween season at Hershey actually is a combination of four sub-seasons referred to as Back-to-School/Halloween, or B.T.S.H. for short. The sub-seasons are Great Outdoors, Back-to-School, Fall Harvest and, the largest of the four, Halloween. The 2000 B.T.S.H. season was Hershey's largest ever in terms of retail sales.
[4]

After candy, the second biggest Halloween money-spinners are costumes. The market for Halloween costumes is estimated as being worth between $1 and $1.5 billion. In 1999 the Second Annual American Express Retail Index on Halloween Shopping reported that 78% of children planned to wear a costume while 28% of adults planned to dress up too. The National Costumers Association survey of costume shops reported that October sales average more than 30% of annual sales.

above:
Vintage Halloween
card.

The other $2.5 billion includes everything from pumpkins and house decorations to greeting cards and seasonal movies. Hallmark Cards, Inc. reported that Halloween is the eighth largest holiday for greeting card sales, with sales of approximately 23 to 26 million cards, which translates into about $50 million. They offer 250 different Halloween cards.

I must thank the Halloween Association for gathering these statistics. (Their website address is http://www.halloweenassn.org/index.html)

Halloween has become a cornerstone of the American year. It is now as American as mom, apple pie and, of course, ice cream...

Happy Halloween from...
Ben & Jerry's - Vermont's Finest. Ice Cream & Frozen Yoghurt. ™

Happy Halloween from...
Dead & Buried's - Vermont's Finest I Scream & Frozen Ogres

Most folks familiar with Ben & Jerry's know full well that Halloween is our absolutely most way-favorite time of year...
[5]

The Ben & Jerry's Halloween website has a wealth of online fun and games and demonstrates that this is a fun festival for all the family. It also has its heart in the right place and puts the UNICEF hyperlink at the top of its links page.

For more than half a century UNICEF has been helping governments, communities and families to make the world a better place for children. The United Nations International Children's Emergency Fund is now known simply as the United Nations Children's Fund but has kept UNICEF. Since 1955 UNICEF have undertaken a major fundraising drive every year at Halloween.

Trick-or-Treat for UNICEF is a key component of UNICEF's efforts to raise money to help children in need. More than 2 million young ambassadors participate each year, and over $63 million has been raised from Halloween trick-or-treating since 1955!
[6]

At the end of October you suddenly find that regular TV shows feature a special Halloween episode and products are strangely wrapped with bats, witches and pumpkins on the packaging. It's as though the whole nation is sniggering to itself and secretly grinning at the chance to dress up and pretend to be spooky.

The big theme parks get a seasonal Halloween makeover.

Mickey's Not-So-Scary Halloween Party
Trick-or-Treat throughout the Magic Kingdom® Park in your favorite spooky

costume. Be awestruck by the beauty of a special Halloween Fireworks display or experience your favorite Disney characters in a unique not-so-scary Parade at the most magical Halloween party, sure to leave your entire family smiling.
[7]

Party in the streets or scare yourself senseless at Universal Studios Florida Premier Events. Throughout the year you'll find events like Mardi Gras and Halloween Horror Nights to make your Studio experience even more unique...

You'll have a scream at the most spooktacular event of the year: Halloween Horror Nights. Experience all new haunted mazes, "live" entertainment, a spine-tingling parade, and a backlot swarming with monsters, mutants, maniacs and more.
[8]

But as well as the vast industry players like Disney and Universal there are dozens of independent Halloween theme parks and Haunted attractions.

The International Association of Haunted Attractions is a non-profit organization dedicated to the advancement of Haunted Attractions through communication, education and information.

"IAHA was founded two years ago to give a forum for haunters to network, exchange ideas, learn, brainstorm and inspire one another. Young or old, professional or amateur, large or small operations-all are welcome to draw from the vast pool of knowledge and experience this group represents."
D'Ann Dagen, IAHA President
[9]

No matter which state you are in you will find that there is someone creating an extra special Halloween frightfest. One of the best is the 'Headless Horseman Hayrides and Haunted House' in New York state. They are justifiably proud of their reputation. 'Named Number One Hayride in America by American Airlines Magazine, and Named Number One Outdoor Haunt in America by Fright Times Magazine.'

The entertainment includes a thirty-five minute hayride, corn maze, two haunted houses, two food concessions, Ghoulish Gifts, and The Magic Moon Gift Shop. Professional technicians from the lighting, costume, sound, set design, and special effects industries, assist with the creation of the show each year. The family oriented event is presented on 44 landscaped acres, which includes a historic 200-year-old stone residence, orchards, ponds, fields and wooded areas with mountain views.

On the Hayride, the riders will encounter The Curse of the Headless Horseman. Evil has returned to the Hudson Valley. A graduate student in archeology, while researching his famous ancestor Icabod Crane, unearthed a strange box from deep beneath an ancient Indian burial ground. Inside he found the skull of a hessian mercenary, known in local folklore as the Headless Horseman. Now as Halloween approaches, the Horseman rides again, surrounded by the

spirits of the dead and bloodthirsty horrors from myth and legend. Will the Horseman find his head and return to the grave, or remove yours for his growing collection. Will you survive The Curse of the Headless Horseman?
[10]

You only have to read a few of the emails in their guest book to realise that there is a thriving community of fantastically loopy folk that come together every year to work at the park and scare the public senseless. The discerning public appreciate the extra effort put into their frights...

"PREPARE TO SCREAM AND HAVE THE TIME OF YOUR LIFE!!!
A bunch of us went last year for the first time and we were all havin' fun on the hayride when all of a sudden... from the pitch black and I mean pitch... someone/something grabbed my ankle and tried to yank me off the flatbed.
I NEVER SCREAMED SO LOUD IN MY LIFE AND LOVED IT!!!"
Brenda, Kingston, NY USA

"Being that Halloween is my favorite holiday, I've been anxiously waiting for October to roll around!! I've been visiting the Headless Horseman Hayride for at least 5 years now. Last year I went every weekend! Every year it gets better and better. Keep up the good work and thanks for keeping us entertained! P.S. I'm usually with the group of freaks that gets dressed up (costumes) for your hayride - such a blast!"
Eleanor, Pleasant Valley, NY USA
[10]

Jon Keeyes is the epitome of the creative guy brought up on a healthy diet of Halloween fun. He is the director of a new movie entitled 'American Nightmare'. It is the latest in a prestigious line of scary movies to be set on Halloween night.

"American Nightmare is a film about a group of friends on Halloween night that share their greatest fears on a pirate radio show. Unbeknownst to them, a serial killer is listening and begins a deadly game of cat-and-mouse bringing their greatest fears to life throughout the night.

I chose to set it on Halloween because of the feel that Halloween evokes in people. People associate Halloween with horror movies, spooks, and things that go bump in the night. Halloween was an easy format to use as a foundation of fear since we never really know who is sitting next to us when they are in costume."
[Jon Keeyes]

Halloween was a special, magical time in Jon's childhood. Each year his aunt would hold incredible Halloween parties and put together a homemade Haunted House. Across small town USA it is the creative energy of thousands of enthusiastic amateurs that truly brings Halloween to life. The time and effort they spend to turn their homes into phantasmagoric spook houses is incredible - but the thrilled screams and fun memories make it all worthwhile.

"She would decorate the entire house for Halloween, have scary music playing and family and friends from near and far would show up for the party. In her large garage, the Halloween house was built with white sheets for walls creating corridors that mazed through the garage. Each section was done up with monsters, tricks and gimmicks. As the years progressed, the Halloween house grew and expanded, gradually spilling out into further corridors out on the patio.

As my cousins and I grew older, we became part of the Halloween house, not only helping her build it but acting in it as well... at one of my aunt's Halloween parties we walled her entire patio with black tarps and turned it into a mausoleum filled with funeral wreaths, candelabras, etc. And we built a life-size casket that I was in, done up like a zombie. This was the last room of the Halloween house after people had finished going through the garage portion. The last group of the night were three teenage girls from the neighborhood. Lying in the coffin, I heard them enter the room and start getting scared waiting for someone to leap out of the coffin, so I bided my time. Eventually, one of them got brave enough to approach the coffin. I leapt up and the girls screamed hysterically. They tripped over each other trying to get out and ended up falling into the tarped walls, pulling everything down around them. No one got hurt, and later that night they all had a great laugh out of how scared they had gotten.

My Aunt did these Halloween houses for nearly fifteen years and is still a legend in her neighborhood for them. This last Halloween I sat on my porch reflecting about the Halloweens of my childhood. These were magical days when the two worlds of the human and spirit collided. Days when children still roamed the streets in droves on the hunt for candy, and teenagers hid in bushes to scare the children with ghostly sounds. I feel sad that the current generation has to experience trick-or-treating in malls but feel grateful that at least I have some of those 'magical movie memories' of Halloween to fill my dreams."

[Jon Keeyes, Director, American Nightmare - http://www.american-nightmare.com]

As C.S. Lewis so eloquently said 'Nothing will persuade me that this causes an ordinary child any kind or degree of fear beyond that what it wants, and needs, to feel. For, of course, it wants to be a little frightened.' Halloween allows children and grown ups to face scary things and maybe even their own fear of mortality in a safe, fun environment. The true evils of this world are not a bunch of fairytale witches, vampires and ghosts - they are the promotion of hatred, bigotry and the attempts to limit personal freedom.

Unfortunately the Abundant Life Christian Center of Denver has recently subverted the Haunted House idea; they created 'Hell House' to depict modern scenes featuring subjects ranging from abortion to school massacres. Here the fun Halloween Haunted Attraction is transformed into another vehicle for religious propaganda.

Hell House is an outreach event that is structured very much like a typical haunted house that people visit and walk through. Hell House capitalizes on the "Halloween" time of year, when people are thinking about ghoulish and frightening images and attractions. Hell House is much more than a haunted house. It is a spiritually-based

adventure that takes people on a 7-scene journey, each scene depicting the hell and destruction that Satan and this world can bestow on those who choose to not serve Jesus Christ. Literally, choices that can also have an end result of ushering people into hell.

Hell House is an exciting, contemporary, timely vehicle that shares in dramatic fashion the timeless message that Jesus is the Way, the Truth, and the only Life.

Groups of 20-25 people will tour Hell House with their own personal demon acting as their tour guide. The 7 scenes each last 2-3 minutes.

Scene 1 is a funeral scene of a teenage homosexual boy who has died of AIDS.

Scene 2 is a drunk-driving scene where a father realizes he has just killed his family.

Scene 3 is a teen-suicide.

Scene 4 is a teenage drug usage scene where everyone will be surprised who is really in control.

Scene 5 is a riveting abortion scene.

Then the final two scenes are hell and heaven. In hell the Tour meets Satan himself. Hell will be hot, smoky, loud, visually disturbing, and sensually confusing. Satan will boast that everything they have witnessed in Hell House has been his handiwork, and that he will have their souls, too. They are then rescued out of hell by angels that escort them to heaven where they finally meet Jesus. Before leaving heaven they are given the opportunity to pray a prayer of salvation, and to also visit or pray further with a counselor. It is an unforgettable 20 minutes.

Hell House is cutting edge, it is shocking, it is offensive. But it is Truth. What Satan and his entourage of demons inflict on people through the killing of innocent unborn babies is offensive to the Christian. Convincing the naive and ignorant they are born gay and then sentencing them to a life of bondage and oppression is offensive to the Christian. Teenagers influenced by the poison they listen to through their CD's, telling them over and over again that suicide is the escape they're searching for is offensive to the Christian. Letting societies message that casual drug use is something everybody does is offensive to the Christian. That is why Hell House must be bold. Hollywood is bold.

Tickets are $7.00 per person.

[11]

'Convincing the naive and ignorant they are born gay and then sentencing them to a life of bondage and oppression' may be 'offensive to the Christian' but it is the ignorance and bigotry of some factions of so called Christians that oppresses and breeds intolerance against other peoples lifestyles. I was brought up as a Christian and my mother is an elder in the Church of Scotland. I was taught that Christianity was a religion that was based on love and hope. That true Christians believed in freedom and equality for all people - that they gave to the needy and offered help and compassion not condemnation and prejudice. It is a shame that a few narrow-minded individuals have to do so much harm to the reputation of the Christian religion.

Denver, Oct. 27

A Halloween display at a Texas church featuring a re-enactment of the April massacre at Columbine High School has offended and shocked some of those connected to the attack.

THE "HELL HOUSE" at Trinity Church in Cedar Hill, Texas, features a skit in which young actors dressed in trench coats re-enact the shooting in which 15 were killed and more than 26 were wounded. The skit ends with the gunmen being sent to Hell.

The parent of two Columbine students, Nancy Shakowski, said the Assembly of God church made a poor choice by choosing Columbine as a theme... "I'm repulsed by it," she told the Denver Rocky Mountain News. "I don't know what purpose it serves. My family will live with this forever."

Her daughters, Jill and Courtney, attend the school in Littleton where seniors Eric Harris and Dylan Klebold opened fire with guns and bombs before killing themselves.

Trinity's youth pastor, Tim Ferguson, has said he must scare teen-agers in order to save them from sin and another attack like the one at Columbine.

"Maybe I can make one person think not to do it," he said.

Ferguson told the newspaper the re-enactment is tasteful.

"It's not graphic," he said. "There is no blood."

The skit begins with two boys playing violent computer games and planning an attack, then donning trench coats and going into a library. A girl in the library prays to God before the gunmen kill her and then themselves.

Jesus appears and rewards the girl. The boys are taken to Hell after insisting the attack was "just a game, we didn't think we'd have to pay a price."

The portrayal of the Columbine attack is not unusual for Trinity, which has staged other school shooting scenes over the past several years.

[12]

If just once the same groups that blame computer games and music for shootings would come out and openly condemn the gun industry they might be worthy of some respect.

Thankfully the vast majority of Americans and Christians have a lot more respect for personal freedom and the right to choose and they also see Halloween for what it really is - a lot of fun for young and old alike. But for many Americans Halloween is much more than just a night of fun and fright. For America's pagans Halloween is a major religious holiday often known by the old Celtic name of Samhain. The Wiccan movement in particular has become large enough to gain official recognition in the US military.

Witches in the military? Yes, with official blessing.
Despite objections, Pentagon holds firm.
August 12, 1999
By John Boudreau
Knight Ridder Newspapers

Fairfield, Calif. - In today's military, witches can be all they want to be.

At bases across the country, Wiccans are coming out of their secret covens - with the blessing of the U.S. Department of Defense. They wear pentagram pendants underneath their spit-and-polish camouflage fatigues. They practice candle magic and meditation when off duty. They attend on-base circle rituals, the Wiccan equivalent of a Roman Catholic mass.

"The base provided us with what we wanted - equality," said Staff Sgt. Loye Pourner, a high priest, military lean and ramrod straight, and leader of the Travis Air Force Base circle. "We didn't want special treatment. We wanted exactly what everybody else had."

Of course, compromise is sometimes required. Wiccans don't practice base rituals "skyclad," their sacred term for nudity.

From the Bible to Shakespeare, witches have received a bad rap, pagans say. After all these centuries, they are finally getting some respect - at least in the United States Armed Forces.

But trouble is brewing in this pagan paradise.

National Christian leaders and some members of Congress, after learning of moonlit rituals at Ft. Hood, Texas - America's largest military post - are demanding an end to what they say is satanism in the barracks.

The military, however, is not standing down: It defends the right of those practicing "minority" religions to worship on bases, just like Christians, Jews and Muslims.

Wiccans do not believe in Satan. They embrace pre-Christian paganism; a polytheistic belief in which male and female deities are worshiped and nature is revered.

Pourner went public with his paganism about three years ago. He requested base support for witch rituals. Now he holds circle worships and classes in the chaplain complex.

"We may not agree with them, but we have to defend their right to worship," said senior Master Sgt. Lisa Olsen, a spokeswoman for the Travis chapel services.

Federal courts have recognized Wicca as a faith protected under the First Amendment, said Pentagon spokesman Lt. Col. Tom Begines.

No one knows for sure how many pagans have a connection to the military. John Machate, coordinator of the Military Pagan Network, figures there are 10,000 neopagans - Wiccans and other faiths, such as Asatru and various Druid sects - on active duty, in reserve or the National Guard, and dependents. There are open circles at 11 bases and one ship, and study groups at five other bases, he said.

However, U.S. Air Force Maj. Gen. Richard Carr, chairman of the Armed Forces Chaplains Board, estimates that fewer than 100 people on active duty, out of a force of about 1.4 million people, practice Wicca.

The first official Wiccan ritual held at a U.S. base was in 1992 in Kaiserslautern, Germany, Machate said.

"There are incidents of harassment or discrimination, but they are limited and usually dealt with quickly," he said.'

There has inevitably been opposition to the recognition of Wicca by the military.

above:
Vintage Halloween
card.

"We believe God hates witches," said the Rev. Jack Harvey, pastor of Tabernacle Baptist Church, located near Ft. Hood. "I'd like to see them saved. But they are a bunch of wicked witches. They are pacifists. They are nature lovers. They admit this. We don't need those kinds of people in the Army."

Rather more worrying is the following quote from a rather well known politician.

"I don't think witchcraft is a religion. I would hope the military officials would take a second look at the decision they made."
George W. Bush. Former Governor of Texas, and at the time of writing, President of the United States of America.
[13]

Other vocal groups against the moves include the 'I Love Jesus Worldwide Ministries', 'Traditional Values Coalition' and the 'American Association of Christian Schools'.

When all things are considered it is hardly surprising that the more conservative element of the religious orthodoxy should confront the new faith as a threat. When Christianity began it was similarly dealt with - scorned and attacked - it was also the victim of slurs and hateful propaganda.

VIII. ...Is it not then deplorable that a gang - excuse my vehemence in using strong language for the cause I advocate - a gang, I say, of discredited and proscribed desperadoes band themselves against the gods? Fellows who gather together illiterates from the dregs of the populace and credulous women with the instability natural to their sex, and so organize a rabble of profane conspirators, leagued together by meetings at night and ritual fasts and unnatural repasts, not for any sacred service but for piacular rites, a secret tribe that shuns the light, silent in the open, but talkative in hidden corners; they despise temples as if they were tombs; they spit upon the gods; they jeer at our sacred rites; pitiable themselves, they pity our priests; they despise titles and robes of honour, going themselves half-naked!...
[14]

Around the end of the second century AD Minucius Felix wrote 'The Octavius' which details some of the common charges that the Romans levelled against the Christians. 'The Octavius' does in fact give equal time to the Christian point of view later on. This is a courtesy that contemporary pagans do not receive.

IX. "Already - for ill weeds grow apace - decay of the morals grows from day to day, and throughout the wide world the abominations of this impious confederacy multiply. Root and branch it must be exterminated and accursed. They recognize one another by secret signs and marks; they fall in love almost before they are acquainted; everywhere they introduce a kind of religion of lust, a promiscuous 'brotherhood' and 'sisterhood' by which ordinary fornication, under cover of a hallowed name, is converted to incest. And thus their vain and foolish superstition makes an actual boast of crime. For themselves, were there not some foundation of

truth, shrewd rumor would not impute gross and unmentionable forms of vice. I am told that under some idiotic impulse they consecrate and worship the head of an ass, the meanest of all beasts, a religion worthy of the morals which gave it birth. Others say that they actually reverence the private parts of their director and high priest, and adore his organs as parent of their being. This may be false, but such suspicions naturally attach to their secret and nocturnal rites.

To say that a malefactor put to death for his crimes, the wood of the death-dealing cross, are objects of their veneration is to assign fitting altars to be abandoned wretches and the kind of worship they deserve. Details of the initiation of neophytes are as revolting as they are notorious. An infant, cased in dough to deceive the unsuspecting, is placed beside the person to be initiated. The novice is thereupon induced to inflict what seems to be harmless blows upon the dough, and unintentionally the infant is killed by his unsuspecting blows; The blood - oh, horrible - they lap up greedily; the limbs they tear apart greedily; and over the victim they make league and covenant, and by complicity in guilt pledge themselves to mutual silence.

Such sacred rites are more foul than any sacrilege. Their form of feasting is notorious; it is everyone's mouth, as testified by the speech of our friend at Cirta. On the day appointed they gather at a banquet with all their children, sisters, and mothers, people of either sex and every age. There, after full feasting, when the blood is heated and drink has inflamed the passions of incestuous lust, a dog which has been tied to a lamp is tempted by a morsel thrown beyond the range of his tether to bound forward with a rush. The tell-telling light is upset and extinguished, and in the shameless dark lustful embraces are indiscriminately exchanged; and all alike, if not in act, yet by complicity, are involved in incest, as anything that occurs by the act of individuals results from the common intention.
[14]

The arsenal of accusations has not changed in two thousand years: Ignorance, profanity, secrecy, sexual perversions, infant and animal sacrifice, incest, worshipping false idols, blood drinking and cannibalism. Today neo-paganism is accused of the same atrocities as Christianity was at its birth. Despite the propaganda of the fundamentalists Halloween still thrives.

Halloween is increasingly becoming a festival for adults as well as children. Many Haunted Attractions are aimed squarely at adult audiences and grown ups are rediscovering the joy of dressing up in costume and partying.

The New York Village Halloween Parade is the Mount Everest of Halloween events. Over two million people come to watch and participate in the festivities which involve more than 30 thousand costumed folk, dozens of giant puppets and stiltwalkers, 38 marching bands playing music from around the world and a phantasmagoria of jugglers, dancers and street performers.

This year marks the 27th Anniversary of New York's Village Halloween Parade. Started by a Greenwich Village mask maker and puppeteer Ralph Lee in 1973, the

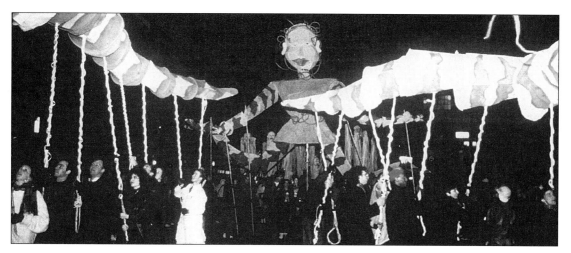

Parade began as a walk from house to house in Mr. Lee's neighborhood for his children and their friends. After the second year of this local promenade, Theatre for the New City asked Ralph Lee to produce the event on a larger scale as part of their City in the Streets program. That year the Parade went through many more streets in Greenwich Village and attracted a larger participation because of the involvement of the Theatre. After that the Parade grew like Topsy, attracting more and more participants and spectators over the years. After the third year the Parade formed itself into a not-for-profit arts organization, discontinued its association with Theatre for the New City and produced the Parade on its own. Today the Parade is the largest grass roots celebration of its kind in the country.
[15]

From humble beginnings the Parade snowballed into a gigantic spectacular. The founding concept of the Parade was that everyone would dress up and be an active participant - there would be no mere spectators. This has always been at the heart of Halloween - you do not simply consume - you create.

Gradually, however, the number of people watching the Parade became greater than the number walking in it, and adjustments had to be made for the larger numbers of people standing along the sidelines and watching. After the 9th year, when the crowd had reached the size of 100,000, the Parade's originator retired and asked Celebration Artist and Theatre Director, Jeanne Fleming, a long-time participant in the Parade, to continue the tradition. She began working closely with the local Community Board, residents, merchants, schools, community centers, and the Police to ensure the continued grass-roots, small "Village" aspect of the event, while at the same time preparing for its future growth.' ...In 1993 Mayor David M. Dinkins recognised the Parade for its role in "bringing the City together" and declared October 24-31 to be 'Halloweek' in New York City in perpetuity.
[15]

Over the years the subversive edge of what was principally a celebration of gay culture has remained. The Parade has inevitably had its highs and lows but has

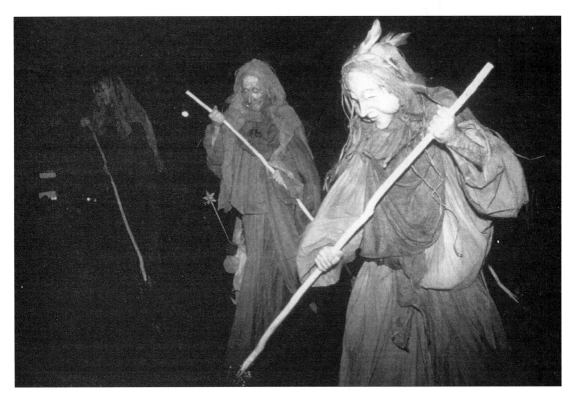

remained faithful to its roots. As AIDS struck the gay community in New York the Halloween Parade with its themes of death and the celebration of life gained a new poignancy. Lou Reed wrote a song called 'The Halloween Parade' where he mourns the passing of so many familiar faces - taken before their time.

Only one parade captures New York as the truly unruly, smartass, media-mad, unshockable, incredibly resourceful, unfailingly humorous, irreverent but tolerant, tangled mass it is: the Halloween Parade in Greenwich Village, naturally.
[Elle Magazine]

The importance of the Halloween Parade cannot be overestimated. For that one night the whole of New York comes together to party but throughout the year outreach work is going on behind the scenes with numerous community groups getting unique opportunities to learn carnival skills and creative festival arts.

This pageant evokes the muses. It explodes in a forest of colors and a sea of smiles onto blocks of dazzled onlookers. The New Yorkers lining the streets are doused in a living waterfall of freedom. The pageant is liberation for lifestyles, cultures, and individuals who are given the chance for one night to show themselves as they wish to be seen.
[16]

Unlike other Halloween events in countless towns and cities the New York Halloween Parade grew from a tiny community seed. It was never a big municipal corporate

affair designed to increase tourist revenues - it was a spontaneous act of fun - a festival for and by the diverse inhabitants of New York. The fact that the festivities now account for a $60 million boost to tourism is just an extra bonus.

Because of its beginnings in the artistic community of Greenwich Village and its invitation to all who wish to look into their imaginations and step out into the streets, the Parade is the most broadly representative event in the nation including everyone - regardless of race, age, sexual orientation or ethnic background - in a night of joyous celebration of themselves, the City, and the creative imagination...

Over the course of its history, the Parade has developed visual images of Halloween and its traditions that have joined forces with the sounds of the City - African, Brazilian, Dixieland, Irish, Jewish, Italian, Caribbean, Chinese, Mexican and Japanese to name just a few of the 38 different types of music in the Parade. This fusion of images and rhythms has fostered a new brand of Carnival, uniquely reflecting the diverse community from which it springs.

[15]

Edinburgh has for many years had a huge grass roots celebration on the eve of May. The Beltane Fire Festival is a glorious loopy extravaganza that has grown to capacity with about 300 participants and 15,000 spectators. [www.beltane.org] It was rekindled out of disenchantment with the political landscape of Thatcher's Britain. As the Criminal Justice Bill sought to restrict gatherings Beltane thrived and protested through the ecstatic rites of carnival. Through the campaign for a Scottish Parliament which was centred at the foot of Calton Hill the Beltane fires were burning on its summit and when the Tory party was finally voted out we went staggering to the polling booths still painted mad colours and reeking of wood-smoke. We survived the old government and saw in Scottish devolution. Amid the chaos and raw energy that Beltane generates I came up with a wee suggestion. Why don't we do a festival at Halloween too?

That year the Samhuinn Festival was born. It started life as a little event nestled behind the Tron Church on the High Street. Over the last few years it has spiralled in size and now we fill Parliament Square in the shadow of St. Giles Cathedral. There was a consensus opinion that I had probably lost the plot when I suggested that we start at Edinburgh Castle Esplanade and parade down the Royal Mile to Parliament Square.

The main event that takes place on the Esplanade is the Military Tattoo. The Royal Mile is the historic heart of the city with cobbled streets and medieval wynds and closes. Parliament Square is surrounded by the pillars of the establishment - St. Giles is the city's largest Cathedral, the High Court, the Advocates Library and offices of the Scottish Parliament. Were we really going to get away with raucous drumming, running about dressed like lewd gargoyles, painted funny colours and brandishing fiery torches?

As the saying goes: if you don't ask - you don't get....

Dear Mr Oxbrow

EDINBURGH CASTLE - USE OF ESPLANADE, 31 OCTOBER 1996

Thank you for your letter of 2 October.

I am pleased to confirm our approval to your request to use Edinburgh Castle Esplanade as a gathering point for a torchlit procession on Thursday 31 October 1996 from 9.30 pm to 10 pm.

This approval is given subject to your acceptance of the standard conditions detailed in the enclosed indemnity forms. Please sign and return one copy - the other is for your retention.

In addition, the following specific conditions will apply:-

1. Any litter generated by the event must be cleared by the organisers.

2. Any instruction given by a Historic Scotland representative must be strictly observed.

3. Please ensure that the torches are not lit on the esplanade.

Due to the large number of people involved, we will require a member of staff to be present. This will amount to £16 plus VAT and will be invoiced to you after the event. Should you wish to discuss your detailed requirements further, please contact Mr Neil Young, Castle Manager (Tel: 0131 —- ——).

I look forward to receiving the completed indemnity form together with your acceptance of the additional conditions.

Yours sincerely

CLAIRE SMITH Events Assistant

cc: Mr N Young, Edinburgh Castle

You should have seen the grin on my face when that letter arrived. Samhuinn has become a magical festival: a massive collaborative effort with hundreds of individuals coming together to perform and produce the event. They work wonders on a tiny budget - like cultural alchemists turning lead to gold. Beltane and Samhuinn are wholly voluntary - no one is ever paid and everyone gives their time, energy and expertise for free. We have a thrilling community that lives on throughout the year and has led to happy couples and bouncing babies. These festivals are models of what do-it-yourself culture can accomplish and Halloween has always been about doing it yourself.

The secret history of Halloween is a weird and tangled web with many cultures and faiths meeting and mingling to spawn a hybrid holiday. It has been in turn a religious and a secular festival and has come full circle to re-discover its roots as a life affirming celebration. Its rites, rituals and traditions have never been carved in stone and have developed and evolved through every generation - so that Halloween has always been an engaging contemporary experience. It has been deliberately attacked, derided, condemned and plagued by misinformation and pet theories, yet it is more popular now than at any time in its whole history. On Halloween night men, women and children meet the grinning skeletal spectre of death, face to face, and what do we do? We embrace our fears, dance with the dead and invite him in to the party... Treat or Trick?... Treat.

Notes

[1] 1938 Mercury Theater broadcast of H.G. Wells's 'War of the Worlds'

[2] A magician among the spirits
 Harry Houdini, New York & London, 1924

[3] Death and the Magician
 Raymond Fitzsimmons, Hamish Hamilton ltd. 1980

[4] http://www.hersheys.com/index.shtml

[5] http://www.benjerry.com/halloween/

[6] http://www.supportunicef.org/halloween/

[7] http://disneyworld.disney.go.com/

[8] http://www.universalstudios.com/themeparks/

[9] http://www.iahaweb.com/

[10] http://www.headlesshorseman.com/

[11] http://www.alccdenver.com/

[12] http://www.imedia2000.com/halloween.html

[13] Interviewed on ABC's Good Morning America
 1999-JUN-24 by Peggy Wehmeyer
 online source - http://www.religioustolerance.com

[14] Minucius Felix, 'Octavius'
 Translated by G. H. Rendall and W. C. A. Kerr, Cambridge, Mass. 1931

[15] http://www.halloween-nyc.com/

[16] NYU Performance Studies Journal
 Professor Greg Steinbrenner

above:
Vintage Halloween
card.

Post Mortem

'Afterword' didn't seem terribly appropriate and 'postscript' wasn't exactly right either, so welcome to the 'post-mortem'. Imagine the festival of Halloween as a merry grinning corpse: the all-singing, all-dancing living dead laid out on the autopsy slab so we can rummage around in its innards. In this book we've been on a quest to the dark heart of Halloween's history – examined the where's, why's, when's and how's of winter's eve. We've found cavorting skeletons using rib cages for xylophones, hooded goddesses hiding in the shadows, faeries and witches flying by moonlight and graves covered in bright golden marigolds. Now we'll face the dead and see what secrets they can tell us.

When I began to research Halloween I came across the same inaccuracies and misinformation time and again. One antiquated reference leads to hundreds of years and hundreds of quotations perpetuating a mistake like a little snowball rolling down a hill getting bigger and bigger till it's the size of a house. In this 'post-mortem' I'll tackle some of these falsehoods and hopefully melt some of the bigger 'snowballs'.

First up and by far the most enduring nonsense about Halloween is the sorry tale of 'Samhain – the Druid God of Death.' You'll find him on the web pages of virtually every anti-Halloween site and on the lips of every fundamentalist spouting fire and brimstone about the 'evils' of the holiday. The fiction is simple – the Druids worshipped a God of death named Samhain who was a huge scythe wielding, black cloak wearing skeleton whose festival at Halloween was marked by human sacrifice and this dire deity came down to us as the grim reaper. It's an entertaining wee tale, marred only by its total lack of anything resembling an actual fact or even a half-truth. The following quotes are quite typical of the religious right's misinformation:

The Feast of Samhain was a fearsome night, a dreaded night, a night in which great bonfires were lit to Samana the Lord of Death, the dark Aryan god who was known as the Grim Reaper, the leader of the ancestral Ghosts.
[1]

The origin of Halloween is the Celtic Festival of Samhain, lord of death and evil spirits... Druid priests led the people in diabolical worship ceremonies in which horses, cats, black sheep, oxen, human beings and other offerings were rounded up,

stuffed into wicker cages and burned to death. This was done to appease Samhain and keep spirits from harming them. It is clear to see that HALLOWEEN HAS ALWAYS BEEN A CELEBRATION OF DEATH.
[2]

Actually - if you've read any of this book and not just skipped to the end then you should know by now that HALLOWEEN WAS <u>NEVER</u> A CELEBRATION OF DEATH FOR 'THE CELTS'. It isn't even a celebration of death now – it is, in many cultures, a time to remember ancestors and friends that have passed on but is not 'a celebration of death'. The problem may well lie in the fact that many fundamentalist evangelical Christians are not only anti-Halloween but also anti-Catholic. All Hallows is a Catholic festival and considering the amount of abuse leveled at Catholicism and the Pope it is perhaps unsurprising that Halloween gets caught in the firing line.

Thankfully not all Christians are intolerant or seek to spread religious hate material.

Nothing in the extant literature or in the archaeological finds supports the notion that there ever existed a god of the dead known as Samam (sometimes spelled, 'Samhain,' pronounced 'sow-en'), though hundreds of gods' names are known. Rather, Saman or Samhain is the name of the festival itself. It means 'summer's end' and merely referred to the end of one year and the beginning of the new.
[3]

I took the time to talk to a few Celtic scholars, including the head of the Celtic Studies Department at Edinburgh University, and they all agreed that there was no evidence whatsoever for a 'Samhain, Druid God of Death'. He is a being entirely without substance – conjured from a couple of 19th century quotes from books that were discredited decades ago.

The sources of information that Satanic Panickers use are extremely few:

Books written over a century ago, especially 'Two Babylons or the Papal Worship', a work of nasty anti-Catholic propaganda written in 1873 by Alexander Hislop, and a book by a man named Godfrey Higgins, 'The Celtic Druids', published in 1827
 [...and] Decades-old editions of encyclopedias which simply quote Hislop or Higgins.
[4]

Higgins's book - *The Celtic Druids; or, An Attempt to shew, that the Druids were the priests of oriental colonies who emigrated from India, and were the introducers of the first or Cadmean system of letters, and the builders of Stonehenge, of Carnac, and of other cyclopean works, in Asia and Europe* – is particularly entertaining. Grossly inaccurate and out of date but still entertaining and worryingly still in print – which seems a terrible injustice when so many wonderful books are out of print. Higgins says of the night of Samhan:

This solemnity was consecrated by the Druids, to the intercession of the living for the souls of those who had died the year preceding, or in the current year. For, according to their doctrine, Samhan called before him these souls, and passed them to the mansions of the blessed, or returned them to a re-existence here, as a punishment for their crimes. He was also called Bal-Sab or Lord of Death. It was probably this epithet which induced the commentator to call Samhan by the name of Ceisil, which, in modern Irish, means devil.
[5]

A review on Amazon.com sums it up nicely.

Vicki Copeland from Colorado Springs, CO
The text is dreadful, but what can you expect from a book that was written some 200 years ago! There have been a lot of advances in Celtic archaeology since then. But the illustrations which are old steel engravings of the megalithic sites are absolutely worth the price.

Nice pictures – shame about the text.

Halloween has been burdened with a reputation of being the 'Night of the Dead'. This has been blamed falsely on 'the Celts' but they had nothing to do with it. So the question is whether there is anything particularly bizarre about Halloween night - is there something especially dark and spooky about October 31st? Is it just the lingering shadow of the festivals of All Saints and All Souls that led to a thousand ghost stories and the enduring character of Halloween as a 'dark night'? Just how does Halloween keep its strange and morbid reputation?

Throughout the years there have been some dark events that have, by curious coincidence, fallen at Halloween time and have left a piece of their shadow behind.

In 1828 Edinburgh was cursed by the activities of body snatchers. Under the cover of darkness men would creep into graveyards to dig up the recently buried dead. They carried the corpses from their caskets and sold them to anatomists to be dissected in lecture theatres before classes of medical students. As relatives began to watch over their departed loved ones by night and graves were covered with hefty stone slabs the business of supplying fresh bodies became increasingly difficult.

Burke and Hare hit upon a novel solution. Rather than going to the effort of digging up the recently deceased they began to meet the demand for fresh bodies - by murdering their own. By the end of October they had killed sixteen men and women and sold their corpses to Dr. Knox, a respectable medical professional. On Halloween night 1828 they committed their last murder - killing an old lady named Mary Docherty. Next morning her dead body was discovered hidden beneath a bed. As the police were being sought Burke and Hare snuck Mary's corpse out of the flat in a tea chest. Burke and his wife were quickly arrested and told conflicting stories to the police. An anonymous tip off led to the discovery of Mary Docherty's body in Dr.

Knox's classrooms. Hare was soon arrested and turned King's Evidence - testifying against Burke. Burke was later executed by hanging and his body was itself dissected in an anatomy lesson.

In America by 1900 Halloween was becoming a dangerous night. The poor and disaffected took out their frustration at overcrowding in the cities by random acts of mischief but in the first two decades of the 20th century their pranks became more destructive and dangerous. They went from switching shop signs and tipping over outhouses to vandalising property and committing acts of random violence. In reaction, groups like the Boy Scouts, local committees and neighborhood groups started campaigns to encourage positive alternatives and by the 1930s Halloween became a night when children went house to house collecting little treats as rewards for their good behaviour.

From 1927 to 1929 there was an artificial boom in American stocks and shares. On 24th October 1929 the New York Stock Exchange saw 13 million shares change hands as panic selling began. The panic spread and 16 million shares were sold on 'Black Tuesday' – 29th October. The Wall Street crash ruined shareholders, broke banks and businesses and led to the Great Depression.

In 1947, exactly twenty years after 'Black Tuesday' Adrian Scott was summoned to appear before the House Committee on Un-American Activities. He was asked to answer questions about Communist influence on the motion picture industry. His lack of testimony resulted in his prosecution for contempt of court, a year in prison and over sixteen years of blacklisting. Scott was one of the 'Hollywood Ten' – one director and nine screen writers who claimed their Fifth Amendment right and refused to testify.

'Mike', the first Hydrogen bomb ever was exploded on November 1st 1952 at 7.15am. The H-bomb or Thermonuclear bomb created a mushroom cloud 8 miles across and 27 miles high over Enewetok – a circular atoll in the central Pacific. 'Mike' was the first ever megaton yield explosion – it vaporized 80 million tons of earth. Ten years later the world was facing nuclear holocaust as the Cuban Missile Crisis threaten to escalate. On Wednesday October 24th 1962 Defcon 2 is declared - only one stage from all-out war.

But Halloween hasn't just been a time for death, chaos, panic, persecutions and nuclear brinkmanship. During the 1968 Democratic rally for the 'New Coalition for Humphrey-Muskie' came a moment of pure Halloween mischief. At the Manhattan Center on West 34th Street actress Shelley Winters was presiding as mistress of ceremonies. She had just introduced the main speaker, John Kenneth Galbraith, when a dozen 'Yippies' in raincoats jumped onto the stage shouting "Humbug! Humbug!" They proceeded to dump a pig's head on the speaker's lectern, whipped off their raincoats flashing their naked bodies the audience and promptly ran off pursued by security guards. Shelley Winters stood on the stage screaming hysterically.

above:
Vintage Halloween card.

The fear of Communism was an altogether less healthy form of hysteria. Half a century after the House Committee on Un-American Activities hearings a commemorative event was held. On October 27th 1997 the American Federation of Television and Radio Artists (AFTRA), Directors Guild of America (DGA), Screen Actors Guild (SAG) and Writers Guild of America, west (WGAw) came together at the Academy of Motion Picture Arts and Sciences in Beverly Hills, California to remember the injustices that were done and those who stood up to them.

It is a strange coincidence that the last of a group of writers and producers known as 'The Hollywood 10' - Academy Award winning writer Ring Lardner, Jr. - died on October 31st, 2000 - 43 years after he had defied the McCarthy House Un-American Activities Committee. He was blacklisted and imprisoned. Ringgold Wilmer Lardner Jr. went on to earn Oscars for his scripts for 'Woman of the Year' and 'M*A*S*H'.

Bizarrely one man's death certificate was falsified to state he died on Halloween. Anton Szandor LaVey was the notorious High Priest of the Church of Satan. He wrote 'The Satanic Bible' and was a favourite bogeyman of the American media for three decades. When he expired in late October 1997 the rumor grew that Anton had died on Halloween night – his death certificate even recorded that date. Anton, born Howard Stanton Levey, was to put it mildly a flamboyant character who wantonly embroidered his personal history so it seems only fitting that someone should tamper with his death certificate and write in 'October 31st (Halloween)'. An official investigation by City of San Francisco officials determined that Anton Szandor LaVey's actual date of death was October 29th.

Death struck prematurely at one Halloween party on October 28th 2000. Anthony Dwain Lee was shot dead by the LAPD. The 39 year-old Lee was an actor who had turned from gangs to Buddhism. He had appeared in TV shows including 'ER' and 'NYPD Blue' and the Jim Carrey movie 'Liar Liar'. The Police officers were called to the Halloween party at a Hollywood Hills mansion in response to a noise complaint. They fired nine shots at Anthony through a glass door after seeing him holding a rubber replica handgun.

In truth there should not be anything special about any one night in particular. If we had centuries of spooky tales about September 23rd then kids would go Trick or Treating on my birthday. Or would they? It may make no logical sense that out of 365 days one should be weird, but somehow it just is. Maybe it's because Halloween is the threshold between light and dark – between summer and winter. Maybe it's invisible faery folks flying by night or the spirits of our dearly departed but there is definitely something odd about Halloween.

Odd but not bad.
I've left the worst / best for last. Of all the anti-Halloween texts the grand prize for publishing utter nonsense in the face of all common sense must go to Jack T. Chick for his comic book 'Spellbound' and his *Chick Tracts* 'The Trick' and 'Boo!' These are such funny little kitsch booklets that if wasn't for the fact that they spread religious

intolerance, hate propaganda, lies and misinformation they would be quite good fun. Luckily for the forces of truth these publications are brimming over with ridiculously stupid mistakes and laughably incompetent historical incidents.

Halloween started in the British Isles with the Druids. Those guys were really spooky. October 31st was a night of terror called 'Samhain'. That night the druids went house-to-house, taking victims for human sacrifice. In exchange for the victim, they left a Jack O' Lantern... which was supposed to protect the home from the death demons that night... The Lord hates Halloween and its evil origin.
[6]

Er... it's hard to know where to start, and the illustrations are as troublesome as the texts; for example, there is a picture in the comic book 'Spellbound' that depicts a helpless virgin sacrifice being dragged from a castle by dastardly Druids. Basically this is all total rubbish but let's take it bit by bit.

Halloween is a Catholic festival - not a Druidic one.

The Druids may or may not have been spooky but they certainly weren't all 'guys' as there were Druid Priestesses.

October 31st wasn't a night of terror - the feis of Samain was a happy celebratory feast.

No house-to-house - no Druidic Trick or Treat - not ever - not even a little bit.

Druid sacrifices as testified by Julius Caesar were of criminals, not helpless damsels.

Jack O' Lanterns are millennia later than the Druids and pumpkins aren't exactly native to the British Isles...

What death demons??

The Lord quite likes Halloween actually - it's the evening before All Hallows, All Saints Day.

Halloween doesn't have an evil origin.

Oh... and castles were not being built until many centuries after the demise of the Druids.

There are some dark corners of the internet where Jack T. Chick seems to be an open minded, pro-choice, fluffy liberal. Welcome to 'yourgoingtohell.com' – ignoring the fact that it should really be 'you'regoingtohell.com' we find that the site revels in

hotlinks like: Homosexuals click here, Satanist/Witch click here, Whoremongers click here, New-Agers click here, Praying to dead people click here, Tarot Cards and other garbage click here, Perverts and other sickos click here, Catholics click here, Allah worshippers click here, Think Buddha is your God?, and Gothic and Vamp Freaks click here. The site is a good example of misinformed books and old out of date reference works being quoted to back up anti-Halloween propaganda.

What is this holiday? Where did it come from and why is it celebrated? It certainly did not come from the Bible or the early Christian church raised up by Jesus Christ and the apostles (Mt. 16:13-17). Consider what authorities say regarding the origin and practice of Halloween.

Ralph Linton, on page four of his book, 'Halloween Through Twenty Centuries', explains the connection between the current practice of Halloween and a pagan rite practiced by the ancient Druids.

"The American celebration rests upon Scottish and Irish folk customs which can be traced in direct line from pre-Christian times. Although Halloween has become a night of rollicking fun, superstitious spells, and eerie games that people take only half seriously, its beginnings were quite otherwise. The earliest Halloween celebrations were held by the Druids in honor of Samhain, Lord of the Dead, whose festival fell on November 1."

Further, the Encyclopedia Britannica, 11th edition, Volume 12 says:

"It was a Druidic belief that on the eve of this festival, Saman, lord of death, called together the wicked souls that within the past 12 months had been condemned to inhabit the bodies of animals..." (pp. 847-858)

However, among the heathen Druids, Samhain or Saman, is the lord of the dead and that lord is none other than Satan himself! Therefore, when people celebrate the dead, they unknowingly honor the devil!

[7]

I'd hate to give the impression that I believe ALL Christians share these views – even that all Fundamentalist and born-again Christians are extremists and hate propagandists. They are not. There are just as many if not more reasonable, intelligent, well-informed Christians out there – it's just that they tend to be a bit quieter than their hellfire and brimstone neighbours. The following quote comes from one such Christian: Dennis Rupert, the pastor of the New Life Community Church of Stafford.

Every year, right around Halloween, we are treated to an outpouring of literature making false statements about the origins of Halloween. (In years past, I even helped distribute this type of literature to my congregation.) But my research on this subject has found that the Christian Halloween literature is vastly mistaken. Christians are guilty of spreading falsehood (perhaps out of ignorance, but falsehood none the less). Believers do no service to God or to other Christians by creating very frightening fantasies masquerading as historical facts. Sloppy and improper scholarship makes Christians look deceitful. It also makes God appear deceptive to unbelievers.

above:
Vintage Halloween
card.

What I am arguing for is accurate information, rather than falsehood. No, I'm not a "closet pagan." No, I'm not "a wolf in sheep's clothing." No, I haven't "bought into pagan propaganda." I'm a born-again, fundamentalist, Bible-believing, filled with the Spirit Christian (did I use enough labels?) trying to get at the historical truth.

At the Christian college I attended, I was taught that all truth was God's truth and that we don't need to fear truth — whether it comes from secular, pagan, or Christian sources. Over a period of three years I have been reading and talking with folklorists, historians, Christians, pagans, and people from Scotland and Ireland. The origins of Halloween are NOT what most Christian literature teaches. Sorry, no pumpkins with candles of human fat! Sorry, no human sacrifices by evil druids. Sorry, dressing up can't be historically connected to the Celts. Sorry, treat-or-treat is not a Satanist plot to captivate our children.
[8]

But it is an unfortunate fact that the more extreme elements in the religious right do wield a great amount of power in America and influence public opinion. The battle between the anti-Halloween factions and the pro-Halloween folk will not just fade away. Hopefully, with time and education informed dialogues and intelligent conversations can take place instead of name-calling and misinformation. For an excellent essay on Halloween and Evangelical Christians please seek out religioustolerance.org [http://www.religioustolerance.org/hallo_ev.htm]

The internet is also home to literally thousands of pro-Halloween websites. You can find everything from funky costume designs and children's poetry to seasonal recipes for leftover pumpkin innards and guides for turning your home into a haunted Halloween house. There is a bizarre smorgasbord of Halloween clip art with green grinning witches, little black kittens and glowing Jack O' Lanterns. There are academic essays and personal reminiscences, Celtic texts and wiccan rituals. You will be rapidly overwhelmed by hundreds of brightly coloured sites - full of animated dancing skeletons and bubbling gif cauldrons - it can be a bit off-putting but do persevere.

Online is home to a wealth of information and images of the 'Pumpkin Chunkers.' These fantastically eccentric folk design and built immense machines with the sole purpose of launching a pumpkin through the air for the greatest possible distance. This fine art has developed over the years, with mediaeval style mechanical catapults and pneumatic Pumpkin Cannons that can hurl a pumpkin up to three quarters of a mile.

"The hurlers, they're amazing," said Gary Johnson of Celoron about the cannons. "Look at these things. They're monsters."
[9]

There are some real gems out there in cyberspace: created by the vibrant community of Halloween lovers whose infectious enthusiasm shines through their web sites. One of these is Rochelle of the Global Halloween Alliance who I interviewed about her personal experiences of Halloween. [http://www.halloweenalliance.com/]

above:
Vintage Halloween card.

Q: What did you do at Halloween when you were a child?

A: *"The elementary school I attended had an annual costume parade that was a big event. Each room had their own Halloween party, then in the afternoon we would parade through the other classrooms in full costume. As I write this I'm remembering the thrill of assuming a disguise for that one magical day. Even now, the smell of cheap plastic masks pulls me back to these fond memories!*

Trick-or-treat was a ritual in my neighborhood. There were two houses I especially remember. One was always dark and they had spooky music playing from the windows on the second floor. The neighborhood kids were drawn to this house like a magnet and we would congregate and giggle with fright as we timidly approached the "haunted house." The other house was more a safe harbour where the owners provided donuts and small bottles of sweet, fruit flavored soda to the neighborhood kids in their garage. While not scary or typically Halloween in look, it was a great place to gather and talk with kids and parents alike in the area.

When I was eleven, Halloween took on a new meaning for me. My grade school participated in a citywide essay contest. The subject was the history of Halloween. I visited our local bookmobile and, to my delight, there WAS a book on the history of my beloved holiday. I remember retrieving the book and the thrill of discovery as I read of the secret history of Halloween.

That night I hand wrote an essay and entered the contest. While I didn't win, that essay marked the first time I truly enjoyed writing! After writing the essay, I asked, and was granted, permission to host a Halloween party. I designed the invitations for what would be a costume party, decided on a menu and games. It was a small group of friends, probably six or so girlfriends, and took place in our basement. To the extent an eleven year-old can, I tried to create a spooky atmosphere. Little did I realize that 30-some years later I would become the hostess/event planner for the 1st Global Halloween Convergence in Salem, Massachusetts!

I decided I needed a Ph.D. to be a primary researcher...hence the doctorate degree. I had every intention of doing a traditional dissertation but somehow, well, as I like to say...I zigged when I was supposed to zag! By the end of my first year in the program I began to feel panic as I had yet to discover my dissertation topic... Our school offered a side-trip to Salem...my dream come true! Two of my closest classmates and I ventured to Halloween Mecca and I was literally transformed. Although I had ALWAYS loved Halloween, I didn't realize how much I did until that trip to Salem. I was giddy as a kid and felt like I'd died and gone to heaven!

Within a month of that experience I had arranged a telephone conference with the chairman of my dissertation committee to hopefully come to a conclusion about my topic. I thought I'd finally found the perfect topic... the relationship between one's dissertation question and their career path five years post-doctorate. I hypothesized that there was little, if any connection. To my chagrin, my chairperson informed me "Well, of course there's no relationship..."

I was frustrated and heartsick. I responded, "Well, if that's the case... I should be able to research anything I want!" ... Only he would have asked me, "Okay... what do you want to research?" ... "I want to research Halloween!" ... He said, "Okay, what about it?"

And so, my path switched right then and there. I found myself pulled into the holiday's history so much so that my dreams were infused with images of Halloween. There is a mystical connection with Halloween like no other topic for me. Why? I'm not sure. But I do know that for many Halloween fans, this too is the allure.

In time, I decided to do a Halloween business... but doing what?? Fast forward to October 1997. I'm in a store called "Somewhere In Time" that was Victorian in style and offered replicas of items typically seen in the film with Jane Seymour and Christopher Reeves, entitled "Somewhere in Time." While in the store I'm drawn to a small table with a display of newsletters. I discover a fan club for people who LOVE the film; they call themselves INSITE (International Network of Somewhere In Time Enthusiasts). I'm intrigued!! They number 500 and have a newsletter and annual gathering. Incredible! I had no idea so many people, like myself, loved that film. Well... the seed was planted. Within two hours I had come upon the idea to do the same thing... but for Halloween fans. I decided to focus on the publication and make it a magazine. The annual gathering was a MUST and what better place to begin than in Salem. So, the first cover of Happy Halloween Magazine featured a story on Salem's Haunted Happenings and our 1st Annual Global Halloween Convergence took place in August 1999 in Salem. Later, the fan club came into existence, the Halloween Alliance, and provided members with subscription to the magazine, a discount admission to the Convergence, plus discounts with affiliated Halloween vendors.

So... that's essentially how it all began. This year marks the fourth year of our publication and in June we'll be doing the 3rd Global Halloween Convergence in San Jose, California. There's much more to do in the world of Halloween and we continue to be committed to our mission statement of networking people hopelessly in love with Halloween."

Q: What do you do at Halloween today?

A: *"Now I try to extend my Halloween adventures over the entire month of October. That will typically include going to / hosting a party; attending as many community festivals and haunted attractions as I can. For the last 15 years I've created a large display in my front yard beginning on October 1. We have a theme along with two or three "stations" that trick-or-treaters stop at to receive goodies. We have a slightly different custom in my yard. I call it "reverse trick-or-treat." Briefly, kids (and their parents) have to pay an admission to enter the yard. Depending on the theme, the admission varies but ALWAYS the last choice is a piece of chocolate.*

For example, one year we paid homage to the brilliant author Edgar Allan Poe. Our sign for the yard (so folks know what the theme is) simply said "Nevermore." The admission price sign read: the feather of a black raven, a candelabrum of finest silver, or a sweet morsel of pure chocolate. Upon entering the yard, kids are given the choice of which admission price they'd like to pay. If they refuse to pay we thank them for coming, ask them to leave and allow one of the HUNDREDS of other guests waiting to come in BEHIND them to enter.

After a few years, the kids just got used to the fact that they'd have to give up chocolate to come in. My neighbors soon got smart and decided to NEVER give

out chocolate or it would simply go from their house to mine. Once inside the yard the kids would take a tour through the yard, via the stations, and typically be either entertained or given a small trinket at each station. Since they always left with much more than they came in with, the ritual taught them several life lessons. First, if you're willing to give up something you love, you'll get even MORE of something else that you love. Terrific. Second, you DO have to make a sacrifice AND take a risk if you want to experience the strange and unknown but always thrilling tour."

There is an innocence and freedom allowed on Halloween that gives us a chance to play like no other time of year. It's exhilarating and spiritual all at the same time. I have to agree wholeheartedly with Rochelle – Halloween is a wonderful and thrilling night, full of magic and wonders. That's why it felt important to me that there was a decent festival in Edinburgh to celebrate it. The Samhuinn Festival is the work of hundreds of dedicated volunteers who come together and make real magic. At the very beginning of this book I told you a little bit about myself and my family and one dark Halloween night. I also mentioned the wonderful lady who takes on the role of the Cailleach at Samhuinn - Girl Tom. We talked about her role as the Cailleach as I began to write this book. She shared a dream she had had about a wild giant black raven and she told me how she had prepared with nighttime walks on Arthur's Seat and at the Hermitage. She also gave me a copy of a poem she had written a few short weeks after the first Samhuinn Festival. I'd like to end my book with an extract from it.

I met the Cailleach this weekend
Whirling about
In a furious rage through the Cairngorms
Icy fingers slapping our faces
Stinging our eyes
Throwing our voices and catching our breath

Just two weeks since I wore her colours
At the Samhuinn
Amidst fire torches and pagan drums
Hooded cloak of velvet black, blue
Skin, screaming eyes
Twisted spine writhing with arms wide

The journey is done. We have fearlessly ventured into the darkness and sought out the monsters in our closets. Faced death and joined him for a wee jig. It seems a mad task to try to bring illumination to the darkest night of the year – but hey. Halloween has been and will probably always be my favourite night. It is the time when everyone can forget exactly who and what they are and become someone or something entirely different. October 31st is the night that the world forgets about science and reason and embraces the strange and spooky. Halloween is the one weird and wonderful night when we can truly believe in faeries and ghosts.

It is a night where just about anything can happen – and it usually does.

Notes

[1] Your Child and the Occult: Like Lambs to the Slaughter
Johanna Michaelsen, Harvest House, Eugene OR, 1989

[2] The Dark Side of Halloween
http://home.computer.net/~cya/cy00061.html

[3] Can Christians Celebrate Halloween?
Pator Richard P. Bucher, Lutheran Church, http://www.ultranet.com/~tlclcms/canhallo.htm

[4] The Real Origins of Halloween
Issac Bonewits, http://www.neopagan.net/Halloween.HTML

[5] The Celtic Druids
Godfrey Higgins, 1827, reprint by Kessinger Publishing Company, 1997

[6] Boo!
Jack T. Chick, http://www.chick.com/

[7] http://yourgoingtohell.com/hell/halloween.html

[8] http://www.new-life.net/halowen1.htm

[9] http://www.bustifire.com/pumpkin.htm

The Bodysnatcher
Pen and ink on paper, 1913, by Morris Meredith Williams.

(Courtesy of City of Edinburgh Museums and Art Galleries. With thanks to David Patterson.)

Bibliography

The American Heritage Dictionary of the English Language
Fourth Edition, 2000

Apollodorus, Library and Epitome
Trans. by Sir James George Frazer, London, 1921

The Bridal of Caolchairn; and other poems
Allan, John Hay, calling himself John Sobieski Stolberg Stuart, formerly John Carter Allen, London, 1822

British Calendar Customs: Scotland
Mary Macleod Banks, London: W. Glaisher for the Folk-Lore Society, 1937-1941

Carmina Gadelica
Alexander Carmichael, 1928

The Celtic Druids
Godfrey Higgins, 1827, reprint by Kessinger Publishing Company, 1997

A Celtic Miscellany
Prof. Kenneth Hurlstone Jackson, Penguin Classics, 1951

Celtic Mythology and Religion
Alexander MacBain, Inverness, 1885

Chambers Popular Rhymes

Chambers Scots Dialect Dictionary

Chambers Traditional Scottish Nursery Rhymes

County Folklore
Ruth Tongue, vol. VIII, Folklore Society

The Dance of Death
Hans Holbein the Younger, Dover Edition, 1971

The Days of the Dead
John Greenleigh and Rosalind Rosoff Beimler, Pomegranate 1998

Death and the Magician
Raymond Fitzsimmons, Hamish Hamilton Ltd, 1980

Dictionary of Celtic Mythology
J. MacKillop, Oxford University Press

A Dictionary of Fairies Hobgoblins, Brownies, Bogies and other supernatural creatures
Katherine Briggs, London: Allen Lane, 1976

Dictionary of the Middle Ages
American Council of Learned Societies

Discoverie of Witchcraft
Reginald Scot, 1584

Do You Do Voodoo?
Shannon R. Turlington, Garnet Publishing, 1999

Dwelly's Illuminated Gaelic to English Dictionary

Early Irish Myths and Sagas
Trans. Jeffrey Gantz, Penguin Classics, 1981

Ecclesiastical History of the English Nation
Bede

Encyclopaedia Brittanica, 1771

European Witchcraft
E. William Monter, Department of History, Northwestern University, John Wiley & Sons, Inc.

The Evergreen – Winter 1896-7

The Fairy Faith in Celtic Countries
Walter Yelling Evans-Weinz, London, 1911

Fahrenheit 451
Ray Bradbury, London: Corgi, 1973

Folk Lore and Genealogies of Uppermost Nithsdale
William Wilson, 1904

Folklore in the Old Testament: studies in comparative religion, legend and law
Sir James Frazer, London, 1918

Folklore Journal

Folktales of the West Highlands
Campbell of Islay

Fortean Times Magazine

Galoshins - The Scottish Folk Play
Brain Hayward, Edinburgh University Press, 1992

The Golden Bough: a study in magic and religion
Sir James George Frazer, London: Macmillan, 1911-15

Great Architecture of the World
John Julius Norwich, ed. London: Mitchell Beazley, 1975

The Great Pyramid - Its Divine Message
D. Davidson & H. Aldersmith, London: Williams and Norgate Ltd, 1941

The Halloween Tree
Ray Bradbury, Hart-Davis MacGibbon, 1973

'Hamlet's Mill' - An essay on myth and the frame of time
Giorgio de Santillana and Hertha von Dechend, London:
Macmillan, 1970

Happy Halloween Magazine

Highland Superstitions
The Rev. Alexander MacGregor, M.A.

History of Herodotus
Trans. by George Rawlinson, London, 1875

The Kiltartan Poetry Book
New York: G. Putnam's Sons, 1919. pp. 68-71.

The Lion, the Witch and the Wardrobe
C.S. Lewis, London: Geoffrey Bles, 1950

A Magician Among the Spirits
Harry Houdini, New York & London, 1924

Mediaeval Plays in Scotland
Anna Jean Mills, Edinburgh, 1927

Medieval Studies journal

Minucius Felix, 'Octavius'
Translated by G. H. Rendall and W. C. A. Kerr,
Cambridge, Mass. 1931

Minstrelsy of the Scottish Border, ed. T. F. Henderson
Sir Walter Scott, 1902

Le Morte D'Arthur
Sir Thomas Malory

National Geographic magazine

*The National Trust Guide to Traditional Customs of
Britain*
Brian Shuel, Exeter: Webb & Bower, 1985

Old Greasybeard: Tales from the Cumberland Gap
Leonard Roberts Ed. Detroit Michigan: Folklore Assoc.
1969

Pagan Celtic Britain
Anne Ross, Cardinal, 1974

Perthshire in History and Legend
Archie McKerracher, Edinburgh John Donald, c1988

*Popular Superstitions and festive amusements of the
Highlanders of Scotland*
William Grant Stewart, Edinburgh, 1823

Popular Tales of the West Highlands
J. F. Campbell, 1895

Queen Victoria's Highland Journals
Edited by David Duff, Exeter Webb & Bower, 1980

Remains of Nithsdale and Galloway Song
R. H. Cromek, 1810

Scotland: The Ancient Kingdom
Donald A. Mackenzie, Blackie, 1930

*Scottish Folk-lore and Folklife: studies in race, culture
and tradition*
D. A. MacKenzie, London, 1935

*Scottish Studies, the Journal of the School of Scottish
Studies*

Shetland Traditional Lore
Jessie Margaret Edmondston Saxby, Edinburgh, 1932

*The Silver Bough, A Calendar of Scottish National
Festivals, Vol. Three Hallowe'en to Yule*
F. Marian McNeill , Stuart Titles Ltd., Glasgow, 1961

Sir Gawain and the Green Knight
Everyman's Library Edition, 1962

Sketches of Perthshire
P. Graham, 1812

Social Life in Scotland
Rogers

Something Wicked This Way Comes
Ray Bradbury, London: Corgi, 1975

Stations of the Sun
Ronald Hutton, Oxford University Press, 1996

Strange Britain
Charles Walker, Brian Trodd Publishing House Ltd,
1989

Superstitions of the Highlands and Islands of Scotland
John Gregorson Campbell, 1900

The Tain Arans from the Irish epic Táin Bó Cuailnge
Trans. Thomas Kinsella, Oxford paperbacks, 1970

Thistledown (new edition)
R. Ford, 1922

*Tim Burton's Nightmare Before Christmas: The Film –
The Art – The Vision*
Frank Thompson, Boxtree, 1993

Twilight Zone Magazine

Watson's Collection of Scots Poems - 1709

*Witchcraft and the Second Sight in the Highlands and
Islands of Scotland*
J.G Campbell, 1902

The Worst Witch
Jill Murphy, Young Puffin Modern Classics

Your Child and the Occult: Like Lambs to the Slaughter
Johanna Michaelsen, Harvest House, Eugene OR, 1989

Index

the author

Mark Oxbrow was born in Edinburgh, Scotland, at around midday on September 23rd 1971. He spent his early years in assorted castles, forests, historic houses, nature reserves and wild places learning about history, native culture and nature. His parents were biologists and folk enthusiasts while one pair of grandparents ran a butcher's shop and the other pair were vegan for over half a century.
Mark finds food occasionally confusing...

Studies in art and design led to work in advertising and graphics and further post graduate studies in multimedia technologies. This 'real' work has been interspersed with entertaining stints as a theatre puppeteer, festival giant puppet-maker, pyro street theatre designer and performer, children's artsworker and illustrator.

Mark has spent the last few years researching and lecturing on Scottish folklore, Arthurian, mediaeval and grail legends, Beltane and Samhuinn, Rosslyn Chapel, folktales and faerylore. He has taught and lectured at Edinburgh College of Art and at Edinburgh University, contributed to BBC radio programmes and live webcasts and he has given talks at the Sauniere Society Symposia alongside authors including Henry Lincoln, Alistair Moffat and Nigel Tranter.

For about the past decade Mark has been involved with the Beltane Fire Festival and the Samhuinn Festi. He has had various roles and responsiblities including at different times rehearsal director, production, police and fire dept. liason, puppet-making and puppeteering, bonfire maker, folklorist and spokesperson, web-content writer, fireball maker, red man and winter king.

This is his first book and you might like to visit his accompanying website at:

www.thehalloweenbook.com

This book was edited and designed by Harvey Fenton

Cover designed by Harvey Fenton and Mark Oxbrow
Cover Picture Credits:
Front: **Manfred Jahreiß** (www.jahreiss.de)
Back main: **Dogworrier.com**
Back 1: **Elijah Cobb** (Used with permission of the Village Halloween Parade)
Back 2: **Mariette Pathy Allen** (Used with permission of the Village Halloween Parade)
Back 3: **Deborah Bacci**